Piety and Patronage in Renaissance Venice

Piety and Patronage in Renaissance Venice

BELLINI, TITIAN, AND THE FRANCISCANS

Rona Goffen

Yale University Press

NEW HAVEN AND LONDON

Published with assistance from
The Gladys Krieble Delmas Foundation.

Designed by Margaret E.B. Joyner
and set in Bembo type by
Brevis Press, Bethany, Connecticut.
Printed in the United States of America by
Halliday Lithograph, West Hanover, Massachusetts.

Library of Congress Cataloging-in-Publication Data
Goffen, Rona, 1944–
Piety and patronage in Renaissance Venice.
Bibliography: p.
Includes index.
1. Mary, Blessed Virgin, Saint—Art. 2. Catholic
Church and art. 3. Bellini, Giovanni, ca. 1430–1516—
Criticism and interpretation. 4. Titian, ca. 1488–
1576—Criticism and interpretation. 5. Altarpieces,
Renaissance—Italy—Venice—Themes, motives.
6. Pesaro family—Art patronage. 7. Franciscans—
Italy—Venice. 8. Art and state—Italy—Venice.
9. Basilica di Santa Maria Gloriosa dei Frari
(Venice, Italy) I. Title.
ND1432.I8G64 1986 755'.55 85–91280

ISBN 0–300–03455–5 (cloth)
0–300–04696–0 (pbk.)

*The paper in this book meets the guidelines for permanence
and durability of the Committee on Production Guidelines
for Book Longevity of the Council on Library Resources.*

10 9 8 7 6 5 4 3 2

For My Parents

Contents

Contents

Illustrations

Illustrations

[xi]

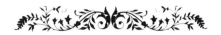

Preface

The church of Santa Maria Gloriosa dei Frari in Venice is a microcosm. Within its walls it contains, quite literally, the history of Venetian Renaissance art. At the same time, the history of the Frari encapsulates that of the Friars Minor, from their thirteenth-century beginnings to the division of the order in 1517. The theological issues and the compassionate spirituality represented by the altars and decoration of the Frari represent the particular concerns and the character of the Franciscan order while also alluding to the special relationship between church and state in Renaissance Venice. All of this is embodied in the altarpieces painted for the Frari by Giovanni Bellini, the greatest master of the fifteenth century in Venice, and by Titian, the sublime genius of sixteenth-century painting.

Three of these works still grace the sites for which they were made: the triptych of the Madonna by Bellini in the sacristy and, by Titian, the *Assunta* of the high altar and the *Madonna* in the left aisle. Titian's *Pietà,* now in the Accademia in Venice, was also originally intended for the same church. Moreover, both Bellini's triptych and Titian's *Madonna* were commissioned by members of the same family, the noble Ca' Pesaro of Venice, and both were endowed as altarpieces of family

funerary chapels. These works bear a special relationship to each other in the context of the Pesaro family history and in regard to the other monuments commissioned by them in the Frari—namely, their tombs.

The Pesaro Madonnas—Bellini's and Titian's—are also kindred in another way: both are altarpieces of the Immaculate Conception of the Virgin. Indeed, Bellini's triptych was one of the first Venetian altarpieces of the Conception painted after recognition of the feast by the Franciscan Pope Sixtus IV. The *Assunta* likewise honors the Immaculate Virgin, and it is probable that the *Pietà* does so as well. But it is not so much the subject as the way in which it is represented that is significant. These images of the Madonna were intended to convey at once several interrelated meanings, both sacred and civic; and the ways in which they do so are also related. It is as though there were a silent colloquy among them, a discourse about theology and spirituality, about the Franciscan order and the Catholic church, about the individual family and the state—and about style and content as well. Conflicts among the Friars Minor and among the Ca' Pesaro are interwoven in the fabric of Santa Maria Gloriosa dei Frari and in the form and content of its great altarpieces by Bellini and Titian.

Bellini's triptych was restored almost a half-century ago. Titian's *Assunta* and the *Pesaro Madonna* have been cleaned in recent years, and Benedetto Pesaro's funerary monument was restored in 1984. Conservation of Titian's *Pietà* has also now been completed, and with happier results than one might have expected given the fragile appearance and poor condition of the canvas. These restorations allow us better to understand the visual reality of the works of art. In this volume I have attempted another kind of restoration, the restoration of these and other works in the Frari to their original context, the unseen reality of civic, social, and spiritual concerns of the patrons and of the Franciscan church that they endowed so splendidly. The influence of Franciscan spirituality, and of secular concerns as well, is reflected in these works by Bellini and Titian both explicitly and implicitly, both iconographically (as one would expect) and also visually. Understanding the ways in which Bellini and Titian expressed these spiritual, theological, and civic interests permits us to appreciate more fully the essence of their art and the greatness of their achievement. Consideration of these masterpieces in their original context helps us to understand what it is that makes the Frari both Franciscan and Venetian. So this book is part art history and part Franciscan history, part Venetian history and part family history. But in Venice, these are almost one and the same thing.

Acknowledgments

I first began to think about the idea of "Franciscan art" several years ago, in the context of studying Mendicant influence on the imagery of the Madonna and saints in the fourteenth century. That work was greatly facilitated by a fellowship from the American Council of Learned Societies in support of a year at the Harvard University Center for Italian Renaissance Studies at the Villa I Tatti in 1976–77. It is a pleasure for me to begin the acknowledgments of this volume by re-iterating my gratitude to the ACLS and to I Tatti.

The American Council of Learned Societies also supported my work on Franciscan influence in Italian art with a grant-in-aid. A grant from the American Philosophical Society and the frequent support of the Research Council of Duke University during the past six years made possible my return to Italy to continue my studies. I am deeply grateful also to the Gladys Krieble Delmas Foundation for a grant for research in Venice in 1980. My research and the writing of this book, and of other publications as well, would not have been possible without the financial support of these several foundations and institutions. An additional grant from the Delmas Foundation permitted the illustration in

color of the works by Bellini and Titian which are the focal points of this book. I am most thankful for this assistance.

I want also to thank the directors and the staffs of the libraries in Venice where I did most of my research: Dott. Francomario Colasanti of the Biblioteca Nazionale Marciana and Dott. Giandomenico Romanelli of the Biblioteca Correr, where I owe special gratitude to Sig. Urbano Pasquon, who knows where everything is. At the Archivio di Stato, the director, Dott.ssa Maria Francesca Tiepolo, and her associates, in particular Dott.ssa Giustiniana Colasanti Migliardi O'Riordan, Dott.ssa Francesca Romanelli, and Dott.ssa Alessandra Schiavon, were most helpful to me. While working there I was also often the beneficiary of Professor Guido Ruggiero's patience and expertise. My work in S. Maria Gloriosa dei Frari was always greatly facilitated by the friars themselves and most especially by Father Domenico Carminati. In particular, I am grateful for his allowing me to consult the archives of the convent.

Art historians need photographs, and for their help with that sine qua non I thank the efficient and courteous staff of the Archivio Fotografico of the Museo Correr in Venice. I am also especially grateful to Gianfranco Spinazzi, Fernando Quaglia, and Patricia Peck, who very kindly photographed several monuments for me in the Frari. Dott.ssa Fiorella Superbi Gioffredi of the Fototeca Berenson helped me to obtain photographs that I would not have been able to get without her kind intervention.

My research has been assisted most generously in many ways by Professor Francesco Valcanover, Soprintendente ai Beni Culturali, who has encouraged my work in Venice since I first came there in the summer of 1967. Maria Giovanna Valcanover frequently offered kind hospitality, and their daughter Anna Francesca Valcanover gave me her company and assistance during many trips to the Frari. I express my infinite thanks also to Dott.ssa Giovanna Nepi Scirè, the Director of the Gallerie dell'Accademia, who has helped make my time in Venice both enjoyable and productive.

Several kind friends and fine scholars helped make this book much better than it would have been without their assistance. I thank Professor Salvatore I. Camporeale, O.P., for his erudite counsel about theology and about history; Professor David Rosand for innumerable knowledgeable suggestions about Venice and Venetian art; Professor Sarah Wilk for her sage advice, particularly about sacred imagery; and Professor Ronald G. Witt for saving me from some lapses of logic and of Latin. Professors Francis Newton and Robert Wallace were also most helpful with some of the Latin passages in this text. With patience and

zeal, Professor Frank Borchardt taught me how to use the computer on which this book was written (and rewritten). I gratefully acknowledge, too, the recommendations and advice of other generous scholars, including Professors Caroline Bruzelius, Melissa Bullard, Howard Burns, Howard McP. Davis, and Diane Finiello Zervas. Finally, I thank Judy Metro and Barbara Folsom. Their editorial suggestions improved the form and substance of this book, and their enthusiasm for it improved the mood of the author.

1

Santa Maria Gloriosa dei Frari: The Ca' Grande of Venice

Were you ever at Venice? Sometimes there of an eve-
ning, there comes a little wind which goes over the face
of the waves and makes a sound upon them, and this
is called the voice of the waters. But what it signifies is
the grace of God, and the breath breathed forth by him.
The little breeze—that is the word of God, which is full
of the melody of the holy Spirit, and the waters are
those who stay to give it ear.
—St. Bernardino of Siena, 1427[1]

1. The Friars in Venice

The Franciscans came early to Venice and the surrounding islands. Saint
Francis himself (1181/2–1226) had visited Venice and the islands of the
Lagoon, probably in the spring of 1220.[2] According to tradition, the
modest church of S. Francesco del Deserto was built on the site where
the marsh birds miraculously obeyed the saint's command for silence
while he and a brother said the office (fig. 1). "One time when Francis
was walking with another friar in the Venetian marshes," Bonaventure
recounts,

they came upon a huge flock of birds, singing among the reeds. When
he saw them, the saint said to his companion, "Our sisters the birds
are praising their Creator. We will go in among them and sing God's
praise, chanting the divine office." They went in among the birds
which remained where they were so that the friars could not hear
themselves saying the office, [the birds] were making so much noise.
Eventually the saint turned to them and said, "My sisters, stop singing
until we have given God the praise to which he has a right." The birds

[1]

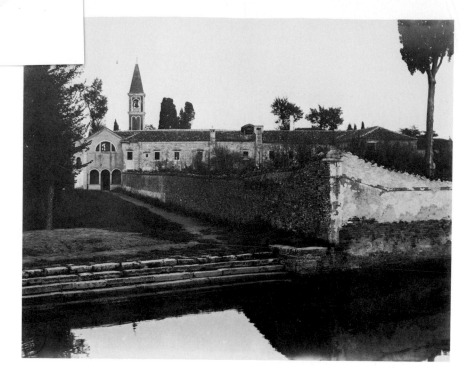

1. Venice, San Francesco del Deserto.

were silent immediately and remained that way until Francis gave
them permission to sing again. . . .[3]

Constructed in 1233, the church built where Francis silenced the birds
is the earliest recorded Franciscan institution in the Veneto, and among
the first churchs to have been dedicated to the saint, possibly second
only to S. Francesco in Assisi, which was begun in 1228.[4] By 1234,
only a year after the completion of S. Francesco del Deserto, the first
Franciscan community in Venice itself was living in the area around
S. Tomà, near the future site of S. Maria Gloriosa dei Frari (fig. 2).

The church of the Frari was (and is) the largest establishment of the
friars in Venice and arguably the most important, *pace* S. Giobbe and
S. Francesco della Vigna. Thus, in Venetian sources and documents,
the Frari was commonly identified by terse and seemingly vague ref-
erences to the "Francescani," the "Frati Minori," or even the "Ca'
Grande."[5] It is one of the most splendid monuments of the Renaissance:

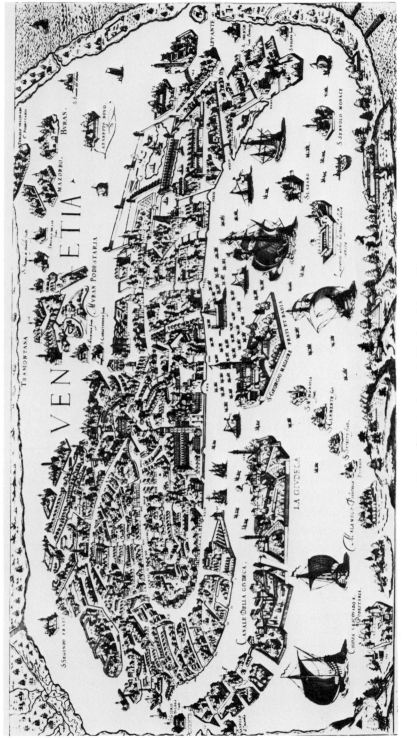

2. Map of Venice in 1596. Venice, Museo Correr.

altarpieces and sculptural decoration are some of the greatest
es of Italian art, and, remarkably, almost all of these are still

ifference between the remote and comparatively modest church
ancesco del Deserto and the central and lavishly decorated Frari
is related in turn to differences within the Franciscan order. These con-
flicts, tragically arising from Francis himself, chiefly concerned the own-
ership of property and the proper role of the friars in society. Francis
was torn between two self-contradictory impulses, the desire for a con-
templative life devoted to prayer—as at La Verna, the site of the stig-
matization—and an active life dedicated to preaching and teaching the
faithful. The right to preach was a fundamental privilege of the Men-
dicants and their raison d'être, differing from the traditional monastic
orders, which were often expressly forbidden to preach to laymen.[6] This
was reflected in their diverse living arrangements: monks lived a rural
life in monasteries isolated in the countryside, while the friars were
essentially urban, living in convents in cities. But preaching and teach-
ing raised problems for the Franciscan order about the very practical
matter of ownership of property—essentially churches, convents,
schools, and even books—as opposed to strict adherence to an ideal
poverty precluding ownership of any property whatsoever. Eventually,
these differences proved insolvable for the contending Franciscan fac-
tions, primarily the Observants and the Conventuals, and led to the
division of the order in 1517.[7] S. Francesco del Deserto, as its name and
perhaps even its location imply, was not an ideal foundation for the
Conventuals and was abandoned by them. S. Francesco became a
church of the Observants, a community favoring strict adherence to
Francis's injunctions against ownership of property, whereas the Frari
was (and is) Conventual.[8]

The church of the Frari became the Ca' Grande of Venice as a con-
sequence of patronage, and in some ways the history of this Venetian-
Franciscan patronage is typical of the history of Franciscan patronage
elsewhere in Italy. The friars were sponsored locally by the government
and by various wealthy families. And they were supported "nationally"
and internationally by the papacy, which promoted the construction of
Franciscan churches and convents by granting numerous special privi-
leges to the order and by awarding generous indulgences to contribu-
tors.[9] But in addition, the Frari in Venice also benefited from certain
local conditions and circumstances that helped assure its prosperity and
hence its historical—and art historical—importance.

2. Building the Frari

It may be that followers of Saint Francis remained in Venice after his visit to the area in 1220. In any case, the friars were certainly residing in Venice by 1227, although perhaps not yet in any fixed location. In that year, one Achillea Signolo bequeathed ten lire to the Franciscans of Venice in her testament.[10] At the same time, the Dominicans were also settling there. The Preachers' most important church in the city, SS. Giovanni e Paolo (Zanipolo), was founded ca. 1230 with donations from Doge Jacopo Tiepolo. According to Venetian chroniclers, the doge had been inspired by a celestial vision.[11] The foundation of the Frari, however, was terrestrial. In 1234 the Venetian Giovanni Badoer gave the Franciscans a plot of land and a house between S. Stin and S. Tomà (fig. 2). The document of donation mentions a church of the friars, presumably the deserted Benedictine abbey mentioned by Sansovino: "Ecclesiam eorumdem Fratrum Minorum habitant."[12] Badoer's land was evidently the same plot that he had received a year earlier in a division of property, at which time it was still described as an empty lot.[13] Consequently, if indeed the documents refer to the same property, it appears that the house he gave to the friars was in fact constructed expressly for them: Giovanni Badoer had built the first convent of the Frari.[14] Two years later, in 1236, the Franciscans acquired further properties in the vicinity of S. Tomà, "versus locum Fratrum Minorum," *locus* meaning either "place" or "monastery."[15] Thus the friars were already established in the area that was to become so closely associated with them. Whether by accident or, more likely, by design, their "locus" was on the opposite side of the city from the contemporary Dominican settlement at SS. Zanipolo. Such geographical opposition was typical for Franciscan and Dominican churches. One sees the same configuration in other Italian cities—for example, Florence, where the Franciscan S. Croce is at one end of town and the Dominican S. Maria Novella is at the other, and both are equidistant from the center of secular power at the Piazza della Signoria.[16] Similarly, the Mendicants of Treviso also sought to keep a certain distance from each other. The diarist Marino Sanuto recorded that in 1515 the Council of Treviso had conceded to the Observant Franciscans the right to build a new church and convent near the Dominican church of S. Nicolò. But in 1521, when the friars wanted to begin construction, the Dominicans protested that they did not want the Franciscans quite so close. A new location had to be found.[17]

The first Franciscan construction at S. Tomà must have been modest,

and this was no doubt intended as a visible reflection of the austerity of their avowed poverty.[18] Originally neither Franciscans nor Dominicans had churches of their own but attended services wherever their ministry took them and preached either in open squares or in churches borrowed for the occasion.[19] However, according to church law, every religious community was required to have a *titulus,* that is, a determined church— even a community of itinerant preachers.[20] The earliest Mendicant churches were often humble buildings, sometimes little more than abandoned shacks, like S. Damiano, S. Pietro, and the Portiuncula, the three churches that Saint Francis himself restored.[21] Similarly, the friars of Venice took possession of a deserted Benedictine abbey. Such churches served only the brothers themselves and not a lay congregation. Indeed, early Franciscan communities might not necessarily include a priest among the brothers.[22] Thus, the church near S. Tomà mentioned in the document of 1234 would likely have been intended only for the friars. But this situation soon changed for two elementary reasons. The number of friars was growing, and priests of established churches were increasingly reluctant to welcome them and their audiences, despite encouragement to do so by the papacy.[23] At any rate, the Venetian friars must have outgrown their first buildings rather quickly. In 1249, only a dozen years after Badoer's endowment, a bull was promulgated by Innocent IV on March 25, the feast of the Annunciation, conceding forty days' indulgence for contributions for the construction of a new church of the Frari to be dedicated to the Madonna.[24] The structure that had served the Franciscan locus of 1234–36 was no longer considered satisfactory; if the construction promoted by Innocent IV was in fact to be the first church built for—indeed, built *as*—the Frari, then their success in the community presumably warranted this development.

The first stone was laid almost a year later, 3 April 1250, by Ottaviano, cardinal deacon and apostolic legate, who announced indulgences of one hundred and forty days for assistance in the building. Dedicated to the feast of the Assumption of the Virgin, the church was named "Santa Maria Gloriosa" (meaning "Assunta") to distinguish it, Ottaviano explained, from other churches consecrated to the Madonna in Venice.[25] Too, the dedication of the Frari expressed the profound devotion of Saint Francis and his followers to the Virgin Mary. This devotion was reflected in the policies of the order and in the writings of individual Franciscan friars as well. For example, the high altar of the Upper Church of S. Francesco in Assisi was dedicated to the Madonna. It was the Franciscans who introduced the feast of the Visitation to the Western church in 1263, over a century before it was extended to the universal church in 1389.[26] And it was a Franciscan friar who

wrote some of the most beautiful and most influential poems dedicated to the Madonna in the Italian language, Jacopone da Todi, the author of such lauds as the magnificent "Stabat Mater" and "O Vergine più che femina."[27]

Papal patronage greatly assisted the Franciscan church of the Virgin in Venice, as it did the Franciscan order in general. Innocent IV's bull of 25 March 1249 was followed three years later by another concession of forty days' indulgences for those who contributed to the costs of building the church and convent of the Frari.[28] Alexander IV, Innocent's successor, further encouraged the new Franciscan church by granting indulgences in bulls of 1255, 1256, and 1261, rewarding visits to the Frari on the feasts of saints Francis, Anthony, and Clare.[29] And these concessions of indulgences were followed by many more: to cite only two of many possible examples, in 1291 the Franciscan Nicholas IV granted indulgences of a year and forty days for visiting the altars of the Madonna and of Saint Mark on their feast days;[30] and in 1463, Pius II granted still further indulgences to the Frari in response to the request of Cardinal Pietro Barbo, whose parents were buried there.[31]

The thirteenth-century church of the Frari stood until it was replaced by the present building, begun ca. 1330 (figs. 3–9).[32] The older structure had the opposite orientation; its altar was where the present-day portal is, facing toward the *rio*.[33] The new apse and flanking chapels were constructed first, and work proceeded toward the facade. At first, work progressed rapidly, and the liturgical east end of the new church must have been effectively completed by 1336, the date inscribed on the tomb of the Florentine ambassador to Venice, Duccio degli Alberti, constructed in the former chapel of the Scuola di S. Francesco, the second to the right of the high altar (fig. 10).[34] Duccio was a member of the wealthy Alberti family of Florence, a brother of Alberto di Lapo Alberti, the patron of the high altar of S. Croce, the major Conventual Franciscan church in that city. Duccio had died in the Brenta, but his body was brought back to Venice for burial in the Frari.[35] His entombment there demonstrates a loyalty to the Franciscan order that transcended "state" boundaries.[36]

The equestrian monument of the condottiere Paolo Savelli to the left of the entrance to the sacristy—the earliest equestrian monument in a Venetian church and another instance of family loyalty to the Franciscan order—also provides evidence regarding the construction of the building (fig. 11).[37] Savelli died in 1405, and one may estimate a date of ca. 1415–20 for the completion of the condottiere's tomb, a date consistent with the stylistic evidence. Logically, the Frari must have been vaulted by the time Savelli's monument was completed.[38] Indeed, San-

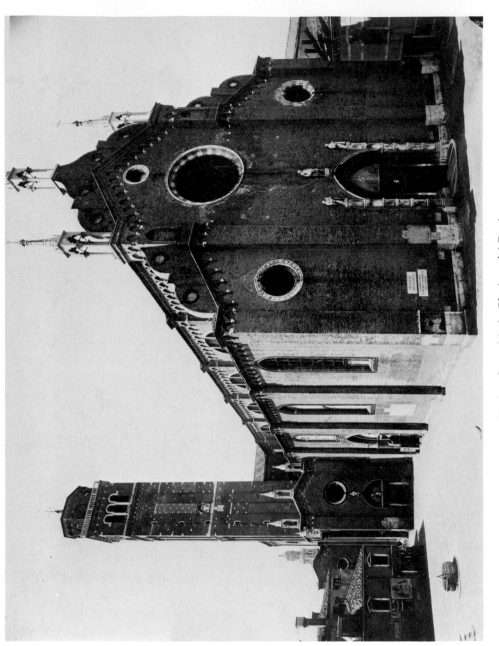

3. Venice, Santa Maria Gloriosa dei Frari.

4. Venice, Santa Maria Gloriosa dei Frari. Plan. (A) Corner Chapel of the Madonna and St. John the Baptist; (B) site of the Florentine Chapel of the Madonna and St. Mark; (C) *campanile* and altar of the Madonna del campanile; (D) Miani (Emiliani) Chapel of St. Peter; (E) Choir; (F) Pesaro di San Benetto Chapel of the Immaculate Conception in the sacristy; (G) Monument of Benetto Pesaro; (H) Porta di S. Carlo (site of the monument of Girolamo Pesaro); (I) Milanese Chapel of St. Ambrose; (L) Monument of Doge Giovanni Pesaro, with the Pesaro dal Carro Chapel of the Immaculate Conception to the liturgical east.

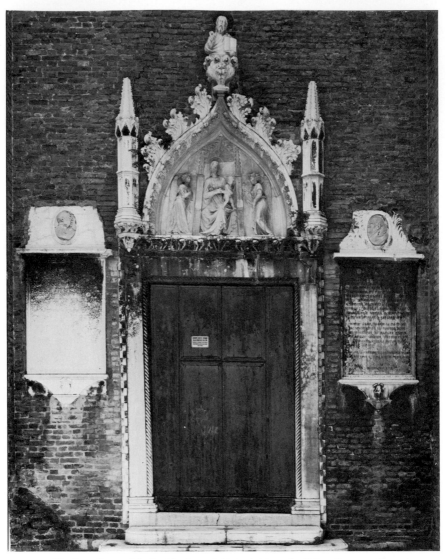

5. Venice, Santa Maria Gloriosa dei Frari. Portal of the Corner Chapel.

sovino wrote that Savelli himself was the patron of the vaults.[39]

The entire construction of the Frari must have been essentially fin-
ished—and the thirteenth-century church totally demolished—by 1428,
according to the Franciscan archivist Antonio Sartori. In that year a
bridge was built over the rio outside the entrance: completion of the
church would have created the necessity for a bridge facilitating access

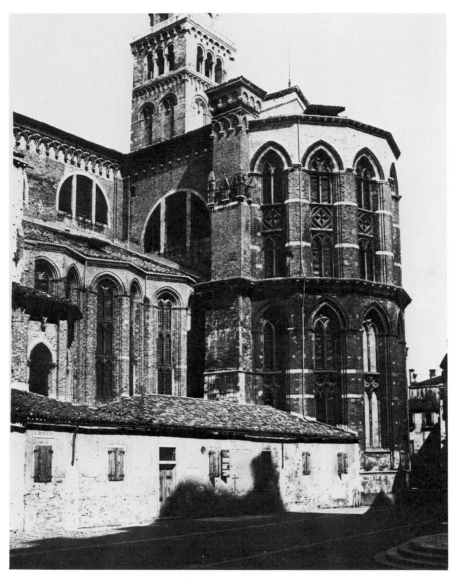

6. Venice, Santa Maria Gloriosa dei Frari. Apse before restoration.

to the new main portal from the direction of S. Polo and Rialto.[40] Even if Sartori's reasoning was faulty here, he cannot have been mistaken by more than fourteen years, for by 1442 construction of the chapel of the

[11]

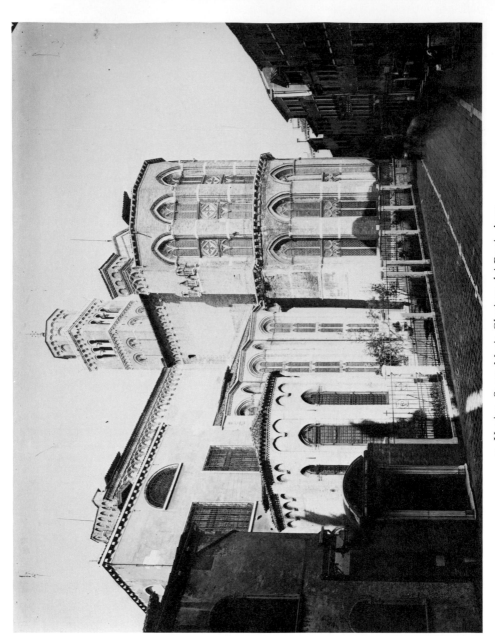

7. Venice, Santa Maria Gloriosa dei Frari. Apse.

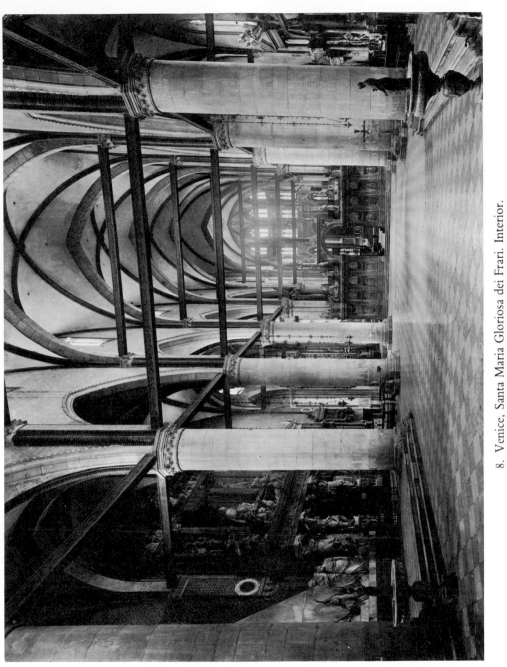

8. Venice, Santa Maria Gloriosa dei Frari. Interior.

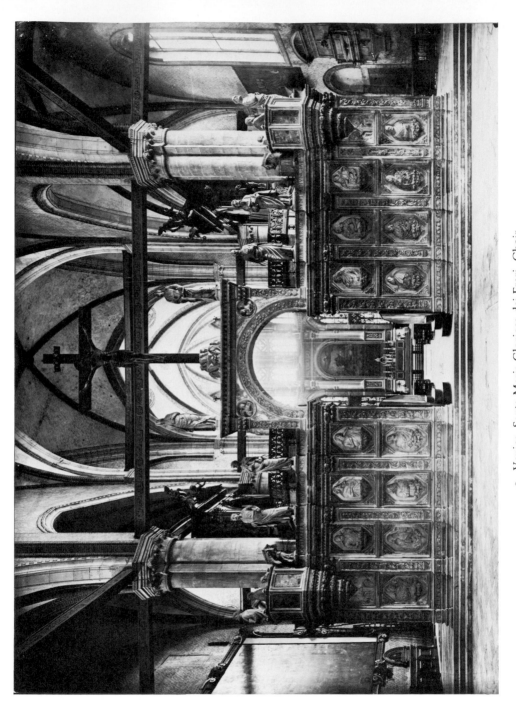

9. Venice, Santa Maria Gloriosa dei Frari. Choir.

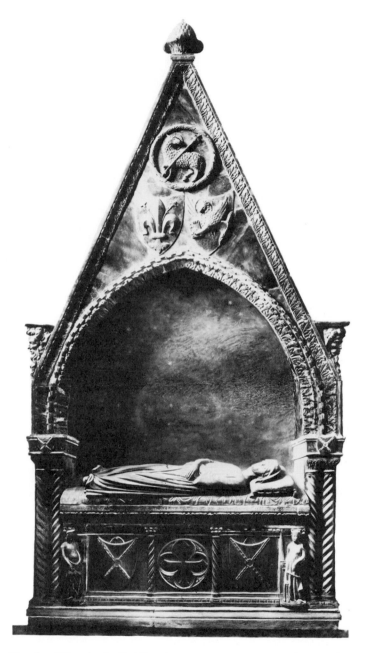

10. Tomb of Duccio degli Alberti. Venice, Santa Maria Gloriosa dei Frari.

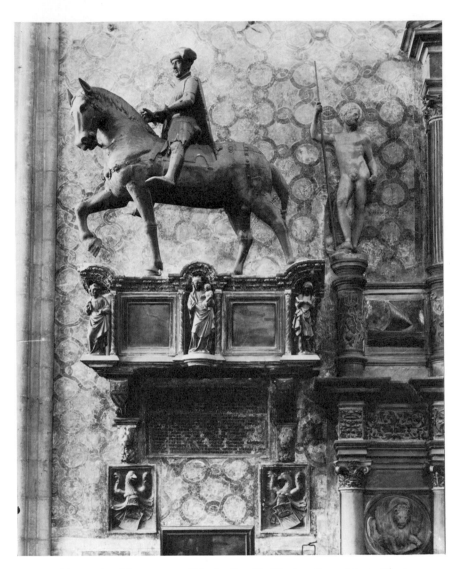

11. Equestrian Monument of Paolo Savelli. Venice, Santa Maria Gloriosa
dei Frari.

Florentine confraternity was completed, including their oculus in the
facade to the left of the main portal (fig. 3).[41] Thus, from start to finish,
the church of the Frari had taken approximately a century to complete.
 Next to the church, rising to an impressive fifty-three feet, the bell

[16]

tower is second in height only to that of S. Marco itself.[42] This con-
spicuous display of Franciscan *campanilismo* was endowed by several
patrons and completed in 1396.[43] Meanwhile, work continued on the
convent, which had been destroyed by fire in 1369. It was finally re-
constructed by 1463.[44]

In 1469, the Frari was the site of a *Capitolo Generale* of the Franciscan
order, and this would have presented the occasion for the consecration
of the high altar to "S. Maria Gloriosse per festo assumptionis," and to
saints Barbara, Catherine, Dionysius, Francis, and Stephen.[45] The Frari
itself was finally dedicated on 27 May 1492 by the Franciscan Pietro
Pallagari of Trani, Bishop of Telesino, in honor of the Assumption of
the Virgin.[46] And almost another thirty years after that the high altar
was at last completed and Titian's great *Assunta* installed, the trium-
phant conclusion of the essential decoration of the Frari (figs. 9, 32, and
33).

3. The Plan and Organization of the Interior

The plan of the Frari is basically that of a T-shaped basilica, probably
meant to invoke the Tau, Saint Francis's beloved symbol of redemption
(fig. 4): "Francis always had great reverence for this particular sign, and
he often recommended others to use it. He used to put it at end of all
his letters, as if his only desire was 'to mark the brows of the true
disciples of Jesus Christ who weep and wail with this sign of the cross,'
as we read in the prophet Ezechiel (9, 4)."[47]

In its plan, the Frari resembles the Upper Church of S. Francesco in
Assisi, which is vaulted in stone, and the Florentine church of S. Croce,
more modestly roofed in wood. These and other thirteenth-century
Franciscan churches interrupted the severity of the basic T-shape with
the polygonal form of the apse, thus distinguished as the focal point of
the church. In Assisi and Florence the chapels flanking the apse are
rectangular in plan.[48] But the friars of Venice varied this simple and
static Franciscan pattern with the polygonal profiles and zigzag move-
ment of the chapels at the liturgical east end (figs. 6 and 7). The staccato
rhythm of the apses charges the rather stolid, massive building with
energy. Later (as indeed at S. Croce and the Lower Church in Assisi),
the original plan was elaborated by the addition of private family cha-
pels, those of the Corner (St. Mark), the Miani (St. Peter), and the
Pesaro chapel of the Madonna in the sacristy (figs. 12 and 13). These
variations in the plan also affect the plain brick exterior of the Frari,
providing most of the decorative interest, as the portals leading to the

Corner and Miani chapels are adorned with sculpture. A statue of Saint Peter stands in the lunette of the entrance to his chapel of the Miani, and above the lunette is another figure, presumably representing Christ. The portal of the Corner chapel of St. Mark is more elaborate, with an elegant relief of the Madonna and Child enthroned between angels (fig. 5).[49] The Child seems almost to walk off his mother's lap, approaching the angel on his left, who proffers a cross. The meaning is clear: Christ's Passion is adumbrated in his childhood, and even as an infant he is prepared to accept his sacrificial role. A similar theme was reiterated in the decoration of the main portal of the church (fig. 3). Here a figure of the Resurrected Christ is accompanied by Saint Francis and by Mary, once again holding her Child.[50] Thus Christ's triumph over death is associated with his childhood and with two benevolent intermediaries for mankind, the Virgin and Saint Francis, himself marked with the wounds of Crucifixion.

Aside from the sculptural decoration of these three entrances, the broad surfaces of the brick exterior are interrupted only by giant pilasters, arched corbel tables, and the fenestration. The smaller oculi of the facade are original, with reliefs of the confraternities of the Florentines (lilies) and of Saint Anthony (a half-figure of the saint). However, the larger oculus and the ogive windows of the clerestory are reconstructions (figs. 3, 6, and 7).[51]

The interior of the basilica has a wide nave—the better to accommodate a preacher's audience—and flanking aisles, all three with groined vaults (fig. 8). The brick walls of the aisles are sectioned by pilasters, also in brick but with stone capitals. These pilasters, which correspond to the pilasters of the exterior, were no doubt intended to mark the bays and to suggest the boundaries of individual altars or chapels, although some later constructions have ignored these clear demarcations. The nave is divided into six ogival bays by widely spaced piers, massive stone cylinders with stepped bases and narrow capitals. Both the first level of the bases and the echinus of the capitals are octagonal, and this was probably meant to be symbolic. The number eight traditionally refers to birth and rebirth, which also explains the familiar octagonal structure of so many baptistries.[52]

Brick was used for the ribs of the vaults, and stone for the moldings of the transverse arches. The brick ribs join in clusters above the capitals of the piers. These ribs receive capitals of their own, at the springing of the vault, where they are joined by the stone molding of the arches. Wooden tie-beams project from this level, cutting across the nave. Another series of tie-beams rests on the capitals of the piers and helps support the vaults of both the nave and the aisles.

The nave is interrupted by the great stone choir, constructed between the fifth and sixth piers, just before the crossing (fig. 9). Thus, the organization of the interior of the church expressed its dual function: preaching and the celebration of divine services.[53] The choir—one of the few to survive in Italy—divides the church, reflecting those two purposes of the Frari and the two communities that it served, the friars of the convent and their lay congregation.[54] The choir and transept are raised two steps above the floor level of the public area, underscoring this duality of purpose and the division of the church. According to the inscriptions, the wooden choir stalls, which provide places for one hundred and twenty-four friars, were completed in 1468, and the richly carved stone facing, added in 1475, includes figures of Old and New Testament saints, saints of the Franciscan order, Doctors of the Church, the Virgin Mary, and the Crucified Christ.[55] The structure is an unusual one, in effect a hybrid that combines a choir stall with a rood screen— but a screen of a particular kind. Completely covered with half-length figures that were originally gilded, the Frari "choir" resembles a Byzantine iconastasis, though made of stone reliefs instead of gold-ground icons.[56]

Now, much of this is against the letter, and all of it against the spirit of the rules governing church architecture for the Franciscan order as set down by the Chapter of Narbonne in 1260.[57] However, it is well known that those rules were more honored in the breach than in the observance, and the Frari was far from the only Franciscan building to have been elaborately decorated.[58] And elaborate it was. While most of the original altarpieces and much of the sculptural decoration are intact and in situ in the Frari, very little of its frescoes or stained glass has survived (figs. 11–13).[59] But it was precisely these decorative elements that would have dominated one's impression of the church. The Frari that Bellini and Titian knew would have made a very different impression from today's indeed, with the bright polychromy and gilding of its tombs and other sculpture, the vivid colors of the mural paintings, and the jewel tones of the windows. In addition to all this, on certain feast days the church would have been further embellished with tapestries and banners.[60] Compared to its former splendor of varied color, texture, and pattern, the Frari of modern times is stark and bare. One must restore this lost glory in the mind's eye and at the same time restore also the invisible setting of the church, that is, the cultural environment established by the original altar dedications and their historical, social, and spiritual associations.[61]

4. The Spiritual Setting

Two significant themes were expressed by the dedication of chapels in the Frari during the Renaissance, which resembled other great Franciscan houses of Italy—for example, S. Croce in Florence and S. Francesco in Assisi—in this concern with a unifying program for the church decoration.[62] First of all, S. Maria Gloriosa was very much a church of the Madonna. At the beginning of the sixteenth century, there were no less than *eight* altars consecrated singly or jointly to the Virgin Mary in the Frari.[63] The following chapters of this book are concerned with three of those altars and with historical, art historical, and theological aspects of the cult of the Virgin in Venice.

The other theological theme of the Frari was the fundamental Franciscan belief in Saint Francis as the compassionate intermediary whose efficacy is guaranteed by his stigmata. The stigmata were the seal of divine approbation for the saint and his order, and the sign of Francis's irresistible power as a mediator at the time of judgment.[64] This faith is announced on the facade by the sculptures of the Madonna and Child and of Saint Francis standing to either side of the Resurrected Christ (fig. 3).[65] Inside the church, the theme was conveyed by means that may now seem arcane but which would have been readily understood by the Renaissance friars and their congregation. Thus, the Crucifixion itself was venerated at the second altar on the right of the entrance.[66] In a Franciscan context, the cult of Christ Crucified was inextricably associated with the cult of Saint Francis himself, and this is made explicit by the dedications of two chapels in the chancel. The second chapel to the left of the chancel had been dedicated to the Archangel Michael as early as 1348 and was later conceded (with the same dedication) to Melchiore Trevisan, who was buried there in 1500.[67] Angels in general, and in particular the Archangel Michael, had special significance for the Franciscan order. Francis himself was considered an angel, the Angel of the Sixth Seal.[68] His own devotion to the angels was well known, and especially his love for Michael, "because it is [the archangel's] task to bring souls before God."[69] And this is how the archangel was represented in the carved and gilded altarpiece made for the chapel in the late fifteenth century: trampling a devil and weighing souls, and flanked by saints Sebastian and Francis.[70]

For the Franciscans, the stigmatization of Saint Francis was profoundly associated with the cult of Saint Michael and with the saint's own veneration for the archangel. Francis had gone to La Verna to observe "a forty-day fast in honor of St. Michael . . . , as was his custom," and it was during that vigil that he received the wounds of

crucifixion.[71] Saint Bonaventure described the miraculous event: "True love of Christ had now transformed his lover into his image, and when the forty days which he had intended spending in solitude were over and the feast of St. Michael had come [September 29], St. Francis came down from the mountain. With him he bore a representation of Christ crucified which was not the work of an artist in wood or stone, but had been reproduced in the members of his body by the hand of the living God."[72] These are powerful associations indeed for a Franciscan community, and they explain the early dedication of a chapel to the archangel in the Frari—where it must have been among the first altars dedicated in the new church—and in other churches of the order. In S. Croce in Florence, the chapel of St. Michael was the earliest to be decorated.[73] And above the thirteenth-century altar of St. Michael in the Upper Church of S. Francesco in Assisi, Cimabue painted his cataclysmic vision of the Crucifixion, in which a grieving St. Francis clings to the foot of Christ's cross (ca. 1280–83). Nearby, on an adjacent wall, the Archangel Michael himself appears, and choirs of angels populate both real and fictive arcades.[74]

In 1480, probably at the time of his endowment of the chapel of St. Michael, Trevisan had presented the Frari with a very great donation, a relic that had been cherished in Constantinople, a drop of the Blood of Christ mixed with some of Mary Magdalen's unguent.[75] A marble tabernacle was designed by Tullio Lombardo to contain the Blood, originally placed in the Chapel of St. Michael, and a dedicatory inscription at the chapel entrance commemorated Trevisan's gift.[76] This relic was endowed with a specifically Franciscan significance. In its original setting in the Chapel of St. Michael, which evokes the miracle of the stigmatization, the relic of the Blood recalled the basic Franciscan belief that the wounding of Saint Francis was a (nonfatal) reenactment of the Passion of Christ. The relic of the Blood was brought to the Chapel of St. Michael in part for this reason—to assert the equivalence of the stigmatization of Saint Francis and the Crucifixion of Christ.

The relic was greatly venerated in the Serenissima, and its presence in the Frari was duly noted by authors of Renaissance guidebooks and other volumes on Venice. Sabellico wrote that it was miraculous.[77] And Sansovino described the annual procession in honor of the Blood: "[At the Frari] every year on Passion Sunday, the Sunday of Lazarus, all the people honor the Blood of Christ, which was brought from Constantinople by Marchio [Melchiore] Trevisan, as recorded in an inscription near its shrine, and given to this church, together with some unguent with which the Magdalen bathed the feet of Our Lord."[78]

The chapel next to Trevisan's was dedicated to Saint Andrew in the

late fourteenth century.[79] Saint Andrew had also been crucified, and this repetition of the theme of crucifixion may be understood in relation to the Passion-stigmatization iconography of the adjacent chapel of St. Michael and the Blood of Christ, and to the theme of *Franciscus Alter Christus* as the benevolent intermediary, whose prayers for mercy cannot be denied precisely because he carries those wounds. Perhaps the most familiar expression of this faith is the famous prayer that Thomas of Celano, the first biographer of Saint Francis, attributes to the friars.[80] Similarly, it is the theme of a Franciscan laud in a fifteenth-century Venetian manuscript:

Lauda[m]o Ih[es]u et la sua dolce ma[d]re e l'umile Franc[esc]o nostro padre. . . . Sa[n] Franc[esc]o beato el mo[n]do ai ilumi[n]ato p[er] tua hu[mil]tà la s[an]cta t[ri]nita i[n] te volse habitare B[e]nedeto Franc[esc]o vaso de dio . . . chi gua[r]da el tuo aspeto co[n]te[m]pla el crucifixo. . . . in te fo transformato la sancta passione. . . . France[sc]o p[er] amore è stato crucifixo. . . .

[We praise Jesus and his gentle mother and humble Francis our father. . . . Blessed Saint Francis, you have illuminated the world with your humility, the holy Trinity wants to live in you, Blessed Francis, vessel of God. . . . Who beholds you contemplates the Crucifix. . . . In you the holy Passion was transformed. . . . Francis has been crucified for love. . . .][81]

5. Patterns of Patronage

Concorsero alla spesa molti, così nobili come citta-
dini.—Francesco Sansovino, 1581.[82]

The friars enjoyed some of their greatest successes during the latter part of the fifteenth century, that is, during the approximately fifty years prior to the dissolution of the Franciscan order in 1517. Much of the decoration of the Frari was completed during this period and was surely promoted, in a general way at least, by official approbation and encouragement.[83] In 1475, for example, the Senate decreed that the feast of Saint Francis be observed with a public celebration.[84] However, it was neither the papacy, the Republic, nor any governmental agency, but rather the private patrons of the Frari who, quite literally, made the church the splendid monument that it is. Among these patrons were various confraternities, foreign and Venetian, as well as numerous in-

dividual benefactors, "così nobili come cittadini," as Sansovino described them.

The great work of building and decorating the Frari was achieved almost entirely through contributions from such private donors and with comparatively little assistance from the state.[85] To be sure, like all other churches in Venice, the Frari might benefit from the *decima,* a tax of which one-quarter was earmarked for the construction and maintenance of churches.[86] But, precisely because the *decima* was allocated among all the churches of the city, it represented a different kind of public financial support from that granted similar foundations in Florence, for example. In Florence, a church might be the responsibility of a particular guild or of the *gonafalone* in which the church was located. Thus, work at S. Croce, the Florentine counterpart of the Frari, was directed by the *Calimala,* the great Cloth Merchants' Guild.[87] In Venice, official concerns were rather different. Traditionally, the issue of primary importance was this: any powerful ecclesiastical position must be given to a faithful son of the Republic. Only after 1521 did the government concern itself with the financial (and moral) business of convents and monasteries, through the office of the Magistrato sopra i Monasteri. And then their purpose was as much to suppress certain houses as to encourage others.[88]

There was an underlying reason for the success of the Frari (and of Mendicant churches in general) with private donors. In 1256 (if not before), the Frari had been granted the still exceptional right of burying the dead by Pope Alexander IV in a bull of 15 May, "Cum a nobis petitur."[89] One is so accustomed to tombs of laymen in churches that the extraordinariness of such burials is often taken for granted. Even with most of its Medieval and early Renaissance tombs destroyed, S. Croce in Florence, for example, almost seems to be a necropolis, its floor in effect paved with tombstones.[90] But the historical reality is that—always excepting the burials of monarchs and other rulers—the burial of laymen in churches was rare before the twelfth century and became common only with the establishment of the Mendicant orders. Perhaps this more than any other privilege granted by the popes to the new orders assured the success of their churches: the right to burial in one's parish church was the irresistible quid pro quo exchanged with patrons by the friars for the building, decoration, and endowment of their churches.[91] A case in point—a typical example of modest patronage by one of Sansovino's "cittadini"—is Olda, a notary's wife whose son was a friar in the Frari. Olda wished to be buried there and bequeathed funds in her testament of 1361 for the friars who would attend her funeral service and for the purchase of candles.[92]

[23]

A great patron of the Frari, any one of Sansovino's "nobili," wanted essentially the same thing as Olda, namely, burial in the church. For example, the nobleman Federico Corner endowed a family chapel of St. Mark in the Frari and stipulated that he was to be interred there. The relevant clause in his testament of 15 March 1378 reads as follows: "First, I want a chapel in the church of the Friars Minor in Venice, to be constructed in whatever part [of the church] my commissaries think best . . . and in that chapel a sepulchre will be constructed in which will be placed my body and that of my brother's blessed soul."[93] Corner's chapel was finally completed almost a century later.[94] His donation, and its execution by his son and heir Giovanni, are recorded in a most elegant (and conspicuous) cenotaph by Jacopo Padovano on the wall of the chapel facing the nave of the church (fig. 12). An angel carved in very high relief holds a gilded dedicatory inscription. He stands in a niche, also decorated with gilding, with the Corner arms at the base and an eternal lamp burning at the top. The monument is surrounded by a fresco decoration of classicizing motifs, putti, garlands, and portrait medallions.[95]

All of these bequests, great and small, were essentially the same in their intent and typical of the arrangement made between a Mendicant church and its private patrons. In exchange for an endowment, to be administered by the testator's commissaries, the donor would be interred in sanctified ground, either inside the church itself or in one of the cloisters, and his soul would benefit from friars' masses and the prayers of the faithful, including his family and friends. By definition such arrangements must not be transitory. Because souls are immortal, these endowments were obviously intended to be perpetual, and we have seen how the commissaries and heirs of Federico Corner, for example, continued to support the construction and decoration of his funerary chapel long after his death. In practice, "in perpetuum" might turn out to mean two or three hundred years, if not longer, obviously depending on the wealth and number of the testator's heirs.[96] Thus, for example, in 1733, approximately two centuries after their deaths and in compliance with their last wills, various members of the Pesaro family buried in the Frari were still the beneficiaries of masses being said for their souls. Anniversary masses were said at their altar of the Immaculate Conception for Bishop Jacopo Pesaro and his brothers and nephew, and similarly, masses were offered for their cousins, the family of Girolamo Pesaro, in the sacristy.[97]

Being mortal, the individual commissaries of such trusts could not fulfill their fiduciary responsibilities forever. In Venice, this duty might then be assumed by the powerful private agencies of the confraternities,

12. Jacopo Padovano. Cenotaph of Federico Corner. Venice, Santa Maria
Gloriosa dei Frari, Corner Chapel of St. Mark.

scuole, or by the government offices of the *procuratie.* As Mueller has shown, the state took this obligation very seriously indeed. In a deliberation of 1318, it was noted that souls suffered when masses were not said on schedule because of a delay or even a suspension of funding.[98] Consequently, on 25 March 1319, the feast of the Annunciation, the Maggior Consiglio increased the number of procurators from four to six, the better to attend to these important matters, both spiritual and financial.[99]

A primary function of the numerous *scuole* in Venice was comparable to that of the *procuratie.* When a testator's commissaries died, they might be replaced by officers of his confraternity if he so specified.[100] But whether or not they were asked to undertake these testamentary obligations, the confraternities were always profoundly concerned with the proper burial of their members and with the well-being of their souls, insofar as this might be assured by the prayers of the living. The rules and regulations of *scuole,* the *mariegole,* placed great emphasis on the responsibility members had toward deceased brothers to arrange masses and provide candles for their burials, to attend their funerals, and to pray for their souls.[101] And in much the same way as families maintained chapels where their kin could be interred and masses said for them, so too the *scuole* endowed chapels and cemeteries where the confreres would offer prayers for deceased members.

The Frari benefited greatly from the patronage of such brotherhoods, both Venetian and foreign.[102] In 1361, the Milanese confraternity had agreed to endow a chapel consecrated to St. Ambrose and St. John the Baptist,[103] and in 1435 the Florentines received permission to establish their *scuola* dedicated to the Baptist and the Madonna at the Frari, abandoning their original plans for a chapel in the Dominican church of Zanipolo in order to do so.[104] The Florentine endowment in the Frari explains the presence of the only work by Donatello in Venice, the polychromed wooden *John the Baptist* that he carved for his countrymen in 1438.[105]

It seems that the Franciscans must have been actively wooing certain confraternities away from rival churches, because in 1439, at about the same time as the Florentines were making their arrangements, the Scuola di Sant'Antonio was moving to the Frari from S. Simeone Profeta.[106] Moreover, it was agreed that the confraternity of St. Anthony in the Frari would be the only confraternity of the saint in Venice—a right that was protected by law.[107] This exclusivity was vigorously asserted by the Franciscans and by the confraternity itself. Their concern that the Scuola di S. Antonio in the Frari be the only one in Venice derived from the great prestige of the titular saint. They wanted no rivals for

the spiritual and financial benefits that would result from this association.[108]

The endowments of individual patrons in S. Maria Gloriosa dei Frari equaled (and sometimes surpassed) those of the scuole. These men and women made the Frari one of the great monuments of Christian art. How did they come to endow this church? The pattern of patronage was different in Venice than elsewhere. In part because of the unique position and prestige of S. Marco, the role of neighborhood churches was different in the Serenissima. Very different, too, was the social and political structure of the Most Serene Republic. For example, the wealthy Florentine who wished to assert and to preserve the position of his family would, like the Bardi of S. Croce, seek to establish financial, political, and marital ties within his neighborhood. His family chapel, like his family palace, was intended to be the visible sign of the importance, and indeed the very identity, of his house.[109] In Venice, however, the "equivalent" of the Bardi banking family in financial, political, and social prestige would be one of the noble families, the self-defined and self-perpetuating aristocracy of Venice. The identity and prestige, and even to some extent the financial security, of these aristocrats were all inherent in their very class.[110] A great Florentine family might be all but destroyed by bankruptcy or political upheaval. A noble Venetian family could be destroyed only by biological extinction. This is not to say that Venetians, any less than their Florentine contemporaries, would have been indifferent to enhancing the prestige of their house, but rather that Venetians, unlike Florentines, did not require the geographical security of neighborhood ties.

Legislation of the late 1290s had relieved the powerful families of Venice of such mundane concerns and had effectively guaranteed their ongoing political and social dominance, at least so long as they were able to produce male heirs.[111] The culminating act was the Serrata, in effect the "closing," of the Maggior Consiglio in 1297: membership in the Great Council was restricted to male members of those families who had already been represented during the preceding four years. As the Maggior Consiglio was the exclusive source of candidates for any and all other government offices, the restriction of membership in the Council was tantamount to a restriction of eligibility for all government positions and authority. With the legislation of 1297, the Venetian patriciate had created itself.[112] Little over two hundred years later, in an "ultimate elaboration of patrician self-consciousness,"[113] the Venetian noble families began compiling the so-called *Libro d'oro,* the Golden Book in which were entered the births of noble men and their marriages. Noble fathers were obliged to list births according to a decree

of the Council of Ten on 31 August 1506, and in compliance with a law of 26 April 1526, patrician marriages also had to be registered.[114]

Among the families who were patricians at the time of the Serrata[115] were some of those who became the major patrons of the Frari, including the Bernardo, Corner, Dandolo, Foscari, Giustinian, Marcello, Miani, Trevisan, Tron—and of course, the Pesaro. Indeed, at one time or another, members of most if not all of the noble Venetian families endowed the Frari in one way or another. Freed from the constraints of loyalty to a particular neighborhood, which often characterized patronage elsewhere in Italy, noble Venetians might endow a church anywhere. Indeed, as Chojnacki has explained, the *estimo* (political census) of 1376 demonstrates that 76.9 percent of all patrician families in Venice were represented in more than one *sestiere* or division of the city.[116] As noted, their family identity did not depend upon neighborhood alliances but rather, first of all, upon the very fact of their nobility; and, secondarily, upon the allegiances established by matrimony, money, and politics. So, whereas neighborhood seems to have been a determining factor in Florentine patronage of churches, other, more personal considerations influenced Venetian patrons. For example, the Bardi of Florence surely chose to endow the chapel of St. Francis in S. Croce because that church was the most prestigious in their traditional family neighborhood. There is no evidence of their feeling any particular devotion to Saint Francis prior to their patronage of the chapel—at any rate, Francis was not the onomastic saint of any member of the Bardi family in the early fourteenth century—although one may well imagine that they became fervent in their devotion to the saint once they had made such a serious financial, social, and, indeed, spiritual commitment.[117] The same seems to be true of the other great patrons of the Franciscans in Florence: neighborhood was a primary consideration, although once a commitment had been made to S. Croce, they developed a loyalty to the Franciscan order that might cross national borders. Thus, for example, we recall that the Florentine Duccio degli Alberti, whose family lived in the quarter of S. Croce and whose brother was the patron of its high altar, was buried in the Frari in 1336—a hundred years before the establishment of the Florentine scuola there (fig. 10).[118] Similarly, the Peruzzi remained loyal patrons of the Franciscan order, continuing payments to S. Croce even after their exile from Florence in 1434.[119] The family found refuge in Avignon, and they supported the Franciscans there as well. The visual documentation of this is the "Pérussi" altarpiece, dated ca. 1480, which represents saints Francis and John the Baptist with two Peruzzi donors.[120] When they were permitted to return to

Florence, the Peruzzi resumed their patronage of their family chapel in S. Croce.[121]

All of this is not intended to suggest that neighborhood was of no significance in Venetian decisions regarding patronage, but rather that it was not the critical issue, not the primary concern. For example, the following noble Venetian families had palaces very near the Frari, at S. Polo or at S. Tomà: the Dolfin, Donà, Mocenigo, Tiepolo, and Vendramin—but none of them was a significant patron of the Franciscans. Rather, they took their patronage elsewhere, to the rival Dominican institution of Zanipolo some considerable distance away from their family neighborhoods (fig. 2). But it is also true that others of the great patrons of the Frari were in fact families who lived nearby, such as the Bernardo, Corner, Dandolo, and the Tron. And in the extraordinary case of the Ca' Pesaro—surely the most important of all, art historically at least, as the patrons of Bellini and Titian—one branch lived near and the other some distance away from the Frari.[122] What brought them there?

2

Bellini and the Ca' Pesaro in the Frari

1. The Funerary Chapel of Franceschina Tron Pesaro

Franceschinae Tron Pientissimae Matri Nicholaus
Benedictus et Marchus Pisauri.[1]

The unique distinction of having provided the Frari with *two* of its most splendid treasures belongs to the noble Venetian family of the Pesaro, the patrons of Bellini's triptych in the sacristy and of Titian's *Madonna di Ca' Pesaro* in the church itself (figs. 16 and 42). In addition to these masterpieces, the Pesaro also commissioned several impressive funerary monuments, most notably: Benedetto's, around the entrance to the sacristy (fig. 29); his son's, originally across the nave, but now destroyed; his cousin Jacopo's, to the right of Titian's *Madonna* (fig. 49); and the extravaganza designed by Longhena for Doge Giovanni Pesaro, to the left of that altarpiece (figs. 43 and 59).[2] No other patron or patrons so dominated the decoration of the Frari. The quality and art historical significance of their two altarpieces in the Frari make it impossible to discuss the Renaissance in Venice without considering the Ca' Pesaro.

The individuals who commissioned the two altarpieces by Bellini and

by Titian were not the first members of their family to endow the Frari. According to the Venetian genealogist Barbaro, their patronage of the church can be documented to the first half of the Duecento, thus placing the Pesaro among the earliest supporters of the Frari. Barbaro recorded that a certain Palmiero Polonio Pesaro, who was a senator in 1230, was buried in the cloister of the church.[3]

The first documentary evidence for patronage of the Frari by members of the Pesaro family directly related to the patrons of Bellini and Titian is the will of Palmiero's grandson Angelo, dated 15 June 1309. "Angelus da Pesaro de confinio Sancti Jacobi de Luprio" (S. Giacomo dell'Orio) provided for his burial in the Frari, for which purpose he bequeathed three hundred pounds: "Item loco Fratrum Minorum de Sancta Maria ubi corpus meum ordino sepelliri, dimitto libras trecentas. . . ."[4] No trace of Angelo's monument survives: the Frari in which he was interred was destroyed when the present church was constructed, beginning in the 1330s; it was completed approximately a century later.[5]

Angelo's great-grandson, Caroso quondam Fantin, became a patron of this final church of the Frari. In his testament of 1432, which was copied in 1435 after his death, Caroso identified himself as residing in the parish of S. Zan Degolà (S. Giovanni Decollato).[6] This was the traditional neighborhood of the Pesaro in Venice, near San Giacomo dell'Orio and the future site of their seventeenth-century palace at San Stae designed by Longhena—and not far from the Frari (fig. 2).[7] Caroso provided for his burial in his tomb ("archa") in the church of the Friars Minor: "Mi Charoxo da Cha' da Pesaro de la contrada de S. Zuane Degolado . . . volo quel mio corpo sia sepelido ali Frati Menori in la mia archa."[8]

It seems significant that Caroso referred to "his" tomb, "la mia archa." A tomb of this sort was meant for multiple occupancy, and deceased relatives and descendants of the original tenant would commonly be included in such a grave. Thus Caroso's language may imply that his tomb was the first such endowment made by his immediate family in the Frari. In any case, by the time one of Caroso's sons and commissaries, Alvise, dictated his testament in 1446, the reference was to "our tomb" in the church of the "Frari Menori dove voio sia meso el mio chorpo in la nostra archa."[9] Clearly the tomb was no longer that of an individual, but belonged to the family.

Caroso *q.* Fantino may not have been the first Pesaro patron of the Frari, but with him and his family one sees the beginning of an uninterrupted pattern of Pesaro patronage of the church in the Renaissance. In addition to his son Alvise, Caroso's brother, Andrea, was also buried

in the Frari, in the cloister of the convent.[10] And Andrea was the grand-father of Bellini's patrons and the great-grandfather of those who commissioned Titian's *Pesaro Madonna* (fig. 42 and Pesaro Family Tree).

The first great Pesaro commission in the Frari was the construction and decoration of the chapel in the sacristy, including the altarpiece triptych by Giovanni Bellini, signed and dated 1488 (figs. 13–16). The elaborate Pesaro endowment of the sacristy is one of the more remarkable commissions of the Quattrocento because it honors not a man but a woman, Franceschina Tron Pesaro. Indeed, her privilege may well have been unique: the surviving evidence of documents and inscriptions indicates that Franceschina was the only woman to have been remembered in this way in the Frari in the fifteenth century.[11]

Franceschina died in 1478. That year suggests the terminus post quem for the chapel construction and decoration, and is consistent with the stylistic evidence of the architecture and of the frescoes, as we shall see. And the history of the Pesaro decoration of the sacristy is related in turn to all the later Pesaro commissions in the Frari, including Titian's *Madonna*. Earlier Pesaro endowments had been limited to tombs, such as Andrea's in the cloister. Franceschina's funerary chapel in the sacristy was the first conspicuous Pesaro donation to the Frari, the first chapel that they constructed and endowed in the church. How did their close association—even identification—with the Frari come to begin with a woman? Answers to this rhetorical question may be found in the history of the Pesaro family and in a consideration of their interests, concerns that were secular as well as spiritual.

Franceschina was the widow of Pietro Pesaro, a son of Andrea and a nephew of Caroso *q.* Fantino. Pietro had been married for the first time in 1419, to Alessandra, called Alessandrina, the daughter of Alessandro Priuli. The couple had several children, including at least four sons.[12] Alessandrina was still a young woman when she died in 1427, after having dictated her will, probably as a precaution during one of her pregnancies.[13] The testament is very brief and does not specify the place of burial, a decision that Alessandrina left to her commissaries, including her husband Pietro.

Pietro remarried in 1428, the year following the death of his first wife.[14] His new bride was Francesca or Franceschina, the daughter of Nicolò Tron of S. Benetto, and she gave Pietro three sons, Nicolò, Benedetto (or Benetto), and Marco. These three brothers became the patrons of Giovanni Bellini in the Frari, and of what was originally the very rich decoration of the sacristy chapel, all in memory of their mother, who survived their father by ten years.[15]

The earliest known "document" regarding the patronage of the

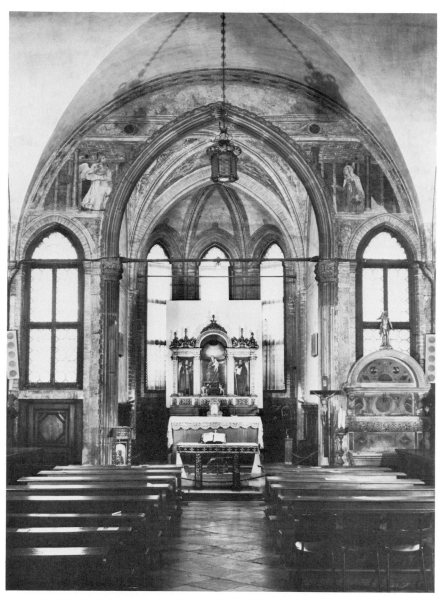

13. Venice, Santa Maria Gloriosa dei Frari, Sacristy Chapel of the Pesaro of San Benetto.

14. Attributed to Jacopo Parisati da Montagnana. *Symbols of the Evange-lists*. Frescoes. Chapel of the Pesaro of San Benetto. Vault.

chapel is the inscription of the carved tomb slab in the center of the pavement before the altar. This inscription declares that the grave belongs to Franceschina Tron, and that the patrons were her sons (fig. 15). Their names and the year of her death are inscribed: "Franceschinae Tro[n]. Pienti/ssimae matri Nicholaus Be/nedictus et Marchus Pisau/ri Petrii Patricii Ven[eti]. sibii/que et posteris/posuere/MCCCCLXXVIII An[n]o saluti[s]/quarto/nonas iunii." Thus Pietro's name was included in the tomb inscription as the patronymic, to identify Nicolò, Benedetto, and Marco as his sons, and surely in remembrance as well. The four men were honored also by the depiction of their onomastic saints

[34]

15. Venice, Santa Maria Gloriosa dei Frari, Chapel of the Pesaro of San
Benetto (detail). Tomb of Franceschina Tron Pesaro.

in Bellini's triptych—Peter and Mark on the left, Benedict and Nicholas
on the right (fig. 16).

Franceschina had composed at least two testaments, one in 1432 and
another ten years later.[16] The earlier document, a holograph written in
Venetian dialect, is the more intriguing: it reveals something of Fran-
ceschina's personality, as well as her circumstances, with a directness
and vigor not often found in the formulaic phrases composed by no-
taries. "I, Franceschina," she begins,

> wife of Misser Piero da Ca' da Pesaro, son of Messer Andrea, of the
> parish of S. Benedetto, healthy of body and mind, want this to be my
> testament, and I want my faithful commissaries to be my husband,
> Ser Piero da Ca' da Pesaro, and my mother and my brother and my
> sister, and I want these my commissaries to pay all my legacies, and

I leave 2 ducats for masses of St. Gregory to be said for my soul and I leave 3 ducats to Corpus Christi for my soul and I leave 3 ducats to S. Andrea for my soul and I leave 3 ducats to S. Alvise for my soul and I leave 3 ducats to S. Gerolamo for my soul and I leave 3 ducats to the nuns of S. M. degli Angeli of Murano for my soul and I leave 3 ducats to the nuns of S. Bernardo for my soul and I leave 6 ducats so that a person of good reputation [may] be sent to Assisi to pray to God for my soul and I leave 4 ducats that masses of the Madonna be said for my soul and I leave 3 ducats to be given to some good person to go to S. Pietro di Castello to worship for one year to get pardon for my soul and I leave 2 ducats to be given to some person of good conscience to go one year to get pardon at S. Lorenzo and I leave 6 ducats that a prayer be offered for my soul . . . and I leave 10 ducats to be given to the poor who are of the greatest need for my soul and I leave 6 ducats for the poor of S. Lorenzo and I leave 2 ducats to S. Brigida that they pray God for my soul and I leave 2 ducats to S. Maria della Carità for my soul and I leave 3 ducats to S. Giorgio to require that masses be said for my soul and I leave 40 ducats to my mother and I leave 25 ducats to my brother and I leave 23 ducats to my sister and I leave 100 ducats to my husband and I leave all my residual [possessions] to my children, both boys and girls, equally . . . I leave 400 ducats to my husband [and] I leave 90 ducats to my mother and I leave 90 ducats to my brother and I leave 50 ducats to my sister. . . .[17]

Franceschina's breathless will reveals several facts. First of all, her numerous bequests indicate that she maintained considerable control over the monies of her dowry, although the bulk of her estate, bequeathed to her husband and children, was clearly intended to remain the property of Pietro Pesaro's family. Then, like Pietro's first wife, Franceschina made no provisions for burial. Nor did she make any bequest to the Frari. And yet Franceschina demonstrated a certain devotion to the Friars Minor by leaving 3 ducats to S. Alvise, dedicated to the Franciscan bishop Saint Louis of Toulouse, and, more important, by providing six ducats for "a person of good reputation" to go to Assisi and there to pray on her behalf. To be sure, this was not an uncommon request. Yet Francis was Franceschina's onomastic saint, and it is reasonable to suppose that she was particularly devoted to him. Perhaps she wrote nothing regarding her burial because her husband's family had already endowed a tomb in the Frari?

It is noteworthy, too, that Franceschina identified herself as living in the parish of S. Benedetto, the neighborhood of her own family, the Tron. Thus, by 1432, Pietro's family may have left the traditional Pe-

saro neighborhood of S. Zan Degolà, where they had still lived in 1427.[18] But it is unclear what exactly this information signifies for the dating of the splendid—and undocumented—Palazzo Pesaro built by Pietro at S. Benedetto.[19] The problem is this: in her second will, dated 7 June 1442, Franceschina identified herself as living in the parish of S. Pantalon, near the Frari and across the Canal from S. Benedetto (fig. 2).[20]

Franceschina made bequests to three churches in this later will— S. Andrea della Zirada, S. Bernardo di Murano, and Corpus Christi, all mentioned in the earlier document.[21] Once again there is no mention of the Frari or indeed, this time, of any other Franciscan house. However, Franceschina did repeat her bequest for prayers to be said on her behalf at Assisi.[22]

Again, Franceschina tacitly left decisions regarding her burial to her commissaries, who are specified by name in this more formal document: her husband, Pietro; her mother, Fantina Tron; her brother, Michele; and her sister, Elena Morosini—all as in the earlier will. But this time Franceschina added all her children to the list of commissaries. When she named "all her sons and daughters" among her commissaries and also in a bequest of property to "Zenevra, Nicholao, Benedicto, Antonio, Andreas et Jacobo filyorum meorum et omnibus alys filys et filyabus," Franceschina was treating Alessandrina's children as her own.[23] In fact, only Benedetto and Nicolò were actually Franceschina's sons. (Her youngest, Marco, was not yet born.) To be sure, Franceschina may have made another testament before her death in 1478, and may have revised the list of commissaries.[24] Moreover, 1478 was a plague year, and some of the younger Pesaro may also have died at that time.[25] However, whether any of Alessandrina's children survived, or whether Franceschina had any daughters who outlived her is in a sense irrelevant in connection with the commission of Bellini's triptych and the sacristy chapel, as the inscription of her tomb informs us. Her own three sons claimed exclusive credit for the endowment. Any others either were excluded from the patronage of the chapel or they excluded themselves.

The sacristy that her sons endowed in memory of Franceschina Tron Pesaro became the funerary chapel of their line, the Pesaro of S. Benetto, although of their later commissions only Benedetto's tomb survives (fig. 29). It seems clear that the endowment of their mother's grave site was intended by her sons as the visible declaration of their family's identity. Of course, that was a traditional function of family chapels in the Middle Ages and the Renaissance. What makes this one different is that it honors not the father of the family but the mother.

And there was a clear reason for this. These men were both the sons of a second marriage and the first generation of a new branch of the Pesaro family, the Pesaro of S. Benetto, whose new neighborhood was the traditional residence of their mother's house. This explains, at least in part, the importance given to Franceschina and the exclusion of her adopted children and heirs from the imagery of her altarpiece and from the patronage of her chapel. But by endowing their mother's funerary chapel in the Frari, and not in S. Benetto, perhaps her sons also meant to reiterate their association with their Pesaro kinsmen across the Grand Canal. In life, they might reside in their splendid new palace next to the church of St. Benedict, but in death they would return to the more prestigious church of the Frari, where some of their Pesaro ancestors had long since been interred and for which they evidently felt a compelling spiritual affinity.

Originally the sacristy extended only so far as the crossing of the church, that is, it did not project beyond the chapels of the (liturgical) east end. The Pesaro had the cross-vaulted chapel (or chancel) of the sacristy constructed as an addition, breaking through the old walls, and in the process doing some structural damage to the fabric of the building (figs. 6 and 13).[26]

The sacristy chapel was clearly identified as the personal and private domain of the Pesaro family. First of all, it seems likely that the Pesaro chapel had a gate, which indeed was customary for such family chapels in the Middle Ages and the Renaissance. Two holes are cut into the surface of the first step leading into the Pesaro chapel, and the piers of the entrance arch likewise have holes cut into their sides where a gate could have been attached. Thus the Pesaro chapel would have resembled those of the Corner and the Miani, which were also constructed as additions to the church, and where (restored) cast iron gates still separate the chapels from the nave.[27] Similarly, the Rinuccini chapel of the sacristy of S. Croce, the Franciscan church of Florence, is also gated. The Pesaro Chapel resembles other private family chapels, too, in the display of arms. The Pesaro *stemma* is carved into the sides of the capitals of the entrance piers and again, more conspicuously, declares the ownership of the chapel on the keystone of the entrance arch facing the sacristy. Logically, at least these details of the architectural decoration must originally have been polychromed, painted in the Pesaro colors, blue and gold.[28]

The chapel itself was originally frescoed, although only fragments survive in poor condition.[29] Symbols of the four Evangelists are represented in the vault, while all that remains of the mural decoration are the ornamental borders painted in black and white (figs. 13 and 14).

These borders, or friezes, divide each wall horizontally into two sec-
tions, a lunette and a rectangle, but nothing is known of what might
have filled those spaces. Looking for clues elsewhere in the Frari, one
may speculate that either or both of the larger, horizontal areas may
have carried wall tombs. This is the case, for example, in the Bernardo
Chapel of the Madonna, a space not much larger than that of the sacristy
chapel. Moreover, the Bernardo wall monument, like so many others
in the Frari, is enframed by fresco decorations. But perhaps a more
likely reconstruction of the sacristy decoration would be a narrative
cycle. Presumably the narratives illustrated scenes from the Madonna's
life, because she is the central figure of the altarpiece, indicating that
the chapel was dedicated to her. To be sure, nothing is certain about
the mural decoration of the Pesaro chapel except that it included four
sections. Nonetheless, perhaps one may infer something of its original
appearance. There is in Venice another chapel of the Virgin decorated
with four episodes from her life, and that is the very conspicuous and
very prestigious Cappella dei Mascoli in S. Marco. The mosaics of the
Mascoli Chapel, begun by Castagno in 1442 and completed by Michele
Giambono in the early 1450s, represent the Madonna's Birth and her
Presentation in the Temple on the right wall and, on the left, the Vis-
itation and Dormition (the last by Castagno).[30] One may imagine that
the Pesaro chapel fresco cycle would have included the same four epi-
sodes from Mary's life as appear in the Mascoli Chapel. From the Vene-
tian point of view, this was surely an obvious and distinguished model
for such a program.

The only narrative painting to have survived, however, is the *An-
nunciation* decorating the wall around the entrance arch. This fresco has
been ascribed to Jacopo Parisati da Montagnana in the late fifteenth
century, although the work has been so heavily restored that attribution
is uncertain (fig. 13).[31] The *Annunciation* is the traditional scene for the
arches of chancels or chapels, appropriate for its location above the altar
because it is the beginning of the Incarnation, the moment when the
Son of God takes on human flesh, the sacrifice of which is reenacted by
the celebration of mass.[32] In the sacristy fresco, Mary and the Archangel
Gabriel occupy rectangular chambers—in fact, the opposite ends of one
long structure supported by columns—on either side of the entrance
arch.[33] Each figure kneels, gestures and glances toward the other, so
that their comportment, no less than the illusion of the fictive architec-
ture, cuts across the actual spatial division of the arched opening.

Beneath the *Annunciation* and to either side of the entrance arch are
ogive windows—authentic according to Ongaro, who superintended
the extensive restoration of the church at the beginning of this century.

On the left is a doorway leading outside, which is probably not original; unlike the Miani and the Corner (figs. 3, 4, and 5), the Pesaro were evidently not provided with their own exterior entrance to their family chapel. Unfortunately, it is impossible to be certain about this. An old photograph shows that houses had been constructed abutting part of the apse and all of the chapels to the right, including the sacristy (fig. 7). Although Ongaro removed these extraneous structures during his restoration, he published nothing about what he found behind them.[34]

2. Bellini's Triptych

Ianua Certa Poli Duc Mentem Dirige Vitam/Quae
Peragam Commissa Tuae Sint Omnia Curae.[35]

Like the Frari itself, the sacristy chapel was also dedicated to the Madonna. However, while the dedication of the Frari is to the Virgin Assumed into Heaven, the Pesaro altar honors Mary as the "Sure Gate of Heaven," as she is described in the inscription of the fictive gold mosaic of the altarpiece (fig. 16).[36] The Madonna is enshrined beneath the mosaic in the central panel of the triptych, with the Child standing on her lap in the attitude of blessing. They are accompanied by two musical putti and flanked by the patron saints of the Pesaro in the wings, Nicholas and Peter to their right, Benedict and Mark to their left.

As in his S. Giobbe altarpiece (ca. 1480) and other works, here Bellini placed the holy figures in an ecclesiastical setting (fig. 19).[37] In both altarpieces, Bellini represented the apse of a barrel-vaulted church. And in each case, the actual architecture of the frame, carved stone in S. Giobbe and gilded wood in the Frari, is decorated with the same motifs as the illusionistic architecture within the painting. Consequently, the frame is understood both as the terminus of the fictive architecture and also as the point (or plane) where the two worlds, sacred and mundane, meet and coincide.[38] Thus the holy realm inhabited by the Madonna and saints seems to be accessible from our own, and the place where the one may be entered from the other is the altar. There, and indeed only there, during the offering of the mass, may the faithful worshiper indeed see his God. Saint Francis had explained how this can be so: "in this world I cannot see the most high Son of God with my own eyes, except for his most holy Body and Blood," that is, the Eucharist.[39]

Although Bellini established continuity between the heavenly and

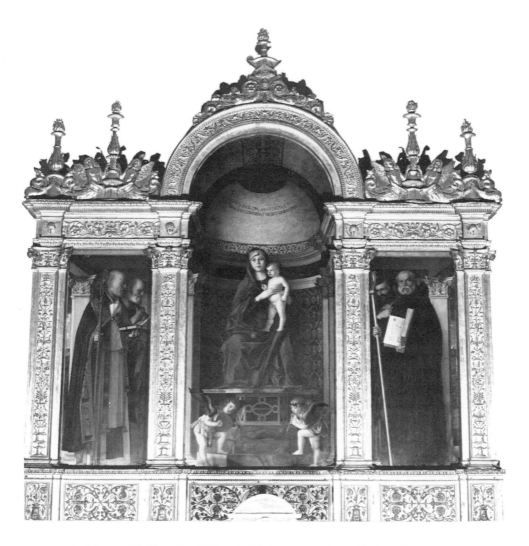

16. Giovanni Bellini, *Frari Triptych*. Venice, Santa Maria Gloriosa dei Frari. Chapel of the Pesaro of San Benetto.

earthly worlds by the frame that exists in both, he also insisted upon a separation between them. This seemingly contradictory purpose is achieved by the low view point that Bellini used in all his major altar-pieces and which he favored in images for private devotion as well.[40] It is consistent, of course, with the placement of these images on or above altars: the viewer-worshiper's vantage point is naturally low, which perforce requires him to look up at the holy beings. And this, in turn,

is suitable psychologically and spiritually as well, for physical lowliness before the altarpiece encourages the appropriate humility of the worshiper.

The Frari triptych was Bellini's third altarpiece to represent the Madonna and saints in an ecclesiastical setting, and with it he found the solution to a particular problem: how to depict, in a convincing, naturalistic way, the pervasive luminosity of sunlight and open air inside a church—a setting which is obviously appropriate to the Virgin but which is, of course, an interior. Piero della Francesca, who apparently introduced to Italy the Netherlandish idea of an ecclesiastical setting for the Madonna, had represented a completely closed church interior flooded with sunlight of which the source is concealed (ca. 1472).[41] Antonello da Messina evidently introduced the scheme to Venice in 1476 with his S. Cassiano altarpiece, but it is not certain whether he too painted a closed interior, like Piero, or created a church partly open to the sky.[42] Bellini, in his first version of this motif, the now destroyed *Madonna* for the Dominican church of SS. Giovanni e Paolo, tried a different idea—a church without walls (ca. 1476).[43] He represented only a cross vault and its supporting piers, but their ecclesiastical character, with the lamp, were enough to hint that the setting is the crossing of a church. The apse was omitted and the background completely open to a cloudy sky. Other Venetians repeated this motif,[44] but when Bellini himself returned to the theme of the Madonna in a church a few years later in his altarpiece for S. Giobbe, he chose instead to create a complete architectural structure, a magnificent church interior with a coffered barrel vault and a gold-ground mosaic in the semidome and patterned marble panels in the apse (fig. 19). He had translated Piero's Albertian text into his own Venetian idiom. One of the advantages of Bellini's solution was symbolic, the gold mosaic and veined marble being clear

18. Giovanni Bellini, *Frari Triptych* (detail). St. Benedict's Bible.

references to the church of S. Marco—a subject to which we shall re-
turn. Indeed, Bellini's fictive church in the S. Giobbe altarpiece is in
effect a recreation of S. Marco (fig. 23). The high altar of S. Giobbe is
dedicated to Saint Bernardino of Siena, and Job, thus displaced, was
honored instead at the high altar of Bellini's illusionistic church.[45] But
perforce, this represents a completely closed interior setting, excluding
the luminosity of the out-of-doors.[46]

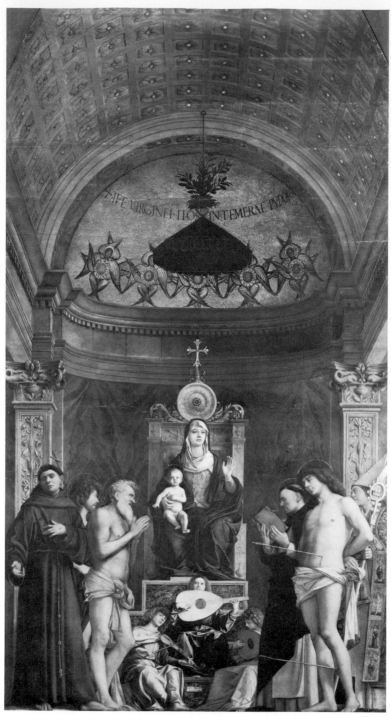

19. Giovanni Bellini, *San Giobbe Altarpiece*. Venice, Gallerie
dell'Accademia.

In the Frari triptych, Bellini opened the side walls of his church interior to views of sky and landscape.[47] By means of this architectural incongruity, he was able to provide the naturalistic raison d'être for the soft, diffuse sunlight that illuminates his church interior. The light that flows from left to right through the lateral openings of Bellini's fictive church binds the three panels of the triptych together, and is no less effective in this unifying function than the mathematical perspective that unites the three sections of the illusionistic architecture into one structure. And he matched this luminosity with a brilliant palette. The tonality of the central panel is warm, seemingly as though tinted by the golden mosaics. Aside from the blue of Mary's mantle, shades of red, yellow, and brown dominate here—the red of Mary's gown and of the gold-thread brocade behind her, the yellows and browns of the angels' garments, wings, and hair, and the reddish browns of the veined marble steps. In the wings, however, different harmonies were used, bold combinations of red, black, and white. It is natural that Saint Benedict here wears his black habit, as in life and elsewhere in art. But Bellini relieved this austerity, pulling the black mantle aside to reveal a striking fold of the bright red worn by Saint Nicholas, repeated in the red of the monk's book. Opulent in contrast to the monk's simplicity, Nicholas is juxtaposed with Benedict coloristically as well, with reversed proportions of red, black, and white. These diverse combinations of the same and similar colors both underscore and vary the architectural and compositional symmetry of the triptych, like the counterpoint of a musical theme.

Bellini exploited the triptych format to elaborate the conceit of the Madonna in a church. In the S. Giobbe altarpiece, he had revealed a view of the east end of a church with a glimpse of the transept opening to either side, but truncated by the frame. The frame of the triptych, however, corresponds precisely to its fictive setting, with the effect of suggesting a cross-section of a church interior. The central panel is tall, arched, and barrel-vaulted with a semidome, while the wings are rectangular with a low, flat roof, and the frame conforms completely to these differences. At the same time, however, the architecture is continuous from one panel to the next, with open passageways leading from the central space to either side (figs. 16 and 17). Thus the wings of the triptych represent neither the aisles nor the arms of the transept in Bellini's fictive church. Aisles and transept cannot be combined in this way: that would be an architectural oxymoron, nonexistent in Italian architecture. Nor did Bellini intend this. Instead, what the master has depicted is a form of Byzantine pastophories, the chambers adjacent to and accessible from the apse. Pastophories were used in the Eastern

church for the reservation of the Eucharist and were represented in the illusionistic reliefs of numerous Italian Renaissance tabernacles.[48] As we shall see, that sacramental purpose is consonant with Bellini's imagery in the Frari triptych, just as the Greek structure is stylistically consistent with other features of his Byzantinizing architecture.

Bellini accomplished apparently contradictory ends with his illusionistic architecture. The same forms that unite the Madonna and Child with their saintly companions also separate them hierarchically, as in traditional triptychs and polyptychs by earlier masters. This is exactly comparable to the relationship that Bellini establishes between the image and the viewer-worshiper: the same illusionistic means that imply the accessibility of the holy realm are used to debar us from it.[49]

It has been observed that Bellini's use of the triptych for the Frari altarpiece was archaic and perhaps a reflection of the outmoded tastes of his patrons.[50] On the contrary, far from being obsolete, Bellini's use of the triptych for this commission was adventuresome, all but unprecedented and unique.[51] Or, rather, the combination of elements is unique, for Jan van Eyck and Rogier van der Weyden had anticipated Bellini in certain respects. Rogier's Seven Sacraments Altarpiece (ca. 1460) includes the nave of a church in the central panel and an aisle in the left wing. The right wing, however, represents a view into a side chapel (fig. 20).[52] More like Bellini, Jan van Eyck used the wings of a triptych to represent the two aisles of a church in the Dresden altarpiece, dated 1437 (fig. 21).[53] But van Eyck's exquisite work differs significantly from Bellini's. The Eyckian frame is a rectangular interruption of the illusionistic space and not its continuation and culmination. And the central panel of Jan's triptych represents the nave of a church, including part of the clerestory, whereas the wings represent the lower aisles, which are shown up to the springing of the vaults. At the same time, the Virgin is seen much farther back in the nave than are the figures in the aisles, Saint Catherine on the right and, on the left, Saint Michael with the patron. Thus the saints who flank the Madonna are not in fact next to her, but in a space closer to our own. Bellini, on the contrary, has not represented aisles but pastophories flanking the apse at the east end of his illusionistic church. His saints are not in front of Mary but by her side: their spaces are contiguous.[54]

Bellini's triptych is also different from its immediate Venetian predecessors in the Frari, the two altarpieces signed by Bartolomeo Vivarini in 1474 for the Corner Chapel of St. Mark and in 1482 for the Bernardo Chapel of the Madonna (fig. 22).[55] In the earlier triptych, Vivarini's flamboyant Gothic frame demarcated completely separate spaces for the saints in each panel. In the Bernardo triptych, finished

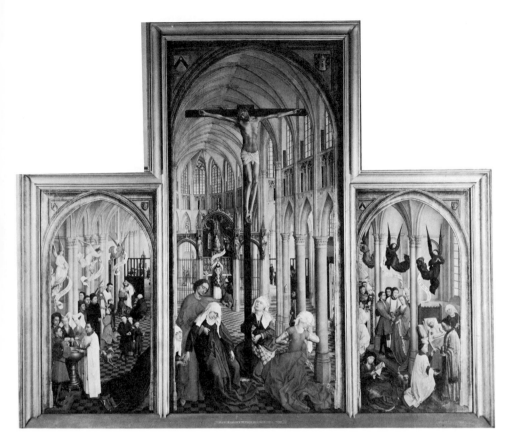

20. Rogier van der Weyden, *Seven Sacraments Altarpiece*. Antwerp,
Koninklijk Museum voor Schone Kunsten.

only eight years later but belonging finally to the new world of the
Renaissance, Bartolomeo represented a unified background of sky and
a pavement continuous through all three panels. The round arches of
the classicizing frame that opens to reveal these scenes and the Man of
Sorrows above, also set against open sky, are like window frames,
unrelated to the spatial illusion of the panels they enclose.[56]

Bellini instead revived the trecento conception of an altarpiece frame
as the facade of a church, combining this with the newer idea of a church
interior as a setting for the Madonna, a fictive space represented with
complete command of Renaissance perspective. The pictorial space is
represented as a cross-section of apse and pastophories, revealed by the
frame that corresponds in every particular of its form and decoration

[47]

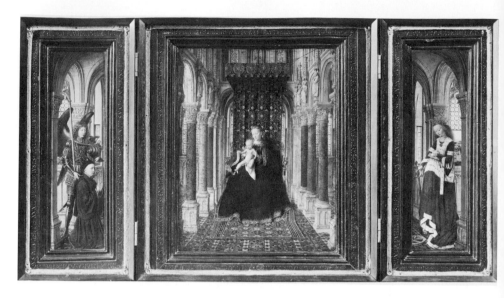

21. Jan van Eyck, *Dresden Altarpiece*. Dresden, Gemäldegalerie.

to the illusionistic structure. Bellini's formula is so perfect that we think we have always known it. But we have not. And Bellini never used the conceit again.[57]

In the central panel, Mary is seated with Christ in an apse decorated with a brocade suggesting the cloths of honor traditionally suspended behind the thrones of earthly monarchs.[58] The fictive architecture of the triptych and the actual architecture of the gilded frame are completely in keeping with the classicizing style of the Lombardo in the 1480s—comparable to S. Giobbe, for example, or the facade of S. Zaccaria. Above, the gold mosaic vault and semidome allude to a different tradition. The gold mosaic is an archaic device in that it is quite unlike the decoration of most actual fourteenth- and fifteenth-century Venetian churches, including the Frari itself, consecrated in 1492 (fig. 8).[59] The mosaic is an obvious and familiar reference to the Basilica of S. Marco, and hence to the very identity of Venice herself (fig. 23).[60] At the same time, Venice is also the city (or, more precisely, a city) of the Virgin, having been founded, according to legend, on 25 March 421, the feast of the Annunciation—which is represented above the entrance arch of the Pesaro chapel (fig. 13).[61] Consequently, both the imagery of S. Marco and the imagery of the Madonna allude to the Republic.

In addition to the well-known aesthetic, spiritual, and cultural associations of the gold mosaic setting for the Madonna, surely Bellini and

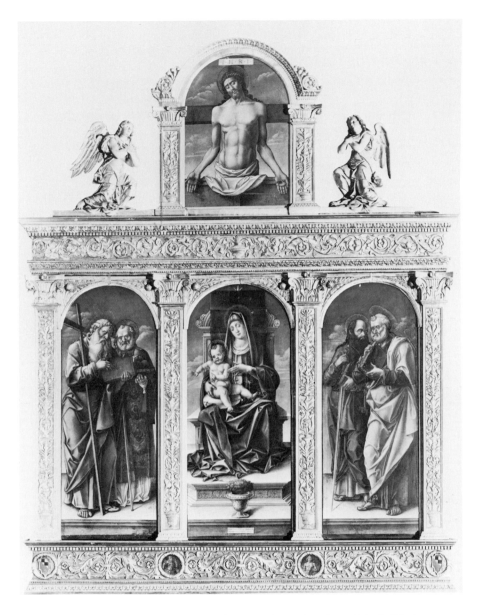

22. Bartolomeo Vivarini, *Bernardo Triptych*. Venice, Santa Maria Gloriosa
dei Frari, Bernardo Chapel of the Madonna.

23. Venice, San Marco. Interior.

his patrons intended political and civic allusions as well. The mosaic is a reference to the fealty of the donors to the Republic, comparable in this sense to the modern display of a national flag: a familiar sight, to be sure, but significant nonetheless. Nor does the popularity of the mosaic motif in Venetian sacred painting preclude its secular meaning—on the contrary, its repetition may be taken as a confirmation of this interpretation enhanced by the unique prestige and significance in Venice of all things Byzantine.[62] (If the fresco cycle that once decorated the chapel walls represented a cycle of the Virgin's life like that in the Cappella dei Mascoli, then the evocations of S. Marco, and hence of the identity of Venice, would have been even more powerful.) In no other work did Bellini give the gold mosaic such emphasis as in the triptych: both the semidome and the vault are covered with golden tesserae. Only the semidome was treated in this way in the S. Giobbe altarpiece painted a few years earlier, and similarly in the S. Zaccaria altarpiece, completed in 1505 (figs. 19 and 24). Moreover, the Frari triptych represents Bellini's second use of this motif, which evidently he himself had introduced only a few years earlier in the S. Giobbe altarpiece. It was still a new idea, and a potent one at that. Benedetto Pesaro was a politically ambitious man and far from indifferent to the power of visual imagery, as we shall see. Perhaps having seen Bellini's S. Giobbe altarpiece, the Pesaro themselves requested the master to repeat the references to S. Marco in their triptych.

Bellini's illusionistic gold mosaic and the pastophories flanking the apse were characteristic of a "Byzantine revival" in Venetian culture during the later fifteenth century. And this revival was related in part to the influence of John Bessarion. Among the most learned prelates of his day and a great patron of the Venetian Republic, this Greek expatriot was Cardinal Protector of the Franciscan order from 1458 until his death in 1472.[63] In 1463, when the Franciscans of Constantinople had been expelled by the Turks, Pius II granted permission for them to join the community of the Frari.[64] As Cardinal Protector and as a Greek who had found "another Byzantium" in Venice, as he himself called it, Bessarion may well have recommended this action to the pontiff, an event of signal importance for the cultural life of the convent, and indeed for all of Venice.[65] Bellini first employed the Byzantine motif of the gold mosaic in two Franciscan commissions, the altarpieces for S. Giobbe and the Frari. Might it not be that the presence in Venice of the Greek friars had something to do with this?

The gold mosaic is included as an embellishment of the triptych's explicitly ecclesiastical setting, and its specifically religious significance is of course foremost, helping to locate the Madonna and Child in the

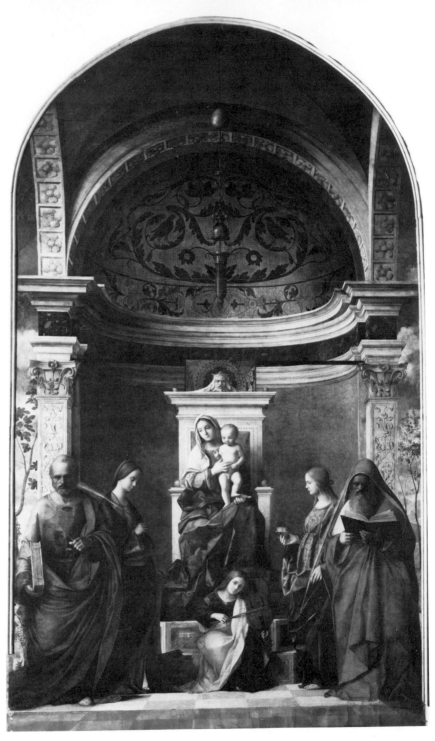

24. Giovanni Bellini, *San Zaccaria Altarpiece*. Venice, San Zaccaria.

apse of a church. But here Bellini departs from our expectations. There is no ordinary altar in this fictive apse, nor are the Madonna and Child enthroned, as is usually the case even in other, similar compositions by Bellini himself, such as the somewhat earlier S. Giobbe altarpiece or the later *pala* for S. Zaccaria (figs. 19 and 24).[66] Instead, in the Frari triptych Mary and her Son occupy the place of the altar and are raised upon a conspicuous and unusual structure, a high, stepped octagonal base bearing the artist's signature and the date: "IOANNES BELLINUS.F.1488."[67] Two putti step on the lowest tier of the base to support their instruments, a flute and a lute, with which they are serenading the Madonna.[68]

The Virgin and Child are raised on their pedestal as the altar table is raised above the level of the chapel pavement. Bellini emphasized this simile in his triptych by echoing the architectural setting of the chapel, where the tall, wide chancel is flanked by smaller windows (fig. 13). Clearly, the viewer-worshiper is meant to identify the Madonna with the altar and the Child with the Eucharist. Bellini's visual assertion of this symbolic equivalence is explained by a common Marian epithet. The Madonna is the "Altar of Heaven," the *Ara Coeli,* that contains the eucharistic body of Christ. This is so because, just as Christ emerged from his mother in the Nativity, so he emerges from the altar as the consecrated Eucharist. In the words of a Medieval sacramental hymn, the Host signifies both birth and sacrifice: "Ave, verum Corpus, natum de Maria Vergine." At the same time, both the Virgin and the altar may be likened to the grave of Christ, from which he emerged in the Resurrection. An Easter hymn wrongly attributed to Saint Ambrose draws this parallel between the newborn infant and the resurrected Christ: "Qui natus olim ex virgine / Nunc e sepulcro nasceris."[69]

In this context, it is clear that Bellini's illusionistic pastophories represent more than a quotation of the plan of a Greek church: their liturgical function is also relevant, for the eucharistic bread (and sometimes the wine) were kept in those chambers for use in the Communion. Likewise, the octagonal form of Bellini's pedestal is meaningful in itself, because the number eight traditionally signified birth and rebirth.[70] Furthermore, the octagonal pedestal has five steps or levels, and on the highest of these the Lombardesque pattern that contains Bellini's signature is subdivided into five parts. At the top of the frame, golden flames burn on four torches and a central lamp—five eternal lights. Five is the number of Christ's wounds, a reference of particular import in a Franciscan church. Through the miracle of the Stigmatization, Saint Francis had received identical wounds, inflicted by Christ himself. For this reason, to symbolize the wounds of Crucifixion the anonymous author of "The Considerations on the Holy Stigmata,"

written between 1370 and 1385, divided his treatise into five sections. He explained his intentions in the opening lines of the text: "We shall contemplate with devout consideration the glorious, sacred, and holy Stigmata of our blessed Father St. Francis which he received from Christ on the holy Mount Alverna. And because those Stigmata were five, like the five Wounds of Our Lord Jesus Christ, therefore this treatise shall have Five Considerations."[71]

Such emphasis on Christ's suffering, compassion for his Passion, was the primary characteristic of Franciscan spirituality. We need not doubt that Bellini understood this, and indeed that he was familiar with such texts as the "Considerations." The Frari triptych was his fourth (and last) great commission of works painted for the Franciscan order or with a specifically Franciscan theme, the others being the *Coronation of the Virgin* (ca. 1474), the *St. Francis* (ca. 1476), and the altarpiece painted for the Observant Franciscan church of S. Giobbe in Venice (figs. 19 and 25–27).[72] In working on these compositions, Bellini learned much about Franciscan sensibility and Franciscan spirituality. Both his knowledge and his sympathy shine forth in the results—not only in their content but in the compassionate spirituality they convey. Thus, for example, in the *Coronation*, the moment of the Madonna's ultimate triumph, her supreme joy (and humility) at being reunited with her son who crowns her Queen of Heaven, was juxtaposed with the pathetic image of the Crucified Christ being prepared for entombment (figs. 25 and 26).[73] And Bellini's characterization of Saint Francis in both the S. Giobbe altarpiece and the Frick panel is the Franciscan ideal of the saint as the perfect imitator of Christ, the irresistible intercessor whose compassion and efficacy are guaranteed by his own experience of Christ's Passion (fig. 27).

Even the frame of Bellini's Frari triptych is related to this Franciscan emphasis on Christ's Passion and its reenactment in the mass. Resembling the form of a tabernacle and lit by its own eternal golden lamp and torches, the frame perforce carries the same associations, reiterating the identification of the Madonna and Child with the sacred shrine and eucharistic offering.[74] Thus, Bellini's triptych represents the chancel of a church with the Virgin and Child as heavenly altar or sacred shrine and eternal Eucharist, elevated on a five-tiered, octagonal pedestal, signifying crucifixion and resurrection; and with the saintly communicants in the wings (or pastophories) as exempla for the mortal congregation who worship before them at the earthly altar of the sacristy.

The Madonna, seated, slightly exceeds the height of the standing saints in the wings, a fact that Bellini explained logically with the Virgin's high pedestal, and which he emphasized by making the base of

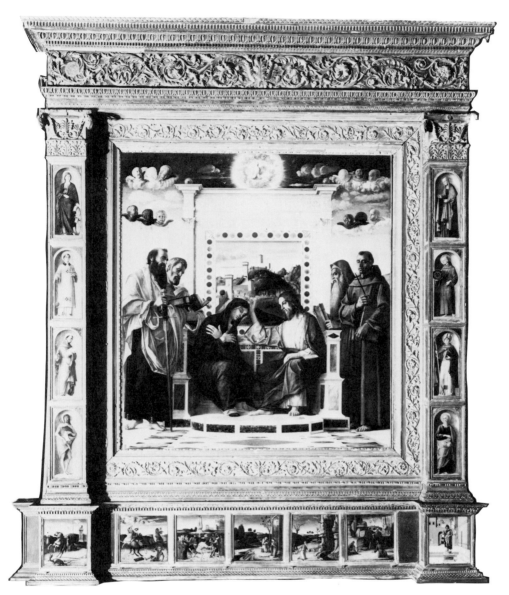

25. Giovanni Bellini, *Coronation of the Virgin*. Pesaro, Museo Civico.

the semidome behind her coincide with the very low ceilings above the saints' heads. The exaltation of the Madonna allows her and her son to exchange a glance with Saint Nicholas on their proper right—the only saint of the four who is looking directly at them. Possibly he was

[55]

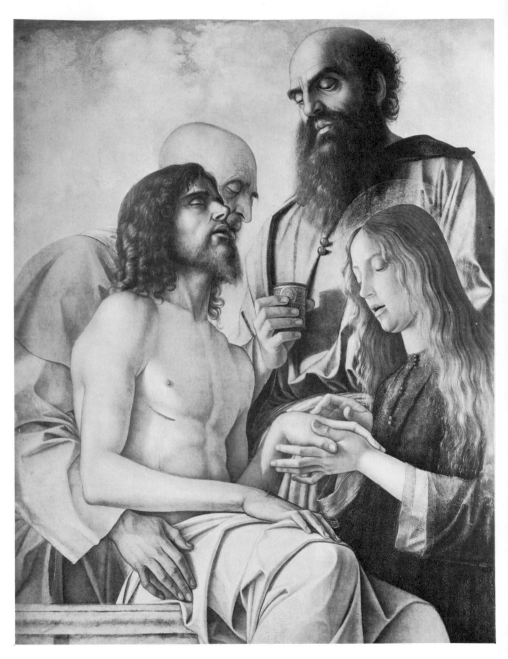

26. Giovanni Bellini, *Pietà*. Vatican City, Musei Vaticani.

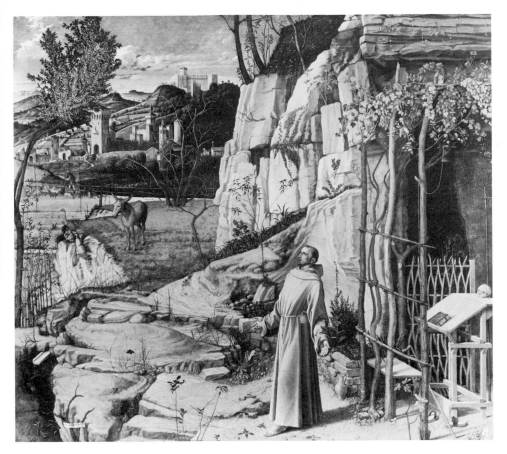

27. Giovanni Bellini, *St. Francis* (detail). New York, The Frick Collection.

privileged in this way as the onomastic saint of the eldest Pesaro brother. With him is the patron saint of their deceased father, Saint Peter, who, like Saint Mark opposite, is rapt in devotion, exemplifying the state of worship that the altarpiece inspires. Their eyes are cast downward and inward, while Saint Benedict looks directly at us, compelling us to pay attention to the image and to the text that he holds (figs. 16 and 18).

The book held by Saint Benedict is open to the beginning of chapter 24 of Ecclesiasticus, commonly interpreted as an affirmation of Mary's Immaculate Conception, her birth unstained by Original Sin. It is appropriate that the text is presented to the congregation by the saint whose order had first observed the feast in England, even before it was

celebrated in Europe.[75] Bellini made reference to the Book of Ecclesiasticus in his visual language as well. The height of the pedestal that raises the seated Virgin to the level of the standing saints is in itself suggestive of her Immaculate Conception. Signorelli's even more explicit rendering of the *Immacolata* in Cortona (1521) likewise raises the Virgin upon a pedestal (fig. 28).[76] Perhaps Bellini's omission of a throne per se in the triptych may thus be explained: Mary herself *is* the throne, the *sedes sapientiae* on which Wisdom—that is, Christ—is enthroned.[77]

Another text in Bellini's triptych also refers explicitly to the Immaculate Conception. The inscription in the fictive mosaic above the Virgin's head addresses her as the "Sure Gate of Heaven": "Ianua Certa Poli Duc Mentem Dirige Vitam / Quae Peragam Commissa Tuae Sint Omnia Curae." This is a quotation from the office written by Leonardo Nogarolis and approved by Sixtus IV for reading at the feast and octave of the Conception. The office was printed in Venice in 1478, the year of Franceschina's death and a plague year in Venice.[78] Earlier, John Duns Scotus, the great Franciscan theologian, had used the word *ianua* in arguments to prove the Virgin's immaculacy. He explained that the gate, "ianua," would not need to be opened for Mary because she had already been redeemed. That is to say, because Mary always existed in God's mind, even before the Creation, she was Immaculate, exempt from Original Sin even though descended from Adam and Eve.[79] *Ianua* occurs rarely in the Bible; hence the context in which it appears is especially significant in such exegetal usage as the texts by Scotus and the Office of the Conception. In I Chronicles 22 : 3, it is the word used to describe the gate of the temple built by David, the *Domus Dei* (in the Vulgate, I Par. 22 : 1 and 3; also II Par. 28 : 24). In Revelation 3 : 20, *ianua* signifies hopeful promise: "Behold, I stand at the door, and knock; if any man hear my voice, and open the door [*ianuam*], I will come in to him, and will sup with him, and he with me."

The feast of the Immaculate Conception, December 8, had been observed (and defended) by the Friars Minor already during the fourteenth century, and probably before then.[80] But not until 1477 was the feast recognized for the universal church by an act of the Franciscan Pope Sixtus IV. His bull *Cum Praecelsa* granted special indulgences to those attending services on the feast.[81] Pope Sixtus's profound dedication to the Immaculate Virgin was expressed in both his private devotions and public actions. The chapel that he had constructed in the Vatican for his own use was consecrated to the *Immacolata,* and Sixtus observed the feast fervently. But the controversy that had always been associated with the doctrine continued and so intensified even after his bull of 1477, that in 1482 and 1483 the pontiff promulgated bulls theoretically

28. Luca Signorelli, *Immaculate Conception*. Cortona, Museo Diocesano.

imposing silence on the contending factions.[82] Bellini's imagery is so gracious that (perhaps intentionally) it belies the acrimony that too often characterized the arguments about Mary's Immaculate Conception.

It was during these same years of papal intervention and heightened controversy regarding the doctrine of the Conception that the Pesaro of S. Benetto were building their chapel. If Bellini's altarpiece represents the subject of the dedication of the chapel—as one can hardly doubt—then this was the first Pesaro altar of the Immaculate Conception in the Frari.[83] To be sure, the dedication of a chapel to the Conception in the Frari—or in any Franciscan church—requires no special explanation.[84] Nevertheless, historical circumstances suggest that there is a specific connection between the chapel dedication and the pope's actions.

Born Francesco della Rovere, Sixtus IV had been educated in the Franciscan order and from 1439 to 1441 had lived at the convent of the Frari as *lector philosophiae*.[85] In 1464, Cardinal Bessarion promoted della Rovere's election as minister general of the Franciscan order. In that year, della Rovere chose the Frari as the site of a *Capitolo Generale* of the order. The chapter met in 1469, the final year of della Rovere's generalate, and it was at this time that the high altar was consecrated.[86] Two years later, the friar was elevated to the papacy.

Not since the early days had the Franciscans had such a powerful "friend at court."[87] During his papacy (1471–84), Sixtus much increased the privileges of both great Mendicant orders, but most especially those of his own Friars Minor, notably with the bull *Mare Magnum* (1474) and the *Bulla Aurea* (1479). In the latter, the "Golden Bull," Sixtus awarded indulgences to those who contributed to the construction and maintenance of Mendicant churches and chapels. In addition to his approval of the feast of the Immaculate Conception—despite Dominican opposition—Sixtus promoted the cult of Saint Francis, making the saint's day a double feast (1472), and canonized Saint Bonaventure in 1482, over two centuries after Bonaventure's death (d. 1274).[88] Surely all of this would have encouraged Franciscan patronage, at least in a general way. In Venice, Sixtus may have influenced patronage in a specific way as well.

On 24 May 1483, when the Venetians continued their siege of Ferrara despite the pope's call to end the war, Sixtus retaliated by imposing an interdict against the Republic. His Holiness had allowed the Venetians two weeks' notice so that they might repent and comply with his wishes regarding Ferrara. But the Venetian response was far from compliant. When the interdict was sent to the patriarch in Venice, he feigned illness

and then went secretly to warn the Council of Ten. The Ten ordered his silence, so that religious rites could be performed "normally."[89]

The papal interdict required the departure of the friars from Venice, and, perhaps remembering that Sixtus was one of them, they were more obedient than the patriarch and the Council of Ten. Hundreds went into exile, leaving their churches and convents abandoned. But in response to the plea of the Franciscan provincial vicar, B. Bernardino of Feltre, Sixtus granted an indulgence allowing the return to Venice of the Franciscan superiors, the confessors of the friars, and their students and professors.[90]

One of the Venetian noblemen who was closely involved in these matters, acting first as *provedator* in the war with Ferrara and then as an agent in the peace treaty negotiations, was Nicolò Pesaro, a patron of Bellini's *Madonna* honoring the Immaculate Conception in the Frari.[91] It is possible that Nicolò and his brothers were aware of Sixtus's personal devotion to the cult; as worshipers in the Frari, it is certain that they would have known of his actions promoting observation of the feast. Perhaps this is another reason why Saint Nicholas and the Madonna exchange a glance in the Pesaro triptych, and why she looks also in the direction of St. Peter, the first pope and the patron saint of the Franciscan order.[92]

In any case, if the three Pesaro brothers meant to please Sixtus by thus honoring the Immaculate Virgin—especially in the aftermath of papal displeasure with Venice and at precisely the moment of his reconciliation with the Republic—they would not have been either the first or the last to have wished to win (posthumous) papal approbation. For example, their cousin Jacopo Pesaro used the art of painting even more overtly to convey his gratitude and loyalty to the pope he wanted to please, Alexander VI (Borgia), in a votive picture begun by Titian less than twenty years after the completion of Bellini's triptych (fig. 47).[93] At any rate, it is clear that the Pesaro family were particularly devoted to the *Immacolata,* considering the dedication of the two Pesaro altars to her in the Frari.[94]

According to Franciscan belief, the Madonna's Immaculate Conception is an integral part of the privileges that make her capable of fulfilling her role as coredemptrix.[95] Thus, Bellini's imagery of the tabernacle, the high pedestal, the prayer inscribed in the fictive mosaic apse, and the Book of Ecclesiasticus held by Saint Benedict all express the confident hope of redemption through the intermediation of the Immaculate Mother of Christ. In this way, Bellini's triptych completely fulfills its purpose as the altarpiece of a funerary chapel in a Franciscan church.

3. Two *Generalissimi da Mar*

Fortissimo personaggio e supremo Capitan General . . .
Oh infausto giorno in cui perdemmo te, ottimo Bene-
detto! Oh giorno lugubre![96]

None of the Pesaro family can have looked like his onomastic saint: Bellini's figures are clearly not intended as portrait likenesses, and in any case the brothers were all younger in 1488 than the men portrayed in the triptych, while their father was long dead. However, Bellini varied his psychological conception of the four saints, and of the group, Benedict—by far the most prominent member of his (Benedetto's) family—stands out as the most energetic, even aggressive. His strong gaze attracts our own: he alone of all the figures looks directly at us. And he holds the open book of Ecclesiasticus, which also demands the viewer's attention (figs. 16 and 18). It is tempting to see in Bellini's powerful interpretation of this saint a reflection of Benedetto Pesaro himself, dominant in his altarpiece as he was in life.

Of course, all three brothers had public careers: that was both the privilege and the obligation of their noble birth.[97] Marco was a senator in 1491 and a Consigliere alla Banca.[98] Nicolò was involved, as we have seen, first in the war and then in the peace negotiations with Ferrara. But of the three brothers, Benedetto was the most successful; he eventually became one of the most powerful men of his generation and was also more conspicuously involved with the Frari than either of his brothers.

Born in 1433, Benedetto married Isabella Duodo in 1465. His early career was spent in London representing the family's business concerns there, which earned him (and his family) the appellation "Pesaro of London."[99] Although not the oldest brother, Benedetto became the predominant member of his family, in both private and public life. For example, in 1486, it was Benedetto who acted in his own name and on behalf of his brothers to buy a plot of land in the Confinio di S. Stefano Confessore (S. Stin in dialect) just to the north of the Frari and close to the traditional Pesaro neighborhood (fig. 2).[100]

Everything that is known about Benedetto's public career reveals a willful, audacious personality that led to difficulties on more than one occasion. A case in point was his abuse of authority ("ex capite suo et auctoritate propria") in 1491 when, as one of the Council of Ten, he wrongfully imprisoned a Venetian citizen. Perhaps realizing his error, he soon had the man freed, but that was not the end of the matter. When Benedetto was elected a Capo dei Dieci on 30 July 1491, he was

not allowed to take office, evidently because of objections to his improper imprisonment of a citizen. On August 1, he was expelled from the council for a period of four years and for another two years barred from the *Consigli secreti*.[101] He was back in the Council of Ten by 1497, when he was first mentioned by the Venetian diarist Sanuto. In November 1498, Benedetto was a Capo dei Dieci and held that office again in March 1499, when he received Piero de' Medici during the Florentine's visit to Venice.[102] A month later Pesaro was a candidate for the extraordinary office of *generalissimo da mar*—he had had previous naval experience as Captain of the Galleys of Flanders—but he lost to Antonio Grimani.[103] The Venetians elected a generalissimo only during wartimes of particular difficulty, and the war with Turkey was indeed such a time. Later in 1499, Benedetto lost again, to Marco Trevisan, but was finally elected to replace Trevisan as generalissimo on 28 July 1500 and granted "gran autorità," as Sanuto recorded.[104]

Benedetto astonished and impressed the Venetians by the speed and efficiency with which he took command, and Sanuto described the splendid ceremony of Pesaro's investiture as generalissimo on July 29 in the Collegio:

And then, Ser Benedetto di Ca' Pesaro came, the captain general of the sea, dressed in crimson damascene, with open sleeves, and a cap of crimson satin. He came with the senate and the doge, according to custom, to take the standard to the church of S. Marco. . . . And after the celebration of mass, the standard was blessed, and, because Pesaro had not had his own standard made [due to lack of time], the standard of the former general Ser Francesco de' Priuli was used. And Pesaro was accompanied by the clergy and the doge until the captain general boarded the great galley. . . . And, I'll say this, it was a great achievement the way he expedited matters so quickly, and an accomplishment worthy of glory to his house. He is going with good spirit and disposed to do himself honor; known as [Pesaro] of London, he used to be captain of the galleys of Flanders.[105]

Soon Benedetto also impressed his compatriots with news of important victories against the Turks in the Dardanelles. On the day before Christmas in 1500, Cephalonia was taken, after earlier attempts by others had failed.[106] Napoli di Rumania and Santa Maura (Leucadia) followed.[107] Having recaptured Santa Maura for the Republic on 30 August 1502, Benedetto proceeded to execute by decapitation the Venetian officials whom he held responsible for the loss of the island to the Turks. The unfortunate victims were two noblemen with important families

to mourn (and avenge) them, Carlo Contarini and Marco Loredan *q.* Alvise—the latter a kinsman of the newly elected Doge Leonardo Loredan.[108] (Although their family connections did not save them from Benedetto's death sentence, their friends and kinsmen retaliated with posthumous charges of embezzlement against the admiral.)[109]

Benedetto continued the fight against the Turks, despite frequently critical shortages of food and supplies and his own advancing age and illness.[110] The armada was chronically short of food, and Benedetto wrote constantly about the lack of biscuits, which had been supplied by a factory built and run by his cousin Antonio *q.* Leonardo, the brother of Titian's patron in the Frari.[111]

The Republic rewarded Benedetto for his victories by electing him to the Procuratia de Supra in 1501, but he never returned to Venice to take office. Benedetto died on his galley at Corfù on 10 August 1503. Santa Maura, which he had fought so hard to conquer, and which he had recommended so strongly to the Collegio as a vital fortress to be maintained by the Serenissima, was returned to the Turks by the peace treaty formally signed on the very day that Benedetto died.[112]

In accordance with the instructions of his testament of 1503, Benedetto's body was returned to Venice for burial in the Frari. The admiral had dictated detailed specifications for his funerary monument in his will, and they were carried out precisely:

> I, Benedetto Pesaro, . . . want and order . . . that my body be buried in the church of St. Francis of the Friars Minor of Venice in our chapel in the sacristy of said church of the Friars Minor, and for my memory I want my aforementioned commissaries to have made above the door of said sacristy a noble marble monument with columns of marble, where my body may afterwards be placed, and they should include an epitaph of my deeds on this monument, and may spend up to 1,000 ducats on it. . . . Item, I want and order mass to be celebrated and said daily in perpetuity for my soul . . . and a daily mass in the aforesaid sacristy.[113]

As he had ordered in his will, Benedetto's grandiose monument surrounds—indeed, encompasses—the entrance to the sacristy from the main part of the church, standing both as a personal memorial and in effect as a surveyor's marker, identifying the sacristy as Pesaro territory (fig. 29). The monument is placed near two tombs also honoring mil-

29. Lorenzo Bregno and Baccio da Montelupo, Monument of Benedetto Pesaro. Venice, Santa Maria Gloriosa dei Frari.

30. Monument of Jacopo Marcello. Venice, Santa Maria Gloriosa dei Frari.

itary men, the Roman condottiere Paolo Savelli and the Venetian Jacopo
Marcello, generalissimo da mar in 1484, represented by a full-length
standing effigy (figs. 11 and 30).[114] In determining the site of his own
monument, Benedetto intended above all to identify and to aggrandize

[66]

the sacristy entrance as the entrance to his family chapel. But at the same time, this choice had the effect of placing his career in the historical context of military service to the state. Like the monuments of his illustrious predecessors, Benedetto's also features an inscription that recalls and extolls his accomplishments, and, like Marcello, Pesaro is also represented as standing and holding his general's standard.

Benedetto's tomb is constructed of white marble, enhanced by gilding in the flutes and capitals of the columns, in the carved flowers in the coffers of the arch, in all the figural reliefs, and in the effigy.[115] The generalissimo had specifically ordered that a laudatory inscription be included as a record of his major military triumphs. The inscription is written on two gilded stone panels set between the columns to the left and right of the entrance arch. The text on the left reads: "Benedictus Pisaurus V. classis imp. Turcorum class. altera ex Ionio in Hellespontum fugata altera in Ambracio sinuvi capta Leucade et Cephalenia." On the right is the inscription: "Expugnatis ali isque recuperatis insulis Nauplia obsidione liberata Richio sae viss. pirata interfecto divi M. proc. creatus pace composita Corcirae obiit."[116] The date of Benedetto's death in Roman numerals, MDIII, is inscribed twice, on the innermost socles to the left and right of the entrance. Between the socles of the columns on the right is a commemorative inscription of Benedetto's son Girolamo: "Hieronynius F. parenti optime de patria merito posuit." It may be that Girolamo's words were intended as a reproach to those who were accusing his father posthumously of embezzlement: "He [Benedetto] deserves the best from his country."

The sculptor of the monument, probably Lorenzo Bregno, represented the visual equivalent of the inscription in the reliefs and in the figure of the deceased.[117] The admiral stands over his monument, eternally the victorious leader. Benedetto's posture and his attribute, the admiral's standard, inevitably evoke figures of the Resurrected Christ with his banner and carry the same connotations of conquest over death.[118] But Benedetto is no Prince of Peace: he is wearing armor (partially gilded) and is flanked by nude figures of the pagan gods Neptune and Mars. Martial motifs are repeated everywhere: in the decorations of the bases supporting the figures of the gods, in the socles flanking the entrance arch, and in the panels between the columns, where two cuirasses are carved, one facing the viewer and the other turned away. Dolphins act as volutes for the admiral's pedestal, evoking the sea and possibly also intended to have funerary connotations.[119] Below, decorating Benedetto's urn, are reliefs inscribed "Cephalonia" and "Leucadia" (Saint Maura), gilded and with porphyry backgrounds. Flanking these panels are reliefs of Venetian galleys, also gilded but

with *verde antico* grounds. The panels recall Benedetto's service to the Republic and in particular two of his greatest victories, of which we have already been reminded by the inscription. The Serenissima itself is symbolized by several lions, one incised on the general's cuirass, by the lion's head brackets that support the reliefs of Cephalonia and Saint Maura, and by the gilded rondels with lions of Saint Mark holding their books above the inscriptions lauding Benedetto's patriotic accomplishments. But their books are closed: perhaps the traditional inscription, "Pax tibi Marce Evangelista meus," was concealed because Benedetto died during wartime.

The architectural framework of the monument is defined by columns—again, in accordance with the demands of Benedetto's testament. This detail won Sansovino's approval; he admired the tomb's "bellissime colonne di marmo."[120] The engaged columns establish the monument's resemblance to a triumphal arch superimposed on the sacristy entrance and thereby convey the same impression of eternal victory as the figurative and literary elements.[121] Benedetto's request for columns shows him to have been au courant with the latest contemporary taste in Venetian architecture at the beginning of the new century, for example, the facades of the Scuola di San Marco and of the Palazzo Vendramin-Calergi.[122]

Nothing in the inscription and almost nothing in the figural decoration refers to Benedetto's Christian faith. The only sacred figures here are the Madonna and Child in the tympanum and the small rondels of the onomastic saints of the admiral and his son, Benedict and Jerome, inconspicuously placed in the inner faces of the piers that define the entrance to the sacristy. The Madonna and saints are clearly subsidiary to the ancient gods of war and of the sea, and to the grand statue of Benedetto himself. With its unmistakable declarations of patriotic service and achievement, Benedetto's monument vigorously reasserts the civic aspects of Bellini's triptych in the sacristy.

Benedetto was buried with elaborate public funerary rites attended (of necessity) even by his enemy Doge Leonardo Loredan, by the Senate and other nobles.[123] Sanuto's detailed description of the ceremonies of 4 September 1503 depicts the splendor of such public spectacles in Renaissance Venice:

And after the galley of General Pesaro had landed in this land, his body was carried in a casket to the church of S. Benedetto, and then today, Monday, the fourth, the obsequies were celebrated with honor in the church of the Friars Minor, where his tomb is in the sacristy and where he will be interred. First, the coffin was taken to S. Marco,

and the chapters of S. Marco and of Castello came, and the Scuola di
S. Giovanni, and all the congregations, and there were one hundred
torches costing 2 lire each and [carried by] the scuola, and one hundred
others costing 8 lire each; of course, twenty were carried by Friars
Minor, twenty by Gesuati, twenty by priests, and forty by sailors.
Around the casket [were] twelve men with cloaks with great trains
and hoods in back; the casket [was] carried by members of the scuola
with the golden finial from the general's standard; and atop the casket
was the golden standard, which covered the entire coffin, with a hel-
met and a sword worked in damascene. The doge accompanied the
casket, with the orators and the Signoria, and a number of noble-
men. . . . And they walked from S. Marco to the Frari, which had
been draped with black cloths, and the casket was placed in the center
of the church; even around the church were black banners and many
lights. It was a beautiful ceremony. The funerary oration was delivered
by Ser Gabriel Moro *q*. Antonio, praising the general highly; it was
put into print. And afterwards the doge returned to S. Marco. . . .[124]

The laudatory funeral oration by Gabriele Moro, appreciated by Sa-
nuto, praised Benedetto's remarkable diligence and energy in the exe-
cution of his duties as generalissimo. Moro also cited Pesaro's brothers,
Marco and Nicolò, both of whom had predeceased Benedetto, and the
distinguished family of their mother, Franceschina Tron.[125]

As the inscription informs us, the patron of the monument was Be-
nedetto's devoted son and commissary, Girolamo who, like his father
before him, became a generalissimo da mar—in 1529 against Charles V,
and in 1536, to fight the Turks once again in Corfù. Just before his death,
on 7 January 1549 (m.v.), Girolamo was named Procurator de Ultra.[126]
In his testament of 7 November of that year, Girolamo followed his
father also in dictating remarkably specific instructions regarding his
sepulchre, which was to resemble Benedetto's monument and to be
constructed on the opposite nave wall, around the Porta di S. Carlo
(fig. 4).[127] And according to the wishes expressed in his testament, Gi-
rolamo was to be interred in the habit of the Conventual Franciscans.
To be sure, burial in the habit of one of the Mendicant orders was a
common request in the Middle Ages and the Renaissance, but was
nonetheless significant as an expression of personal piety and devo-
tion.[128] There are other indications in his will of Girolamo's devotion
to Saint Francis. Like his grandmother (and many others), he requested
that prayers be said for his soul at Assisi.[129] Moreover, Girolamo made
bequests to several Franciscan churches in addition to the Frari: S. Maria

Maggiore, S. Chiara, S. Croce, S. Sepulcro, and the Miracoli—dedi-
cated to the Immaculate Conception.[130]

Girolamo also referred to the (unmarked) tombs of other members
of his family in the sacristy, which had become very much the funerary
chapel of the Pesaro of S. Benedetto since the burial there of his grand-
mother in 1478.[131] Finally, the clauses regarding Girolamo's specifica-
tions for his monument reveal him to be as concerned with "style" and
with posterity as his father had been. Here are the relevant passages:

I want my body dressed in the habit of the Conventual Franciscans.
And at the obsequies there should be four torches of appropriate
weight, and so at my said obsequies for the time when my said body
will remain in the church of S. Benedetto. Item, four chapters, that
is, S. Marco, S. Pietro di Castello, S. Benedetto, and S. Angelo, and
all those beneficed priests who say mass in my said parishes
[S. Benedetto and S. Angelo]. Item, twelve Gesuati with twelve
torches, of four lire each. And I want the bier on which my body will
be placed to be carried by sailors to S. Maria of the Friars Minor, and
there placed in a "deposit" in the sacristy of said church where our
chapel is. . . . Item, I want ten ducats to be given to the convent of
. . . the Friars Minor, and one ducat to the sacristan of this convent
for the expense and alms of my said sepulchre, and likewise two ducats
to be given as alms to the brothers of this monastery. And for respect
[of the fact] that recently, by the grace of the goodness of God and of
this most illustrious dominion, I have been elevated to the rank of
procurator, thus I am content that, as it seems to the majority of my
aforesaid commissaries, they may add to my obsequies that larger
number of clerics and of candles as seems appropriate to them. I want
masses of the Madonna and of St. Gregory to be said for my soul;
I want [someone] sent to Rome and to Assisi with the customary
alms for my soul. Item, I want one ducat given as alms to each of
the said convents of nuns to offer prayers when it seems appropriate
to my commissaries, that is, to S. Maria Maggiore, the Miracoli,
S. Sepolcro, Ognissanti, S. Chiara of Murano, S. Maria degli Angeli,
S. Andrea della Zirada, S. Stefano, S. Giustina, S. Servolo, S. Croce
of Venice, and to S. Croce of the Giudecca. . . . Item, I want my
commissaries to select a chaplain of good life, a priest or friar, who
will continually say mass for my soul in the parish in which my de-
scendants shall live. . . . [for] the good memory of my most enlight-
ened progenitor and most honored father I leave to the convent of
Friars Minor fifteen ducats a year for a mass. . . . Item, I want an
obsequy celebrated by the convent of the Friars Minor for the soul of
the good memory of my father and of my mother, beginning on the

day of the anniversary of my father's death and then of my mother's, with a high mass sung at the high altar, performing the usual obsequies before his tomb as is customary. And [the friars are] to go to the tombs on the day of the dead and likewise in the sacristy where my mother, my wife and my children are buried, and as long as my remains are kept in the said sacristy, and when my body is placed in the tomb, [I want the Friars] to go to the said monument the following year, likewise to observe the anniversary of my death, returning always to the aforesaid manner from year to year. For the said three anniversaries they are to have one current ducat in alms. And my commissaries and heirs are to be obliged every year to have a torch of six lire placed before the tomb of my father and another before my deposit and tomb when it is constructed and my body placed therein, for the vigil of the dead and the day of the dead. Item, I want the aforesaid convent to consent to the construction of my monument above the door exiting the church in the crossing, directly opposite the door of the sacristy where my father's monument is. And that as far as shall be convenient, [the friars] consent to allow that tall window that is immediately above [the doorway] to be covered from the inside. And in order to spend less on said tomb I want it to have two columns where my father's monument has four columns. And in order that one can place two figures, I want that at the sides of these columns it be made as they are at the portal entering the church of S. Giorgio Maggiore, and that that socle should project so far, and also the architrave, frieze and cornice above, so that above the projection of the cornice can be inserted easily. For each of the sides, a figure that will be next to the two columns . . . precisely as in my father's tomb . . . I want [my tomb] to be of stone except in the friezes that are to be decorated with small marble panels, and the revetment that will be above, between the two columns, and the figures and all the rest to be of stone without any gilding, except in the arms that were made, and to be carved in the sarcophagus: in two-thirds of it the city of Brandico, and in the other part the castle of Scoio of said city of Brandico of the sea. And in the other third the city of Scardona [near Zara in Dalmatia]. And . . . this structure of the tomb will be oblong, supposing one builds it above along the length of the pediment ["frontispizio"] of the portal. . . . The three figures: there will be one, i.e., above the tomb in the manner of that of my father, the other two that will go next to those columns above. . . . One of these figures has to hold in his hand the ship's pennant and in the other hand a shield with the arms; and the other [figure is to have] in his hand the visored helmet atop a baton, and in the other [hand] the shield, as I have said of the other [figure]. And because around said framework there is a

certain old frame carved with leaves [foiame] with a figure of Our Lady, in that same place that it [a Madonna] is found in my father's monument, and that has the same effect that that one has, and when the convent wishes that above the tomb be made a little higher, so as not to mar the form of the monument, that antiquity is to be relocated, by installing that figure of Our Lady with . . . [the frame] either above that other door that goes into the Corner chapel, or somewhere else; I want it to be replaced at the expense of my commissary. And in said [tomb] be accommodated the panel of the epitaph in which are to be [written] the public deeds done by me. Which work [the tomb] I want done for the convenience of my commissary in ten years, part by part, so that in said time it be finished. . . .[132]

On 2 February 1550, little more than a year after Girolamo's death, his son and heir, Benedetto, requested permission to construct the tomb "above the door that exits the church opposite the door of the sacristy where the tomb of my deceased forebears is, and again that it [the new tomb] have the form of a *credenza*."[133] The monument would be "no small adornment of the church," Benedetto continued, and its construction would not damage either the wall or the door. Finally, Benedetto offered twenty-five ducats in alms to the friars "in sign of gratitude." The friars granted permission for the building of the new tomb.

The masses that Girolamo requested were still being said in 1733 in the Frari sacristy for his parents and for himself, and "un torcio," a torch or candle, was lit at his sepulchre on All Souls' Day.[134] Unfortunately, his monument was destroyed to relieve the nave wall: despite his son's reassurances to the friars, the tomb did indeed cause structural damage.[135] According to the archivist Sartori, writing in 1949, only the arms of the Pesaro remained at the site.[136] Today, however, nothing is visible there—unless, indeed, the doorway itself is the enframement of Girolamo's monument.

While it stood, Girolamo's tomb must have been a conspicuous reminder of his own eminence and of his family's patronage of the Frari. With his father's monument, it would in effect have bracketed the east end of the church, and it would of course have completely overshadowed the more modest wall-tomb of Jacopo Pesaro—his cousin, his father's ally (and rival) at Santa Maura, and Titian's patron in the Frari.

3

A Franciscan Victory and
a Franciscan Defeat

1. Victory: The Immaculate Conception

Nel peccato mortale en to voler non sale
et dall'oveniale tu sola è emmaculata.
 —Jacopone da Todi[1]

Tota pulchra es Maria, et macula originalis non est in
te.
 —Bernardino de Bustis, Office for the
 Feast of the Conception[2]

Titian's first work for the Frari, the sublime *Assunta* of the high altar, was commissioned by the guardian of the convent, Germano Casale, in 1516—that is, just at the time of the separation of the Conventual Franciscans from the Order of the Friars Minor (figs. 32 and 33).[3] Leo X's divisive "Bull of Union" of 1517 was the climactic conclusion of the crises that had tormented the Franciscan order almost since its beginning.[4] The bitter mood of the friars in the early sixteenth century and the events culminating in the division of the order in 1517 are the historical, and indeed the psychological, context of Germano's very

[73]

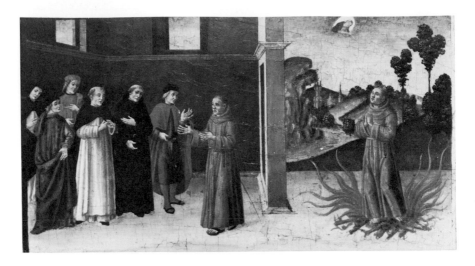

31. Master of the Immaculate Conception, *A Friar Defends Belief in the Immaculate Conception with the Proof of Fire*. Vatican City, Musei Vaticani.

public commissions of the altarpiece and of the altar itself. The theological and spiritual context is the triumph of the Immaculate Conception.

The question of the Madonna's Conception touched upon the most fundamental and profound issues of the Catholic faith and was the subject of theological debate for centuries: although the feast was approved in 1476, the dogma was proclaimed only in 1854.[5] During the Middle Ages and the Renaissance, the dispute was very much divided along "party lines," with the Friars Minor the staunch defenders and the Dominicans the vociferous opponents of the Immaculate Conception. Thus in 1480, Henricus de Sassia published a tract criticizing both Mendicant orders for their fractious disagreement about the doctrine.[6] And the diarist Sanuto, writing in 1521—nearly fifty years after observance of the feast had been approved for the entire church—noted "the enmity between the friars of St. Francis and of St. Dominic regarding the Conception of the Virgin Mary."[7]

Their long-lived battle was waged not only in words but also in pictures. A fifteenth-century panel by the Lucchese "Master of the Immaculate Conception" illustrates this confrontation between the two great Mendicant orders with straightforward naiveté (fig. 31).[8] A Franciscan debates with a group that includes two recalcitrant Dominicans

(wearing white habits with black mantles). The brave friar defends belief in the Virgin's Immaculacy by the proof of fire, just as Saint Francis himself was willing to defend his belief in Christianity before the sultan. The Franciscan's efforts are witnessed, and surely endorsed, by the apparition of the Virgin, a half-length figure in the sky. While it is doubtful that a fifteenth-century friar actually ever employed self-immolation as a defense of Mary's Immaculacy, these flames represent accurately enough the heat of the argument between the two great Mendicant orders. What follows here is a summary of their complex disputations.

Saint Thomas Aquinas had reasoned that all men must be saved from Original Sin through Christ: "If the soul of the Blessed Virgin had never been defiled by original sin, this would derogate from the dignity of Christ as Redeemer of all mankind. . . . The Blessed Virgin . . . did contract original sin, but was cleansed therefrom before birth."⁹ As a human being, perforce Mary too required Christ's redemption. To claim otherwise would be to delimit his redemptive act. To assert that Mary was conceived immaculate meant that by definition she could not have been a human being, a descendant of Adam. Thus, Aquinas argued, Mary was conceived like all other human beings but was sanctified *after* conception—that is, cleansed of Original Sin in her mother's womb.

The Franciscan response to the Dominican argument was provided by the Marian Doctor, also appropriately known as the Subtle Doctor, John Duns Scotus. Scotus agreed that Mary indeed required Christ's redemption, like all descendants of Adam. But the order of nature and the order of time are not the same thing, and Mary had always been destined to be the mother of the Redeemer. Scotus asserted that preservation of Christ's mother from Original Sin was a "pre-redemption." "Mary had the greatest need of Christ as Redeemer," Scotus reasoned, "for she would have contracted original sin by reason of her descent [from Adam], unless this had been prevented by the grace of a Mediator. . . . she needed even more [than others] a Mediator preventing this, that she might not at any time be under debt of contracting it [sin], and that she be preserved from actually contracting it."¹⁰ Had she been stained with Original Sin, Mary would not have been ready to become the Temple of Christ. Therefore, Mary was saved in anticipation of Christ's redemptive act, literally saved in advance by a "pre-redemption" that exempted her from Original Sin and prepared her to become his mother.¹¹ Bernardino de Bustis alluded to this in his office for the feast of the Conception, declaring that Mary had been appointed and prepared by God "from the beginning and before time": "Ab initio et ante saecula Deus ordinavit eam et Filio suo praeparavit eam."¹²

As the *Socia Christi Redemptoris* who must be close to Christ and must share his destiny, the Virgin must also suffer death—but not to atone for Original Sin, by which she is unstained. Rather, the Madonna gained merit by her suffering, as Scotus explained, whereas her being stained with Original Sin would have been without purpose.[13] God was surely able to preserve her from Original Sin; it was becoming to honor her in this way; therefore, we may presume that he did so: "Potuit, decuit, ergo fecit." The famous phrase, attributed to Scotus, was already found in William of Ware, Petrus Thomae, and others.[14] But Scotus was indeed the first to teach the doctrine of Mary's Immaculacy at Paris.[15]

When a Scriptural basis was sought in this matter, perhaps the single most important biblical text was the phrase with which the Archangel Gabriel greeted Mary in the Annunciation, *Gratia plena,* "Full of Grace" (Lk 1: 28).[16] The angelic salutation was considered prima facie evidence for the attribution of all her special privileges to the Virgin. That is why, for example, Domenico Ghirlandaio inscribed the words *Ave Maria Gratia* on Mary's tomb in the *Assumption of the Virgin* (1492) he designed for the window of the chancel in S. Maria Novella, the great Dominican church of Florence.[17] Being "Full of Grace," Mary was exempt from the corruption of death. Naturally, the Franciscans extended the interpretation of the angelic salutation: for them, "Full of Grace" also implied "Immaculate."[18]

Among the first to buttress arguments for Mary's immaculacy by reference to biblical texts was Petrus Thomae, citing in particular the Psalms and the Books of Wisdom. Ecclesiasticus was read on the Feast of Mary's Nativity (and later for the Conception), and Petrus Thomae referred to verse 5 of chapter 24, which identifies Mary as the "first-born" of God's creatures—signifying, that is, her priority of dignity, not of historical time.[19] Mary's redemption "in advance" anticipates our own salvation, just as her Assumption anticipates the resurrection of the Blessed at the time of the Last Judgment.

Many, if not most, of the great defenders of the Immaculate Conception were Friars Minor, but the doctrine itself preexisted the Franciscan order by centuries. The feast of the Conception was first celebrated in the East at the end of the seventh century or the beginning of the eighth, and became a universal feast of obligation in the Byzantine Empire before the end of the ninth century.[20] The first certain record of the feast in Italy is a mid-ninth-century liturgical calendar from Naples which lists for December 9 (*sic*) the "Conceptio sanctae Mariae Virginis."[21] However, the feast probably commemorated Mary's *biological* conception without necessarily signifying her freedom from

Original Sin.[22] The Conception was evidently not celebrated in the Immaculatist sense in Europe before the Norman invasion of England in 1066. At the Council of London in 1129, the feast was confirmed for the English province. From England, observance of the feast spread to Normandy and to the rest of Europe. Indeed, it was the increasing popularity of the feast that led in turn to explicit statements of the idea of Mary's Immaculacy.[23] By the end of the fourteenth century, the doctrine of Mary's Immaculacy had become the "more common teaching at Paris and elsewhere," but the debate was frequently acrimonious and far from resolved.[24]

On 17 September 1439, the doctrine of the Immaculate Conception was proclaimed by the Council of Basel, but only the first twenty-two sessions of the council were acknowledged by the papacy. The proclamation of the doctrine of Mary's Immaculacy came in a later, hence illegitimate session of the council, and consequently the validity of the decree itself was moot.[25] The Venetians had withdrawn their delegation in late December 1435, and so did not participate in the unacknowledged sessions, partly because of their political alliance with the Venetian pope, Eugene IV (Condulmer).[26]

One of the greatest champions of Mary's Immaculate Conception in the fifteenth century, and certainly the most powerful, was Pope Sixtus IV (della Rovere). A friar educated in the order and before his elevation to the papacy the Franciscan minister general, Sixtus himself was profoundly devoted to the cult of the Immaculate Virgin.[27] In his bull *Cum Praecelsa* of 28 February 1476, the pope promulgated the feast of the Conception for the entire church and granted special indulgences to worshipers attending services of the feast. *Cum Praecelsa* evidently represents the first official act from the Roman Curia in favor of Mary's Immaculate Conception.[28] Sixtus adopted an office for the feast written by Leonardo de Nogarolis, which was published in Venice in 1478.[29] Two years later, on 4 October 1480—not coincidentally, the Feast of Saint Francis—the pope issued the brief *Libenter* permitting the Friars Minor to recite an office composed for the feast of the Conception by the Franciscan Bernardino de Bustis.[30] Although the office by Nogarolis ultimately prevailed, Fra Bernardino's office continued to be in use among the Franciscans until the mid-nineteenth century.[31] The office by Bernardino is a compendium of Marian epithets: she is the Temple of Solomon, the *Sponsa Dei,* the tabernacle, the Gate of Heaven. And throughout his text, the friar relied greatly on the Song of Songs, wherein verse 7 of chapter 4, in particular, inspired such exegetical use: "Thou art all fair, my love; there is no spot in thee."[32]

Clearly, had he been able to do so, Sixtus would have had the Im-

maculate Conception declared dogma. But, despite the pope's ardent support, there was no consensus among theologians about the doctrine. Indeed, the response to Sixtus's recognition and encouragement of the feast was the continuation and even the aggravation of the debate about Mary's Immaculacy, and with such acrimony that the pope acted in 1482 and again in 1483, reiterating support for the feast and forbidding further debate on pain of excommunication.[33] Papal intervention was necessary largely because of disobedient Dominicans. For example, Vincenzo Bandello, who became general of the Dominican order from 1501 to 1506, composed his own, emended version of an office for the feast of December 8, substituting the word *sanctification* for *conception* to signify his belief that because Mary was conceived as a human being, a descendant of Adam, she was not conceived immaculate but rather was sanctified in her mother's womb.[34] Repeating Bandello's arguments, another Dominican, Pietro da Vicenza, wrote a treatise in opposition to Sixtus's acts and beliefs, the *Opusculum de Veritate Conceptionis Beatissimae Virginis*. Pietro's essay was published in Venice in 1494.[35] So much for Sixtus's injunctions against debate about the Conception. His threats of excommunication had not silenced opponents, and a similar papal injunction had to be repeated in 1503.[36]

The Dominican *Opusculum* opposing the doctrine of Mary's Immaculacy that was published in Venice in 1494 probably did not find a very receptive audience there. Even before Sixtus's recognition of the feast for the universal church, the cult of the Immaculate Conception had a particularly powerful champion in Venice, the first patriarch, Lorenzo Giustiniani (1381–1456).[37] The Venetians venerated Giustiniani as a *beato* long before his canonization in 1690, a veneration reflected in devotional images and in the continued availability of his pious writings. Jacopo Bellini probably painted the earliest surviving image of the patriarch, executed shortly after his death in 1456 and displayed above his tomb in S. Pietro di Castello.[38] Only nine years later, in 1465, Gentile Bellini depicted the patriarch in an imposing hierarchic image, haloed (thus anticipating formal action by the church) and very much larger than the two angels and the two praying monks who accompany him.[39] At the request of the Serenissima, Sixtus IV introduced the cause to obtain recognition of the cult of Giustiniani in 1472, and it was authorized for the territories of the Republic in 1524 by Clement VII.[40] Giustiniani's religious writings were readily available in Venice and the Veneto after his death, and the first complete edition of his works was published in 1506.[41]

The patriarch avowed his belief in the Immaculate Conception of Mary in many writings, asserting the argument used also by Francis-

cans: Mary was always intended to be the mother of Christ, and hence she was preserved from the stain of Original Sin. Thus, in the opening words of his sermon on the Annunciation, Giustiniani explained "that from the very beginning of her conception, [Mary] was anticipated by blessings of sweetness, and she was alien to the autograph of damnation . . . the grace of sanctification was resplendant upon her . . . plainly as she was exempt from carnal impurities, so too was she foreign to every kind of sin."[42]

In his sermon for the Feast of the Nativity of the Virgin, Giustiniani apostrophized Mary as God's "immaculate temple."[43] Again, in his sermon for the feast of the Purification of Mary (Candlemas), the patriarch praised the Madonna as the Lord's "immaculate Virgin mother." She came to the Temple to be purified not from necessity, he explained, but out of "humility for the law."[44] Giustiniani's reference is of particular significance in the context of a sermon on Mary's Purification. He seems to be responding to one peripheral argument in opposition to belief in Mary's Immaculacy, based on the fact that the Virgin had been purified prior to her presenting her Child in the Temple (Lk 2: 21–22). If Mary had been born Immaculate, free of Original Sin, why then did she have to undergo purification? This would have been redundant and illogical. A contemporary of Giustiniani, the greatest Franciscan preacher of the fifteenth century, provided an answer. Saint Bernardino of Siena (who preached in Venice and became a patron saint of the Republic) explained in a sermon that Mary was "Immaculate, yet [also] purified, because God sanctifies his tabernacle and the tabernacle of Jesus is Mary."[45]

In these and other similar passages, Bernardino and Giustiniani declared their belief in the Immaculacy of the Madonna. Their influence on Venetian piety must have been as pervasive during the Renaissance as it is difficult today to gauge in any precise way. Nonetheless, their thoughts and writings constitute part—a very important part—of the original context of sacred art in Renaissance Venice. One must attempt to reconstruct that context in the historically informed imagination.

2. Defeat: The Conventuals On Their Own

Papal recognition of the feast of the Immaculate Conception for the universal church represented a great victory for the Franciscans, for whom the doctrine had long been a pious cause célèbre. But if the order was united on this point, it was divided about numerous other issues, and the same years that saw the official triumph of their cult of the

Immacolata witnessed also the dissolution of the Order of the Friars Minor.

The struggle between the Conventuals and the Observants for dominance was especially painful and discordant among the friars of Italy where the Conventuals controlled the two most powerful and prestigious Franciscan houses, S. Francesco in Assisi, the *caput et mater* of the order, and S. Antonio in Padua.[46] The Observants had considerable support throughout Europe, however, and were generally considered to be the more faithful to Francis's ideal of poverty. Indeed, it was not uncommon for supporters of an Observant group to take over a Conventual house, ousting the original residents. Sixtus IV, himself a Conventual, had tried to put a stop to these unseemly evictions in his bull *Dum singulos* in 1474 forbidding the Observants and their supporters from evicting Conventuals and taking their houses. The bull was not honored, and so Sixtus renewed it in 1480.[47]

The first two decades of the sixteenth century were terrible and momentous years for the Franciscan order. By the early sixteenth century, it was clear that compromise for the sake of unity was impossible. There was no longer any hope that the Franciscans themselves might be capable of resolving their painful conflicts: the factions ignored appeals by the Cardinal Protector of the order, the Venetian Domenico Grimani, at the General Chapter held in Rome in 1506.[48] In 1508, Grimani gave his approval to new statutes intended to reform the Conventuals, but these were revoked two years later by Pope Julius II.[49] In 1516, his successor, Leo X, appointed a commission, including Grimani, to tackle these profound problems. It was at the suggestion of the commission that the pope decided to convene a *Capitulum Generalissimum* of the Order of Friars Minor.[50]

This extraordinary Franciscan chapter was summoned by Leo to meet during May 1517, in Rome. The states of Europe, including the Serenissima, were concerned, and some intervened (not for the first time) on behalf of the Observants.[51] Sanuto recorded letters from the Venetian ambassador in Rome documenting the futile attempts at reconciliation:

> Today the assembly was held on the matter of the Friars Minor and Observants regarding the selection of the generalate [of the order], and seven cardinals were chosen to expedite this thing [including Grimani]. . . . [On May 27] How he [the ambassador] has received letters of our Signoria carried by the minister of the Province of St. Anthony of the Order of Conventual Friars of St. Francis, and another [letter] brought . . . for the Observants, commanding them, in their recommendation, to speak to the pope and most reverend cardinals [asking]

that they not make any changes in said orders, but leave things as they have been up until now. And thus this morning, the cardinals having joined together to consider this matter, he [the ambassador] went to the palace; entering, he found the first room full of the said friars of St. Francis, Conventuals and Observants, who were there in great number. Then he entered among the said most reverend cardinals [who were] already joined together, and at length [came] the pope who, having heard mass, ate a good meal, and he [the ambassador] spoke to the pope about the letters cited above. He [the pope] said he has respect for these things and for [the friars'] religions, and that His Holiness himself was of the same mind, and he had had letters on this matter from the Most Christian king and from the Catholic king, persuading him to make the Conventuals Observants. . . .[52]

But the Conventuals would not become Observants: they were unable to resolve their great differences. On May 29, the pope sealed his "bull of unity." The result of this bull, *Ite vos in vineam meam,* was in effect the exclusion of the Conventuals from the Franciscan order: the "Order of the Friars Minor" now meant the Observants and other reformed groups.[53] Two weeks later, on June 12, the pope announced in *Omnipotens Deus* that the Conventuals could continue to exist but would henceforth be considered a separate order. As Sanuto explained it, "the Observant friars are electing their own general, and the Conventuals another . . . , and neither general will owe obedience to the other."[54]

On July 17, little more than a month after these shocking announcements in Rome, the Conventuals and the Observants of Venice came to an agreement among themselves. "On this day," Sanuto recorded, "began the accord made between the Observant friars and the Conventuals of S. Francis, namely, that all of them will go under the cross of the Conventuals, but where formerly they [the Conventuals] went after the Fraticelli Observants, now the Conventuals go first and the Observants remain in back [in processions]."[55] Since the less distinguished religious participants of a procession generally came first, this reversal was clearly intended to reflect the greater prestige of the Observants and the diminished status of the Conventual friars.[56] Their "accord" was both symbolic and symptomatic of the troubles that faced the Conventuals.

A more critical and substantive issue was the suppression of Conventual houses of nuns, which, for various reasons, was made a matter of state policy. Beginning in 1519, in agreement with the patriarch, B. Antonio Contarini, the Council of Ten acted to reform and suppress

the Conventual houses. The reform movement was supported by a bull of Leo X addressed to the patriarch in July of that year.[57] In 1521 the council decided to elect three noblemen as provedditori to serve with the patriarch in a Magistrato sopra monasteri established to consider and resolve the problems of the Observants and the Conventuals. Leo also gave his approval to this action.[58] Crucial among the new magistracy's decisions was the prohibition against future Conventual professions: henceforth, no novice would be permitted to become a Conventual nun.[59]

Clearly, the Conventual nuns had no future in Venice. And the patriarch also acted to make their present life less amenable, hoping thereby to encourage their (theoretically) voluntary conversion to the Observant way. Sanuto recorded a visit made by the patriarch Contarini to the Conventual nuns of the Convent of the Madonna; when he asked the abbess whether the sisters wished to join the Observants, she and the other nuns replied "that in no way did they wish to make themselves Observants."[60] Similar episodes were repeated many times.

Three years later, on 2 August 1521, Sanuto described the pathetic appearance before the Collegio of the abbess of S. Chiara, an aged noblewoman of a hundred and six, together with six of her Conventual nuns. The sisters protested, according to Sanuto, "that the Observant nuns were not giving them enough to live [on] and that they were dying of hunger."[61] Accompanying the nuns on this occasion were some of their relatives and also the guardian of the most powerful Conventual church in Venice, Magister Germano of the Frari.

3. Magister Germano

Hodie cum ingenti gaudio triumphavit in coelis.
—St. Lorenzo Giustiniani[62]

Germano Casale is commemorated as the "patron" of the high altar of the Frari by the inscription on the stone frame (fig. 32). As though to temper this conspicuous display of his name, Germano modestly identified himself as "frater," rather than with his more exalted titles as guardian of the convent of the Frari and master of the Franciscan province of the Holy Land.[63] At the right are inscribed the words: FRATER GERMANUS HANC ARAM ERIGI CURAVIT MDXVI. The inscription at the left refers to the dedication of the altar, represented by the image within

32. Venice, Santa Maria Gloriosa dei Frari. Apse.

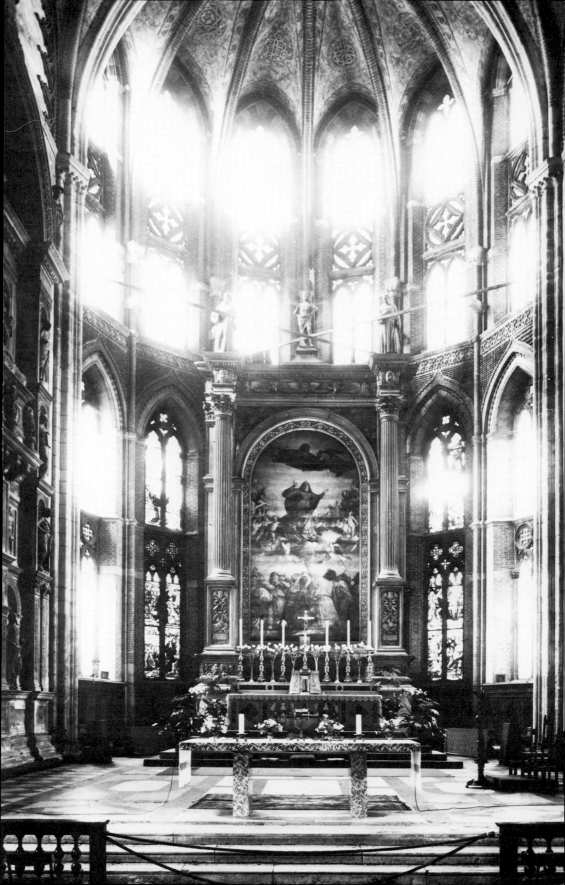

the frame: ASSUMPTAE IN COELUM VIRGINI AETERNI OPIFICIS MATRI. Above these inscriptions are reliefs of the *stemma* of the Franciscan order, the crossed arms of Christ and of Saint Francis, each revealing the stigma in the palm.[64] Thus while the verbal language of the inscriptions asserts Germano's patronage, the heraldic language of these devices reminds the congregation of the order he served.

Although not written on paper or parchment, the inscription is comparable nonetheless to a document recording the patronage and the date of the commission.[65] Similarly, inscribed plaques to the left and right of Bellini's altarpiece of the *Baptism* in S. Corona in Vicenza commemorate the name of the donor, Giambattista Graziano Garzadori, the titular saint, and the date of the endowment: ANNO/.M.D. (left), and BAP.GRATIANUS/EX/HIEROSOLYMIS/SOSPES/HOC SACELLUM/DIVO IOANNI/DICAVIT (right). This is confirmed by the document recording the concession of the site to Garzadori in 1500.[66] In point of fact, work on his chapel was not begun until 1501 and was completed in 1502—two years after the date of the inscription, the endowment, and the concession—which is suggestive, in turn, vis à vis the date of Germano's inscription.[67] The year 1516 may, then, be a terminus post quem for the altar of the Frari, which is implied also by the tense of the verb: "In 1516 Fra Germano arranged raising this altar to the Virgin Mother of the Eternal Creator Assumed into Heaven."[68] In any case, the subject of the altarpiece was long since determined by the dedication of the church, and its scale must have been decided by the time the altar itself was constructed in 1516 or shortly thereafter.[69] Titian's great altarpiece was installed only two years later (fig. 33).

This momentous event and Germano's patronage of the altar were duly noted by Sanuto: "May 20, 1518. . . . yesterday the high altarpiece painted by Titian was installed on the altar of Blessed Mary of the Friars Minor, and a great work in marble had already been constructed around the altar at the expense of Master Germano, who is the guardian now."[70] Sanuto does not state explicitly that Germano commissioned the *Assunta* as well as its altar, but the diarist's language may imply this.[71] To be sure, as a Mendicant friar, Germano could not own property but must have used bequests to the Frari to commission the high altar and perhaps the altarpiece as well. This situation was not unique. For example, the sculptured high altarpiece by the Dalle Masegne representing the *Coronation of the Virgin with Saints*—a theme inherently related to the Assumption—was commissioned in 1388 by the friars of S. Francesco in Bologna with funds provided by several benefactors.[72] At almost the same time as Germano's presumed commission to Titian, the guardian of the Conventual church of S. Francesco in the town of Correggio was

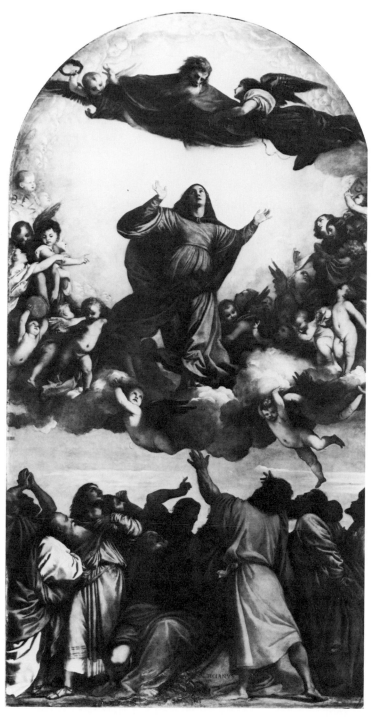

33. Titian, *Assunta* (after restoration). Santa Maria Gloriosa dei Frari.

able to commission a high altarpiece for his church, the *Madonna of St. Francis,* the first documented work by the young master Correggio, completed in 1515.[73] And seven years later in Venice, Germano had his name inscribed once again on an altar adorned with a painting by Titian, this time in the little church of S. Nicolò della Lattuga, originally adjacent to the Frari.[74]

The frame that carries Germano's name in the Frari bears an obvious resemblance to an arch of triumph, and the spandrels are decorated *all'antica* with figures of winged victories, possibly painted by Titian himself.[75] Such connotations of victory are of course appropriate here, because, as the Venetian patriarch Lorenzo Giustinian had declared, the Assumption signifies the Virgin's joyful triumph in heaven: "hodie cum ingenti gaudio triumphavit in coelis."[76] More precisely, the imagery of the frame refers to the Franciscan theology of the Virgin—the victory of the cult of the Immaculate Conception—and to the Franciscan politics of the division of the order, as the defeat of the Conventuals by the Observants was fast becoming a certainty.

At the bottom of the frame, a rectangular relief represents a tabernacle, but without a door, that is, nonfunctional. This is carved with a half-length figure of Christ in a state between life and death and flanked by two standing angels. The fictive ceiling of their setting is carved with coffers painted a dark color, and perhaps the entire relief was originally polychromed. The illusionistic stone tabernacle signifies Mary's identification with the Eucharist. Thus, in his sermon on the Body of Christ, Saint Bonaventure had explained that the Eucharist is "sweet like honey, a honey produced by our bee Mary; who wishes to know the sweetness of the honey concealed in the Sacrament must have her patronage."[77] In an association of images not unlike Titian's, Bellini had combined the *Coronation of the Virgin* with the *Pietà* in an altarpiece for the Franciscan church of Pesaro (figs. 25 and 26), and similarly, the Dominican master Fra Angelico had represented the *Pietà* as the central panel of the predella of his *Coronation of the Virgin,* now in the Louvre.[78] The same theme, the association of the Eucharist with Mary's glory as Queen of Heaven, was depicted in Venice by Tullio Lombardo in his *Coronation* altarpiece for S. Giovanni Crisostomo, not many years before Titian began his *Assunta.*[79] And there is another precedent for this imagery in the Frari itself, the *Madonna* signed and dated by Bartolomeo Vivarini in 1482, still in place as the altarpiece of the Bernardo Chapel of the Madonna (fig. 22).[80] Here, "real" angels—carved, gilded, and polychromed—kneel in adoration of a half-length painting of the Man of Sorrows. These figures and this theme, which were traditional for

the decoration of altar tabernacles, are now set above the Madonna and Child Enthroned in the central panel of Bartolomeo's triptych.

In the Franciscan environment of the Frari, the symbolism of the fictive tabernacle of the high altar expresses the meaning of the *Assunta* as an image of the Immaculate Conception. To a Franciscan, the tabernacle would suggest an allusion to the Immaculate Virgin precisely because Mary herself is the tabernacle, the ark that contains the Eucharist. This equivalence was cited by the Franciscans as a proof of her Immaculacy. Evidently the first to use the argument was Petrus Thomae (ca. 1316–27), quoting the Book of Genesis. Because Mary is the Ark of the Covenant, he explained, she contains God himself and not only his law. Consequently, she too is of incorruptible material.[81] Later, Saint Bernardino of Siena reiterated the argument: Mary was Immaculate, yet purified, because God sanctifies his tabernacle and the tabernacle of Jesus is Mary.[82]

At the top of Titian's frame, the statue of the Resurrected Christ is flanked by figures of Saint Francis and Saint Anthony of Padua. The sculptures are clearly related to each other and to the kindred themes of the Assumption and the Conception. The Resurrection of Christ anticipated the Assumption of the Virgin, and the Resurrected Christ awaits his mother in heaven where her own ascent will culminate in her coronation as *Regina coeli*.[83] (In Titian's altarpiece, an angel approaches Mary with a crown.)

Two great ducal tombs flank the *Assunta* in the chancel: on the right, that of Doge Francesco Foscari, who died in 1457; and on the left, Doge Nicolò Tron, who died in 1473 (figs. 34 and 35).[84] These monuments formed a conspicuous part of the preexisting environment to which Titian had to accommodate his panel. He has indeed done so. The Resurrected Christ stands above a sarcophagus in the lunette of Tron's monument, and the Ascendant Christ appears at the top of the tomb of Doge Foscari.[85] First of all and perforce, we associate the victorious Christ of the tombs with the Christ of the high altar. But we are also encouraged to associate the Risen Christ visually and thematically with the Virgin of the *Assunta*. Both the *Assumption* and the funerary monuments illustrate the promise of redemption made possible by the Incarnation, and Christ's fulfillment of that promise by his conquest over death. Death is vanquished and mankind redeemed when Christ sacrifices himself for man's sake and then triumphs over death in his Resurrection and Ascension. So, too, will the blessed rise at the time of the Last Judgment—and, evidently, among them these two doges of Venice. The figure of the Risen Christ reminds the viewer-worshiper

[87]

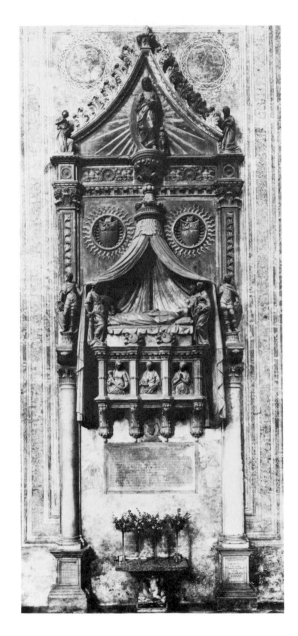

34. Monument of Doge Francesco Foscari. Venice, Santa Maria Gloriosa
dei Frari.

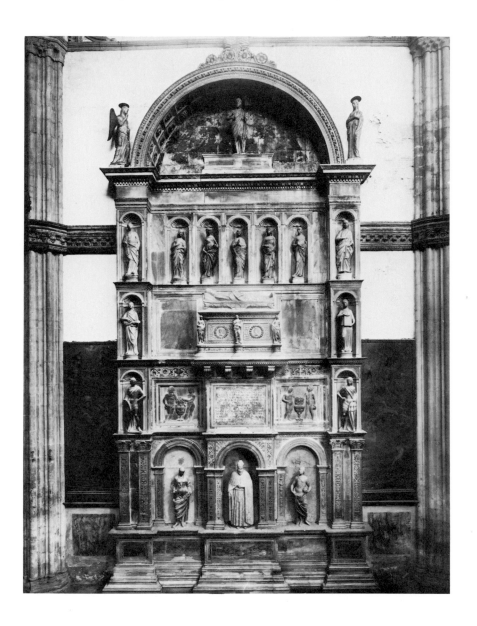

35. Antonio Rizzo, Monument of Doge Nicolò Tron. Venice, Santa
Maria Gloriosa dei Frari.

of the Virgin's identification with her son even in her triumph over death, anticipating the resurrection of the blessed at the end of time. Mary's identification with Christ was adduced as another argument in favor of her Immaculacy: she died, like her son, not because of guilt but to share his suffering and his work of redemption.

St. Francis and St. Anthony of Padua, whose figures flank Christ above the frame of the *Assunta,* were also closely associated with the *Immacolata.* They accompanied the Virgin Immaculate in the private chapel of the Franciscan pope Sixtus IV, the first papal chapel to have been dedicated to her, and they were represented again in Titian's *Madonna* for the Pesaro family altar of the Immaculate Conception in the Frari.[86]

St. Francis and St. Anthony participate in the heavenly triumph of the *Assumption* in which they share not only as individuals but as embodiments of the institution that they represent, of which one has already been reminded by the Franciscan coats of arms. St. Francis is the personification of his order, and the wounds he displays, won by his perfect imitation of Christ, are the sign of God's approbation of the saint and of his Rule, the Rule to which the Conventuals avowed obedience.[87]

Both Saints Francis and Anthony were venerated at their own altars and as titular saints of confraternities in the Frari. In fact, according to Venetian law, the Scuola di Sant'Antonio in the Frari was the only confraternity that could be dedicated to the saint in Venice, exclusivity in this matter being a measure of Anthony's great prestige.[88] The Franciscan province of the Veneto was named for Saint Anthony, a circumstance explained in large part by the presence in Padua of his miracle-working tomb.[89] The presumed day of the saint's birth, March 25, is, of course, also the date of the feast of the Annunciation, a feast with particular significance in Venice as the anniversary of the (mythical) founding of the state—and which is represented by the sculpted Annunciation groups of the ducal tombs in the chancel (figs. 34 and 35).[90] And still another aspect of the saint's character and historical role is relevant here: Anthony is the Conventual *exemplum virtutis.*

As a great preacher and teacher, Anthony personified the public life of scholarship and service to the faithful that the Conventuals professed.[91] Moreover, Francis himself had written to Anthony, granting him permission to teach theology.[92] This letter was far more than a private communication between two great contemporaries: it was understood not only as Francis's permission to one of his brothers, but as the founder's implicit endorsement of theological study by the Friars Minor. Inevitably, this had a profound (and ultimately divisive) effect

on the order, which had begun with a group of pious laymen and Francis's feigned protestations of illiteracy. In part, the result of Francis's letter to Anthony was the increasing importance of priests and scholars in the order. Simply put, Francis had seemingly authorized the "Conventuals," and three hundred years later the dissension between this faction and the other Friars Minor could not be resolved and led to their separation.

Anthony's presence atop the high altar of the Frari was clearly intended as a conspicuous declaration of the Conventual identity of the church at a time when dissension between the Conventuals and the Observants was fast becoming intolerable.⁹³ The desire, if not the necessity, to declare the Conventual allegiance, and indeed the glory of his church and convent, must have been important concerns to the guardian, Frater Germano. Perhaps the connotations of triumph in the high altar of the Frari—the triumph over death and the triumph of the church in the person of Mary—allude also to a wished-for triumph of *this* particular church and its Conventual cause, exemplified by Saint Anthony.

4. The Assumption: *Macula Non Est in Te*

The feast of the Immaculate Conception was associated with the Assumption both theologically and liturgically. The Assumption, August 15, was first celebrated in Rome in the late seventh century under the primitive Byzantine title of the Dormition of the Mother of God. It is so described, for example, in the *Liber Pontificalis* of Pope Sergius I (687–701), who was Syrian by birth.⁹⁴ The name of the feast was changed in the eighth century to the title Assumptio Sanctae Mariae, as in the Sacramentary addressed by Hadrian I (772–95) to Charlemagne sometime between 784 and 791.⁹⁵ This change of title from the Byzantine *Dormitio* to the Roman *Assumptio* also signified a change in doctrine. Obviously, the Assumption of Mary was preceded by her resurrection, and the Assumption itself—not Mary's death—became the principal focus of the feast.⁹⁶

Saint John Damascene, whose writings on Mary recapitulated the teaching of the Greek Fathers and inspired medieval Marian writings in the West, argued that death could not consume the Madonna because she was antithetical to Eve, whose fall from grace had introduced death to mankind. From the moment of the Annunciation, the Incarnation united Mary with God. Hence, she was incapable of subjection to death.⁹⁷ This is explained in the Damascene's Second Homily on the

Assumption: "[Eve] who listened to the message of the serpent . . . is punished with sorrow and grief, is subjected to the pains of childbirth, together with Adam condemned to death and placed in the depths of Hades. But this truly blessed Virgin who inclined her ear to God, was filled with the energy of the Spirit and was assured of the good pleasure of the Father by an archangel, who . . . conceived the Person of the divine Word . . . , who brought him forth without pain and was wholly united to God—how could death devour her?"[98]

In the thirteenth century in the West, such Scholastic theologians as the Franciscan teacher Alexander of Hales (d. 1245) affirmed the Madonna's privilege.[99] Belief in Mary's assumption into heaven, body and soul, was finally embraced by the church in the mid-fourteenth century: "assumpta est in coelum cum corpore et anima."[100] These fourteenth-century texts put considerable emphasis on the exaltation in heaven of Mary's body—an emphasis that Titian's *Assumption* makes palpable.[101]

Similarly, a fifteenth-century Venetian life of the Virgin describes the physical reality of the assumption of her incorruptible, immaculate body into heaven: "After the third day had passed . . . the Son of God descended from Heaven together with a vast company of angels and approached that precious body of the Virgin Mary which was in the tomb, so that the Archangel Michael might remove the stone from the grave . . . the Apostles and the rest of the company fell away . . . and with angels singing [Michael] took the Virgin Mary out of the tomb and led her in the living flesh to her gentle son. . . . And the angels of God took the holy body, the body without any stain, of the Virgin Mary."[102]

The description of Mary's body as "senza alguna machula," "without any stain," is an allusion to the innate relationship discerned between her Assumption and her Immaculacy. Indeed, the former was taken as inherent proof of the latter by analogy: as the Assumption of Mary's body into heaven demonstrated that her flesh was "senza machula" and incapable of physical corruption, defenders of her Immaculate Conception asserted a priori that her soul must have been unstained by spiritual corruption.[103] Giustiniani alluded to the familiar argument in his sermon on the feast of the Assumption: "as she was free of every corruption of the mind and of the body, thus she was foreign to the sorrow of death."[104]

When two offices were composed for the feast of the Conception and approved by Sixtus IV around 1480, the authors purposefully repeated the same biblical texts that had traditionally been used in the liturgy of the Assumption, namely, Ecclesiasticus and the Song of Songs.[105] Verses are repeated in the offices of the Virgin's Immaculacy and her Assumption not only because the texts are appropriate to each feast, but also in

order to underscore the profound relationship between these two extraordinary privileges of the Madonna: identical words were used to convey identical meaning. In particular, the Canticle, Giustiniani's primary biblical source for his sermon on the Assumption, also offered a verse that exegetes could (and did) apply to the Immaculate Madonna: "tota pulchra es amica mea et macula non est in te," "Thou art all fair, my love; there is no spot in thee" (Ct 4 : 7). This and other verses from the Canticle were quoted in both offices composed in the late fifteenth century for the feast of the Immaculate Conception.[106] For Titian and his Franciscan patrons, there can be no doubt that "S. Maria Gloriosa" implied "S. Maria Immacolata."

The discussions of Mary's Assumption and her Immaculacy were inextricably bound together in relation to the same theological conundrum: Did Mary die? The question was (and is) a vexatious one, never in fact answered by the church.[107] Death is the wages of sin, as Saint Paul had explained in his Epistle to Romans (5 : 12–13): "Through one man sin entered the world, and through sin death; and thus death passed into all men because all have sinned." If Mary died—as indeed all human beings must—this was a natural consequence of her humanity, which was necessary for Christ's Incarnation. But if Mary died, then was she not also paying for Original Sin as a descendant of Adam? So thought Augustine, according to the words of a prayer recited for the solemnity of the Assumption of the Virgin: "Descended from Adam, Mary died because of [Original] Sin, Adam died because of Sin, the flesh of God, formed from Mary, died because of annihilating Sin."[108] But others argued that the Virgin indeed did not die—in fact, "dormitio," the ancient name of the feast of the Assumption, means literally "falling asleep." Yet Christ himself had died in the Crucifixion, and if Mary merely slept, was she not, then, more privileged than her son? If we assume that Mary did not die because she was unstained by Original Sin, it would appear that she alone of all humanity did not require her son's redemption. As we have seen, Franciscan theologians had argued that Mary indeed required redemption by Christ in order to fulfill her preordained role as his mother, and that she had received this redemption even before her conception. If she had died, it was not from necessity but voluntarily, not because she was paying "the wages of sin" but to share in her Son's suffering.

Given the liturgical and theological assimilation of the Virgin's Immaculate Conception with her Assumption, it comes as no surprise that the visual imagery of the former was frequently based upon representations of the latter. For example, the *Immaculate Conception* by Giovanni Bellini and his studio (ca. 1513) appears at first glance to be a rather

static depiction of the Assumption (fig. 36).[109] Of course, the very stasis of the composition is expressive of its meaning: it is not a narrative image but the depiction of a theological belief. The eight saints who stand in a precise semicircle in the lower part of the composition include two Franciscan champions of the cult of the Madonna, Francis and Louis of Toulouse, with Peter, John the Evangelist, Mark, Anthony Abbot, Augustine, and John the Baptist. Their postures and their upward glances recall the comportment of the Apostles at the Assumption, but these saints bear witness instead to the Virgin's Immaculate Conception. Bellini's immobile composition has been compared to Titian's vibrant *Assunta,* completed five years later but representing another era (fig. 33).[110] And yet the underlying resemblance between Bellini's *Immacolata* and Titian's *Assunta* suggests Titian's intentional evocation of depictions of the *Immaculate Conception.*

5. Titian's *Assunta*: Santa Maria Gloriosa

Nihil est candoris, nihil est splendoris, nihil est numinis,
quod non resplendeat in Virgine gloriosa.

—St. Jerome[111]

Quae est ista quae ascendit per desertum sicut virgula
fumi. . . .

—Canticles 3, 6

In Titian's epideictic *Assunta,* the Apostles who came to bury the Virgin in the earth witness instead her bodily assumption into heaven.[112] Their expansive gestures and astonished glances draw our eyes upward along with their own, establishing a visual transition from earth to heaven and psychologically convincing us of the reality of their vision. With them, we too witness the actual Assumption of the Virgin into heaven, as she is carried upward on clouds both substantial enough to carry her majestic form and yet penetrable by the divine light and by the cherubim who accompany her. It is this luminosity above all that distinguishes Titian's composition from Mantegna's fresco *Assumption* in Padua (ca. 1456), which otherwise might be considered the model for the Venetian work (fig. 37).[113] In the Titian, the boundary between the sacred and the mundane realms, just now crossed by the Madonna, is clearly marked both by the semicircular formation of the clouds and angels and by the changing light, more intense and golden in the heavens than on earth and reaching its full density at its source, God the Father: "ecce gloria Domini apparuit in nube" (Ex 16 : 10). Mary rises

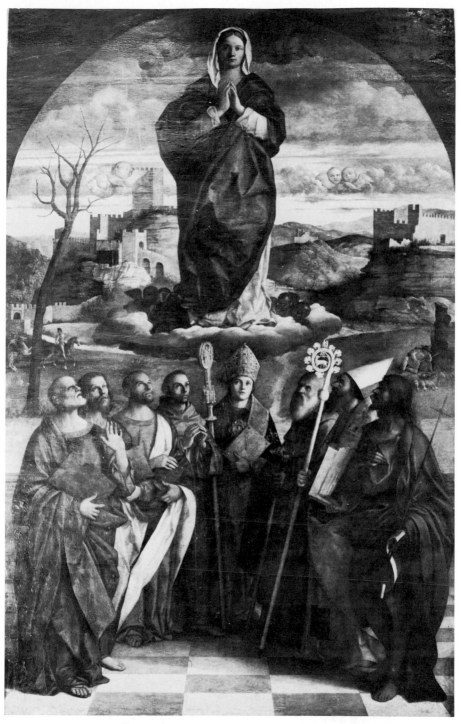

36. Giovanni Bellini and Assistants, *Immaculate Conception*. Murano, San
Pietro Martire.

37. Andrea Mantegna, *Assumption of the Virgin*. Fresco. Padua, Chiesa
degli Eremitani, Ovetari Chapel.

toward the Lord, and toward her celestial crown, proffered by an angel
approaching above from God's left. Thus, the dramatic and composi-
tional climax of Titian's *Assunta* anticipates the doctrinal culmination of
Mary's Assumption, the Coronation of the Virgin as Queen of Heaven.

Titian's celestial metaphor of divine illumination is a translation of
Bellini's gold mosaic in the sacristy triptych (fig. 16). Gold tesserae

become a semidome of clouds and golden light, warmest and most intense around the figure of God the Father, who indeed is the source, symbolic and actual, of this effulgence. At the same time, the illumination alludes to Mary as she is described in Saint Jerome's phrase that serves as an epigraph for this chapter. Her very conquest over death, the heritage of Eve's fall from grace, is embodied in Titian's golden light.

While the changing light and the semicircular boundary between heaven and earth divide Titian's composition, it is united dramatically by the gestures and poses of the Apostles and angels, chromatically by the repetition of various shades of red, and geometrically by the reiteration of circles, semicircles, and arcs. The clouds supporting Mary evoke the base of the semidome of an apse, and even her gesture and the pose of God the Father repeat the circular motif.[114]

David Rosand has shown how Titian used these circular forms to unify the composition within itself and with its site, the curved architecture of the choir screen and of the apse (figs. 9 and 32).[115] The major horizontal divisions of the composition are made to coincide with those of the apse, and by enframing the *Assunta* stereoscopically with the fifteenth-century choir screen, Titian asserted his panel's role as the spiritual and visual climax of the church. And these circular forms are more than an organizational and a dramatic device. Titian's insistence on circular forms is to be understood also as a metaphoric reference to God himself, circles being His geometric equivalent, just as the golden light represents His divine illumination. Like immortal God, a circle is without beginning or end. This old and familiar concept, possibly Pythagorean in origin, was expressed succinctly in the words of Thomas Bradwardine: "God is an infinite sphere whose center is everywhere and whose circumference nowhere."[116]

Titian's triumphal image is inscribed with the artist's signature, TICIANVS, on a rock and, in the sky, with the words BE VI (that is, "Beata Virgo") and GLO, for "Gloriosa," referring to the dedication of the Frari and to the subject of the altarpiece.[117] The adjective *gloriosa* applied to the Madonna signifies her assumption into heaven. Thus, for example, a fifteenth-century Venetian prayer to the Virgin refers to her "altissima asunzione e glorifuhazione,"[118] and a contemporary Venetian life of the Madonna describes both the body and the soul of the Virgin assumed into heaven as "glorious." In this text, Christ addresses his dying mother with the promise of her assumption: "and I shall make [your] body glorious, like [your] soul, and your seat will be placed next to mine in heaven where there will be no tribulation but perpetual joy."[119]

[97]

Then, after her death, in fulfillment of this promise, "that glorious and blessed soul was raised up from the earth and carried into heaven with joy and songs."[120]

Mary's Assumption is to be understood as the equivalent of Christ's triumph, depicted on the two ducal tombs and on the frame of the *Assunta* itself. Saint Bernardino of Siena expressed this symbolic equivalence: "And as the flesh of Christ was incapable of corruption, so too that of Mary; and thus one reads that when she died she was assumed into heaven."[121] Like the Resurrection of Christ, the Assumption of the Virgin anticipated, indeed promised, the resurrection of all the blessed. Moreover, her bodily presence in heaven assures a more valid mediation for the faithful, as explained by Fra Bartolomeo da Pisa.[122] Similarly, an early fifteenth-century Venetian text describes how the Madonna assumed into heaven "above the angels . . . always prays to God for us sinners."[123] Faith in the intermediation of the Virgin assumed into Heaven probably explains the adjective *gloriosa,* meaning "assunta," commonly applied to the Virgin in sixteenth-century Venetian testaments such as those written for Jacopo Pesaro and his brothers—a formula, to be sure, but one not without significance.[124] Such emphasis on Mary's intercessory role is in itself characteristic of Franciscan spirituality. And this hopeful message of resurrection and mediation is reiterated by Titian and transferred to the entire congregation of the faithful by the *Assunta* with a directness and a generosity that are Franciscan in spirit.

It is his interpretation of the theme, rather than the subject matter per se, that distinguishes Titian's *Assumption* for the Franciscan church of the Frari from depictions of the same subject in Dominican churches, such as Filippino Lippi's in S. Maria sopra Minerva in Rome (1488–93).[125] Unlike Titian, Lippi did not adumbrate the Coronation in the Assumption in his fresco on the altar wall of the Cappella Carafa dedicated to the Madonna and to Saint Thomas Aquinas (fig. 38). The narrative is viewed through an illusionistic arch and is interrupted by the chapel altarpiece, a fresco *Annunciation* superimposed on the scene of the *Assumption.* In the upper left of the *Assumption,* one angel approaches Mary with his raised tambourine, while others hold burning tapers and incense and accompany her ascent with music. Compared to Titian's luminous theophany, moreover, Lippi's *Assumption* is earthbound. Titian's immense panel shines through its triumphal arch-frame like an apparition. Lippi's *Assumption* is viewed through a framework of fictive architecture that pretends to open the wall of the church to a view of the world beyond. There, the Apostles who witness Mary's Assumption and Coronation are enclosed in extensive and detailed land-

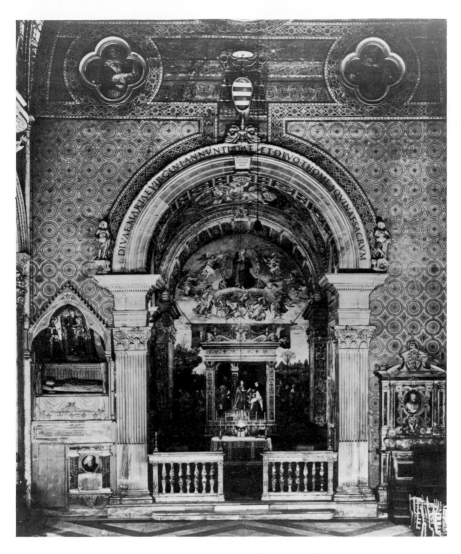

38. Filippino Lippi. Frescoes. Rome, Santa Maria sopra Minerva,
Carafa Chapel.

scape settings with horizon lines well above their heads. Their earthly
sphere is separated by a great distance from the Madonna and angels
above them, even though the same cool light surrounds them all. Be-
low, on the left, part of the Virgin's empty tomb is visible, the rest
being concealed behind the altarpiece. In this altarpiece, Saint Thomas
Aquinas introduces the donor to (or into) the Annunciation. Thus Lippi
has conflated several images or narrative moments: the Annunciation—
that is, the Incarnation—with Mary's funeral, her Assumption and im-

[99]

minent Coronation. The Virgin's praying figure in the Annunciation/ Incarnation altarpiece appears below and on the same central axis as her praying figure in the Assumption. Clearly, the first event is the precedent for the second, not only historically but doctrinally and theologically as well. It was because of her role in the Incarnation that Mary was exempt from the corruption of death.[126]

There are still more substantive differences between Titian's *Assumption* for the Franciscans of Venice and Lippi's for the Dominicans of Rome. In Titian's composition the earth has all but disappeared. The grand figures of the Apostles completely fill the foreground and effectively obliterate their worldly realm except for a minimal platform of soil and a rock incised with the artist's signature. There is no insistent reference to Mary's death and funeral here. Whereas Titian suppressed allusions to Mary's death, Lippi recalled it, by including her tomb, by representing tapers and censers, and indeed by his very emphasis on this world. Whereas Titian has created a celestial vision, Lippi has painted a historical narrative on earth. And the difference is not only one of style and composition but of meaning. Titian's omission of overt references to Mary's funeral should be considered in light of the theological arguments about her death.[127]

Lippi's compatriot and contemporary Domenico Ghirlandaio had also combined scenes of Mary's death and her Assumption in his fresco cycle in the chancel of the great Dominican church of Florence, S. Maria Novella, painted between 1485 and 1490.[128] Ghirlandaio represented the Virgin's *Dormition* and *Assumption* as one composition in the lunette of the left wall (fig. 39). The *Assumption* was represented again in the uppermost panel of the chancel window. Mary's tomb is inscribed "Ave Maria Gratia," the angelic salutation that was considered scriptural evidence of her privileges, including this, her exemption from the corruption of flesh. Meanwhile, St. Thomas kneels to receive her girdle from the rising figure of the Madonna. Above this window and to the right of the fresco *Dormition/Assumption,* Ghirlandaio painted the *Coronation of the Virgin* in the lunette of the altar wall. Thus Mary's ultimate triumph in heaven is juxtaposed with two scenes recalling her funeral on earth.

In Titian's composition, no significant distance separates the Apostles from the Virgin's Assumption. Yet, despite their proximity, Mary clearly belongs to another realm. The separation between her and the Apostles and between heaven and earth is achieved not by scale or space, but by Mary's glance upward and by the dramatic use of light. Titian distinguished the golden light of heaven from the cooler light of earth, separating the two with an arc of clouds. In the paintings by Lippi and

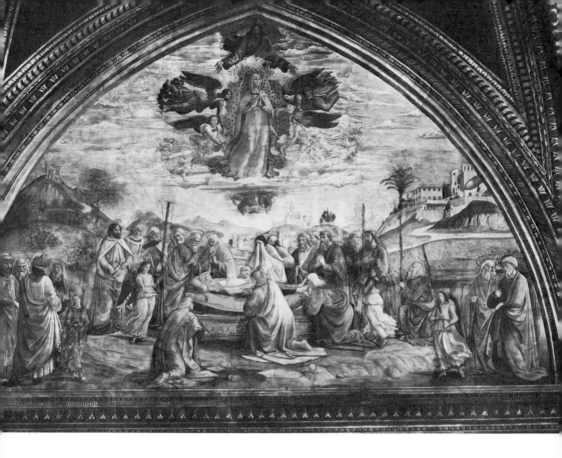

39. Domenico Ghirlandaio, *Dormition and Assumption of the Virgin*. Fresco.
Florence, Santa Maria Novella.

by Ghirlandaio, Mary's heaven is still the sky of this earth. To be sure, such differences have much to do with the different stylistic concerns of the Venetians as opposed to the Florentines, but it is also true, here at least, that style and meaning are inextricably combined and consistent. Thus, when Titian himself returned to the subject of the Assumption in an altarpiece for the Cathedral of Verona—which is not a Franciscan church—he made the Madonna's tomb prominent in the foreground and emphasized the Virgin's departure from earth rather than her reception into heaven (fig. 40).[129] Instead of the warm reds and golds of the *Assunta,* Titian used cooler tones, emphasizing, for example, the blue of Mary's mantle. There are no putti or angels here to accompany her, nor does God the Father come to welcome her. Rather, by her downward glance, the Virgin calls our attention to her tomb and to the Apostles, including Saint Thomas, who has received her girdle.[130]

[101]

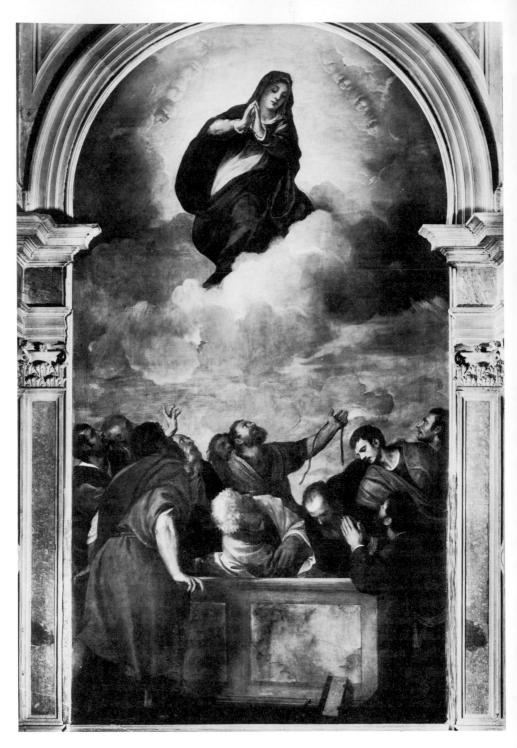

40. Titian, *Assumption of the Virgin*. Verona, Cathedral.

In Titian's Verona *Assumption,* as in Lippi's Dominican narrative, the Madonna folds her hands in prayer and looks downward. In Titian's Franciscan *Assunta,* the Virgin looks up toward God the Father and He toward her with expressions of sublime love—hers tinged with wonder, his with tenderness. At the same time, while Mary's raised arms help visually to propel her upward toward God, her gesture also anticipates an embrace, and this is echoed by the Father, who opens His arms to her in welcome. Imagery of their love is a leitmotiv of pious writings about the Assumption, and Titian depicted this divine love, interpreting it with a Franciscan warmth.[131] For example, the *Assunta* may be compared in this regard to Cimabue's extraordinary fresco (ca. 1280–83) in the Upper Church at Assisi (fig. 41).[132] Cimabue represented the Virgin's Assumption by showing her sharing a throne with Christ. They sit close together, holding hands and with Mary's head resting on her Son's shoulder. Their comportment conveys the tenderness, even sweetness, of their love.

Perhaps we may see in Titian's representation of divine love the imagery of the "Cloud of Unknowing," the cloud between God and men that cannot be transcended by the intellect but only by love.[133] It is God's love for Mary and hers for Him and for her Son that enable her to transcend the cloud of unknowing and to approach the source of light.

There is another text, however, that can almost be read as the libretto for Titian's "opera," and that is the sermon for the feast of the Assumption by Lorenzo Giustiniani, the venerable first patriarch of Venice.[134] Giustiniani's language in this sermon is derived from the great biblical canticle of love, the Song of Songs. Gregory the Great had provided a most distinguished precedent for this exegesis: his antiphon for the feast of the Assumption is almost a paraphrase of its biblical source.[135] This may well have influenced Giustiniani's use of the Canticle, although the patriarch introduced references and allusions not found in the pope's text.

If we read Giustiniani's sermon standing before the *Assunta*—as, historically and theologically, one ought to do—then a significant equivalence is revealed between the words and the image. The patriarch's sermon might almost be a description *avant la lettre* of Titian's altarpiece; and, for reasons that will become apparent, it seems that the artist or his Franciscan patrons must indeed have been referring to Giustiniani's text, or something very like it. However, if Titian and/or his patrons were reading Giustiniani's sermon on the Assumption, their use of the text also involved a significant editorial revision, so to speak. Whereas the patriarch described Mary's funeral, Titian alluded to it only indi-

41. Cimabue, *Assumption of the Virgin* (detail). Assisi, San Francesco,
Upper Church.

rectly and perforce by representing the Apostles who had come to bury
her.

Giustinian introduced his narrative of the Assumption with images
of God's redemptive love for mankind. We are reminded "with what
great charity omnipotent God loves us, and equally how for his great
love he sent us his only begotten Son [Jn 3 : 16] . . . so that by the
Passion of the Cross he might befriend those who, by the disobedience
of Original Sin, had made themselves his enemies . . . ; hearts burn

[104]

with the fire of divine love. And who of grace is not aflame with love, the love shown us by the mediator? . . . and the incomparable suffering of the Passion that he endured. O pure love . . . , o spontaneous feeling, o lovable love of our Redeemer. . . . Fill our beings with this love."[136] Giustinian's sermon closes with a reiteration of this theme of salvation and Mary's role as our benevolent mediatrix. Exalted as the queen of heaven "above the troops of angels," the Virgin turns her merciful gaze toward us, interceding with her son for our pardon.[137]

Titian's *Assunta*, "aflame with love," is enframed by the statue of the Redeemer above and, below, the tabernacle relief of the Man of Sorrows. Thus the *Assunta*, like Giustiniani's sermon, is surrounded, as it were, by the theme of God's loving act of redemption and Mary's role in making this possible.

The Assumption is a joyous triumph: "today with great joy the Virgin has triumphed in heaven, and she has seen what she desired to see. . . . And she saw . . . face to face, the face adorned with the whiteness of immortality, and she held in her arms . . . with embraces of pious love the one she had sought." The patriarch continues, "no one . . . can describe the Virgin's ardor, with what fire of desire she was burned. . . . As she was free of every corruption of mind and body, she was thus foreign to the pain of death" (quoting Ct 4 : 7).[138]

Mary's assumption into heaven even evoked the wonderment of the angels who witnessed it, as envisioned by Titian and expressed in the question ascribed to them by Lorenzo Giustiniani, again quoting the Song of Songs (3 : 6 and 6 : 9). The heavenly host exclaim: "Who is this who comes to us with such a great party of angels, almost like the breaking dawn, beautiful like the moon, elect like the sun . . . ? Let us honor her who comes to us like a pillar of smoke of the aromas of myrrh and of incense."[139] Giustinian went on to relate, and Titian to anticipate, how Christ greeted his mother in heaven, addressing her in the language of the Canticle as he welcomed her to her throne as *Regina coeli*: "Come, my mother of Lebanon, come my dove, my Immaculate one, my lovely one, gentle and dignified as Jerusalem, you will be crowned. . . . Ascend to the throne that I have prepared for you, take the crown set with gems."[140]

In Giustiniani's sermon, the Virgin responds to this welcome with wonder and humility: "Have I merited this? . . . you lead me with great honor to the height of perfect joy, and to the triumph of glory, and into the most beautiful chambers of heaven. What can I render to my Lord in exchange for all these things . . . ? I shall choose the holy words of customary humility that you have taught me. I shall not draw back, nor shall I contradict, but consent to your will, with a reverent acqui-

escence of mind, and with those same words that I spoke when I conceived you . . . 'Behold the handmaid of the Lord; be it unto me according to thy word.' "[141]

In the altarpiece, as in the sermon, Mary accepts her glorification, and love is the cause and the means of her ascent. Mary's wondering humility is equally expressed in the visage that Titian gave her and in the words that Giustinian ascribed to her. This interpretation of Mary's reaction, references to her mediating role and to Christ's Passion, are common to the account of the Assumption as written by the patriarch and as visualized by Titian.

Representing the triumph of the Virgin, Titian's *Assunta* became a personal triumph for the artist as well. The installation and unveiling of his great panel—one might almost say its revelation—marked the beginning of a new age in Venetian, indeed, in European art, an age dominated by Titian. Surely Titian's successful completion of the high altarpiece inspired, at least in part, his commission to paint another work for the Frari, the *Madonna* for the altar of the Immaculate Conception, the family altar of his early patron, Jacopo Pesaro.

4

Titian's *Madonna di Ca' Pesaro*

1. The Altarpiece of the Chapel of the Immaculate Conception

> Altare et sive capellam Beatissime Verginis Marie sub
> titulo eius Conceptionis.[1]

Titian's *Madonna* was commissioned in 1519 for the chapel of the Immaculate Conception by Jacopo Pesaro (1464–1547), Bishop of Paphos (on Cyprus) (figs. 42 and 43).[2] Jacopo's altar represents the second Pesaro dedication to the Immaculate Virgin in the Frari: we have seen that the Pesaro chapel in the sacristy must also have been consecrated to her, given Bellini's clear references to the liturgy of the feast.[3] However, as Franciscans, the friars of S. Maria Gloriosa dei Frari would have observed the feast long before either Pesaro endowment, and there had been a chapel of the Conception at or near the site of the Pesaro altar in the nave by 1361, according to documents cited by Sartori.[4] In 1498, a Scuola della Concezione was founded with the consent of the friars, as noted in the confraternity's *mariegola* or rule book.[5] It seems likely that the new confraternity's chapel would have been at the same site already associated with the cult in the fourteenth century and which

[107]

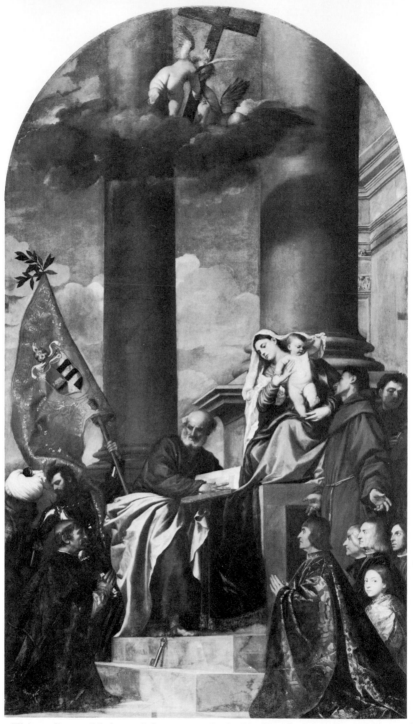

42. Titian, *Pesaro Madonna* (after restoration). Venice, Santa Maria Gloriosa dei Frari, Pesaro dal Carro Chapel of the Immaculate Conception.

43. Venice, Santa Maria Gloriosa dei Frari, Pesaro dal Carro Chapel of
the Immaculate Conception.

has been continuously dedicated to the Immaculate Conception since the late fifteenth. (In front of the altar, a pier with the Pesaro arms carries an inscription dated 1582 commemorating the indulgences granted by Pope Gregory XIII to this altar and to the Confraternity of the Immaculate Conception; fig. 44.) Finally, it is logical that the same location was intended also by Lodovico Querini in his testament dated 1499, a year after the establishment of the scuola.[6] Querini alluded to a future altar of the Conception: thus the friars were planning a new (or another?) altar of the Immaculate Virgin in 1499. Pending (re)construction of the chapel, Querini's body was to be given temporary burial (kept "in deposito"). "I want my body buried in S. Maria of the Friars Minor," Querini ordered, "in the habit of St. Francis . . . and my said cadaver put in deposit until an adjacent chapel shall be made under the title of the Conception of the Glorious Virgin, and my said body placed there. . . ."[7] Querini had to wait rather a long time, twenty years, before the Pesaro came to the Frari to do the good work.

Because it is both very familiar and very beautiful, one forgets how strange a scene Titian's *Madonna di Ca' Pesaro* (1519–26) presents (fig. 42). In an architectural setting of individually identifiable forms constituting an unrecognizable structure, the Madonna and Child are seated on a high socle or base to one side of the picture space. To their proper right, the position of honor, is the primary donor, Jacopo Pesaro, being presented by his patron, Saint Peter.[8] To Mary's left, saints Francis and Anthony of Padua present four of the bishop's brothers and their nephew. Francis turns to gaze upward at the Christ Child, while the face of St. Anthony is all but hidden in the shadows as he looks down upon the donors.

Immediately behind the Virgin and Child is an immense column that rises beyond the uppermost edge of the canvas; but what practical architectural function it fulfills one cannot know. To the left, another column also rises beyond the picture space, and this column is markedly narrower in circumference than the first. This difference in diameter would seem to indicate a considerable distance in space between the two columns, but that effect is contradicted by the proximity of both columns to the figures of Mary and St. Peter, who themselves are in the same picture plane.[9] The very unreality of these architectural forms—the giant, disparate columns and the impractical throne of the Madonna—implies that they are not to be understood in mundane terms. These structures are likely symbols of Mary's Immaculate Conception. Both the high throne, as in Bellini's Immaculatist image of the Madonna in the sacristy triptych (fig. 16), and the huge columns are

44. Venice, Santa Maria Gloriosa dei Frari. Pier with the Indulgence of
Pope Gregory XIII.

probable allusions to the Virgin's Immaculacy and to the text of Ecclesiasticus 24.[10]

To the right, Titian's picture space is enclosed by a wall. Here, too, the practical architectural purpose is uncertain: the wall resembles no actual structure. Its moldings and pilaster capitals repeat the motifs of the carved stone frame surrounding the altarpiece. However, there is little if any attempt to exploit the spatial illusionism suggested by this repetition of actual forms in the fictive architecture of the altarpiece. Rather than establishing an illusionistic continuity between the actual and fictional spaces of church and picture, Titian insisted on a disjunction between the two realms.[11] This represents a notable departure from the Venetian tradition of the Quattrocento and early Cinquecento, represented, for example, by Bellini's Frari triptych of 1488 (fig. 16) and his altarpiece in S. Giovanni Crisostomo (fig. 45), signed and dated 1513—just three years before the artist's death and six years before Titian signed the receipt for the *Pesaro Madonna*. Bellini's frames— gilded wood in the Frari and carved stone in S. Giovanni Crisostomo— function as the terminus and frontal plane of the pictorial architecture. In S. Giovanni Crisostomo, however, Bellini achieved a new effect. By echoing the architectural forms of Tullio Lombardo's relief of the *Coronation of the Virgin* on the altar across the nave, Bellini's architecture, both real and fictive, establishes a visual link across the actual space of the church, capturing the viewer-worshiper in the central axis of this five-sided building.[12]

Even Titian's own *Assunta* for the high altar of the Frari, painted between 1516 and 1518, belongs to that same tradition of Venetian illusionism (figs. 9 and 32). The stone frame of the altarpiece, possibly designed by the master himself, repeats the forms of the choir screen arch and establishes a stereoscopic link across the long nave of the church.[13] But in the *Pesaro Madonna* Titian abandoned that kind of illusionistic scheme after much experimentation on the actual surface of the canvas, which has been revealed by recent technical and X-ray examinations.[14] The only link, as we have seen, between the pictorial and the actual spaces is the minor one of the repeated decorative motifs in the moldings and the capitals. Thus the viewer's access to the scene is not made possible by the traditional Venetian means of visual illusionism, but rather is established exclusively by the psychological means of direct *human* contact between the viewer and the youngest donor, the only being in the *Pesaro Madonna* who regards us directly.[15] This is not the compulsory demand to worship of the medieval Hodegetria, the Madonna Who Indicates the Way (fig. 52), or of the commanding saintly exemplar, such as Bellini's insistent St. Benedict in the Frari

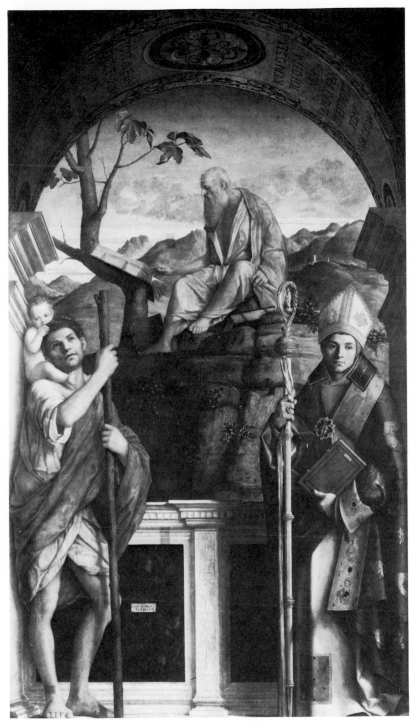

45. Giovanni Bellini, *San Giovanni Crisostomo Altarpiece*. Venice, San Giovanni Crisostomo.

triptych, but, rather, a welcome offered by a child to the mortal congregation.

Something wonderfully generous happens here: not only the donor and his family but we, too, are included—explicitly by the direct gaze of the youngest Pesaro whose eyes invite us to join him and hence to share in the donors' reception by the Madonna and Child, and implicitly by St. Francis's open arms. The compassionate, embracing gesture of Francis, who simultaneously reveals his stigmata to the Christ Child and to us, is characteristic of the saint in life and in art, although it is obvious that Titian had one particular model in his mind's eye—the *St. Francis* by his former teacher, Giovanni Bellini (fig. 27).[16] Francis's posture evokes the famous prayer of his first biographer, Thomas of Celano: "Remember . . . your sons crying thus sadly to you: 'Present, Father Francis, to Jesus Christ his sacred stigmata, and let him see the marks of the cross, that he may mercifully deign to show his own wounds to the Father, who because of them will indeed be ever gracious to us miserable ones. . . .' "[17] This compassionate spirituality, typical of Saint Francis and of Franciscanism, was understood and expressed by Titian in the composition and the characterizations of his *Pesaro Madonna*.

The Christ Child responds to Francis's display of the wounds in an extraordinary way, by smiling, kicking, almost squirming on his mother's knee and pulling at her veil. This is a verisimilar and charming representation of a playful infant, but at the same time his behavior is symbolic of the Child's own future suffering and death. It is likely that we are intended to see in his foot the future locus of a terrible wound of the Crucifixion, while the Madonna's veil recalls the winding cloth, ritualized as the *corporale,* the cloth spread on the altar to receive the Host of the Mass.[18] These various allusions to the Passion become explicit in Titian's depiction of the two putti in the dense clouds that float before the columns. The putti are supporting, or rather, elevating a large wooden cross, and the posture of one of them, standing on one leg with his back toward us, echoes the position of the Christ Child. The cloud casts shadows on the two columns, but the shadow on the column just above the Virgin and Child is noticeably stronger, and indeed threatening. This dark shadow seems to presage the darkness of the sepulchre, as in Titian's deeply moving *Entombment,* painted about the same time as the *Pesaro Madonna* (fig. 46).[19] Here Christ has been absorbed by the darkness of the tomb even before his actual placement within it. Emphasis on Christ's Passion in general, and in particular the association of the Child with the suffering of the Adult, are specifically expressive of Franciscan piety, which emphasizes the vulnerable hu-

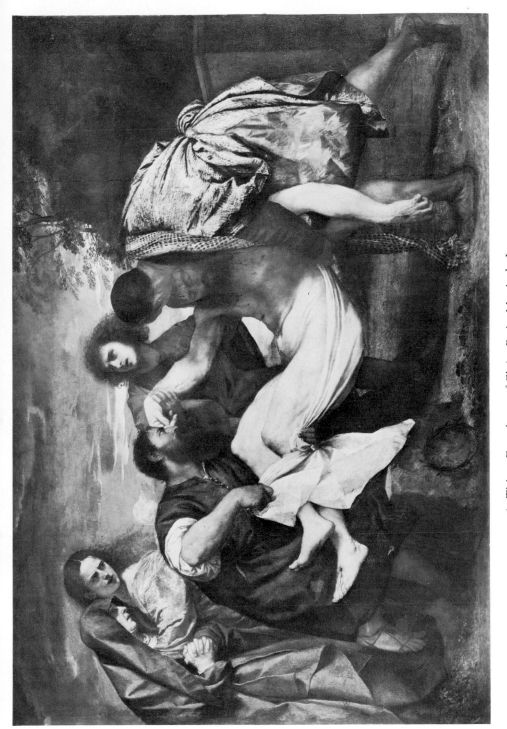

46. Titian, *Entombment of Christ*. Paris, Musée du Louvre.

manity of Jesus, both as the newborn Child and as the Man on the Cross.[20] This spirituality is represented in the two archtypal miracles of Saint Francis, the Crèche at Greccio, when the doll of the Newborn Christ seemed to come to life in the saint's arms, and the stigmatization at Laverna, when the wounds of Crucifixion were impressed upon his flesh.[21]

The *Pesaro Madonna* is equally remarkable for its emphasis on certain secular qualities, such as the importance of the donors in the composition.[22] Indeed, the members of the Pesaro family literally outnumber the sacred characters (unless we count the two putti), and so dominate the scene that St. Anthony is all but crowded out of the composition on the far right. Moreover, on the left, Titian has included two figures who are neither donors nor saints—that is, the turbaned Turk and the young black man who are led by a soldier toward the Madonna and Child. It is well known that this group was included as reference to the military career of the primary donor, Jacopo Pesaro.

Apostolic legate and general of the papal fleet, Jacopo had fought for Pope Alexander VI (Borgia) against the Turks in 1502 as an ally of the Venetian forces.[23] The *Pesaro Madonna* was intended in part to commemorate Jacopo's role in the Christian victory over the Turks at Santa Maura on 30 August 1502, almost twenty-five years before Titian completed the altarpiece. Titian alluded to the battle of Santa Maura in several ways: Jacopo is not dressed as a bishop but in a black brocade garment evidently associated with his papal office; his banner, with the victor's laurel affixed at the top, includes both the Pesaro arms and those of Alexander VI; the soldier who holds the banner is wearing the pope's colors; and the Turk and the black whom he leads toward the Madonna and Child are prisoners of war, signifying an offering to the Church.[24]

The secular and civic emphasis here, in both content and composition, is such that the identity of the soldier is unclear: is he a saint, possibly the soldier-saint Mauritius, a punning reference to the place conquered by the Christian forces in 1502? or is he in effect an anonymous supernumerary included for the practical purposes of holding the banner and presenting Pesaro's prisoners to the Virgin?[25]

In any case, the point is that the *Madonna* does not resemble other altarpieces so much as it does votive pictures such as that painted by Titian earlier in the sixteenth century for Bishop Pesaro to commemorate the same victory of Santa Maura (fig. 47).[26] Here an enthroned St. Peter turns to bless Pesaro, who kneels before him, introduced by Pope Alexander. Peter's keys rest on his high, stone base carved with fictive antique reliefs.[27] The background opens behind the pope and the

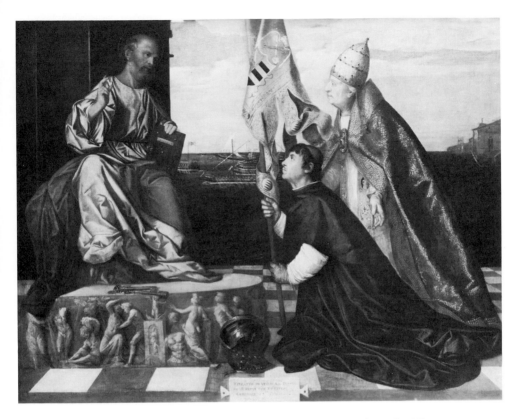

47. Titian, *Bishop Jacopo Pesaro Presented to St. Peter by Pope Alexander VI.*
Antwerp, Koninklijk Museum voor Schone Kunsten.

bishop to reveal their victorious galleys sailing the sea. Jacopo's helmet
is on the ground before St. Peter's throne, and the bishop himself holds
his battle standard, similar to the one in the *Pesaro Madonna* but bearing
a more conspicuous display of his family arms. His garments in the
votive picture also resemble his costume in the altarpiece, a black
gown—although not brocade as in the Frari—with white sleeves and
gloves. The votive portrait differs from that of the altarpiece, however,
in a significant psychological, or spiritual, detail. In his votive picture,
Jacopo stares intently at St. Peter, and his gaze is returned. In the altar-
piece of his funerary chapel, Jacopo is less bold: he looks across the
picture space toward his brothers, while St. Peter continues to turn his
eyes toward his servant.

Having already commissioned that first painting to recall his military

success, why should Jacopo have ordered another, and so many years after the event? Why should that second work be the altarpiece of the Immaculate Conception in the Frari? Why should the bishop employ that altarpiece to remind his compatriots of his close association with the notorious and much disliked Borgia pope? And who's who in Titian's *Madonna di Ca' Pesaro?*

2. The Family of Jacopo Pesaro and Their Funerary Chapel

> Ex nobili inter Venetos ad nobiliorem inter angelos familiam.[28]

Of the six portraits in the *Madonna* only one has been identified with absolute certainty, that of Jacopo Pesaro himself, a son of Leonardo (Lunardo) and a grandson of Giovanni (Zuanne) of the "dal Carro" branch of the Pesaro family.[29] Fra Germano, Guardian of the Frari and Magister of the Province of the Holy Land, ceded the altar of the Immaculate Conception to Jacopo and his brothers on 3 January 1518 on condition that they establish endowments for masses and for the feast of the Conception. In return for these endowments, the Pesaro might construct a tomb in the pavement before the altar and another tomb on the wall for themselves and other members of the family—both monuments to be decorated with their arms. They would also decorate the chapel, and the friars would say mass and place candles there for the souls of the Pesaro dead. Thus Titian's *Madonna* was commissioned as the altarpiece of a family funerary chapel, as Jacopo and his brothers always planned to be buried at the site. The concession was "made by agreement of the friars of the Convent of Mary, the Ca' Grande of the Conventual Friars Minor of Venice . . . the Reverend Guardian of the Convent, Master Germano de Casale, Master of the Province of the Holy Land," to

> The present Most Reverend in Christ the Father, Lord Jacopo Pesaro, Bishop of Paphos and his brothers for themselves and for their heirs and successors, in perpetuity . . . [who are conceded] the altar or chapel of the Blessed Virgin Mary under the title of her Conception located in the church of the aforesaid friary in the right aisle between the Chapel of S. Peter and the middle door of the church itself called the door of the Madonna, with all legal rights . . . to have, enjoy, construct, furnish and adorn the altar and to put in order, with this declaration, obligation and condition, of course, that the Lord Bishop

build and, much more, is obliged in truth to build and adorn said altar or chapel, likewise to construct and have made a tomb in the pavement and also a tomb on the wall on the other side of said altar, with his arms, epitaph and ornamentation as is fitting and acceptable to the aforementioned Lord Bishop, and by his own order to have executed at his cost both on the altar or chapel and on the aforesaid tombs in the pavement and on the wall. Item, that the aforesaid Reverend Lord Bishop will not fail to give and contribute a perpetual endowment of twenty-five to thirty ducats every year to be received by the aforesaid Lord Guardian and convent and their successors . . . [who] agree and promise that they must officiate and celebrate a mass every day in perpetuity for the health and souls of the aforesaid Lord Bishop and his brothers and the deceased members of their family. Item, that the aforesaid Lord Bishop with his heirs and successors are obliged to pay and release two ducats annually on the aforementioned feast of the Conception of the Blessed Virgin Mary to the aforesaid Lord Guardian and convent and their successors to provide the meal for the feast in the convent every year. Item, that the aforesaid Lord Guardian and convent with their successors be obligated throughout the year in universal commemoration of the dead to illuminate the aforesaid tomb with . . . tapers as is fitting both at mass and at vespers and matins and thus successively from year to year in perpetuity. . . .[30]

The Pesaro reiterated their agreement with the friars a year later, 17 January 1519, clarifying the provisions regarding the annual donation of thirty ducats.[31] Finally, the contract and obligations were renewed once again in a document of 1524.[32]

In their wills, both Jacopo and his oldest brother, Francesco, provided perpetual endowments in fulfillment of their agreement with Fra Germano. In his testament dated 1547, Jacopo referred to his own obligation and also to Francesco's legacy, which the bishop intended to honor: "Because we are obliged to endow a fund for two bequests to the Friars Minor of thirty ducats a year and two ducats for the feast on the day of the Conception of the Madonna, and as the late Ser Francesco, who was our brother, has bequeathed fifteen ducats from the Paduan harvest fees for one of the said endowments, let fifteen ducats be consigned in our name to the aforesaid friary of Friars Minor on account of the other endowment."[33]

In exchange for these bequests, as we have seen, the brothers' contract with the Frari allowed them to construct their family tombs at the altar of the Conception. (Later, Antonio's descendant, Doge Giovanni Pesaro, also constructed his monument there; figs. 43 and 59.) Hence, Titian's *Madonna* was intended to serve a double function: it is both the

48. Venice, Santa Maria Gloriosa dei Frari, Pesaro dal Carro Chapel of the Immaculate Conception (detail). Tomb of Francesco Pesaro and his brothers.

altarpiece of the chapel of the Immaculate Conception, and it is a funerary image "before the fact," in which the Pesaro family are sponsored by their patron saints and received in heaven by the Virgin and Child, a theme originally developed in the context of funerary monuments.[34] The modest tomb slab in the pavement before the altar marks the grave of "Francesco Pesaro and his brothers, sons of Leonardo," and their families, patrons of "this chapel": "Fran. Pisaurus Fratresq[ue] Lionardi Liberi Sacellum Hoc Pr...con...ser...o Pr...Sibi...d..." (fig. 48).[35]

The far more elaborate wall tomb belongs, of course, to Jacopo (figs. 43 and 49). It was fitting that he be given prominence in the funerary arrangements as in the altarpiece that he commissioned: he was both a major benefactor of the altar of the Conception, and, as Bishop of Paphos, apostolic legate, and former general of the papal fleet, the most distinguished and conspicuous member of his family. Jacopo's monument is related to his adjacent altarpiece by several means, visual and thematic, and may have been constructed at the same time, as Jacopo referred in his testament to the "monument that we have had made."[36] Both the frame and the tomb were carved from the same veined marble, and identical decorative motifs were used in both—disks of porphyry and of serpentine, Corinthian capitals and carved rosettes (gilded in the tomb and perhaps originally so in the frame). Shields with the Pesaro arms are displayed in each case, held by angels at the top of the altar frame, and by putti beneath the bishop's effigy, who also hold reversed torches and step upon death's heads.[37] The figure of Jacopo himself is repeated, as a kneeling donor in the altarpiece and reclining on his bier in the tomb.[38] If Pesaro's effigy was originally polychromed, then the association with his portrait in the altarpiece would have been

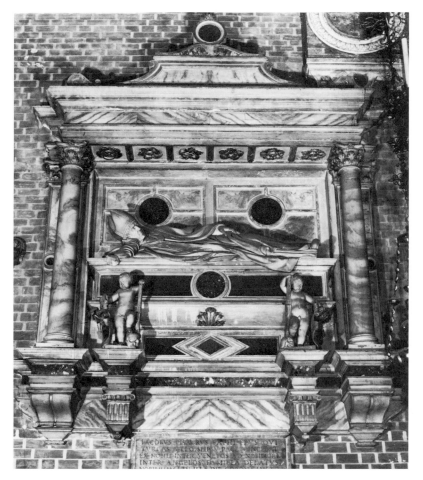

49. Venice, Santa Maria Gloriosa dei Frari, Pesaro dal Carro Chapel of the Immaculate Conception (detail). Tomb of Bishop Jacopo Pesaro.

more powerful still. However, in Titian's portrait of him, the bishop was portrayed in the fine garments presumably associated with his command for Pope Alexander, whereas his tomb effigy shows Jacopo in his cope and miter. This no doubt corresponds to the way in which Jacopo was actually interred, in accord with the instructions of his testament: "We want our body dressed in the pontifical gowns and to be placed at rest until the day of Holy Judgment in the monument that we have had made above [on the wall] in the church of the Friars Minor in the Ca' Grande of Venice, with the performance by our aforesaid commissaries and heirs of funerary exequies according to our status and con-

dition and honor and [that] of our House; and it should not appear that we desire immoderate pomp."[39]

Despite the difference in clothing worn by the bishop in his tomb and in his altarpiece, taken together the two monuments may be understood as a dramatically revised version of older funerary types in which the deceased is represented twice, once in death and once as though in life, being introduced to Mary and Christ by his patron saint. In Jacopo's monument, only the deceased is depicted: the Madonna and Child traditionally included in such monuments were in effect represented separately by Titian. Finally, repeating a theme of the altarpiece, the self-assured inscription of the tomb commemorates Jacopo's role in the Turkish war, spelling out what Titian expressed in his visual imagery: "Iacobus Pisaurus Paphi Ep[isco]pus Qui / Turcas Bello, Seipsu. Pace Vincebat / Ex Nobili Inter Venetos Ad Nobiliore. / Inter Angelos Familia. / Delatus, / Nobilissima. In Illa Die Corona. Iusto / Iudice Reddente, Hic Situs Expectat, / Vixit An[n]os Platonicos, Obiit / M.D.XLVII.IX.Kl.Apr." ("Jacopo Pesaro, Bishop of Paphos, conquered the Turks in war and himself in peace. He has been carried from a noble family among Venetians to a more noble family among angels. He awaits in this place that most noble crown on that day when the just judge shall come. He lived deeply thoughtful years. He died 9 April 1547").

Jacopo had had an active secular career in his earlier years, evidently in connection with Pesaro business in the east.[40] In the opening paragraphs of his will, the bishop was careful to specify that his bequests concerned properties and wealth acquired in Constantinople and elsewhere before he had become a cleric: "we have the time to dispose of our worldly goods . . . which were not acquired or attained by us as a result of ecclesiastical benefices, but as paternal and fraternal inheritance, and which we have earned with our great effort and a lot of sweat in Constantinople and elsewhere while we were [still] a layman."[41]

Jacopo's ecclesiastical career began with his taking minor orders, but he must have been ordained a priest before becoming Bishop of Paphos.[42] As a cleric, he was tonsured and was represented with the tonsure in Titian's two portraits of him, in Antwerp and in the Frari.[43] Jacopo was already Bishop of Paphos by age thirty-five, when he was first mentioned by Marino Sanuto in 1500, and possibly also Master of the House of Cardinal Grimani, with whose family his own was closely associated.[44] Sanuto recorded as well that Jacopo was apostolic legate in the armada in May 1501 and the pope's captain and commissary in April 1502.[45] The bishop left for the war on 28 June 1502 and fought in the Dardanelles as an ally of the Venetian fleet led by his cousin the gener-

alissimo, Benedetto of the S. Benetto branch of the Pesaro family.[46] Jacopo was back in Venice, reporting to the Collegio, on November 13.[47]

The bishop's brothers shared the Frari concession of 1518—but Jacopo had five brothers, while in the Pesaro family altarpiece there are only four other adult men and one boy. Who are they? Biographical and historical information help to answer this rhetorical question. Jacopo's brothers, in order of their birth, were Francesco (1451–1533), who has already been mentioned, Vittore (ca. 1458–1510), Antonio (ca. 1458–before 1529), Giovanni (or Zuanne, 1459–1533), and Fantino (1468–after 1547). Born in 1464, Jacopo himself was the second youngest. He died in 1547.[48] Antonio and Vittore, the two who predeceased the other brothers, were evidently the only ones who succeeded in producing male heirs, judging from the evidence of testaments made by members of the family.

Vittore's son was named Giovanni Maria. It is not known who the boy's mother was.[49] Vittore's marriage to Schiavona, a daughter of Antonio Morosini, was listed by the Avogaria di Comun in 1506, but in fact the wedding never took place.[50] In 1510, Vittore died in Cyprus at age fifty, and Schiavona married another man. This biographical information comes from Sanuto, who closed his account of Vittore's death and his fiancée's marriage to someone else with the suggestive phrase, "et questa cossa ho notata non sine causa."[51] Unfortunately, the diarist did not explain—but there may be a breath of scandal here. Moreover, Vittore's son, Giovanni Maria, was omitted entirely from the wills of his uncles Francesco (1529, with a codicil of 1533) and Fantino (1547), whereas they made provisions for the well-being of their other nephew, Leonardo.[52] But the main point regarding Vittore and Titian's portraits is this: the *Pesaro Madonna* is the altarpiece of a family funerary chapel, as the deliberation of 1518 clearly states and as the tombs themselves demonstrate. Intending to be buried next to the altar, surely Jacopo and his brothers also meant that their portraits in the altarpiece should be associated with the traditional imagery and purpose of funerary monuments. Although it is certainly possible that Vittore's body was brought back from Cyprus for burial in Venice, it seems unlikely that his remains would have been disinterred for reburial at the Pesaro altar in the Frari, which was conceded in 1518 and not completed until 1526, sixteen years after his death. The Pesaro altar in the Frari has no relevance for Vittore, who must have been buried elsewhere. The men portrayed by Titian are Vittore's surviving brothers, to whom the altar was conceded and who planned to be interred at that site in the Frari.[53]

The death and burial of Vittore Pesaro long before the chapel was endowed do not have bearing, however, on the identity of the boy depicted by Titian. The omission of his father would not in itself justify the exclusion of the son from the family group portrait, and yet one of the two Pesaro nephews was excluded, even though Giovanni Maria's fatherless condition might have warranted the special interest of his uncles. When their other nephew, Leonardo, was likewise orphaned, the Pesaro brothers were deeply concerned. For example, Francesco declared in the codicil to his will that Giovanni's wife had become a second mother to Leonardo, and made generous financial provisions for the boy.[54] There is no reference to Giovanni Maria. And in Fantino's testament, the only mention of Giovanni Maria, who had by then become a priest, is a statement of disinheritance: "Item, let no one marvel if I leave nothing to the Reverend Messer Giovanni Maria da Ca' da Pesaro my nephew, because he has ecclesiastical benefices."[55]

Jacopo was more affectionate and more forthcoming in his testament of 1547. The bishop bequeathed silverware, some books and other items to his nephew:

> We bequeathe to the Reverend ser Giovanni Maria di Ca' Pesaro, son of the aforesaid deceased ser Vittore who was our brother, our dear nephew who has always been most obedient to us, . . . as a sign of love a silver basin and a silver vase, a half dozen silver plates, a half dozen silver spoons, and a half dozen small silver bowls, a dozen silver forks . . . a pair of silver salt cellars, and a dozen knives with silver handles, and three or four cassocks and two of the best coats to select and as it shall seem to this Messer Giovanni Maria, and all the books in theology and philosophy and in law that are ours. And we have not left him more because we have accommodated him in the episcopate and in all our benefices . . . without any expense to himself so that he can live honorably as a gentleman, and we know that for his gentle nature he will always remain affectionate and well-disposed to his cousin Leonardo our nephew, and thus the said Leonardo will do for mutual love, not as cousins but as true and gentle and dear brothers, and thus we exhort them and pray this Messer Giovanni Maria to remain and to do unto the sons of the said Leonardo as we have done unto him.[56]

In the context of Jacopo's substantial estate and significant legacies to other members of the family, his bequests to Giovanni Maria seem modest, as the bishop himself acknowledged. Moreover, like Francesco before him, Jacopo also specified that only the legitimate male issue of

legitimate Pesaro marriages could succeed either commissary. If there were no such heir, then the Guardian of the Scuola Grande di S. Marco was to serve as commissary. (Jacopo, Francesco, and Fantino were all members of the scuola.)[57] To be sure, such precautions about legitimacy were not uncommon in Venetian wills; nor were they irrelevant. It appears that Giovanni Maria was illegitimate and had been encouraged (or perhaps compelled) to follow a clerical career. Nor would he have been the only noble Venetian bastard to do so.[58] If he had been born out of wedlock, Giovanni Maria would have been banished from the Pesaro altarpiece of the Immaculate Conception, as he was excluded from the family bequests (except Jacopo's), precisely because of his illegitimacy. It was one thing for Giovanni Maria to live a gentleman's life with his cousin Leonardo, as Jacopo counseled in his testament, but it was evidently out of the question that he join the lineage in death. Whatever his private virtues, Giovanni Maria was not to be publicly remembered in the family funerary chapel in the Frari.

The only other male descendant of Jacopo's brothers—or at least the only one to survive to adulthood—was the son of Antonio Pesaro and Elena Malipiero, who were married in 1506.[59] Antonio had won the grateful praise of his countrymen for the rapid construction and efficient management of a biscuit factory that supplied the Venetian fleet with provisions during the war with the Turks: the references in the *Pesaro Madonna* to that war are relevant to him as well, even though explicitly associated with Jacopo.[60] Antonio died intestate in 1529, and his widow dictated her own will a year later.[61] Elena wished to be interred in the family tomb in the Frari, wearing the Franciscan habit: ". . . volo corpus meus indutus habitu B. Francisci sepeliri in archa nostra di Cha da Pesaro in ecclesia Sancte Marie Fratrum Minorum." Burial in the habit of a religious order was a fairly common expression of piety, and at least one other member of the Pesaro family made the same request, Benedetto's son Girolamo, whose monumental tomb was later constructed to the liturgical east of Jacopo Pesaro's altar.[62] Elena, of course, was referring to the family sepulchre in the pavement before Titian's altarpiece, where the friars had conceded the Pesaro the right to build a tomb. Indeed, it seems that her husband, Antonio, may have been the first member of the family to have been buried there.

Elena listed three children in her testament of 1530, the boy, Leonardo (named for Antonio's father), and two daughters, Maria and Bianca (named for Antonio's mother).[63] Another son, Nicolò, must have died before 1530, the date of Elena's will.[64] Leonardo was nominated as one of Elena's commissaries and a commissary of other Pesaro testaments as well, namely, those of his uncles Francesco, Fantino, and Jacopo.

Moreover, this nephew was one of the primary beneficiaries of the bishop's will. Realizing that he was dying, Jacopo allocated part of his estate to his surviving brother, Fantino, and to Leonardo: "these [properties] we have lately divided between our aforesaid brother [Fantino] and nephew [Leonardo] and the commissary of my deceased brother Francesco."[65]

The boy depicted by Titian in the altarpiece can only be Leonardo, everyone's commissary and heir: there simply is no other possibility. Born in 1509, the child appears to be the right age, about ten years old, for Titian's portrait begun in 1519.[66] Titian's composition of the group around Leonardo suggests the unique importance of the boy to his family. Surrounded by his uncles, Leonardo is the central figure of the group in three-dimensional space and in the two-dimensional design on the picture surface, and the great sweep of the first man's red brocade gown enfolds his nephew in a protective way.

One of the five men must be Leonardo's father, Antonio, who was honored by the inclusion of his onomastic saint Anthony in the altarpiece, and who was buried in the floor tomb before the altar. So Titian represented Leonardo, his father Antonio, and his uncles, Francesco, Fantino, Giovanni, and Jacopo. But which is which? The most obvious answer to this question is probably correct—namely, that the brothers are represented according to their ages: Francesco, the oldest, in the position of honor, followed by Antonio, Giovanni, and Fantino. One notable precedent for such a scheme is Gentile Bellini's group portrait of his own family in the *Miracle of the Relic of the True Cross at the Bridge of S. Lorenzo,* which was completed in 1500, less than twenty years before Titian began his *Madonna* in the Frari (fig. 50).[67]

Francesco was first not only because he was the oldest but because he was the head of this branch of the Pesaro family, as he himself declared in the codicil added to his will in 1533. Giovanni had recently died intestate, and Francesco, as head of the house, took upon himself in their name the responsibility of supporting Giovanni's widow, Maria Malipiero, who was the sister of Antonio's wife Elena.[68] So, despite his comparatively youthful appearance in the Pesaro altarpiece, Francesco, the oldest, is surely the first man in the group, a conspicuous figure in the composition, leading the family here as he did in life, and privileged also by the presence of his onomastic saint. Indeed, only his name, with the patronymic, was included in the inscription of the Pesaro tomb before the altar. The inscription identifies "Francesco and his brothers," and that is what Titian represented. Admittedly, two of Francesco's younger brothers, Antonio and Giovanni, may appear older than he—

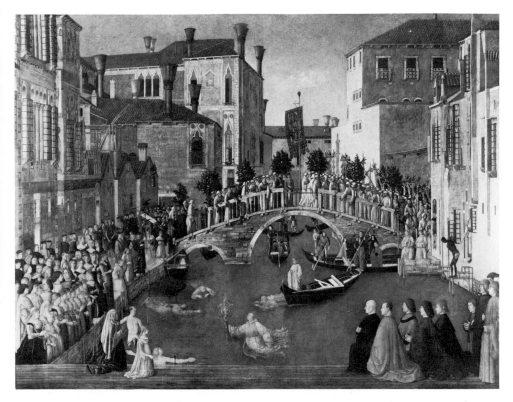

50. Gentile Bellini, *Miracle of the Relic of the True Cross at the Bridge of San Lorenzo*. Venice, Gallerie dell'Accademia.

but they also predeceased him. Moreover, there is another reason to conclude that Francesco is the first man in the group portrait: he was a patron of the altar.

From his will itself, dated 1529, we learn that Francesco—not Jacopo, as one might have thought—was funding daily masses at the family altar of the Immaculate Conception in the Frari. Francesco provided a legacy to continue the celebration of masses in perpetuity: "At present I am having mass said every day at our altar of the Conception of Our Lady, and I want and order mass to be celebrated there every day in perpetuity."[69] To be sure, Francesco's having taken on this financial obligation was related in part to his role as head of the Pesaro family, being in charge of their charitable accounts as he was also in charge of the business interests of the Pesaro *fraterna*.[70] But there is also some

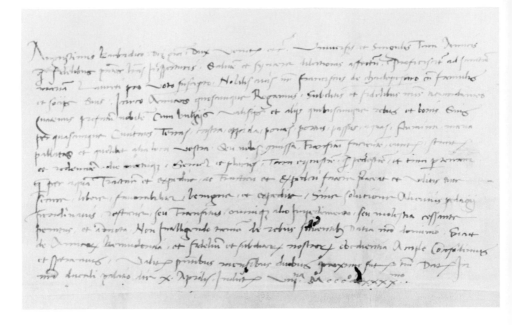

51. Document of 1490. Doge Agostino Barbarigo asks that no one impede
the pilgrimage of Francesco Pesaro and his companions to Loreto. Venice,
Biblioteca Correr.

evidence that Francesco's endowment of daily masses at the altar of the
Conception during his lifetime and after his death reflects not only his
responsibility for the family finances but reveals his personal piety as
well.

In 1490, Francesco set forth with his servants and companions on a
pilgrimage to the shrine at Loreto in fulfillment of a vow that he had
taken. A laissez-passer was provided by Doge Agostino Barbarigo to
facilitate the voyage, "ad sanctam Mariam Laureti pro voto suscepto
Nobilis civis noster Franciscus de Cha de Pesaro cum famulis et sociis
suis" (fig. 51). The doge asks that no one impede the Pesaro group's
progress wherever they go, by whatever "land, castle, gate, bridge,"
as they travel "night and day, . . . both riding on horseback or walking,
and both by land and by sea."[71]

The Pesaro undertook what sounds like an arduous journey in ful-
fillment of Francesco's vow to visit Loreto at a time when such a voyage
and such a vow were still comparatively unusual. The popularity and
prestige of the shrine were much increased during the late fifteenth
century, promoted by a great champion of the Virgin Mary, the Fran-

ciscan pope Sixtus IV. The Holy House of the Madonna had come to Loreto in the thirteenth century, after its several previous miraculous translocations from places where it had been insufficiently venerated.[72] But not until 1482 was the shrine made a parish by action of Pope Sixtus. Then, two years later, Sixtus placed the shrine under the protection of the papacy.[73] This was one of the pope's last acts: he died later in that same year, 1484. The pontiff's measures regarding the Holy House and his ardent promotion of the cult of the Madonna in other ways as well—including his recognition of the feast of the Immaculate Conception—surely encouraged and may even have inspired such voyages as Francesco's pilgrimage in 1490. It is, of course, possible that the Pesaro parents had known Sixtus when he lived in the Frari as a *lector*.[74] But whether or not Sixtus influenced the Pesaro personally or directly, inevitably he must have done so in a general way, by his official actions.

At the same time, it is also possible that the Pesaro pilgrimage in 1490 was somehow related to their cousins' chapel of the Madonna in the sacristy of the Frari, completed only two years earlier with the installation of Bellini's altarpiece. But whether or not it is related to a family pattern of devotion to the cult of the Madonna, one thing is certain: Francesco's vow to visit Loreto, his endowment of daily masses at the family altar of the Conception, and his burial at that altar are all evidence of his own devotion to the Madonna. Admittedly, in itself none of these actions was unique. Nonetheless, taken together, these historical facts become more than data documenting a commitment of time and money. Surely they betoken a spiritual commitment as well, the pious devotion of Francesco Pesaro and his family to the cult of the Virgin. Earlier in this chapter a rhetorical question was posed regarding the Pesaro family's decision to endow the chapel of the Immaculate Conception in the Frari. Clearly Francesco must have played an important role in that decision. Francesco's seniority in the family and his piety, his endowment of daily masses at the Pesaro altar, and his prominence in the altarpiece—all are consistent with this suggestion.

In Venice, piety and politics were synonymous. The Pesaro meant to be recognized and to be remembered both for their pious devotion and also, as Jacopo declared in a statement before the Collegio, for their loyal service to the Serenissima.[75] And these desiderata are realized in the high seriousness and the dignity of their portraits in Titian's altarpiece. In a sacred image of extraordinary tenderness, the master has been able to convey simultaneously the Pesaro's active citizenship and their piety, their civic concerns and their spirituality.

Titian's combination of sacred and civic elements in the altarpiece is represented in an exceptional asymmetrical composition that requires

52. Paolo Veneziano, *Doge Francesco Dandolo and His Dogaressa Presented to the Madonna and Child by Sts. Francis and Elizabeth of Hungary.* Lunette of the Tomb of Doge Dandolo. Venice, Santa Maria Gloriosa dei Frari, Capitolo.

the Mother and Child to divide their attention among the donors. The Madonna and St. Peter turn toward Jacopo Pesaro. Meanwhile, the attention of the Child is directed by St. Francis toward the other members of the Pesaro family. There is no real precedent in earlier altar paintings for this asymmetrical scheme. However, Titian could have found in the Frari itself a model for the concept of the Virgin and Child looking in different directions—not an altarpiece but a funerary image. This is the lunette painted by Paolo da Venezia in 1339 for the wall tomb of Doge Francesco Dandolo in the Chapter House (fig. 52).[76] If Titian was referring to this painting, the reference was not only formal but was related also to the function of the *Pesaro Madonna,* which, like the Dandolo lunette, is a funerary image.

Paolo depicted the doge and dogaressa being presented to the Madonna and Child by their onomastic saints, Francis and Elizabeth of Hungary. With almost heraldic symmetry, the saints bracket the composition, bending protectively over the donors. The patron saints are identical in their postures and their solicitude, thereby implying the equality of the donors. But no wife is the equal of her husband in a Medieval altarpiece or tomb painting, and Paolo followed tradition (and perhaps reality) by making Dandolo slightly larger than his dogaressa and by having the Christ Child turn directly toward the doge to bless him—thus excluding the two Elizabeths, saint and donor. This favoritism is somewhat redressed by the Madonna. While looking toward the viewer and pointing at her Son—she is the Hodegetria, the Indicator of the Way—the Virgin also inclines toward the dogaressa and St. Elizabeth. Mary's posture implies that she will acknowledge the saint's intercession on behalf of the donor, just as the Infant's response to St. Francis in Titian's canvas promises the reception of the Pesaro family, even though the Child has not yet turned his gaze toward them. And as in Paolo's composition, Titian's Madonna and Child are also turned and look in opposite directions, the division of their attention being used to unite the two groups of saints and donors on either side. Paolo's tomb painting provided the genesis of these motifs later developed and transformed by Titian in his altarpiece for the Pesaro funerary chapel.

Part of Titian's transformation of the Trecento scheme is related to the duality of content in the altarpiece, its combination of sacred and civic elements. Indeed, the two parts of the composition correspond to these two facets of its theme, likewise separate and yet interrelated. One motif, that of salvation assured by the Passion of Christ, is presented by St. Francis. With his glance and the display of his stigmata, Francis pleads with the Child on behalf of the Pesaro family who pray before them. At the same time, the Virgin Mary, who is the personification of the Church, and St. Peter, its foundation stone, turn toward Jacopo Pesaro, identified as a servant of the papacy, with his newly won converts to the faith. Here the public role of the bishop is commemorated, as well as his piety, and it is the institution of the church that leads to salvation. The focal point of the composition which ties everything together thematically and visually is the group of the Madonna and Child who, although simultaneously divided in their attention, as we have seen, are yet inextricably united.

Titian's unification of dualities—dualities of both form and content—may be related in turn to the biblical text often quoted in connection with this and other altarpieces of the Immaculate Conception. The Vir-

gin's high throne in such images is explained by reference to Ecclesias-
ticus 24 : 4: "my throne was in a pillar of cloud," "thronus meus in
columna nubis" (24 : 7 in the Vulgate). Recently this passage has been
more specifically associated with the great columns in Titian's *Madonna,*
and indeed this seems likely, in view of the fundamental importance of
Ecclesiasticus for the theology and liturgy of the Immaculate Concep-
tion.[77] But the succeeding verses, Ecclesiasticus 24 : 5–6 (8–9 in the
Vulgate) are also pertinent here, and relevant to the particular combi-
nation of sacred and civic elements in Titian's masterpiece: "Alone I
made a circuit of the sky and traversed the depth of the abyss. The
waves of the sea, the whole earth, every people and nation were under
my sway" ("gyrum caeli circuivi sola et in profundum abyssi penetravi
et in fluctibus maris ambulavi et in omni terra steti et in omni populo").

Connotations of victory and of dominion over land and sea, over
peoples of every nation—this too has been translated by Titian into the
visual imagery of his altarpiece. The two great columns, associated with
the traditional sacred imagery of the "columna nubis" of the Immac-
ulate Virgin and with the Madonna as Gate of Heaven may, then, also
signify the gateway of Venice, the city of the Virgin.[78] (Similarly, Bellini
had identified Mary as the "Sure Gate" of Heaven in the inscription of
his altarpiece of the Conception in the sacristy.)[79] Thus Jacopo's victory
at Santa Maura, personified by the papal soldier and two prisoners of
war, "every people and nation," is offered both to the Immaculate
Virgin and to Venice.

3. Rivals

Era sempre per far, lui e soi fratelli, a beneficio di questa
Signoria.[80]

Titian's composition recalls—while yet transforming—three traditions,
the *sacra conversazione,* the funerary monument, and the votive picture.
In this last case, the recollection is specific: like the first painting com-
missioned by Jacopo from Titian, the votive painting now in Antwerp,
the Pesaro altarpiece also alludes explicitly to the victory of Santa
Maura, 30 August 1502, over twenty-five years earlier (fig. 47).[81] Ja-
copo's epitaph repeated once again the reference to his role in that Turk-
ish war. The Venetians had entered the war against Turkey in answer
to the pope's call for a crusade. Spain was their only ally, and none too
willing a one.[82] Inevitably, references to the war in the *Pesaro Madonna,*
as in the bishop's votive picture approximately twenty years before,

were politically charged. These images represented visual statements of the bishop's public stand in favor of the papal cause in 1502 as in 1519, for the question of a crusade had arisen again. In the fall of 1517, as Sanuto reported, "Many friars of St. Francis of the Ca' Grande came to the Collegio for certain funds for the Crusade."[83]

This was traditionally a matter of concern to the Franciscan order. St. Francis himself had attempted to convert the Muslims near Damietta in Egypt during the Fifth Crusade.[84] In part because of this event, the Franciscans had been given spiritual custodianship of the Holy Land by Clement VI in 1342.[85] However, the friars had been active missionaries even before Clement issued his bull, and one particularly successful proselytizer, B. Gentile da Metelica, had been martyred in Persia in 1340 by Muslims resentful of his having converted over ten thousand to the Christian faith. His body was brought to the Frari in 1349, and Gentile has been venerated there ever since.[86] In addition, the Frari also honored the "Five Franciscan Martyrs," the friars slain in Morocco in 1219 and represented in a painting ascribed to Licinio ca. 1535 and formerly displayed at the altar to the right of the entrance to the sacristy.[87] During the first decades of the sixteenth century, the Franciscans of the Frari would have been particularly involved with the spiritual and political struggle in the East: the guardian of their convent, Fra Germano, was also the Magister of the Franciscan province of the Holy Land.[88] Here the interests of Germano and Jacopo Pesaro coincided precisely: one of the three Franciscan *custodie* of the Holy Land was that of Cyprus, where Jacopo had his see as bishop of Paphos and where the Conventual Franciscans maintained custody until the loss of the island to the Turks in 1570–71.[89]

Despite the geographical jumble, all of these places (and persons) have to do with the Franciscans' missionary role among non-Christian peoples. Titian's references to the Christian victory of Santa Maura and the conversion of the "infidel" to the faith were thus entirely appropriate and pertinent to the Franciscan setting of the *Pesaro Madonna,* as well as having personal, biographical relevance to the patrons. At the same time, the idea of the Republic's service to the church and to Christianity in the Crusades against Islam had become a leitmotiv of the self-congratulatory histories of Venice. Writing after 1515—that is, after the recovery of Venetian mainland territories that had been lost six years earlier to the League of Cambrai, a group of patricians sought to redress a concomitant and, as it happened, a permanent loss, the loss of Venetian prestige and confidence.[90] Among this group of noble authors was the official historian of the Serenissima, Andrea Navagero.[91] Kindred in patriotic spirit, he and Jacopo Pesaro were also related in the literal

sense. Jacopo and his brothers had a sister, Franceschina, and she had married a Navagero.[92]

Ironically, the Venetian, Christian, and Pesaro victory at Santa Maura was Pyrrhic: the island was returned to the Turks as part of the peace settlement of 1503.[93] Still, the Venetians had tried more than once to reconquer it during the war, and the achievement of taking the island was considered significant.[94] But it was the Pesaro family more than other Venetians who held Santa Maura to be a great triumph: it received far more attention in Benedetto's reports to the Collegio, in his tomb, and in Jacopo's two paintings by Titian than it ever received in the official deliberations recorded by Sanuto. And Jacopo felt that he had not been given proper credit for his role in that victory. His words before the Collegio in 1502 reveal deep resentment of his cousin and colleague-in-arms at S. Maura. The statement of November 21, as recorded by Sanuto, is worth quoting in full:

> In the Collegio. The Reverend Bishop of Paphos came, Ser Jacopo di Ca' Pesaro, who was captain of the pope's galleys, and he said that his deeds . . . were always performed to the benefit of the Signoria; and that he had constructed the defense palisade of Santa Maura, and not the General [Benedetto]; and that he and his brothers always acted on behalf of the Signoria. Then he asked a favor, that . . . he have the first bishopric equivalent to Paphos available in this area, so that he might have his residence here [in or near Venice]. . . .[95]

The bishop was obviously an ambitious man, as revealed in the statement recorded by Sanuto and quoted here. Jacopo cannot have imagined that his close association with the scandalous Borgias would somehow help his Venetian career. Alexander himself was widely disliked, and the pope's son Cesare had temporarily deprived the Republic of certain Venetian territories on the mainland, a scheme thwarted by his father's death in 1503. The Borgias were not loved in Venice.[96] Why, then, would Jacopo wish to reiterate his loyalty to Alexander VI, and to do this so publicly? A votive picture may be a private matter, but an altarpiece in a Mendicant church is a public monument, even if it decorates a private family chapel. Jacopo must have found himself in a quandary. The bishop's dilemma was this: regardless of his own loyalties, he must have realized that identification with Pope Alexander might be detrimental to the success of his career. He devoutly wished for a bishopric in or near Venice but was passed over on more than one occasion.[97] But what could he do? If Jacopo wished to recall his victory in the war with Turkey, then perforce he had to remember the pope from whom

he had received his command. However, the bishop was motivated not only by pride and ambition. Jacopo was genuinely grateful to the pope who had been his early sponsor, as proved by a clause in his will. He instructed his commissaries to establish "a fund in perpetuity whereby they shall select a secular priest of good condition and reputation who shall be obligated every day, excepting one day a week . . . , to say mass for the soul . . . of Pope Alexander VI . . . who [was] our most cordial [patron]."⁹⁸ Furthermore, there was another reason why Alexander would have been more welcome at the Pesaro altar than elsewhere in Venice. The Confraternity of the Immaculate Conception, which also worshiped at that altar in the Frari, had been founded in 1498 under the aegis of the Borgia pope. In their Mariegola of the same year, the brothers of the scuola remembered "the honor and reverence and state and greatness of the Roman Church and of our protector and shepherd Pope Alexander VI."⁹⁹

A quarter of a century after the battle, the Bishop of Paphos (whose request for a bishopric closer to Venice was never granted) had still not forgotten either his pride in his role at Santa Maura or his resentment of his cousin, the generalissimo da mar. The elaborate celebrations held at the Pesaro altar on the feast of the Immaculate Conception in 1529 attest to this. The indefatigable Sanuto witnessed the ceremony, enumerating those who were honored by the display of their standards: "the feast of the Conception was also celebrated in the church of the Friars Minor, at the new altar of the Pesaro dal Carro; the entire church was very well adorned, and, among other things, [the altar] was prepared with sixteen standards of doges and of captains general . . . and also that of the Bishop of Paphos."¹⁰⁰ The captains general who were so honored included Benedetto Pesaro's predecessors, such as Melchiore Trevisan and Jacopo Marcello, also buried in the Frari. But Benedetto himself was excluded. Obviously, this was no mere oversight, given Benedetto's kinship with the patrons of the altar and his own conspicuous monument constructed in the same church not so many years earlier (fig. 29). The admiral's tomb encompasses the entrance to the Frari sacristy, the family chapel of his branch of the Pesaro, and was built according to very specific instructions in Benedetto's will of 1503.¹⁰¹ Standing atop this monument, Benedetto appears triumphant over death as he had triumphed in life, and in his right hand he holds his standard. To be sure, Benedetto's monument cannot be seen from the vantage point of the Pesaro altar across the nave—the choir obstructs the view. But nonetheless the tomb constitutes a very important part of the environment of the Pesaro altarpiece. Indeed, it is no exaggeration to say that the altarpiece makes reference to the tomb, at least contex-

tually. Benedetto's monument is decorated with reliefs of Cephalonia and of Santa Maura (Leucadia), commemorating two of his particularly notable victories over the Turks. This conspicuous display of the admiral's achievements is relevent, in turn, to the emphatic secular, civic, and political elements in Titian's *Pesaro Madonna*. Long after the battle had ended and long after his antagonist's death, Jacopo had still not forgiven Benedetto for taking credit for Santa Maura, both in life and, indeed, in death, in the decoration of his grandiose tomb. Jacopo's *Madonna* represents, in part, his "last word" in the argument, his answer to what he considered to be Benedetto's exaggerated claims.[102] Jacopo seems to have been obsessed by recollection of his military achievement and of his rivalry with his cousin and comrade-in-arms: it is a dominant theme of his two paintings by Titian, the subject of his declarations before the Collegio, the explanation for the military display at his family altar on the feast of the Conception in 1529, and the first accomplishment listed in his epitaph.

Perhaps Titian himself also proceeded with a certain sense of rivalry; but in his case the rivalry was a confrontation with the first Pesaro altarpiece in the Frari, the triptych by his old master Bellini in the sacristy, and a paragone with the sculpture of Benedetto's tomb, the first Pesaro commission to allude to Santa Maura (figs. 16 and 29).[103] Titian revolutionized the scheme of the former, reinventing the *sacra conversazione* in the process. And the lifeless, cartographic representation of Santa Maura in the tomb has been personified in Titian's composition by the brilliant group of the Turk, the Moor, and the soldier in his shining armor that reflects both color and light. Titian won his contest handily. Unfortunately for the bishop, however, two years after his own death in 1547, Benedetto's son, Girolamo, endowed an elaborate monument for himself opposite his father's tomb and just to the east of Jacopo's altar. Girolamo knew what he was doing: he was literally outflanking his cousin's family and asserting the presence, identity, and preeminence of his own line.[104]

Although Sanuto did not explicitly state that the celebration of the feast of the Conception at the Pesaro altar in 1529 was also a commemoration of the victory of Santa Maura, that is certainly the implication of Jacopo's display of soldiers' banners. That the Pesaro connected the victory with the Immaculate Conception can hardly be doubted: Titian's *Madonna* illustrates that association quite clearly, combining historical references to the battle with the imagery of the Immaculate Virgin.

Thus, both branches of the Ca' Pesaro were devoted to the Virgin Immaculate, and the dedication of the Pesaro altar in the church is

inevitably related to the Pesaro endowment of the sacristy chapel—despite (or perhaps in part because of) the animosity between Jacopo, the patron of Titian, and Benedetto, the patron of Bellini. And both Pesaro altarpieces embody that singular combination of sacred and civic elements that characterizes Venetian art, Venetian history, and Venetian piety, together with the very personal concerns and ambitions of the donors, concerns in themselves both spiritual and secular. In Venice, the image of the Immaculate Conception combines the sacred and the secular in a very particular way.

5

The Cult of the Madonna
in Venice

1. *Venezia Vergine*

O Sacra imaculata piena di gracia
Madre de Christo nostro Salvadore
Ti priego per mio amore
Che tu me exaudi o dolze madre pia . . .
Che la serenitade
Del nostro doxe te sia ne la mente. . . .
—Fifteenth-Century Venetian Prayer[1]

The Frari, of course, was not the only church of the Madonna in Venice. Indeed, in his consecration of the second church of the Frari the cardinal deacon Ottaviano had explained that the new church was to be called "S. M. Gloriosa" precisely in part to distinguish it from all the others also dedicated to Mary.[2] In 1457, when Doge Francesco Foscari was buried in the Frari (fig. 34), Bernardo Giustiniani enumerated the impressive number of churches and altars of the Madonna in Venice in a lengthy oration, addressing prayers for the state to: "Mary, gentle Mother of God most high, you who preside not only at this temple,

[138]

but at twenty other great temples in your name, and at three hundred altars dedicated to you here [in Venice]."[3]

To be sure, there were many other Italian states dedicated to the Madonna: indeed, perhaps it would be difficult to find one that was not dedicated to her. She was, for example, simultaneously the protectress of two enemy states, Florence and Siena. When the Sienese defeated the Florentines at Montaperti in 1255, in answer to Sienese prayers for the Virgin's intervention, they commemorated their victory by declaring the Madonna their liege queen.[4] But if the Venetians were not alone in claiming the Madonna as their protectress, nevertheless their devotion was distinguished by a particularly complex and thoroughly Venetian blend of civic and sacred conceptions.

In Venice, the doge honored the Virgin Mary by attending mass at S. Marco on "all the days of Our Lady," according to Sanuto.[5] The Venetians celebrated two major feasts of the Madonna as great civic feasts of the Republic, and a third of the major Marian feasts had particular civic connotations in Venice. To begin at the beginning, because Venice, they claimed, was founded on the feast of the Annunciation, 25 March 421, the *Origo Venetiarum* was celebrated on that day.[6] For the same reason the new year began on March 25, according to the Venetian calendar. Reliefs of the Virgin and of Gabriel adorn the facade of S. Marco, that most politically charged church, where they are accompanied by the other protectors of the city, Saint George, Saint Demetrius, and Hercules, the mythical tribal hero of the Venetii, who is represented twice (fig. 53).[7] On the Rialto Bridge, the Annunciation is represented again, this time accompanied by figures of Saint Theodore, the first patron saint of the Serenissima, and of his successor, Saint Mark himself.[8] And in the paintings by Bonifacio dei Pitati for the Magistrato della Camera degli Imprestidi, the imagery was made even more explicit. The Archangel Gabriel and the Annunciate Virgin flank the central canvas in which God the Father blesses the Piazza di San Marco: the foundation of Venice is thus compared to the Incarnation of Christ.[9] By extension, because the Annunciation recalled the foundation of the state, the traditional representation of Mary and Gabriel on chancel arches—including the Frari sacristy—inevitably carried with it profound political as well as religious associations in Venice.[10] And these same political associations also explain why the Annunciation was more commonly represented in funerary monuments in the Veneto—including the ducal tombs in the chancel of the Frari—than elsewhere in Italy.[11]

However, the greatest celebration of Mary in Venice was not the Annunciation, recalling the Origo. Until the late fourteenth century, that distinction belonged to the Purification, February 2, which was

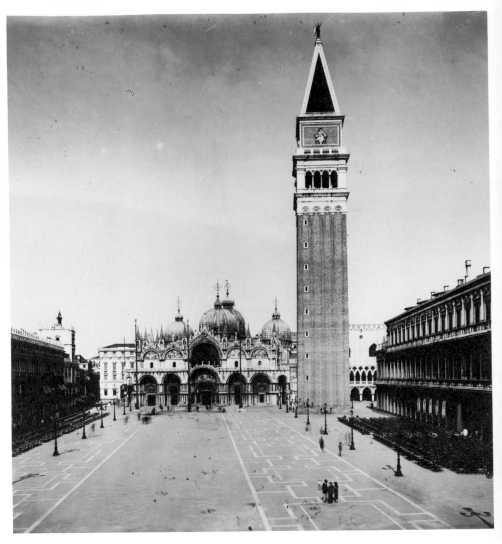

53. Venice, Piazza and Basilica di San Marco.

commemorated by the Venetians with a unique eight-day feast, the Festival of the Twelve Marys.[12] Here, too, civic and sacred elements were purposefully combined. The meaning of the festival is central to the imagery of the Virgin in Venice because, although the celebration was suppressed and transformed in the late fourteenth century, it always remained a vivid memory in the Venetian imagination, as Edward Muir has shown.[13]

The Festival of the Twelve Marys began with a procession in the Piazza di San Marco on January 30, not coincidentally the eve of the feast of the Transfer of St. Mark. The evening's festivities ended at the church of S. Maria Formosa where dowries were presented to impecunious Venetian maidens. On the next day, January 31, the feast of the Transfer of St. Mark, two priests impersonated the Virgin Mary and the Archangel Gabriel in a reenactment of the Annunciation according to the gospel of St. Luke. Muir suggests that this was intended in part to provide new brides with an inspiring example of humble wifely duty, recalling the Virgin's modest acceptance of her role, "Ecce ancilla Dei."

Of course, the feast of the Annunciation, March 25, was endowed with its own special political significance in Venice as the celebration of the Origo Venetiarum. Hence, in addition to the wifely virtues that it no doubt nurtured in individual Venetian bosoms, the reenactment of the Annunciation on January 31 was perforce also a public statement of the identification of the state with its holy protectors. And in point of fact, when the Festival of the Twelve Marys was suppressed and transformed after 1379, it became very much a civic ritual honoring the power of the state.

Muir proposes that there were many reasons for the abolition of the festival after 1379, during the War of Chioggia: it had become costly and often irreverent; it threatened domestic tranquillity; and, with the rise of the scuole grandi, its charitable function was being assumed more and more by the confraternities.[14] Above all, the story of the suppression and transformation of the festival in the late fourteenth century is concomitant with the rise of San Marco—the saint, the place, and the symbol. The feast that had celebrated neighborhood identity became a commemoration of national pride and ducal power. After 1379, the Marian feast of the Purification on February 2 became a celebration in and of San Marco, involving the doge's distribution of candles to clerics and to confraternities.[15] By the mid-fifteenth century, the jewels that had formerly decorated statues of the Twelve Marys and had traditionally been safe-guarded in the treasury of the Basilica of San Marco, were used instead to adorn the Pala d'oro on feast days.[16] Thus, in Venice, two major feasts of the Madonna—the Annunciation and the Purification—were inextricably bound up with the cult of San Marco and the state. And in the sixteenth century the celebration of the Purification of the Virgin found a new locus, a chapel endowed by Nicolò Valier in the Frari in 1517 with the consent of Fra Germano. The guardian's major condition was that Saint Bernardino, to whom the chapel had previously been dedicated, be remembered in the composition of

the new altarpiece that Valier was to provide. In their agreement dated 4 November 1517, the community of the Frari ceded to Nicolò Valier and his heirs "in perpetuity the chapel presently dedicated to Saint Bernardino in said church near the chapel of the Crucifix of the Most Glorious . . . with the manner, form, and conditions written here . . . namely that the aforesaid Lord Nicolò with his heirs place on said altar an altarpiece either painted or sculpted under the title of the most glorious Purification of the Most Blessed Virgin Mary with other saints and figures and ornaments as Lord Nicolò pleases to have done, and among the rest, an image of Saint Bernardino."[17]

Did Germano actively solicit Valier's endowment? In any case, especially during that critical time for the Conventual Franciscans, the guardian must have been pleased to accept a donation that once again offered his church and convent the opportunity to demonstrate their patriotism by the conspicuous celebration of a cult with such particular historical and civic meaning in Venice. In fact, by representing and remembering Saint Bernardino of Siena at the altar of the Purification, the Valier and the friars were also honoring another cult with civic import: beginning in 1470, the great Franciscan preacher was venerated as a patron of the Republic.[18]

Another major feast of the Virgin, the Assumption, also had civic connotations in Venice. This is implied by the cult surrounding what was and is the most revered image of the Madonna in the Republic, the Byzantine icon of the *Nikopeia,* brought to S. Marco in 1234, and still venerated there today (fig. 54).[19] Believed to have been painted by Saint Luke, this precious image was evidently regarded by the Venetians as a palladium of the Republic and was carried in procession in the Piazza di San Marco on August 15, the feast of the Assumption. Sanuto's matter-of-fact record of this ceremony in 1500 suggests that this display of the *Nikopeia* was by that time a customary event: "There was a procession around the Piazza, and the patriarch sang mass, and an image of Our Lady was carried around, painted, they say, by the hand of Saint Luke."[20]

The culmination of Mary's Assumption is, of course, her coronation as Queen of Heaven, and in the *Assunta,* Titian anticipated the coronation by representing an angel who approaches Mary with her crown (fig. 33). Earlier artists had also associated the two events. For example, the Assumption and the Coronation of the Virgin were depicted together in full by Cimabue in the Upper Church of S. Francesco in Assisi (fig. 41).[21] Inevitably, then, both because of the narrative sequence of events and because of the artistic tradition of their representation, the Assumption evokes the Coronation. And the Coronation of the Virgin recalls, in turn, the official imagery of the Serenissima.

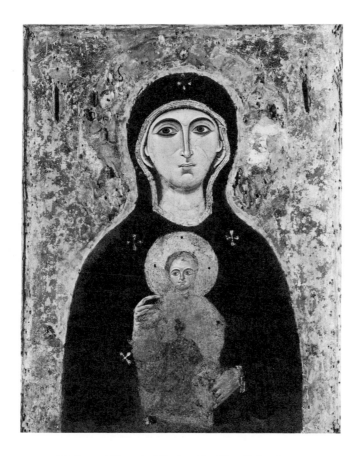

54. *Madonna Nikopeia*. Venice, Basilica di San Marco.

Evidently the only religious decoration of the Sala del Maggior Con-siglio in the fourteenth-century Ducal Palace was Guariento's *Paradiso,* which represented the Coronation of the Madonna surrounded by the celestial court and flanked by the figures of Gabriel and the Annunciate Virgin (fig. 55).[22] Painted on the wall directly behind the tribunal of the doge, the mural had obvious political significance. The inference was clear: the *Paradiso,* in which the Coronation of the Virgin was juxta-posed with the Annunciation, was a visual metaphor for the foundation, triumph, and glorification of Venice.[23]

Whether because of its site, its subject matter, or its location—and most likely for all three reasons—Guariento's fresco of 1365–68 was

55. Guariento, *Paradiso* (detail). Venice, Palazzo Ducale.

highly esteemed by the Venetians. It was copied at least three times in the first half of the Quattrocento and was very influential on the development of the Venetian school of painting in general.[24] When it was severely damaged by fire in 1577, Guariento's fresco was replaced by Tintoretto's great canvas *Paradiso,* of which the central episode is once again the Coronation of the Virgin.[25]

Given the premise of the identification of the Republic with the Madonna, and the example of such influential monuments as the S. Marco facade reliefs and the Ducal Palace *Paradiso* (either Guariento's or Tintoretto's), it seems inevitable, according to Venetian logic, that the secular personification of Venice and the political imagery of the state in art would be based, at least in part, upon representations of Mary. For example, a Ducal Palace relief ascribed to Calendario before 1355 represents *Veneçia* as a queen wearing a crown on her long hair and seated on a lion throne (fig. 56).[26] *Veneçia* holds a sword and a scroll. But if the first attribute were replaced and the inscription of the scroll rewritten, *Veneçia* would become the Virgin, crowned as Queen of Heaven and enthroned on the lion throne, her Seat of Wisdom.[27]

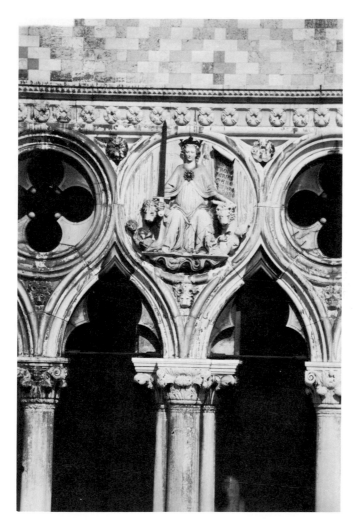

56. Attributed to Calendario, *Veneçia*. Venice, Palazzo Ducale.

No Venetian—and no Venetian Franciscan—could have been un-
aware of the rich associations, both political and spiritual, of the Ma-
donna in Venice, and indeed of the identification of the one with the
other. After all, Venice, too, was apostrophized as a Virgin, always safe
in the embrace of her beloved Evangelist St. Mark, as the Venetian
orator Luigi Groto exclaimed: "quella vergine . . . mai violata da'
tiranni se ne stà quindi abbracciata dal beatissimo Evangelista suo."[28]
And these associations in turn must surely have resonated in one of the

most important churches of the Madonna in Venice, S. Maria Gloriosa dei Frari.

2. *Vergine Immacolata*

The Madonna dominates the Frari: not only the high altar, dedicated to her Assumption, but at least seven other altars were (or are) consecrated to her in that church, including the two Pesaro altars of the Immaculate Conception.[29] Moreover, a miraculous image of the Virgin was venerated in the church, the so-called *Madonna delle Grazie,* formerly kept in the Chiostro della SS. Trinita.[30] So the Frari was very much a house of the Madonna, and in the Franciscan environment of the Frari, the Virgin is inevitably the Immaculate.

Furthermore, the Frari was only one of several centers of the cult of the Immaculate Conception in Venice, where it was celebrated also in the ancient church of S. Giacomo dell'Orio—the traditional Pesaro parish—and in at least two of the scuole grandi, more notably in S. Maria della Misericordia (by 1493), dedicated jointly to the Madonna and to Saint Francis, and also in S. Maria della Carità (from 1496).[31] For example, in 1517 Sanuto recorded that the feast was observed in the Misericordia and in the Frari but did not specify any details of the celebration.[32] A year later, however, the diarist's entry for December 8 reads: "it was the Conception of the Madonna, . . . and one celebrated a solemn feast most especially ["maxime"] at the Frari and at S. Giacomo dell'Orio. And also in the Scuola of the Misericordia. . . ."[33] Why this change between 1517 and 1518? Why had the feast of the Conception suddenly become "especially" important in the Frari? It may be that the installation of Titian's *Assunta* on 19 May 1518, little more than six months before the feast of the Conception, had something to do with this (figs. 32 and 33). To be sure, the chapel of the sacristy had been dedicated to the Immaculate Conception already in the late fifteenth century, but the Pesaro funerary chapel in the sacristy is "a fine and private place," perhaps not appropriate as a public locus for the celebration of the Conception in the Frari (figs. 13–16). Nevertheless, beginning in 1518, the Frari was particularly associated with the feast—eight years before the installation of Titian's *Pesaro Madonna* at the altar of the Conception in the church (figs. 42 and 43). Perhaps the *Assunta* was already providing a focal point for the cult of the Immacolata in the Frari.

In any case, it is clear that the celebration of the Conception in Venice was increasingly associated with the Frari. After the completion of Ti-

tian's *Madonna,* the feast was naturally celebrated at the Pesaro altar, as Sanuto described in 1526: "It was the Conception of the Madonna, and one went and observed the feast at the Misericordia, and indeed in many other churches, and in the Frari at the altar that the Pesaro have constructed in the church."[34] And the family of Jacopo Pesaro did even more than this to promote the cult of the Immaculate Virgin, providing in other ways for its celebration. Francesco saw to it that masses were said every day at the Pesaro altar of the Conception, and Jacopo endowed the pietanza, a feast for the friars on December 8.[35]

Both Pesaro altarpieces of the Conception—the triptych by Bellini in the sacristy and Titian's great canvas—are intended to remind the viewer of the donors' service to the Republic. Bellini's triptych does this rather gently and by implication, by means of the gold mosaic of S. Marco (figs. 16 and 23). Titian and, for that matter, the sculptor of Benedetto Pesaro's monument, were more assertive and aggrandizing in their imagery—making reference to Santa Maura, for example— which commemorates specific achievements by the donors on behalf of the state (figs. 29 and 42). This dual sacred and secular imagery, combining the representation of the Immaculate Conception with references to the Serenissima, is embodied also in Titian's *Assunta* of the high altar. While both the *Pesaro Madonna* and the commissions of the Pesaro of San Benetto allude to the patrons' patriotic service to the Republic, the *Assunta* of the high altar may refer to the identity of Venice herself, suggesting thereby the affiliation of the Franciscan institution with the state. This presumption of civic meaning in the high altarpiece is likely in the context of Renaissance Venice.

First of all, the Assumption was celebrated in Venice with the display of the *Nikopeia* as a palladium of the Republic, and so the feast itself was imbued with civic meaning. But more than this, in Venice the feast may have been endowed with particular civic significance by a process of association. The Assumption of the Virgin is the equivalent of the Ascension of her Son, as we are reminded by the statue of the Resurrected Christ above Titian's *Assunta* (fig. 32).[36] These two triumphs over death are, of course, inherently alike as events, but the specific interpretation of Mary's privilege in emulating Christ's victory was based upon her perfect conformity with her Son, as Saint Bonaventure explained in his First Sermon on the Assumption. "Who is this that cometh out of the wilderness . . . ? [Ct. 3 : 6] . . . she [Mary] is there [in heaven] physically, for . . . she herself has originated the second body [of the Trinity] . . . his body was from her body."[37] Similarly, Saint Bernardino explained in a sermon on the Assumption, that . . . "just as the flesh of Christ was incapable of corruption, so too that of

Mary; and hence one reads that when she died, thus she was assumed into heaven."[38]

The Mother's Assumption is like her Child's Ascension, then, precisely because of Mary's identification with Jesus. And their conformity, in turn, implied certainty about the Madonna's privilege, whereas there might be doubt regarding the assumption of Saint John the Evangelist. Thus, the Franciscan Bartholomew of Pisa wrote with assurance that Mary had been assumed "body and soul," but that Saint John was preserved from death in this way only "according to some."[39] And in Dante's *Paradiso* Saint John himself declares that his body "is earth on earth" and that only "those two lights," Christ and Mary, have risen to heaven. The Evangelist commands the poet to assure his fellow men of this: "Perché t'abbagli per veder cosa che qui non ha loco? In terra è terra il mio corpo, e saragli tanto con li altri ch 'l numero nostro con l'etterno proposito s'agguagli. Con le due stole nel beato chiostro son le due luci sole che salirò; e questo apporterai nel mondo vostro."[40]

Thus, certainty about Mary's Assumption was endowed also with exclusivity: of all humankind, only she shared this privilege with Jesus. And in Venice, the religious feast of the Ascension, the *Sensa* in dialect, was also the occasion of the most important civic celebration of the Republic.

The Sensa commemorated the symbolic marriage of the Republic to the sea, signifying Venetian dominion over the Adriatic. The celebration involved the doge's sailing into the lagoon on a splendid galley, the Bucintoro, in order to throw a wedding ring into the water. With this act, and the patriarch's blessing, the doge renewed the marriage between Venice and the sea, a marriage, like all others in those days, which assumed male dominance. This quaint notion was explicit in Sansovino's account of the thirteenth-century origins of the feast: "Take this," Pope Alexander III supposedly declared to the doge, giving him a ring, "which you and your successors will use each year to marry the sea, so that posterity knows that the lordship of the sea is yours, . . . and that the sea was placed under your dominion, as a wife is to a husband."[41]

The feast of the Assumption, comparable in every other way to the Ascension, would most likely also have been understood as sharing in the special civic significance of the Sensa. Too, this postulation is consistent with the metaphor of marriage in the Sensa: assumed into heaven, Mary is crowned Regina Coeli and takes her place at the side of Christ the King. Similarly, the church, personified in Mary, is the Bride of Christ. For this reason, Mary was commonly equated with the Sponsa of the Song of Songs—for example, in sermons on the

Assumption by Saint Bonaventure and by Saint Lorenzo Giustiniani, and in both offices for the feast of the Immaculate Conception, by Nogarolis and by Bernardino de Bustis.[42] (The same biblical text was used for each feast precisely to underscore the relationship between the two: the Assumption demonstrates the Immaculate Conception.) Concomitant with these familiar images of marriage is the connotation of subservience: Mary is humble and subservient before Christ as the bride is before her husband.[43]

That the Assumption would have been compared to the Sensa in its civic meaning as well as being theologically comparable is characteristic of Venetian political thinking. This comingling of sacred and civic imagery was expressed in the sacral character of the doge, for example, and more generally in what Felix Gilbert has called "an assumption of the existence of a complete integration of all civic activity—political, religious, social and economic."[44] And this integration was conveyed also in the very self-conscious and propagandistic histories of the Republic in which the great events of the Venetian past were said to have occurred on major feast days of Christ and of the Madonna, as we have seen.[45] Thus, in the words of a sixteenth-century poem, Venice is the Virgin, "già mill'anni intatta pura."[46]

Granted that the personification of the Republic in art was influenced by the imagery of the Madonna, and that Venice, founded on March 25, identified itself with the Virgin, is there any evidence that official thinking perceived the Virgin as the Immacolata? Logically, one would assume that papal, Franciscan, and patriarchal support of the doctrine— viz. Sixtus IV, the Frari, and Lorenzo Giustiniani—would have colored official and personal piety in this matter, and there is some indication that this may have been so. For example, an invocation to the Madonna on behalf of Doge Nicolò Tron—whose own faith may be surmised from the fact that he was buried in the chancel of the Frari—addresses Mary as "Immaculate and Full of Grace." The Angelic Salutation was taken as a proof of Mary's privileges, and so the combination of these epithets in the Venetian laud comes as no surprise. The invocation, which is quoted at the beginning of this chapter, asks the Virgin for the doge's spiritual peace.[47]

One of Doge Tron's successors, Agostino Barbarigo (doge, 1486–1501), was also associated with the cult of the Immaculate Conception in Venice. Barbarigo was one of six noblemen charged with superintending arrangements for a new church of the Madonna in Venice to be dedicated explicitly to the Immacolata, S. Maria dei Miracoli.[48] The first stone was blessed on the feast of the Conception in 1480, and the completed church was dedicated to the Immaculate Virgin in 1489.[49]

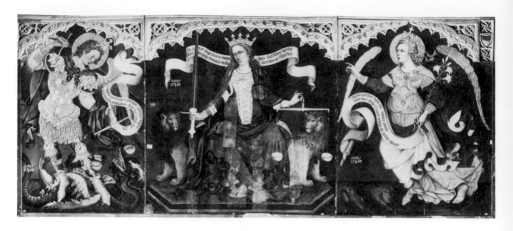

57. Jacobello del Fiore, *Justice Triptych*. Venice, Gallerie dell'Accademia.

When the new church and convent were ready to receive the twelve Franciscan nuns who were to live there, the Procurators of S. Marco sent gondolas to bring them from their church of S. Chiara on Murano. When the Claires arrived at the Miracoli, the patriarch himself dedicated the church and addressed the abbess and her nuns: "Margherita, I entrust to your charity and to your fervent zeal these excellent sisters. Pray with them to the Mother of Mercy that she obtain from God prosperity and perennial peace for our Republic."⁵⁰ Thus in the context of the Miracoli, dedicated to the Conception, the Immaculate Virgin was identified with the Virgin as merciful patron of Venice.

Long before this ceremony, and perhaps even more explicit than it, is the visual language of Jacobello del Fiore's triptych signed and dated 1421, which illustrates the equivalence of the personifications of Venice and Justice with the Immaculate Virgin (fig. 57).⁵¹ The so-called Justice Triptych originally decorated the Magistrato del Proprio in the Palazzo Ducale, and so the official, public nature of the panels is indisputable. The woman enthroned as the central figure has a triple identity. She is Justice, approached on one side by the Archangel Michael with his scales. She is Venice, the civic embodiment of Justice, as claimed in numerous Venetian documents and images—including Calendario's relief (fig. 56)—with a crown on her long blond hair, as in later personifications of the Serenissima by Veronese and others. And she is the Virgin Mary, approached by the Archangel Gabriel in a manner that inevitably recalls the Annunciation and with words referring to the Virgin Birth. The aptness of the image is obvious as an allusion to the

founding of Venice on March 25, the feast of the Annunciation. Clearly, Jacobello (and his patrons) meant his depiction of the central female figure in the triptych to represent, or at least to suggest, the Annunciate Virgin. In turn, this implies the Immaculate Conception by reminding the viewer of Gabriel's salutation at the Annunciation, "Gratia plena," which was considered scriptural evidence of Mary's Immaculacy and so was frequently cited in Immaculatist texts. Perhaps this is why Jacobello embellished the cuirass worn by Justice with the face of the sun, re- calling the Immaculatist image of Canticles 6 : 9, "pulchra ut luna electa ut sol terribilis ut acies ordinata."

That it was Jacobello's—and the official patrons'—intention to rep- resent Venice as the Virgin Immaculate is implied by another detail of the composition. The throne is flanked by two live lions—that is, not fictive reliefs but representations of the beasts themselves. This image is, of course, appropriate to each of the three identities of the central figure. Inevitably suggesting (to a Venetian, at least) the Lion of St. Mark, the animals themselves are the embodiment of the state of Venice. Recalling the two lions of the throne of Solomon, the archtyp- ical just and wise ruler, they are suitable companions for the personi- fication of Justice; and they are the traditional adornment of the Madonna's throne precisely because the Virgin is the Seat of Wisdom, the *Sedes sapientiae*.[52] And that brings us, once again, to the Immaculate Virgin, by way of the Books of Wisdom. In a state where the taste for self-glorification was insatiable, it seems inevitable that every privilege of the Madonna would be included in such political images in order to reflect still further glory on the Republic.

Titian himself evoked the traditional lion motif in the last of his paintings for the Frari, the *Pietà* intended by the master for his own tomb at the altar of the Crucifixion (fig. 58).[53] (Although the paint- ing may have been begun for another patron, the inclusion of his self- portrait indicates that Titian ultimately meant the *Pietà* for his tomb, exactly like Michelangelo and Baccio Bandinelli.)[54] This time the lions are fictive reliefs—although no less animated for that—decorating the bases of the illusionistic statues of Moses and the Hellespontine Sybil.[55] But their meaning is the same here as it was in Jacobello's triptych painted almost a hundred and fifty years earlier: the lions sig- nify at once the Venetian state and the identity of the state with Justice and, by implication, with the Madonna as the Sedes sapientiae. In the Franciscan context for which the *Pietà* was originally intended—and given Titian's continuing relationship with the Franciscans in Venice and in other cities—we need not doubt that this image, too, represents the Immaculate Virgin. Indeed, the presence of Moses here is consistent

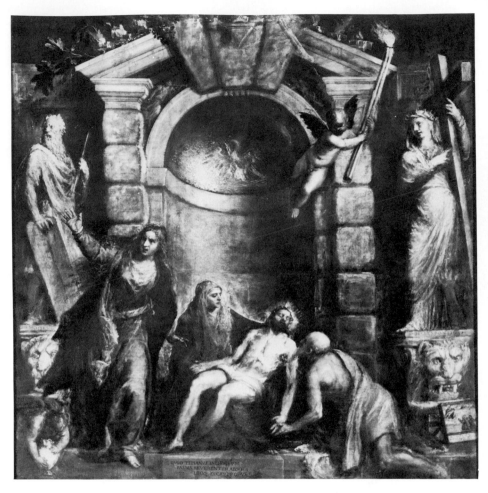

58. Titian, *Pietà* (after restoration). Venice, Gallerie dell'Accademia.

with this interpretation, for the appearance of the burning bush before the Old Testament hero was likened to Mary's Immaculate Conception.[56] Nor is the artist's veiled allusion to an archaic motif—namely, the lion throne—surprising in the context of this most introspective and retrospective work, a visual autobiography that sums up Titian's artistic heritage. This meaning is expressed *in brevis* in the fictive gold mosaic—a motif closely associated with Bellini, as in the Frari triptych (fig. 16). Titian translated this traditional device into a personal citation, recalling his artistic beginnings, his early training as a mosaicist, his debt to and

[152]

independence from old Bellini, and his early triumph in the same church, the *Assunta* of the high altar.[57] At the same time, the mosaic refers to Titian's long association with the state he served for so many years as official painter, a position in which he succeeded Bellini after the latter's death in 1516.[58] The fictive mosaic conjures up visions of S. Marco, evoking both the aesthetic experience of that golden basilica and its rich and varied associations, religious, social, political (fig. 23).

Of course, Titian's *Pietà* was never installed at the altar of the Crucifix, and the master's burial in the Frari was evidently contrary to his last wish.[59] Even so, the canvas was planned for that site and for that church: Titian's self-portrait and his original intention to be interred in the Frari leave little doubt of this. Indeed, the triangular composition of his last work for the Frari purposefully echoes the composition of his earlier canvas for the Pesaro altar, diagonally opposite the altar of the Crucifix (fig. 42).[60] And there is a theological association between these two works as well, and also with the *Assunta* and Bellini's triptych in the sacristy (figs. 16 and 33). In the *Pietà,* the grief of the Immaculate Virgin is set within an arch decorated with winged Victories in the spandrels—a setting and a decoration that recall the high altar of the *Assunta.* There the Virgin's joyous assumption into heaven is juxtaposed with carved images of the Dead Christ and of the Resurrected Christ in the frame, with Victories painted in the spandrels. In the *Pietà,* the sorrowful Mother mourns her dead Son; but their ultimate triumph over death is anticipated in the symbolism of Titian's setting and made explicit in the Sibyl's inscription: "The Lord is Risen."[61] Finally, like the two altarpieces of the Conception—Bellini's and Titian's—and like the high altarpiece itself, the *Pietà* also represents the Immaculate Virgin. Franciscan theologians had argued that the Madonna was Immaculate precisely because God had always foreseen the Fall of Man and hence the necessity for Christ's redemptive sacrifice: *ab initio, ante saecula.* Mary is Wisdom—of which we have already been reminded by Titian's lions—Wisdom, God's first creature, extolled in the verses so often quoted to prove Mary's Immaculacy: "Ego ex ore Altissimi prodivi promogenita ante omnem creaturam, ego in caelis feci ut oriretur lumen indeficiens et sicut nebula texi omnem terram, ego in altis habitavi et thronus meus in columna nubis" (Eccl. 24 : 5–7). In this way, because she preexisted the creation of humankind, Mary was free of Original Sin and could participate in her Son's redemptive act. As Christ is the Second Adam, who redeems the sin of the first man, the Madonna is the Second Eve, who likewise compensates for her predecessor. Precisely because the first man and woman required the atoning death of Jesus and the Immaculate Conception of Mary, whose Immaculacy was

necessitated by her foreordained role as his mother, Immaculatist images frequently included representations of Adam and Eve (fig. 28).[62] Titian recalls this typology by representing fig leaves at the top of the *Pietà*, twining among the sacred lights.[63] Mary, the Second Eve, is the *Socia Christi Redemptoris,* sharing her son's suffering in order to participate in his act of redemption.

Titian's *Pietà* must be considered, therefore, together with Bellini's triptych and Titian's own earlier works for the Frari. The four altar-pieces (or the three alone, in situ) represent the dedication of the Frari to the Immaculate Conception in visual imagery that suggests the similarities of the Madonna, and hence her church, with the Most Serene Republic of Venice.

In his oration before Doge Pasquale Cicogna in 1585, Luigi Detrico da Zara compared the Serenissima to the Queen of Heaven, honored in the *Paradiso* of the Ducal Palace: "Di Venegia dirò adunque per somiglianza quel che con verità canta Santa Chiesa della Regina del Cielo, chi è questa che quasi Aurora, vassene innanzi come il Sol bella, eletta come la Luna, terribile qual d'armati ben ordinata squadra?"[64] The language of the Canticles, long associated by liturgy and by theology with the cult of the Immaculate Conception, makes the orator's metaphor explicit: Venice is like the Immaculate Virgin, "like the dawn, fair as the moon, bright as the sun, terrible as an army with banners."

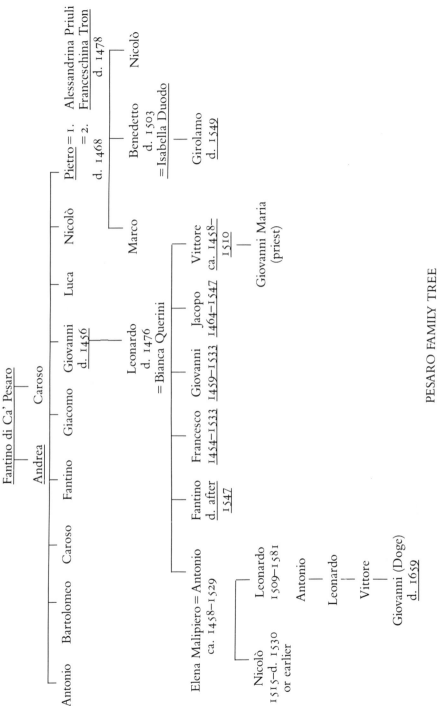

Fantino di Ca' Pesaro

Andrea Caroso

Antonio Bartolomeo Caroso Fantino Giacomo Giovanni Luca Nicolò Pietro = 1. Alessandrina Priuli
 d. 1456 = 2. Franceschina Tron
 d. 1468 d. 1478

 Leonardo Marco Benedetto Nicolò
 d. 1476 d. 1503
 =Bianca Querini =Isabella Duodo

 Girolamo
 d. 1549

Elena Malipiero=Antonio Fantino Francesco Giovanni Jacopo Vittore
 ca. 1458–1529 d. after 1454–1533 1459–1533 1464–1547 ca. 1458–
 1547 1510

Nicolò Leonardo Giovanni Maria
1515–d. 1530 1509–1581 (priest)
or earlier

 Antonio

 Leonardo

 Vittore

 Giovanni (Doge)
 d. 1659

PESARO FAMILY TREE

Appendix I

Saint Bernardino of Siena in Venice

Saint Bernardino of Siena (1380–1444) was especially esteemed by the Venetians. Bernardino had preached in Venice and the Veneto on at least four occasions, 1405, 1422–23, 1428–29, and 1442–43.[1] His presence in Venice itself during 1422–23 is evidently confirmed by the evidence of two Venetian witnesses, the chroniclers Dolfin, father and son, who remembered hearing Bernardino in the Campo S. Polo, one of the largest *campi* in Venice and very near the Frari (fig. 2). The authors' realization that having heard the saint preach was indeed a special privilege is movingly conveyed in the brief paragraph from the chronicle that records his canonization in 1450: "Saint Bernardino of Siena of the Order of Saint Francis was canonized. . . . I Giorgio Dolfin knew him and touched his hand and heard many of his pious sermons at various times, and likewise I Piero Dolfin the author of these annals, Giorgio's son, saw the said saint and heard his sermons in the Campo di San Polo in Venice."[2]

The saint's last visit to Venice, in 1442–43, probably inspired a drawing by Jacopo Bellini.[3] Depicting the saint as he preached, Jacopo provided an accurate record of the circumstances of such occasions: a high wooden pulpit was erected out-of-doors to raise the preacher above his audience so that all could see him and attend his words. As in 1422, on this occasion also Bernardino's temporary outdoor pulpit may have been set up in the Campo di S. Polo. Or perhaps the saint preached in

a campo near one of the two Observant Franciscan churches in Venice, S. Francesco della Vigna or S. Giobbe. In any case, it is likely that Bernardino lived in S. Giobbe during this visit, and that church became especially associated with his cult in Venice.[4]

A confraternity of Saint Bernardino was established at S. Giobbe already in 1450—that is, at the time of his canonization.[5] And Bernardino had a powerful noble patron as well. According to tradition, Bernardino had predicted the election of Cristoforo Moro to the dogate.[6] When Moro did in fact become doge in 1462, he did much to promote the cult of the saint. For example, the doge's endowment made possible the elegant completion of the church of S. Giobbe, dedicated jointly to Saint Bernardino and to Job.[7] But more important from the civic point of view, in 1470 the Sienese friar was declared a patron saint of the Serenissima.[8] An altar was dedicated to him in S. Marco, and the ducal chapel became a primary locus of the saint's cult in Venice, along with S. Giobbe.[9]

The Conventual Franciscans of the Frari also venerated the Observant Bernardino, in part perhaps because they might have seen in him one who had strongly opposed the division of the order.[10] A relic of the saint was preserved in the Frari, and indulgences were granted by Pope Callistus III in 1455 and by the patriarch of Venice in 1457 for contributions and visits to Bernardino's altar.[11] Moreover, the Venetian friars seem to have associated Saint Bernardino with the cult of the Madonna. When the altar of the saint was ceded to the Valier in 1517, the dedication was changed to honor the Purification of the Virgin, but with the understanding that Bernardino would be represented in the new altarpiece by Salviati.[12] Perhaps, given the division of the Franciscan order in that same year, the Conventual friars of Venice were no longer willing to acknowledge the great Observant saint so conspicuously with an altar of his own—but at the same time, they were unwilling to forget him.

Appendix II

Doge Giovanni Pesaro

The last great Pesaro patron of the Frari was the first and only member of the family to achieve the dogate: Giovanni, the son of Vittore Pesaro and a direct descendant of Leonardo *q*. Antonio, the commissary and primary beneficiary of Jacopo Pesaro and his brothers (see Pesaro Family Tree).[1]

Giovanni Pesaro was knighted by Louis XIII of France, where he had been the Venetian ambassador, and he was rewarded for his early political achievements by election to the Procuratia de Supra.[2] These successes were interrupted by a serious failure in 1643 when Giovanni mismanaged the Venetian troops under his command, and his career went into eclipse for fifteen years. But he regained favor—and won the dogate—largely because of a fiery oration he delivered before the Senate in which Giovanni urged his countrymen not to cede Candia but to continue the fight against the Turks. "If we wish to wear the crown on our head," he cried, "let us not cast it at the feet of the Turks!"[3] For this worthy cause of preserving what remained of her territories, Giovanni offered the sum of 6,000 ducats to the Republic.[4]

Elected doge on 8 April 1658, Giovanni held office for little more than a year: he died on 30 September 1659. But at the end of his life, he was able to enjoy the victories won for the Serenissima by his captain general, Francesco Morosini, in the Morea and the Dardanelles. These accomplishments, and Giovanni's awareness of his family history, determined two major commissions by him.

In his palace at San Stae, Giovanni displayed a painting illustrating the victories against the Turks won by his forebears Benedetto and Jacopo Pesaro.[5] Thus, long after their deaths, the two rivals were reconciled in an image ordered by one of their descendants who was, in effect, continuing the same struggle. The lengthy inscription extolling past Pesaro victories against the Turks commemorated "Jacopo and Benedetto, noble Pesaro, the one Bishop of Paphos and Apostolic Legate, the other Procurator of S. Marco, horror of the Turks":

Iacobus, et Benedictus Nob. Pisauri. Ille Paphorum Episcopus, et legatus Apostolicus, iste Divi Marci Procurator, Turcarum Horor, acaicus, Euboicus, Adversus Baiazetem Tracum Regem Venetis, Christianisque in mare copiis, classibusque, praeliis, victoriis, Terra, marique, excidium intentantem, A sancta sede apostolica; a praeclara republica veneta, Pontifice, et Principe consperantibus pisaurorum fidem, virtutem, fortunam, classibus praefecti, Leucadiam insulam in acaico sinu munitissimam, consilio, robore, constantia potenter expugnantes ab oste perfido fidam pacem extorxerunt.[6]

Giovanni also commemorated his own and his family's historical association with the Turkish wars in his extravagant funerary monument in the Frari (fig. 59), for which he provided the princely sum of 12,000 ducats in his will—twice what he had given the Republic to fight the Turks in 1658! The doge dictated these instructions in a codicil to his will dated 29 September 1659, just one day before his death: "We want a monument erected in the church of the Frari within ten years, with an expenditure of 12,000 ducats, with statues and columns and with a statue of ourself seated. . . ."[7]

If, in his painting of Jacopo and Benedetto, Giovanni remembered both predecessors with impartial pride, in his tomb he made clear his descent from the Pesaro dal Carro (figs. 42, 43, and 59). Giovanni's monument surrounds the entrance to the Frari from the campo just to the left of the Pesaro altar of the Immaculate Conception (fig. 4). Indeed, it may be that the Moors who act as caryatids were intended to recall not only the recent victories over the Turks, but that earlier success at Santa Maura, similarly represented by Titian by the figure of a young black.

The doge's monument was designed by Baldassare Longhena, the architect of the family palace at San Stae, and was executed by the German sculptor Melchior Barthel.[8] Elaborately carved of white, black, and other colors of marble, and with gilded inscriptions, the monument represents the doge enthroned and surrounded by numerous allegorical figures such as Concord, Justice, Religion, and Valor, among others. The doge's effigy is vivacious and energetic: he seems to speak, and punctuates his speech with the gesture of his left hand. The weight of his throne is carried on the backs of monsters representing, according to the biographer da Mosto, those who conspire against the state. Two putti hover high above Giovanni's head, at the top of the monument, where they display a fictive drapery decorated with the Pesaro arms. At the bottom, between the figures of the hardworking Moors, two reliefs of skeletons hold other illusionistic cloths inscribed with what da Mosto rightly calls "interminable epigraphs."[9]

The effect of all this is perhaps not much to modern taste. Still, the intentions of

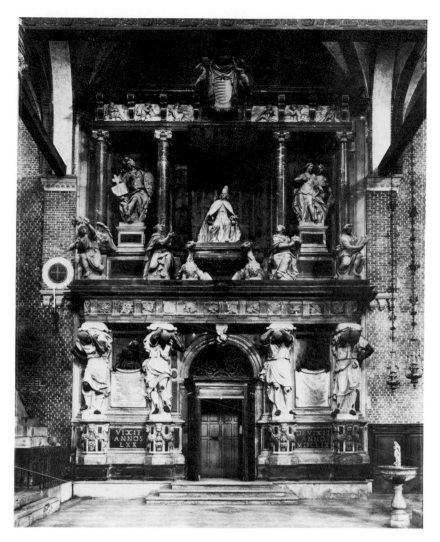

59. Baldassare Longhena and Assistants, Monument of Doge Giovanni
Pesaro. Venice, Santa Maria Gloriosa dei Frari.

the patron and the maker are clear—the monument was to be a grand testimony
to the life and fame of the doge and to the glory of his family. As it happened,
Giovanni's was the last important Pesaro commission in the church. With him ends
an extraordinary chapter in the history of art and patronage in the church of
S. Maria Gloriosa dei Frari.

Notes

Abbreviations

ASF Archivio di Stato, Florence

ASV Archivio di Stato, Venice

ASVi Archivio di Stato, Vicenza

Parish Parish Archives of the church and convent
of S. Maria Gloriosa dei Frari

CHAPTER I

1. *Examples of San Bernardino of Siena,* ed. Ada Harrison (New York and London, 1926), p. 135.
2. See Antonio Sartori, *La provincia del Santo dei Frati Minori Conventuali, Notizie-storiche* (Padua, 1958), p. 11; Sartori, pp. 11–12, notes that almost all the convents of the diocese of Padua existed before 1238 and already during the lifetime of Saint Francis (d. 1226). See also Camillo Bianchi and Francesco Ferrari, *L'isola di San Francesco del Deserto: Ricerca storica e intervento di restauro* (Padua, n.d. [1970?]), p. 23; and Timoteo Spimbolo, *Storia dei Frati Minori della Provincia Veneta di S. Francesco (1517–1800)* (Vicenza, 1933), vol. 1, p. 4, for Francis's sojourn in Venice, and pp. 1–23 for the first Franciscan settle-

ments in the Veneto. Francis was canonized in 1228 by Gregory IX; his papal bull announcing this to the friars of Venice and dated 9 July 1228 (a week before the canonization) is preserved in ASV, Frari, B. 97, no. XII, 1.

3. The story is told by Saint Bonaventure in the *Major Life,* chap. viii, sec. 9, trans. Benen Fahy, in Marion A. Habig, ed., *St. Francis of Assisi, Writings and Early Biographies, English Omnibus of the Sources for the Life of St. Francis* (Chicago, 1972), p. 695. The same story was repeated in the so-called Excerpts by Saint Bonaventure (ibid., p. 841); by Marino Sanuto, *De Origine Urbis Venetae et Vita Omnium Ducum (Rerum Italicarum Scriptores,* vol. 27), ed. Ludovico Antonio Muratori (Milan, 1733), p. 547, D and E; and by Luca Waddingo (hereafter Wadding), *Annales Minorum seu Trium Ordinum a S. Francesco Institutorum* (Quaracchi, 1931), vol. 1, p. 369, for the year 1220. Francis was probably in Venice itself in 1219; see John Moorman, *A History of the Franciscan Order* (Oxford, 1968), p. 50.

4. The island, now also called San Francesco del Deserto, had been given to the Friars Minor in 1228 by the Venetian Jacopo Michieli, and a church dedicated to Saint Francis was documented there already in 1233 (see Spimbolo, *Storia,* vol. 1, pp. 12–13, and Wadding, *Annales,* vol. 1, p. 369). The act of donation of the island was reprinted by Pietro Antonio da Venezia, *Cronica della provincia di S. Antonio dei Minori Osservanti Riformati* (Venice, 1688), bk. 3, chap. 11, p. 125. See also Bianchi and Ferrari, *Isola di San Francesco,* pp. 59–61, for a transcription of the document, which is discussed in ibid., pp. 46–47. According to these authors, p. 37, the church of S. Francesco del Deserto was begun in 1233. Gregory IX's bull approving construction of S. Francesco in Assisi was promulgated 29 April 1228, two years after the saint's death, and over two months *before* the canonization of Francis on July 16 of the same year. For the basilica at Assisi as a papal institution, see Hans Belting, *Die Oberkirche von San Francesco in Assisi* (Berlin, 1977), passim, and my forthcoming study, *Giotto's Bardi Chapel and the Character of St. Francis in Italian Art.*

5. Three other important Franciscan churches survive in the city, S. Giobbe, established in 1378, S. Maria dei Miracoli, built between 1481 and 1489, and S. Francesco della Vigna, first constructed in 1253 and rebuilt in the sixteenth century. (S. Francesco della Vigna was dedicated to Saint Mark but was called "S. Francesco" already in the first half of the fourteenth century; see Bianchi and Ferrari, *Isola di San Francesco,* p. 77.) S. Giobbe, the Miracoli, and S. Francesco became churches of the Observants (see below, n. 8). *Frari* is Venetian dialect for "friars," and *Santa Maria Gloriosa* means the "Virgin Assumed into Heaven," referring to the dedication of the church. For the church and convent of the Frari as the *Ca' Grande,* see, inter alia, Marc'Antonio Sabellico, *Del sito di Venezia città* (1502), ed. G. Meneghetti (Venice, 1957), p. 16; and the chronicle of Giorgio Dolfin (d. 1458) and of his son Pietro, Biblioteca Nazionale Marciana, MS It. VII.794 (8503), fol. 72r. Francesco Sansovino explained that the Frari was the largest Franciscan house, "perciò detta comunemente la Ca' Grande" (*Venetia città nobilissima et singolare* [Venice, 1581], p. 16). Regarding the number of friars in the Renaissance, note that the choir stalls, completed in 1468, had places for 124 (see chap. 1, sec. 3). This number had declined somewhat by the second half of the sixteenth century,

according to a Venetian MS in the Marciana, MS It. VII. 2540 (12432),
fol. 216, which records 110 friars in the Frari, compared to 78 in the Observant
church of S. Francesco della Vigna and 85 in the Dominican SS. Giovanni e
Paolo.

6. See Anscar Zawart, "The History of Franciscan Preaching and of Franciscan
Preachers (1209–1927), A Bio-bibliographical Study," *The Franciscan Educa-
tional Conference* 9 (1927): 242–43. For the use of the vernacular in sermons
and the form of sermons in the thirteenth and fourteenth centuries, see Carlo
Delcorno, *La predicazione nell'età comunale* (Florence, 1974); idem, *Giordano da
Pisa e l'antica predicazione volgare* (Florence, 1975); H. Grundmann, *Movimenti
religiosi nel medioevo*, trans. M. Ausserhofer and L. N. Santini (Bologna, 1974),
pp. 373ff.; and Rona Goffen, "*Nostra Conversatio in Caelis Est*: Observations
on the *Sacra Conversazione* in the Trecento," *Art Bulletin* 61 (1979): 201–02.
Early differences between Franciscan and Dominican sermons and the influence
of "clericalization" of the Friars Minor under Saint Bonaventure are treated
by Delcorno, "Predicazione volgare e volgarizzamenti," *Mélanges de l'Ecole
Française de Rome, Moyen Age—Temps Modernes (Les ordres mendiants et la ville
en Italie centrale (v. 1220–v. 1350)* 89 (1977–2): 679–89. The dedication of the
Dominicans to preaching is reflected in the official name of their order, the
Ordo Praedicatorum, the Order of Preachers. Francis's modesty determined
the name he selected for his followers, the Order of Friars Minor; see Cajetan
Esser, *Origins of the Franciscan Order*, trans. A. Daly and I. Lynch (Chicago,
1970), pp. 29–30, for the name, and pp. 54–58 on itinerant Franciscan preach-
ers.

7. See Esser, *Origins*, pp. 137–202, on the dissension among the Friars Minor in
the thirteenth century. Rosalind B. Brooke considers that the conflicts between
the Conventuals and the Spirituals became bitter starting after the death of
Bonaventure; see her indispensable volume on *Early Franciscan Government,
Elias to Bonaventure* (Cambridge, 1959), pp. 181–82 and p. 284, n. 2; and idem,
"St. Bonaventure as Minister General," *S. Bonaventura Francescano* (Convegni
del Centro di Studi sulla Spiritualità Medievale 14 [Todi, 1974]): 104. On the
ultimate division of the order by Leo X's *Ite vos in vineam meam*, the so-called
Bulla unionis, see chap. 3, sec. 2 of the present volume.

8. Wadding records that S. Francesco del Deserto became Observant officially in
1460 (*Annales*, vol. 1, p. 369). At that time Pius II confirmed the concession
of the church from the Conventuals to the Observants four years earlier, in
1456; see Sartori, *Provincia*, pp. 299–300, and pp. 290–300 for Conventual
Franciscan churches in Venice. Already in 1451, Nicholas V had given the
Observants permission to live in the convent of S. Francesco; see Bianchi and
Ferrari, *Isola di San Francesco*, p. 95 and passim, on the church itself. Bianchi
and Ferrari, on p. 107, note that the Observants of the Veneto held their
provincial chapter at S. Francesco in 1480. For a listing of Observant churches
in Europe in the later sixteenth century, see Francisci Gonzaga, *De Origine
Seraphicae Religionis Franciscanae eiusq. Progressibus, de Regularis Observanciae
Institutione, Forma Administrationis ac Legibus, Admirabiliq. eius Propagatione*
(Rome, 1587). Gonzaga lists the following as churches of the Observants in
Venice: S. Francesco della Vigna; S. Giobbe; S. Francesco del Deserto;

S. Chiara, Murano; S. Chiara, Venice; S. Francesco della Croce; S. Maria Maggiore; S. Sepolcro; and S. Maria dei Miracoli. The splendor of some of these institutions, e.g., S. Giobbe, the Miracoli and S. Francesco della Vigna, precludes any simplistic definition of Observant churches as "plain" compared to "fancy" Conventual houses. On "L'Osservanza francescana in Italia nel secolo XIV," see Lodovico Brengio in *Pontificium Athenaeum Antonianum, Facultas Theologica, Thesis ad Lauream* (Rome, 1963), especially pp. 135–40, on the Spirituals, the thirteenth-century predecessors of the Observants. Brengio notes that there was no talk of division in the thirteenth century. Data regarding the friars in the thirteenth century are published by Domenico Cresi, "Statistica dell'ordine minoritico all'anno 1282," *Archivum Franciscanum Historicum* 61 (1963): 157–62.

9. The Franciscans were granted many privileges, the most basic being papal approval of their Rule. Innocent III had given his verbal confirmation of the Franciscan Rule in 1210, and six years later granted the Second Order (the Poor Clares) the privilege of poverty (see Achille Luchaire, *Innocent III* [Paris, 1905–11], vol. 6, p. 50). Because of Innocent's oral approval, the Franciscans were able to argue that approbation of their Rule antedated the prohibition against the establishment of new orders, canon 13 of the Fourth Lateran Council (1215). Saint Dominic's request for confirmation of his new order was denied on the basis of the canon, and his followers were required to select an already existing rule (the Augustinian) to govern them; see Augustin Fliche in Fliche, Christice Thouzellier, and Yvonne Azais, *La Chrétienté romaine (1198–1274)*, vol. 10 of *Histoire de l'église depuis les origines jusqu'à nos jours,* ed. Fliche and Eugène Jarry (n.p., 1950), p. 203. On 15 March 1241, Gregory IX commanded that no prelate demand manual obedience from a brother of the Order of Friars Minor; the parchment is preserved in ASV, Frari, B. 2, no. 1. M. D. Lambert noted that the order's exemption from the control of local ecclesiastics had negative consequences. It meant that the friars were dependent upon the papacy and that they had to assume the material burdens of parish clergy despite their ideal of poverty. See Lambert, *Franciscan Poverty, The Doctrine of the Absolute Poverty of Christ and the Apostles in the Franciscan Order 1210–1323* (London, 1961), pp. 76–77. For privileges regarding sepulchres in Franciscan churches, see the *Privilegia et Indulgentie Fratrum Minorum Ordinis Sci. Francisci* (Venice, 1502), fols. 11r–13v; Spimbolo, *Storia,* vol. 1, p. 53; and above, chap. 1, sec. 5.

10. The parchment will of Achillea, wife of Angelo Signolo of S. Pantalon, is preserved in ASV, Cancellaria Inferiore, B. C 1, no. 30, Notary Domenico Caravello, cited by Nicolò Spada, "I Frati Minori a Venezia nel terzo decennio del duecento," *Le Venezie francescane, Rivista storico-aristica letteraria* 1 (1932): 75–76. Spada (p. 73, n. 5) also cites the will of Regina Corner, dated 1231, providing 10 lire for the Dominicans and a like amount for the Friars; the testament is ASV, Cancellaria Inferiore, Notary Donato, B. D 1, no. 65. Sansovino, among others, identified the site with a Benedictine abbey (*Venetia* [1581], p. 65v). Henry Thode writes that the Franciscans were living in an abandoned Benedictine cloister in 1227; "Studien zur italienischen Kunstgeschichte im XIV. Jahrhundert," *Repertorium für Kunstwissenschaft* 18 (1895): 82.

11. See, for example, Biblioteca Nazionale Marciana, MS Ital. VII. 794 (8503), fols. 197v–198r; and Nicolò Trevisan et al., *Cronaca de Venetia,* Marciana, MS Ital. VII. 519 (8438), fol. 70r.

12. For Sansovino, see above, n. 10. Badoer's gift of 1234 is recorded in ASV, Frari, B. 2, Libro dell'Archivio N. 4, fols. 9r–v, and published by Flaminio Cornelio (Corner), *Ecclesiae Venetae Antiquis Monumentis* (Venice, 1749), vol. 6, Doc. A, pp. 301–02. Originally to the north of the Frari, the church of S. Stin was dedicated to S. Stefano Confessore, called S. Stefanino to distinguish it from the larger church of S. Stefano Protomartire on the other side of the Grand Canal. The thirteenth-century church of S. Stin was destroyed in the early nineteenth century; see Giuseppe Tassini, *Curiosità veneziane* (1863), ed. Lino Moretti (Venice, 1970), p. 630. The Badoer were an ancient and distinguished family who produced seven doges of Venice and one Blessed of the Church. One branch of the family lived near the future site of the Frari, where their presence is remembered in the names of the *Ramo, Sottoportico,* and *Corte* Badoer. See Tassini, *Curiosità,* pp. 46–47.

13. See Spada, "Le origini del convento dei Frari," *Le Venezie francescane* 1 (1932): 163–65. Spada identifies the site and corrects an error in Corner's transcription of the deed of donation; Corner had mistaken "territorio" for "tentorio." Spada argues logically that records of such gifts would naturally be carefully preserved in order to prove legal ownership in case of dispute. Because the document of 1234 is the oldest surviving record of a donation of land to the Franciscans in Venice, Spada concludes, it is therefore likely also to be the first. Cf. Bianchi and Ferrari, *Isola di San Francesco,* p. 71, who argue that a convent of the Frari already existed in 1227 when Achillea Signolo bequeathed 10 lire to the "frati minori," signifying not only the friars but their convent. (For her testament, see above, n. 10.) While in later documents the Frari was indeed designated in this way, as discussed in chap. 1, sec. 1 and n. 5, I agree with Spada's interpretation of the documents.

14. The building given to the friars by Giovanni Badoer may have been an "infermaria," according to a later record cited by Spada ("Origini," p. 164 and n. 9). Spada (p. 170) published the document of 1236 (ASV, Frari, B. 110, no. 262).

15. For the meaning of *locus,* see Brooke, *Scripta Leonis, Rufini et Angeli, Sociorum S. Francisci, The Writings of Leo, Rufino and Angelo, Companions of St. Francis* (London, 1970), p. 72.

16. For the location of Mendicant churches and other new foundations in thirteenth-century Florence and their influence on the urbanization of their neighborhoods, see Anna Benvenuti Papi, "L'impianto mendicante in Firenze, Un problema aperto," *Mélanges de l'Ecole Française de Rome, Moyen-Age—Temps Modernes* 89 (1977–72), *Les Ordres mendiants et la ville en Italie Centrale (v. 1220–v. 1350):* 597–608. Papi, p. 602 and n. 11, notes the precise polarity of S. Maria Novella and S. Croce and their equidistance from the Duomo.

17. Marino Sanuto, *I diarii,* ed. Rinaldo Fulin et al. (Venice, 1879–1902), vol. 22, cols. 192–93, 1 December 1521. This entry is considered further in chap. 3, sec. 1 of the present volume. On the diarist, see Gaetano Cozzi, "Marin Sanudo il Giovane: dalla cronaca alla storia (Nel V centenario della sua nascita),"

in *La storiografia veneziana fino al secolo XVI,* ed. Agostino Pertusi (Florence, 1970), pp. 333–58, esp. pp. 351ff., for the diaries, and p. 333, n. 1, for further bibliography.

18. For extremely simple buildings as a statement of Mendicant poverty until ca. 1249, see Pierre Héliot, "Sur les églises gothiques des ordres mendiants en Italie Centrale," *Bulletin monumentale* 130 (1972): 231; and Gerard Gilles Meersseman, "Origini del tipo di chiesa umbro-toscano degli ordini Mendicanti," in *Il Gotico a Pistoia nei suoi rapporti con l'arte gotica italiana* (Centro italiano di studi di storia e d'arte a Pistoia, Atti del 2 convegno internazionale di studi, 1966 [Pistoia, 1972]), p. 65.

19. On 11 June 1219, Honorius III had written to all bishops and abbots instructing them to provide the friars with appropriate places for their preaching. This was done at the suggestion of Ugolino, acting during Francis's absence from Italy and against his will, for the right to use such facilities smacked of privilege. See Moorman, *History,* p. 50.

20. Meersseman, "Origini," p. 67.

21. For Francis's restoration of the three churches, see Bonaventure, *Major Life,* chap. ii, in Habig, *St. Francis,* pp. 640–46. S. Damiano was first: it was there that the miraculous Cross had spoken to the saint at the beginning of his religious life, and there, after his death, that Saint Clare and her sisters wept over his body (ibid., xv, 5, p. 744). But S. Maria degli Angeli at the Portiuncula was the place Francis loved "more than any other in the world" (ibid., ii, 8, p. 645). He had brought his first twelve friars to live there (ibid., iv, 5, p. 656), and, at his own request, Francis was brought to die at the Portiuncula (ibid., xiv, 3, p. 738). For the famous Indulgence of the Portiuncula which Francis persuaded Honorius III to grant in 1216, see Moorman, *History,* p. 30 and n. 4, and pp. 63–64, for the friars' use of abandoned houses and churches. Saint Francis himself mentioned this practice of reclaiming abandoned buildings in his Testament; see *Opuscula Sancti Patris Francisci Assisiensis* (Quaracchi, 1949), p. 81.

22. Saint Francis himself, for example, was a deacon but, like many of his earlier followers, never ordained a priest. The Dominican friars, on the contrary, were always ordained and therefore always literate. Francis's modesty in regard to the priesthood is related to his feigned illiteracy. In point of fact, he evidently knew at least three languages—in addition to his native Italian, also French and Latin. On Francis's opposition to study because possession of books would preclude absolute poverty and because a studious and literate man might not make a humble friar, see Moorman, *History,* p. 50; and below, chap. 3, sec. 2.

23. Above, n. 19; and Meersseman, "Origini," pp. 68–69. The building of the Frari fits Meersseman's "second phase" of Mendicant church architecture, beginning ca. 1240, when the new orders had of necessity to build their own churches.

24. ASV, Frari, B. 106, fasc. xxxii, no. 1.

25. "Octavianus miscratione Divina S. Mariae in Via Lata, Diaconus Cardinalis Apostolicae Sedis Legatus, Universis Christi fidelibus salutem in Domino. Devotioni vestrae volumus fieri manifestum, quod nos Fratrum Minorum de Conventu Venetiarum supplicationibus inclinati ad Dei reverentiam, & Glo-

riosiae Matris ejus, primarium lapidem in eorum Ecclesia posuimus, in prae-
sentia Domini Episcopi Castellani, D. Jacobi Episcopi Bononiae, Domini
Vitalis Episcopi Tomasini, & ipsi Ecclesiae nomen imposuimus S. Maria Glo-
riosa, propter differentiam aliarum Ecclesiarum Dioecesis Castellanae, sta-
tuentes Festum ejus celebrari a Christi fidelibus in festo Assumptionis ejusdem
Virginis Gloriosae. Fecimus insuper indulgentiam unius anni, & quadraginta
dierum omnibus auxilium ministrantibus pium ad ipsius Ecclesiae fabricam
faciendam. Actum Venetiis anno Domini millesimo ducentesimo quinquage-
simo die tertio currente Aprilis" (ASV, Frari, B. 1, no. 1, fol. 28r; published
by Corner, *Ecclesiae,* p. 280, and by Pietro di Osvaldo Paoletti, *L'architettura
e la scultura del Rinascimento in Venezia* [Venice, 1893], vol. 1, p. 89, n. 1; ASV,
Frari, Catastico I, 3 April 1250; published by Corner, *Ecclesiae,* p. 280). In
1457, when Bernardo Giustinian delivered an oration at the funeral of Doge
Francesco Foscari in the Frari, there were twenty churches of the Madonna in
Venice in addition to S. Maria Gloriosa; Giustinian is quoted below in chap. 5,
sec. 1; "Orazione recitata da Bernardo Giustiniano nell'esequie del Doge Fran-
cesco Foscari," *Orazioni, elogi e vite . . . ,* 2d ed. (Venice, 1798), vol. 1, p. 58.
For the meaning of the word *gloriosa,* see chap. 3, sec. 5 and n. 118.

26. Wadding records that the Franciscan order celebrated the Visitation according
to the General Chapter of Pisa held in 1263 under the generalate of Saint
Bonaventure; *Annales,* vol. 4, p. 244, for the year 1263. See also Giuseppe
Löw, "M[aria] nella liturgia occidentale da Medioevo ai giorni nostri," in
Enciclopedia cattolica (Vatican City, 1952), vol. 8, col. 102, s.v. "Maria."

27. Iacopone da Todi, *Laude,* ed. Franco Mancini (Rome, 1974), pp. 85–90 and
339–41. Leone Bracaloni argues that Jacopone's laud influenced the depiction
of the Madonna in Sienese trecento painting; *L'arte francescana nella vita e nella
storia di settecento anni* (Todi, 1924), pp. 216–18. Jacopone, who died in 1306,
was himself inspired by a wooden sculpture of the *Virgin and Child* in the
church of the Visitation in Camuccia, outside Todi. The great poet was much
cited by Saint Bonaventure; see Delcorno, "L' 'exemplum' nella predicazione
di Bernardino da Siena," *Bernardino predicatore nella società del suo tempo* (Con-
vegni del Centro di Studi sulla Spiritualità Medievale, 16 [Todi, 1976]), p. 92
and n. 1. On religious writings by Franciscan authors in honor of Mary, such
as the poems of Jacopone and Saint Bonaventure's *Speculum beatae Mariae*
(*Opera Omnia,* vol. 8), see Yvonne Azais, in Fliche, Thouzellier, and Azais,
Chrétienté romaine, p. 398. The extraordinary importance and prestige of the
church of Mary at the Portiuncula—its particular significance in Saint Francis's
life and its consequent special privileges and indulgences—also influenced the
dedication of almost all early Franciscan churches to the Madonna (see Bra-
caloni, *L'arte francescana,* p. 211). The cult of the Virgin in Venice and the
prominent role of the Franciscans as her champions are considered in chapter 5
of the present volume.

28. For Innocent IV's bull dated 1 December 1252, see ASV, Frari, B. 106, fasc.
xxxii, no. 2. Forty days of indulgence were also granted to those assisting the
newly begun construction of S. Croce, the Franciscan church of Florence. See
Gianni Cacciarini, "In S. Croce la chiesa del 1250," *Città di vita* 23 (1968): 57.

29. ASV, Frari, B. 106, fasc. xxxii, no. 3 (in 1255); fasc. xxxii, no. 4 (in 1256);

and fasc. xxxii, no. 5 (in 1261). These and other concessions of Pope Alexander are summarized in ibid., B. 2, fols. 2v–3r. Pope from 1254 to 1261, Alexander was born Orlando dei Conti dei Segni, and, like his kinsmen and predecessors, Innocent III and Gregory IX, was a great patron of the Franciscan order. Alexander succeeded Gregory as Cardinal Protector of the order in 1227 and held the position until his death. It seems clear that the Segni's support of the Friars Minor was motivated by personal as well as papal concerns. Both Innocent and Gregory had known Saint Francis, and both were intimately associated with the foundation of his order. Innocent III had given oral permission to Saint Francis's First Rule, permitting the friars to preach. Gregory IX was the first Cardinal Protector of the order, and it was he who canonized Saint Francis in 1228. The bull of canonization is published in *Magnum Bullarium Romanum a B. Leone Magnum usque ad S.D.N. Clementem X* (Lyons, 1692), vol. 1, pp. 98f.

30. Nicholas IV, 13 September 1291, ASV, Frari, B. 106, fasc. xxxii, no. 7; incorrectly summarized in ibid., B. 2, fol. 9r, in which indulgences are promised for observing the feasts of Mary, Saint Francis, and Saint Anthony (instead of Saint Mark).

31. For the bull of Pius II, see Corner, *Ecclesiae*, pp. 306–07. See also ASV, Frari, B. 106, fasc. xxxii, no. 9, for a bull of Callistus III granting indulgences for observing the feast of Saint Bernardino; the bull is dated 4 July 1455.

32. Thode, "Studien," p. 82, cites a document of 13 July 1330 referring to the new construction: "pro capella Ecclesie nove."

33. For the orientation of the thirteenth-century church, see Sanuto, *Diarii*, vol. 40, col. 50.

34. The arms of the Scuola di S. Francesco are still visible above the entrance arch of the chapel, now called the Chapel of the Sacrament. On the Alberti tomb, see Wolfgang Wolters, *La scultura veneziana gotica (1300–1460)* (Venice, 1976), pp. 166–67. Note, however, that the tomb has been moved: although it was evidently always in the same chapel, it had been placed higher on the wall and later returned to its (presumably) original position during the restorations in the Frari prior to World War I. See Max Ongaro, *Cronaca dei ristauri dei progetti e dell'azione tutta dell'Ufficio Regionale ora Soprintendenza dei Monumenti di Venezia* (Venice, 1912), p. 92.

35. For Duccio's family tree and his death away from Venice, see Luigi Passerini, *Gli Alberti di Firenze, Genealogia, storia e documenti* (Florence, 1869), vol. 1, p. 159 and tables 1 and 5.

36. The issue of loyalty to the Franciscan order is discussed further above, chap. 1, sec. 5, and in the following note.

37. For the monument itself, see W. R. Valentiner, "The Equestrian Statue of Paolo Savelli in the Frari," *Art Quarterly* 16 (1953): 281–92; and Wolters, *Scultura*, vol. 1, pp. 229–30. Savelli, who died in the service of the Republic while fighting in Padua, was evidently given a state funeral and his equestrian monument erected at state expense (see Michael Mallett, "Venice and Its Condottieri, 1404–54," in *Renaissance Venice*, ed. J. R. Hale [London, 1973], p. 129; but cf. Wolters, *Scultura*, on the question of state funding). The monument, made of stone and wood, survives with much of its polychromy intact. Notes

made on the color in the mid-nineteenth century are kept in the Parish archives, B. 2, fol. 38 bis. New (that is to say, clean), the monument must have appeared remarkably lifelike. Regarding family loyalty to the Franciscan order, note that the pope who had approved the Franciscan Rule in 1223, Honorius III, was born Cencio Savelli, a member of the same noble Roman family as the condottiere. Pope from 1216 to 1227, Honorius III Savelli appointed Cardinal Ugolino (the future Gregory IX) as the first Cardinal Protector of the Franciscan order in 1220 and placed the friars under papal protection. It was Honorius who encouraged Saint Francis to write the Rule that was promulgated by the pope on 29 November 1223 (see Fliche, *Chrétienté romaine*, p. 274). The Savelli were patrons of the great Franciscan church of Rome, S. Maria in Aracoeli, already in the thirteenth century. The effigy of Pope Honorius IV Savelli (1285–87) was transferred there after the destruction of Old St. Peter's; and the family were still patrons of the Aracoeli in the eighteenth century, according to inscriptions in the church. For the Savelli tombs in the Chapel of St. Francis in the Aracoeli, see *Roma e dintorni, Guida d'Italia del Touring Club Italiano*, 7th ed. (Milan, 1977), p. 103. The tomb of Luca Savelli predates 1287, and the latest surviving inscription in the chapel marks the tomb of "Catherina Iustiniana Sabelli," 1724, and "Lutius ultimus marchio Tarani in Sabinis," 1728.

38. My colleague Caroline Bruzelius rightly cautions that Paoletti (in *L'Architettura*, vol. 1, p. 46) was too optimistic in wishing to date both Savelli's tomb and the vaults ca. 1405, the year of the condottiere's death.

39. Sansovino, *Venetia* (1581), p. 65v: "Et Paolo Savello Barone di Roma Condottiero allora dell'armi della Republica vi fece i volti."

40. Sartori, *Guida storico-artistica della Basilica di S. M. Gloriosa dei Frari in Venezia* (Padua, 1949), p. 11. Published thirty-five years ago, this monograph is the basis of all the more recent—and less valuable—guidebooks to the Frari. Sartori's book was republished in 1956.

41. On the *scuole* of the Florentines and of Saint Anthony in the Frari, see above, chap. 1, sec. 5, and nn. 105–08 below.

42. Sartori, *Guida*, p. 27, gives the height. Hit by lightning in 1490, the tower has been restored numerous times; see ibid., p. 28.

43. This is recorded in an inscription on the tower itself: "Anno Domini M. CCC. LXI. fuit inceptum istud campanile per magistrum Iacobum Ceilega & reductum usque ade superficiem terrae, sic completum fuit per filium eius, magistrum Petrum Paulum, Anno Domini M. III. LXXXXVI. Procuratores eiusdem operis fuerunt fratres et Thomas Viaro & nobilis viri Petrus de Bernardo Marcus Barbaro & Mafeus Aymo. Orate pro eis & pro i aliis qui porrexerunt manum adiutricem." Viario was Bishop of Trebisond and a friar in the convent of the Frari, according to Sartori, *Guida*, pp. 27–28. When Viario and his family were unable to continue funding the construction, the Milanese confraternity stepped in; see Sansovino, *Venetia* (1581), p. 65v. A payment document dated 5 July 1395 was published by Paoletti, *L'Architettura*, p. 47, n. 12.

44. One "Fra' Poverello," too old to flee, is said to have survived the convent fire by praying amidst the flames (see Spimbolo, *Storia*, p. 68). For the fire itself

and the rebuilding of the convent, see Flaminio Corner, *Notizie storiche delle chiese e monasteri di Venezia* (Padua, 1758), pp. 365–66; and Francesco Fapanni, *Chiese claustrali e monasteri di Venezia,* Biblioteca Nazionale Marciana, MS Ital. VII.2283 (9121), fols. 135r–136v.

45. For the General Chapter convoked by Francesco della Rovere, later Sixtus IV, see above, chap. 2, sec. 2. The altar was consecrated on 13 February 1469. The parchment document of the consecration and relics of Saints Catherine, Dionysius, Stephen, Barbara, and Francis were discovered in 1825 when the mensa was removed from the high altar. Cicogna copied the document: Biblioteca Correr, Codice Cicogna, *Chiese venete ed edificii pubblici,* E-Giobbe, B. 496 (formerly 475), unpaginated. See also Paoletti, *L'Architettura,* vol. 1, p. 47. Attendance at the Frari on the feasts of the Madonna and of Saints Catherine and Francis, inter alia, had been awarded with indulgences. See ASV, Frari B. 106, fasc. xxxii, nos. 1–22, pertaining to the years 1249–1553. Bones of Saint Stephen and Saint Catherine were preserved in the Frari; Biblioteca Correr, Cicogna, B. 3063, no. 14, fol. 2v. The altar of St. Catherine in the Frari probably predates its mention in 1524; ASV, Frari, B. 106, fasc. xxxiii, no. 5ff. For Saint Catherine's importance to the Conventual Franciscans, see n. 93 for chap. 3 of the present volume. Note also that the Venetians celebrated the feast of Saint Stephen with an annual banquet, which was convenient, because the feast, December 26, coincided with the first day of Carnival; see Edward Muir, *Civic Ritual in Renaissance Venice* (Princeton, 1981), pp. 156 and 256, n. 18.

46. The dedication is commemorated by an inscription on the pier outside the first chapel to the right of the chancel: "Petrus Tranesis Artium, & Theologiae Doctor Ordinis Minorum, ac Episcopus Thelexinus consecravit hanc Ecclesiam in honorem Assumptionis Virginis Mariae, & statuit Anniversarium hujus Dedicationis in die Dominico, qui postremus erit ante Ascensionem Iesu Christi semper esse celebrandum, & omnibus, qui eodem die trices XL. dies Indulgentiae concessit, anno Salutis MCCCC LXXXXII. XXVII. KAL. Mai."

47. *Major Life,* iv, 9, *St. Francis,* ed. Habig, p. 660. See also John V. Fleming, *From Bonaventure to Bellini: An Essay in Franciscan Exegesis* (Princeton, 1982), pp. 99–128. On the Tau-plan of Franciscan churches, see Spimbolo, *Storia,* p. 52; and for the symbolism of geometric shapes in ecclesiastical architecture in general, see Richard Krautheimer, "Introduction to an 'Iconography of Medieval Architecture' " (1942), in idem, *Studies in Early Christian, Medieval, and Renaissance Art* (New York and London, 1969), pp. 115–50.

48. Rectangular apsidial chapels are typical of Franciscan churches, as noted by Cacciarini, "S. Croce," p. 59.

49. For the sculpture of the Miani (also called the Emiliani) and Corner portals, see Wolters, *Scultura,* vol. 1, p. 256 (cat. 119) and pp. 276–77 (cat. 234).

50. The statues stand atop a lunette decorated with a very late and very ruined painting of the Virgin. The main portal was designed by Bartolomeo Bon, according to Elena Bassi, "L'architettura gotica a Venezia," *Bollettino del Centro Internazionale di Studi di Architettura Andrea Palladio* 7, pt. 2 (1965): 198. For the statues themselves, see chap. 1, sec. 4 and n. 65.

51. For the extensive restoration of the fabric, see Ongaro, *Cronaca,* pp. 79–95,

and Aldo Scolari, "La chiesa di S.ta Maria Gloriosa dei Frari ed il suo recente restauro," *Venezia, Studi di arte e storia* 1 (1920): 148–71.

52. On the symbolism of numbers and geometrical shapes in medieval architecture, see Krautheimer, "Introduction," pp. 115–50, and especially 122–23, on the number eight. For the symbolism of the octagon in Bellini's Frari triptych, see chap. 2, sec. 3 of the present volume.

53. Meersseman quotes thirteenth-century texts expressing the dual purposes of Mendicant—in this case, Dominican—churches: "ad divina celebranda" (as papal bulls describe it) and "ad capiendos homines in praedicationibus" (from a document of 1243); see "Origini," p. 69.

54. On choirs and similar structures in Mendicant churches, see the following publications by Marcia B. Hall: "The Italian Rood Screen: Some Implications for Liturgy and Function," in *Essays Presented to Myron P. Gilmore,* edited by S. Bertelli and G. Ramakus (Florence, 1978), vol. 2, pp. 213–18; "The *Ponte* in S. Maria Novella: The Problem of the Rood Screen in Italy," *Journal of the Warburg and Courtauld Institutes* 37 (1974): 157–73; *Renovation and Counter-Reformation, Vasari and Duke Cosimo in Sta Maria Novella and Sta Croce 1565–1577* (Oxford, 1979); and "The 'Tramezzo' in S. Croce, Florence and Domenico Veneziano's Fresco," *Burlington Magazine* 112 (1970): 797–99. Milton J. Lewine considered the influence of preaching on sixteenth-century church design; "Roman Architectural Practice during Michelangelo's Maturity," in *Stil und Überlieferung in der Kunst des Abendlandes, Akten des 21. internationalen Kongresses für Kunstgeschichte in Bonn 1964* (Berlin, 1967), vol. 2, p. 25. For liturgy and church design, see Christian-Adolf Isermeyer, "Le chiese del Palladio in rapporto al culto," *Bollettino del Centro Internazionale di Studi di Architettura, Andrea Palladio* 10 (1968): 42–58.

55. For the number of friars, see n. 5 above. For a list of the figures represented, see the Parish archives, B. 2, nos. 25, 25A, and 25D, and Sartori, *Guida,* p. 171. The monument is dated by its inscriptions: "MARC. Q. JOH. PETRI. D. VICENTIA FEC. HOC. OP. 1468" (referring to the sculptor Marco q. Gianpietro, i.e., Marco Cozzi) and "M.CCCC.LXXV. OPTIME JACOBO MAUROCENO PROCURANTE HIS SEDIB HAEC MARMORA SUNT ADIUNCTA" (referring to Jacopo Morosini, procurator of the church in 1475).

56. Sarah Wilk has compared the choir to an iconastasis; see *The Sculpture of Tullio Lombardo, Studies in Sources and Meaning* (New York and London, 1978), pp. 139–40. For the gilding, of which traces survive, see John McAndrew, *Venetian Architecture of the Early Renaissance* (Cambridge, Mass., and London, 1980), p. 56; and for the choir itself, Hall, *"Ponte,"* p. 169 and n. 40. On the "Byzantine Revival" in Venetian art during this time, see Goffen, "Icon and Vision: Giovanni Bellini's Half-Length Madonnas," *Art Bulletin* 57 (1975), pp. 487–90 and 505–11.

57. Michael Bihl, "Statuta Generalia Ordinis edita in Capitulis Generalibus Celebratis Narbonae an. 1260, Assisii an. 1279 atque Parisiis an. 1292," *Archivum Franciscanum Historicum,* 34 (1941): 13–94 and 284–358; n.b. pp. 47–48 on architecture. See also the discussion of the order's legislation of art in Brooke, *Franciscan Government,* pp. 279–82. For the Order of Preachers, see Joanna Louise Cannon's doctoral dissertation, "Dominican Patronage of the Arts in

Central Italy: The *Provincia Romana, c.* 1220–*c.* 1320," Courtauld Institute of Art, University of London, 1980.

58. The architecture of the Mendicant orders has received more attention than other art commissioned by or for them. See, inter alia, Kurt Biebrach, "Die holzgedeckten Franziskaner- und Dominikanerkirchen in Umbrien und Tos-kana," *Beiträge zur Bauwissenschaft* 11 (1908): 1–71; Cannon, "Dominican Patronage," especially pp. 90–99, on churches; Herbert Dellwing's published dissertation (Frankfurt), *Studien zur Baukunst der Bettelorden im Veneto, Die Gotik der monumentalen Gewölbebasiliken* (Munich and Berlin, 1970); Héliot, "Eglises gothiques," pp. 231–35; Krautheimer, *Die Kirchen der Bettelorden in Deutschland* (Cologne, 1925); Wolfgang Kroenig, "Caratteri dell'architettura degli ordini mendicanti in Umbria nell'età comunale," in *Atti del VI convegno di studi umbri 1968* (n.p., 1971), vol. 1, pp. 165–98; Meersseman, "Origini," pp. 63–77; and Renate Wagner-Rieger, "Zur Typologie italienischer Bettelor-denskirchen," *Römische historische Mitteilungen* 2 (1957–58): 266–98.

59. Pale and ghostly fragments of mural decoration survive throughout the church, e.g., in the Corner Chapel, in the chancel, around the tombs of Savelli, B. Pesaro, and Marcello, and in the sacristy. The windows of the Corner Chapel were restored in part by the great designer Mariano Fortuny; see the Parish archives, B. 2, no. 80. The Corner Chapel was restored three times during the nineteenth century, in 1857, 1874, and 1890–91, according to the records in the Parish archives, Armadio G, B. 4. For the attempt to recover the Corner Chapel frescoes, see the Parish archives, Armadio G, B. 1, protocollo 581, 13 April 1894.

60. Sanuto recorded the decoration of the Frari with banners on other occasions. In 1525, Sanuto admired the "most beautiful tapestries, among them some new pieces . . . , and the standards of doges and captains general and other banners" with which the Frari was decorated for the feast of Saint Francis, October 4 (*Diarii,* vol. 40, col. 16). On the decorations for the feast of the Immaculate Conception in 1526, see chap. 4, sec. 3.

61. The main altar dedications in the Frari during the fifteenth and early sixteenth century were as follows, moving left from the main portal: the Virgin and St. John the Baptist (Florentines); the Immaculate Conception (Pesaro after 1518); St. Peter (Emiliani or Miani, 1432); the Madonna del Campanile; St. Mark (Corner, after 1378); St. Ambrose (Milanese); St. Michael (Trevisan, ca. 1480); St. Mark, then St. Andrew, finally St. Francis and the Madonna della Neve; the Assumption; St. Jerome and later B. Gentile da Matelica (after 1482); the Virgin and St. Francis (Merchadenti); B. Gentile da Matelica (ca. 1360), later the Madonna (Bernardo, 1482); the Immaculate Conception, sacristy (Pesaro ca. 1478); St. Catherine; St. Ursula, then St. Lucy (ceded to the Zane, 1562); St. Bernardino of Siena, from 1517 the Purification of the Virgin (Valier); the Crucifixion; and St. Anthony (confraternity of the saint).

62. To be sure, both S. Francesco (especially the Upper Church) and S. Croce (by which I mean the church before Vasari) were more complicated and perhaps more consistent in their programs than the Frari. On Assisi, see Belting, *Ober-kirche*; and on S. Croce, Irene Hueck, "Stifter und Patronatsrecht. Dokumente zu zwei Kapellen der Bardi," *Mitteilungen des Kunsthistorischen Institutes in Flo-*

renz 20 (1976): 263–70. Hueck suggests that the dedications of the chapels of the east end of S. Croce were determined by a program of the friars and not by individual donors. Similarly, in reference to the Peruzzi Chapel of St. John the Evangelist and St. John the Baptist, also in S. Croce, Borsook has pointed out that there is no evidence of the Peruzzi's having a particular devotion for the Baptist, although they did celebrate the feast of the Evangelist; see "Notizie su due cappelle in Santa Croce a Firenze," *Rivista d'arte,* 3d ser., 36, 11 (1961–62): 90–107.

63. Beginning at the left as one enters the church, the eight chapels or altars of the Madonna were as follows: the Scuola dei Fiorentini, dedicated jointly to the Virgin and to St. John the Baptist; the Pesaro altar of the Immaculate Virgin; the altar of Mary at the entrance to the campanile; the high altar, of course, dedicated to the Virgin Assumed into Heaven; the altar of the Venetian Scuola dei Merchadenti or Merchanti, devoted to both the Virgin and St. Francis, and located in the second chapel to the right of the chancel; next to this, the Bernardo family chapel of the Madonna; the chapel of the sacristy; and the Valier chapel of the Purification (formerly the chapel of S. Bernardino). A ninth altar of the Madonna was added in 1563, when the first chapel to the left of the chancel was ceded to the confraternity of the Madonna della Neve. For the Madonna del Campanile in 1488, see ASV, Frari, B. 5, fol. 12r. On the concession of the altar of S. Bernardino to Nicolò *q.* Silvestro Valier, and its rededication to the Purification, see ASV, ibid., fols. 23v–24r, and also chap. 5, sec. 1 of the present volume. For the Bernardo Chapel of the Madonna della Salute in the seventeenth and eighteenth century, see ASV, Frari, B. 106, fasc. xxxiii, no. 5v. The altarpiece by Bartolomeo Vivarini, still in situ in the Bernardo Chapel, is signed and dated 1482.

64. Saint Bonaventure explained that the Stigmatization "was the seal of Christ . . . with which he gave the [Franciscan] rule and its author [St. Francis] divine approval." *Major Life,* iv, 11, Habig, *St. Francis,* p. 662.

65. The facade group associates the Infant Christ with the Passion, evoked by Saint Francis, which is characteristic of Franciscan spirituality, as considered further in chap. 2, sec. 2. The Madonna is attributed to Bartolomeo Bon (or Buon) by Gino Fogolari, "Gli scultori toscani a Venezia nel Quattrocento e Bartolomeo Bon, Veneziano," *L'Arte* 33 (1930): 457, and fig. 14 on 451. Wolters ascribes both the Madonna and St. Francis to Bartolomeo shortly after 1430; *Scultura,* vol. 1, pp. 118–19, 122, 279–80, and 284–85 (cat. 241). Cf. Anne Markham Schulz for an attribution to a Lombard sculptor in the circle of Filippo Solari and Andrea da Carona, in *The Sculpture of Giovanni and Bartolomeo Bon and Their Workshop* (Transactions of the American Philosophical Society, vol. 68, pt. 2 [Philadelphia, 1978]), p. 8. The figure of the Redeemer at the top of the facade lunette is a later work, possibly added after a summer storm in 1579; see Dellwing, *Baukunst der Bettelorden,* pp. 124–25.

66. The concession of the altar of S. Bernardino to the Valier in 1517 (chap. 5, sec. 1) mentions the adjacent chapel of the Crucifix (ASV, Frari, B. 5, fol. 23v). For the Scuola del Crocefisso, which moved to the Frari from S. Giuliano in 1579, see Sartori, *Guida,* p. 189. This is the altar where Titian was buried; see chap. 5, sec. 2.

67. For the dedication of the chapel to St. Michael in 1348, see ASV, B. 106, fasc. xxxiii, no. 5n: Marco Michiel endowed masses to be said at the altar of the Archangel on May 14 of that year. For Trevisan patronage of the Frari from 1478 (the will of Giacomella Trevisan) through the sixteenth and seventeenth centuries, see ASV, Frari, B. 137, s.v. "Trevisan." Inscriptions on his tomb and on the reliquary of the Blood provide the documentation regarding the patronage of Melchiore Trevisan. See also Cornelio, *Ecclesiae* (1749), p. 298. The Scuola dei Boccaleri held their functions in this chapel from 1420 until the conquest of Venice by Napoleon; see Scolari, "Chiesa," p. 153, and Sartori, *Guida*, p. 85.

68. "There is every reason," Saint Bonaventure asserted in the preface to the *Major Life*, "to believe that it is he [Francis] who is referred to under the image of an Angel coming up from the east, with the seal of the living God [i.e., the stigmata]. . . . When the sixth seal was broken, St. John tells us in the Apocalypse, 'I saw a second Angel coming up from the east, with the seal of the living God' (Ap 7, 12)." Habig, *St. Francis*, p. 632.

69. Celano, *Second Life*, cxlix, 197, trans. Placid Hermann, in Habig, *St. Francis*, p. 520; and Bonaventure, *Major Life*, ix, 3, in ibid., p. 699.

70. The sculpture is illustrated in Luciano Marini, *La Basilica dei Frari* (Venice, 1979), p. 24.

71. *Major Life*, xiii, 1–5; Habig, *St. Francis*, p. 732.

72. *Major Life*, xiii, 1–5; Habig, *St. Francis*, p. 732.

73. The chapel was constructed ca. 1300, and the frescoes and stained glass window (the latter now in the Bardi Chapel) date to ca. 1310, according to Wolfgang Braunfels, *Santa Croce di Firenze* (Florence, n.d. [1938]), p. 10. All of this predated the patronage of Gemma Velluti in 1321–40; see Alessandro Conti, "Pittori in Santa Croce: 1295–1341," *Annali della Scuola Normale Superiore di Pisa, Classe di lettere e filosofia*, ser. 3, vol. 2, no. 1 (1972): 251.

74. For the altar of St. Michael at Assisi, identified by an original inscription, and for Cimabue's frescoes, see Belting, *Oberkirche*, pp. 53–54, 61–63, 122–26, and 204–14.

75. Trevisan had fought for the Republic against the Turks as *generalissimo da mar*. He brought the relic with him when he returned from Constantinople in 1480. This is commemorated by an inscription still in situ in his former chapel. Although the Venetian friars probably never doubted the sanctity of Trevisan's relic, the question of whether the Blood of Christ should in fact be venerated had been the subject of intense discussion. Was the blood that Christ shed in the Passion united nonetheless with the Word? In 1449, Nicholas V had confirmed the cult, but the issue was debated again in December 1462, before Pope Pius II, with Dominicans confronting Franciscans. The Franciscan argument was put forward by Francesco della Rovere, the future Sixtus IV, and some nine or ten years later he published his views in his famous *Tractatus de Sanguine Christi*. See M.-D. Chenu, in *Dictionnaire de théologie catholique* 14¹ (Paris, 1939), cols. 1094–97, s.v. "Sang du Christ"; and A. Teetaert, in ibid., 14² (Paris, 1941), cols. 2199–2200, s.v. "Sixte IV."

76. The tabernacle is now in the sacristy. On the tabernacle itself, see McAndrew, *Venetian Architecture*, pp. 189–90; and Wilk, *Sculpture*, pp. 98–99.

77. Sabellico, *Sito,* p. 16.
78. Sansovino, *Venetia* (1581), p. 65v: "Vi si honora ogni anno, nella Domenica di Lazero da tutto il popolo, il sangue di Christo portato da Constantinopoli, si come per una inscrittione presso al suo sepolcro s'attesta, et donato insieme con dell'unguento col quale la Maddalena unse i piedi a N. Signore a questo Sacrario da Marchio Trivisano. . . ." (N.b. that Sansovino speaks of the *tomb* of the blood.) The brothers of the Scuola Grande di S. Rocco participated in this procession; see ASV, Frari, B. 5, fol. 3v.
79. The chapel was first consecrated to St. Mark, and then rededicated to St. Andrew ca. 1396, in compliance with a bequest by Marsilio di Carrara in his testament of 18 March 1398; see Sartori, *Guida,* p. 89. Sartori also notes that St. Mark and his lion are represented in the vault as a recollection of the first dedication. The chapel altarpiece, painted ca. 1524 by Bernardino Licinio, also seems to recall the early dedications to St. Mark and to St. Andrew, while commemorating yet another rededication to the Franciscan saints. The only saints included by Licinio (so far as one can tell) who are not Franciscans are St. Mark and St. Andrew. The Virgin and Child—clearly derived from Titian's *Pesaro Madonna*—are raised on a high throne above a group of saints dominated by Franciscans. To Mary's proper right are Francis, Mark, Bonaventure, and Clare; behind St. Mark, Licinio included a profile portrait presumably representing the donor. To Mary's left are St. Anthony of Padua, Andrew, Louis of Toulouse, and two unidentifiable figures, one of them a woman. In 1563 the chapel was ceded to the confraternity of the Madonna della Neve, and still later in the sixteenth century it was endowed by the Bernardo family. In 1585, Alessandro Vittoria and his studio carved figures of Francis and Helen, the onomastic saints of Francesco Bernardo and his wife, Elena Giustiniani. It is tempting to think that the identification of St. Helen with the Cross was considered relevant to the traditional associations of the chapel.
80. Celano's prayer is quoted in chap. 4, sec. 1.
81. Venice, Biblioteca Nazionale Marciana, MS Ital. I.61 (4973), fol. 83r. Evidently anonymous, the laud is included with others that are ascribed to Jacopone da Todi.
82. Sansovino, *Venetia* (1581), p. 65v.
83. The influence of two prominent clerics, Cardinal Bessarion and Pope Sixtus IV, is considered in chap. 2, sec. 2.
84. Silvio Tramontin, "Il 'Kalendarium' veneziano," in *Culto dei santi a Venezia* (Venice, 1965), p. 316.
85. The Republic had been more generous at first, and public funds subsidized both the Dominican and the Franciscan building campaigns during the first half of the fourteenth century. After 1344, however, the Mendicants had to depend mostly on private donations. See Thode, "Studien," pp. 82–86, for public support of the Frari, and pp. 87–88 for SS. Giovanni e Paolo. Perhaps this evident change in policy is related to the unique position of S. Marco in Venice. At any rate, the Signoria did not abandon the Frari altogether. In 1391, 200 *lire d'oro di grossi* were allocated by the Maggior Consiglio for reconstruction of the convent when the 1,000 *ducati d'oro* bequeathed by Marco

Gradenigo proved to be insufficient. (See Corner, *Notizie*, pp. 365–66; Sartori, *Guida*, p. 12; and Paoletti, *Architettura*, vol. 1, p. 46.) In 1529, 300 ducats were allocated to certain convents and monasteries, to be selected by the Collegio, in return for which the recipients were to pray for three consecutive days for the well-being of the state; see Sanuto, *Diarii*, vol. 52, cols. 203–04, 8 November.

86. Reinhold C. Mueller, *The Procuratori di San Marco and the Venetian Credit Market* (New York, 1977), p. 116. Cf. Felix Gilbert, "Venice in the Crisis of the League of Cambrai," in *Renaissance Venice*, ed. J. R. Hale (London, 1973), p. 283.

87. For corporate public patronage by the *gonfalone*, see D. V. Kent and F. W. Kent, *Neighbours and Neighbourhood in Renaissance Florence: The District of the Red Lion in the Fifteenth Century* (New York, 1982), pp. 156ff. For S. Croce and the *Calimala*, see Luciano Berti, *Firenze / Santa Croce* (Bologna, 1967), p. 309; and Raniero Sciamannini, *La Basilica di Santa Croce* (Florence, 1951), p. 6. Among the richest *Calimala* families were two very great patrons of S. Croce, the Peruzzi and the Castellani. For their wealth, see Lauro Martines, *The Social World of the Florentine Humanists 1390–1460* (Princeton, N.J., 1963), p. 203.

88. Innocenzo Giuliani, "Genesi e primo secolo di vita del Magistrato sopra Monasteri, Venezia 1519–1620," *Le Venezie francescane* 28 (1961): 42–68 and 106–69. (For the *Magistrato* and the Conventuals, see chap. 3, sec. 2 of the present volume.) See also Paolo Prodi, "The Structure and Organization of the Church in Renaissance Venice: Suggestions for Research," in *Renaissance Venice*, ed. J. R. Hale (London, 1973), p. 421. Prodi (pp. 411–12) considers that church-state relations in Venice were different from elsewhere in Europe.

89. ASV, Frari, B. 90, no. 29; see also Bettiolo, *Fradaja*, pp. 95–96.

90. No less than 276 tombs survive in the pavement of S. Croce, according to the count of Braunfels, *Santa Croce*, p. 50.

91. See Borsook, *The Mural Painters of Tuscany*, 2d ed. rev. (Oxford, 1980), p. xviii, with a reference to the *Decretum Gratiani* of ca. 1140; and Annegret Höger, "Studien zur Enstehung der Familienkapelle und zu Familienkapellen und -altären des Trecento in florentiner Kirchen" (doctoral dissertation, University of Bonn, 1976), passim, and especially pp. 20–54. Brooke ("St. Bonaventure," pp. 82–84 and 95) notes that the friars had earned a reputation for greed in their pursuit of testaments and burials in their churches, a problem to which Bonaventure addressed himself when he took office as Minister General, hoping to improve the order's repute and their relationship with the secular clergy.

92. ASV, Notarile Testamenti Simeon, B. 335, no. 199, 24 December 1361 and 29 January 1361. I am grateful to Professor Dennis Romano of Syracuse University for bringing this document to my attention. Such bequests for the clergy attending one's funeral and for candles, etc., were standard.

93. "Prima voglio che al luogo de Frari Minori in Venezia sia fatta una capella in qual parte meglio parerà a' miei commissari . . . et in quella far fare una sepoltura nella quale sia messo il mio corpo e della benedetta anima di mio fratello . . ." (ASV, Frari, B. 106, fasc. v, no. 1; also B. 1, fol. 21r for an

instrumento on the will in 1417). A seventeenth-century copy of Corner's will is in the Biblioteca Correr, Codice Cicogna, B. 3417 (old no. 3834), fasc. 2, fols. 273r–v. Excerpts from the original document were published by Scolari, "Chiesa," p. 154.

94. Progress was slow, and the new Corner Chapel, added to the west flank of the church ("liturgical" north), was not completed for some time. Paoletti cites a *brano* following Corner's will and dated 16 July 1380 as evidence that work was interrupted; *Architettura,* vol. 1, p. 46 and n. 10, referring to the document in ASV, Procuratia de Ultra, B. 121, no. 6 (formerly 372). For the Corner Chapel, see also in the ASV, Testamenti Marsilio Antonio, B. 1211, no. 818; Avogaria di Comun, B. 86, no. 3833C; and Frari, B. 129, s.v. "Corner." Work continued throughout the fifteenth century, and it was only in 1474—nearly a century after the original bequest—that Bartolomeo Vivarini signed and dated the altarpiece, still in situ in the chapel. The triptych represents Saint Mark, the titular saint of the chapel, flanked by saints John the Baptist and Jerome on the left, and by saints Nicholas and Paul on the right. See Rodolfo Pallucchini, *I Vivarini (Antonio-Bartolomeo-Alvise)* (Venice, n.d. [1961?]), pp. 121–22 and fig. 169.

95. The angel was attributed to "Iacomo Padovano" by Sansovino, *Venetia* (1581), p. 66r. See also Anne Markham Schulz, *Niccolò di Giovanni Fiorentino and Venetian Sculpture of the Early Renaissance* (New York, 1978), p. 6; Schulz suggests a probable date of the mid-1450s for the cenotaph. The Mantegnesque frieze was ascribed to Jacopo Parisati da Montagnana by Sartori, *Guida,* p. 67, the same master to whom he attributed the fresco decoration in the Pesaro chapel in the sacristy (see chap. 2, sec. 1). Nineteenth-century restorations of the Corner Chapel are discussed in the Parish archives, Armadio G, B. 1; see fol. 6v for the restoration of the vault in 1857, the windows in 1874, and the general restorations (including installation of a new iron gate) in 1890–91. See also ibid., protocollo 581, for the attempts to recover the frescoes in 1894.

96. Primo da Ronco established seventeen perpetual trusts in his testament of 1293, and his bequests were paid annually until 1556; see Mueller, "The Procurators of San Marco," *Studi veneziani* 13 (1971): 147 and 185, citing documents in ASV, Procuratia de Ultra, B. 138. N.b. that the Frari dunned Girolamo Corner in 1781 for monies bequeathed by his ancestor Pietro Marcello in 1533. The friars complained that the value of the two ducats a year bequeathed in the sixteenth century had changed, and furthermore, that the heirs had not been paying regularly. The amount due for the last 137 years was L. 355.14. See ASV, Frari, B. 132, Processi, s.v. "Marcello," referring to the convent account records.

97. ASV, Frari, B. 106, fasc. xxxiii, no. 4, fols. 44r–v, "obligations to fulfill" for Jacopo and his brothers, for his sister-in-law Elena, and their cousin Girolamo and his parents; fol. 45v, a "fulfilled obligation" for Leonardo and the "dead" of his family; and fols. 48r–v, further "obligations to fulfill" for Jacopo and for Girolamo and his parents.

98. Mueller, *Procuratori,* pp. 3–4 and 8–9.

99. Two procurators were to be responsible for the administration of estates on the S. Marco side of the Grand Canal, *de Citra,* and two for those on the other

side, *de Ultra*. The other two *procuratori* continued to act as administrators of S. Marco, the traditional role of their office since the arrival of St. Mark's body in Venice in A.D. 829. See Mueller, "Procurators," pp. 147 and 185.

100. Two examples are the testaments of Jacopo Pesaro and his brother Fantino, cited in chap. 4, sec. 2. Members of the Scuola Grande di San Marco, they arranged that the guardian of the confraternity act as their commissary after the deaths of the individual relatives who are named as commissaries and, in the case of the lack of a legitimate male heir, to continue in that capacity.

101. For the *mariegola* of the confraternity of the Madonna della Neve (1563), according to which the members would bury defunct brothers and pray for their souls, see Biblioteca Correr, Mariegola 54 (Cicogna 3534 collocamento, MSS IV, N. 54). ASV, Scuole piccole e suffragi, B. 437 bis-C, Mariegola, contains the 1476 mariegola of the Scuola Grande di S. Maria della Valverde della Misericordia (i.e., the Merchadanti), included here, because of an old archival error, as Reg. 7. (I am grateful to Dr. Francesca Romanelli of the Archivio di Stato in Venice for explaining this error and for helping me to find the mariegola despite it.) On Venetian scuole in general, see Lia Sbriziolo, "Per la storia delle confraternite veneziane: Dalle Deliberazioni Miste (1310–1476) del Consiglio dei Dieci, *Scolae Comunes*, Artigiane e Nazionali," *Atti dell'Istituto Veneto di Scienze, Lettere ed Arti* 130 (1967–68), *Classe di scienze morali, lettere ed arti* 126: 405–42. The author publishes archival references for the following scuole in the Frari: the Milanese in 1420, p. 427; the Mercanti, 1433, p. 430; St. Anthony, 1439, p. 432; St. Louis of Toulouse, 1443, p. 433; and St. Bernardino, 1453, p. 437.

102. Among the most important scuole associated with the Frari, and certainly the most conspicuous, was its neighbor and tenant, the Scuola Grande di San Rocco. (See ASV, Frari, B. 5, fols. 3r–4v.) However, instead of maintaining a chapel in the Frari, this confraternity built its own church, as well as the scuola decorated by Tintoretto. For his Passion cycle in the scuola, see, most recently, David Rosand, *Painting in Cinquecento Venice: Titian, Veronese, Tintoretto* (New Haven and London, 1982), pp. 197–206. Other scuole buildings were also originally clustered around the Frari, but it is difficult to imagine that any of them rivaled the magnificence of San Rocco. The plague saint Roch, who died in 1327, had been a tertiary of the Franciscan order. His cult was formally recognized by the church in 1414, and his feast on August 16 was officially observed by the Venetian Republic; see Pietro Antonio di Venetia, *Fasti serafici* (Venice, 1684), pp. 10 and 27; and George Kaftal and Fabio Bisogni, *Saints in Italian Art, Iconography of the Saints in the Painting of North East Italy* (Florence, 1978), cols. 897–900. The wealth and political power of the Scuola Grande di San Rocco, no less than the popularity and the prestige of the institution, surely profited the Franciscans in many ways, tangible and intangible, just as the confraternity must have profited in turn from its affiliation with the Frari. N.b., as an example of their cooperation, that the brothers of S. Rocco marched in the annual procession honoring the Frari's precious relic of the Blood of Christ (see ASV, B. 5, fol. 3v and above, n. 78). In 1489, the Frari and the confraternity had agreed that the friars would attend funerals of scuola members and provide preachers twelve times a year. In addition to

small payments for these services, the confraternity would employ three friars to offer endowed masses, and so on; see Brian Pullan, *Rich and Poor in Renaissance Venice* (Oxford, 1971), pp. 647–48, for this and a brief description of the confraternity's archival records, and passim for the definition and function of the scuole.

103. For the Scuola dei Milanesi, see ASV, Consiglio dei Dieci, Reg. 10, Miste, fol. 28r, kindly brought to my attention by Guido Ruggiero. This document, dated 5 June 1420, is an adjustment to a ruling passed by the Ten on 14 April 1361 allowing the Milanese to have a chapel in the Frari. The chapel was consecrated on June 24, the feast of John the Baptist, in 1421, which is recorded by an inscription on the wall of the chapel. See also ASV, Frari, B. 100, fasc. xiv, no. 1, which is the mariegola of the confraternity in 1453 (fol. 49r), ratified in 1467 and 1475 (fol. 1r). Their altarpiece shows Saint Ambrose enthroned with saints John the Baptist, Sebastian, the Franciscan tertiary Louis IX (?), Jerome, Gregory the Great and Augustine, and other, unidentifiable figures. It was begun by Alvise Vivarini and completed after his death in 1503 by Marco Basaiti. The scuola itself was located to the southwest of the church but later moved when the Corner Chapel was built on that site; see Sartori, *Guida,* pp. 19 and 76. The Milanese usually had an annual procession on December 7, the feast of Saint Ambrose; see Sanuto, *Diarii,* vol. 40, col. 429.

104. Unfortunately, the reasons for their leaving the Dominicans for the Franciscans are not explained by the documents, and one would very much like to know what considerations motivated the Florentines. Recently, Alessandro Parronchi has suggested they may have been influenced by Cosimo the Elder, who had stayed in Venice during his exile, and by Pope Eugene IV, who favored the Franciscan order. The pope was a signatory of the treaty of 1435 with Florence, Venice, and the Duke of Milan. (See Parronchi, *Donatello e il potere* [Florence and Bologna, 1980], p. 94.) For documents of 1435, when the Florentines were negotiating with SS. Giovanni e Paolo, and 1443, when they were in the Frari, see Sbriziolo, "Storia," pp. 431 and 433. For the document of 31 August 1435 allowing the Florentines to establish a scuola at SS. Giovanni e Paolo, see ASV, Consiglio dei Dieci, Misto Registro (1430–37), no. 11, fol. 131r; copied in ASV, Frari, Reg. I-2, fol. 24; and B. 7, Catastico Novo 65, Reg. I-7, fol. 1r. For the concession of the chapel in the Frari, 16 September 1436, see ASV, Frari, B. 103, no. 2, and B. 7, fols. 6r–8r. N.b. also the mariegola in the Biblioteca Correr, MS Cicogna IV, N. 71; ASV, Frari, B. 7, fols. 1r–20v; and B. 103, fasc. xvi, nos. 1, 2, and 3. See also the notice in ASF, MS. 631, fol. 29r: "Nella Chiesa di S. Maria de Frari esiste magnifica Cappella del Consolato di Nazion Fiorentina, con varie sepolture per i morti della stessa Nazione, ora destrutta, instituita con solenne Insorum l'anno 1436." The chapel was originally the first to the left of the main portal, where the Florentine lily in the oculus on the facade still recalls their patronage. The Florentines were granted special permission to construct this window and "una porta grande magnifica" (ASV, Frari, B. 7, fol. 4r). The Florentine altarpiece was renewed ("ha fato rinovar") at the expense of a Florentine merchant in 1524, according to Sanuto, *Diarii,* vol. 36, col. 427, 23 June.

105. The sculpture by Donatello is now at the altar of B. Gentile da Matelica (formerly the Dandolo altar of S. Girolamo d'oro). For the date of the statue, revealed by the recent restoration, see Francesco Valcanover, "Il San Giovanni Battista di Donatello ai Frari," with technical notes by Lorenzo Lazzarini, *Quaderni della Soprintendenza ai Beni Artistici e Storici di Venezia* 8 (1979), p. 27; and Wolters, "Freilegung des Signatur an Donatellos Johannesstatue in S. Maria dei Frari," *Kunstchronik* 27 (1974): 83. As Wolters points out, the *Baptist* is Donatello's earliest work in the Veneto, predating his Paduan commissions by approximately a decade.

106. After some discussion, it was agreed that the scuola would erect its chapel to the right of the main entrance and, like the Florentines, the confraternity of St. Anthony would construct a window on the facade to mark the site: "come a quella scuola stavera più bella" (ASV, Frari, B. 7, fol. 21r). See ASV, Frari, B. 99, nos. 2–3 (eighteenth-century copies of the agreements of 1439), and B. 7, fols. 20r–30r, for concessions regarding the chapel. For the rules of the Scuola di S. Antonio, see ASV, Provv. Comm. Reg. BB, nos. 52–69, and a nineteenth-century copy in the Biblioteca Correr, Raccolta Cicogna, B. 3118, no. 22. A parchment dated 3 June 1232, announcing the canonization of the saint, is preserved in ASV, Frari, B. 99, no. 1.

107. ASV, B. 99, nos. 4 and 6: copies of documents of 23 July 1439 and 15 October 1440, declarations made before the Council of Ten that there could not be any other confraternity of St. Anthony in Venice.

108. It would be difficult, if not impossible, to exaggerate the esteem with which Saint Anthony was (and is) regarded in the Veneto. He is *the* saint, and his church in Padua is known simply as *Il Santo*. Saint Anthony's body was disinterred in 1263, and his tongue was found to be uncorrupt (see Spimbolo, *Storia*, pp. 41–42). Probably inspired by this happy discovery, the Franciscans renamed the province of the Veneto (including Padua, Venice, Verona, and the Friuli) in honor of the saint in 1272 (see ibid., p. 42). According to Sartori, *Provincia*, pp. 14–15, the province was identified as "Santo" from the fifteenth century, for example, in writings of Sixtus IV as Minister General and in the *Regesto* of Samson (Francesco Nani), his successor in that office. The significance of Saint Anthony as the embodiment of Conventual virtue in the Frari is considered in chap. 3, sec. 3, of the present volume.

109. See, inter alia, D. V. Kent and F. W. Kent, *Neighbours*; Martines, *Social World*; and several publications by Richard A. Goldthwaite: *The Building of Renaissance Florence: An Economic and Social History* (Baltimore and London, 1980); "The Building of the Strozzi Palace: The Construction Industry in Renaissance Florence," *Studies in Medieval and Renaissance History* 10 (1973): 99–194; "The Florentine Palace as Domestic Architecture," *The American Historical Review* 77 (1972): 977–1012; and *Private Wealth in Renaissance Florence: A Study of Four Families* (Princeton, N.J., 1968).

110. Certain government positions were intended as sinecures for impoverished noblemen; see James Cushman Davis, *The Decline of the Venetian Nobility as a Ruling Class* (The Johns Hopkins University Studies in Historical and Political Science, ser. 80, no. 2 [Baltimore, 1962]), p. 22 (= p. 228). Moreover, dowries for poor nobles were supplied by the procurators; while in that office,

Francesco Foscari (buried in the chancel of the Frari) had given 30,000 ducats for this worthy purpose. See Robert Finlay, "Politics and the Family in Renaissance Venice: The Election of Doge Andrea Gritti," *Studi veneziani*, n.s. 2 (1978), p. 98.

111. Of course, then as is frequently now the case, political power—as opposed to mere officeholding—required wealth. Finlay ("Politics," pp. 110–14) notes the essential combination of family connections and money as the basis of political power in Renaissance Venice.

112. Davis, "Decline," pp. 19–20 (=pp. 225–26), points out that the legislation was originally intended to increase membership in the Great Council—although it had the opposite effect. He notes that there was no group comparable to the Venetian nobility in sixteenth-century Europe. See also B. Cecchetti, "I nobili e il popolo di Venezia," *Archivio veneto* 3 (1872): 425; and Stanley Chojnacki, "In Search of the Venetian Patriciate: Families and Factions in the Fourteenth Century," in *Renaissance Venice*, ed. Hale, p. 76, n. 3. The legal title for Venetian patricians was *ser*, while procuratori were titled *messer*; see Giovanni Correr and Agostino Sagredo et al., *Venezia e le sue lagune* (Venice, 1847), vol. 1, p. 129. Having in effect declared "l'état c'est nous," the Venetian patriciate passed a series of laws penalizing those who refused a government office; see Vittorio Lazzarini, "Obbligo di assumere pubblici uffici nelle antiche leggi veneziane" in idem, *Proprietà e feudi, offizi, garzoni, carcerati in antiche leggi veneziane, Saggi* (Rome, 1960), pp. 49–60, originally published in *Archivio veneto* 19 (1936). For "The Civic Irresponsibility of the Venetian Nobility," see D. E. Queller in *Economy, Society, and Government in Medieval Italy, Essays in Memory of Robert L. Reynolds*, ed. D. Herlihy et al. (Kent, Ohio, 1969), pp. 223–35; and for the patrician sentiments of patriotism and greed, see Gilbert, "Venice," p. 287.

113. Chojnacki, "Venetian Patriciate," p. 71.

114. See Cecchetti, "Nobili," pp. 429 and 432; Correr and Sagredo, *Venezia*, vol. 1, p. 111. The tendency was to preserve the "purity" of the noble class, although some additions were made to the class in 1381, and much later again in the seventeenth and eighteenth centuries; see Chojnacki, "Venetian Patriciate," pp. 48 and 57; and Frederic C. Lane, "The Enlargement of the Great Council of Venice," in *Florilegium Historiale, Essays Presented to Wallace K. Ferguson*, ed. J. G. Rowe and W. H. Stockdale (Toronto, 1971), pp. 237–73. On the sale of offices to raise money, beginning in 1510, see Gilbert, "Venice," p. 284. One of the functions of the Avogaria di comun was to keep these registers of patrician births and weddings; see Cecchetti, "Nobili," p. 432.

115. Chojnacki, "Venetian Patriciate," pp. 72–73.

116. Ibid., pp. 59–60.

117. See Borsook, "Notizie," passim; Hueck, "Stifter," passim. I consider this further in a forthcoming monograph on *Giotto's Bardi Chapel*.

118. See chap. 1, sec. 2, and n. 35 above. In 1479, Gerolamo Alberti was buried in the chancel of the Frari; ASV, B. 106, fasc. xxxiii, no. 5q.

119. Borsook, "Notizie," p. 99 and n. 50.

120. On the altarpiece, no. 54.195 in the Metropolitan Museum, see Walter Cahn, "A Note on the Pérussis-Altar in the Metropolitan Museum of Art in New

York," in *Essays in Northern European Art Presented to Egbert Haverkamp-Bege-mann on his Sixtieth Birthday* (Doornspijk, 1983), pp. 61–65, with further bibliography.

121. See Stefano Rosselli, *Sepoltuario fiorentino,* Florence, Biblioteca Nazionale, 2, IV.534 (Magliabecchiana XXVI, 22), vol. 1, no. 147. The latest Peruzzi inscription in S. Croce is dated 1714, although this by no means signifies *continuous* patronage.

122. On the Venetian "lack of . . . neighborhood-based particularism," see Dennis Romano, "Charity and Community in Early Renaissance Venice," *Journal of Urban History* 11 (1984): 63–82. As one of the larger houses by the mid-four-teenth century, the Pesaro should also have been one of the more powerful. This was so because of the direct relationship between the number of males in a noble family and their consequent political (and economic) power: since only men of noble birth could hold government positions, clearly the larger the family, the more political offices they could (and, indeed, were obliged to) fill. The Pesaro were seventy-fourth in Council membership in 1353–54, compared to the far more numerous Contarini (second), Loredan, and Trevisan. The Bernardo, however, were few in number. See Chojnacki, "Venetian Patriciate," pp. 67–69, and p. 89, n. 115, citing ASV, *Voci misti,* Reg. I, fol. 61. In 1541, according to the genealogist Marco Barbaro, eighteen members of the Pesaro family were members of the Gran Consiglio, and sixteen in 1568 (*Arbori de' patritti veneti,* Venice, Biblioteca Nazionale Marciana, MS It. 8492, fol. 352a). On the other hand, the only Pesaro doge was Giovanni in 1658–59 (appendix II). Chojnacki (pp. 49–50, and pp. 78–79, nn. 18 and 19) cites the *Annali veneti* of Domenico Malipiero on the two great factions of the Venetian nobility, determined by genealogy, the *case vecchie* and *case nuove.* No member of the "old houses," the Pesaro among them, achieved the dogate between 1382 and 1620. Gilbert ("Venice," p. 290) notes the development of a quasi oligarchy among the Venetian patriciate during the war of the League of Cambrai.

CHAPTER II

1. From the epitaph of Franceschina Pesaro's tomb in the chapel of the Frari sacristy.

2. On Giovanni Pesaro, doge from 1658 to 1659, and his tomb by Longhena, see above, Appendix II.

3. With the following inscription: "SEPOLTURA DOMINI PALMIERII DE CA' PESAURO DE CONFINIO SANTE FUSCCHE ET SUOR. ERED." Marco Barbaro, *Arbori de' patritti veneti* [1536], ed. T. Corner and A. M. Tasca (1743), ASV, Misc. Codici I, Storia Veneta, vol. 6, p. 80. Palmiero and his descendants were also known as the Caroso (a frequently used name in the family) because of their presumed descent from the emperor Carausius of Rome; see the manuscript of Barbaro's *Arbori* in the Biblioteca Nazionale Marciana, MS 8492, fol. 352a; and Giacomo Zabarella, *Il Carosio overo origine regia et augusta della serenissima fameglia Pesari ad Venetia* (Padua, 1659), pp. 2ff. Palmiero's parish, S. Fosca, is near the churches of S. Marcuola and S. Maria Maddalena on the opposite side of the

Grand Canal from the Frari. For the first settlement of the friars at the site of the Frari in 1234 and the subsequent history of the church, see chap. 1, secs. 1 and 2.

4. Angelo's parchment will is preserved among the documents of the family archive, ASV, Pesaro, B. 1, no. 1. In the following clause of his testament Angelo bequeathed 100 pounds to the Dominican church of SS. Giovanni e Paolo ("loco fratrum predicatorum libras centum"). Angelo's commissaries were his brother Marco and his son Nicolò. They and his other heirs were forbidden to sell the family palace at S. Giacomo dell'Orio, but Angelo's descendants did sell it nonetheless. Despite his injunction, the family palace was sold to the Republic by his great-grandsons Maffio and Andrea; see Girolamo Alessandro Capellari, *Il Campidoglio veneto,* Biblioteca Nazionale Marciana, MSS It. VII. 17 (8306), vol. 3, fol. 206r (dating Angelo's will 16 August 1309, which is either erroneous or refers to a later document); and Giovanni Dolcetti, *Il "Libro d'argento" dei cittadini di Venezia e del Veneto* (1922–28; republ. Bologna, 1968), vol. 3, pp. 63 and 66. For the Fondaco dei Turchi, which is on the site of the family palace, see Elena Bassi, *Palazzi di Venezia,* 3d ed. (Venice, 1980), p. 174. On the Pesaro family archives, see Adelaide Albanese, "L'archivio privato Gradenigo," *Notizie degli Archivi di Stato* 3 (1943), pp. 12–13, which was most kindly brought to my attention by Juergen Schulz.

5. Chap. 1, sec. 2.

6. ASV, Archivio Notarile Benedetto Croce, B. 1157, Protocollo 2, fol. 1v. The letter *q,* for *quondam,* is commonly used in sources and documents to indicate both the father's name and the fact that he is deceased at the time of writing. Had Fantino been alive when his son Caroso dictated his will, this would have been indicated by the word *di*: Caroso di Fantino.

7. The Pesaro family had been founders and great patrons of S. Zan Degolà (see Zabarella, *Carosio,* p. 52). Now used as the Galleria dell'Arte Moderna, the Palazzo Pesaro at S. Stae, designed by Longhena, was begun between 1652 and 1659; the *piano nobile* was complete by 1679, the date inscribed on the facade, but the palace was finished only in 1710. See Bassi, *Palazzi,* pp. 53–55 and 174–89; and Rudolf Wittkower, *Art and Architecture in Italy, 1600–1750,* 2d ed. rev. (Harmondsworth et al., 1965), p. 368, n. 55. Cleaning and restoration of the exterior of Palazzo Pesaro were completed in 1984.

8. ASV, Benedetto Croce, B. 1157, Protocollo 2, fol. 1v. "Frati Menori" refers to the Frari in Venetian Medieval and Renaissance documents. For further evidence of Pesaro devotion to the Franciscans, note also the will of Peregrina, the wife of Alessandro Pesaro, dated 1416. Peregrina wished to be buried wearing the habit of a *pinzochera*—that is, a Franciscan lay sister. In 1441, Elena, the wife of Fantino Pesaro, requested burial in the habit of a Poor Clare (ASV, Croce, B. 1157, Protocollo 1, fols. 132r–v, and chap. 4 of this volume, sec. 2). Most interesting is the testament of Francesco *q.* Marino in 1433, providing for his burial in the Observant Franciscan church of S. Giobbe and the foundation of an altar of St. Francis: "In prima . . . ellegande chel mio corpo sia meso in luogo di S. Iop; lasso al detto luogo ducati .C. [100] d'oro chon questa condition che in quela capela che sera meso el mio corpo sia fato uno altar al'onor de dio, e de misser San Francescho. Et . . . voio chel sia fata

una archa davanti l'altar e chel mio corpo sia meso dentro in la detta archa"
(ASV, Notarile Testamenti Croce, B. 1157, Protocollo 1, fol. 96r).

9. ASV, Croce, B. 1157, fol. 65r.

10. Gino Fogolari, *Chiese veneziane, I Frari e i SS. Giovanni e Paolo* (Milan, 1931),
pp. xix–xx. Andrea was an elector of Doge Michele Morosini in 1382; and in
that same year Andrea, with his brother Maffio, sold the Pesaro family palace
at S. Giacomo dell'Orio to the Republic. See Capellari, *Campidoglio,* vol. 3,
fol. 206r.

11. Franceschina's first "successor" in this regard—namely, the next woman to
have her "own" funerary chapel in the Frari—was evidently Elena Giustinian,
the widow of Francesco Bernardo. The Bernardo had been great patrons of
the Frari for generations; their chapel of the Madonna is the last on the right
of the chancel. In 1587, Elena obtained a concession from the friars to have
statues of the onomastic saints Helen and Francis and to build a sepulchre for
her husband and herself in the chapel of the Madonna della Neve, the second
to the left of the chancel. (See ASV, Frari, B. 3, fols. 31v–32r; and the testa-
ment of her husband, 30 December 1580, copied in ASV, Frari, B. 122, Pro-
cessi "BEN-BI.") Earlier consecrated to St. Mark and then to St. Andrew,
the chapel is now dedicated to the Franciscan saints. To either side of the
altarpiece by Bernardino Licinio (ca. 1524) are the statues that Elena commis-
sioned from the shop of Alessandro Vittoria, representing the patron saints of
the donors. Note also that even tomb inscriptions naming a woman seem to
be rare before the sixteenth century; her presence in her husband's grave is
often indicated by the terse word "wife" or "woman." An elegant exception
to this generality is the wall tomb of Generosa Orsini and her son Maffeo
Zen, dated 1498 and located in the left arm of the Frari transept. Another,
very splendid exception is the Emiliani, or Miani, Chapel adjacent to
S. Michele in Isola. The chapel was endowed by Margherita Vitturi Miani in
1530. Names of women can be very difficult to trace: genealogists and authors
of the Avogaria registers described a bride simply as the daughter, *fia* or *filia,*
of her father. See also below, chap. 4, sec. 2 and n. 68 for the omission of
daughters from their fathers' testaments: a woman's dowry was considered
her inheritance, and she usually had no further share in her father's estate.

12. Giacomo, Antonio, Girolamo, and Alessandro. Pietro's marriage to Alessan-
drina is entered in ASV, Avogaria di Comun, Cronaca Matrimoni, B. 106/1,
fol. 57v; and Avogaria di Comun, Registro, B. 107/2, 260r. Barbaro recorded
the names of their sons, but not their two married daughters. (Barbaro did,
however, list the husbands' names; see the ASV copy of his *Arbori,* vol. 6,
fol. 83.) Pietro was a senator in 1426, and podestà and captain of Belluno in
1449. In 1460, he was given custody of the Castello di Siguri by his great
friend, King Giacomo Lusignano of Cyprus. See Barbaro in ibid., and in his
compilation of noble marriages, *Nozze* [1538], Biblioteca Nazionale Marciana,
MS It. VII.156 (8492), fol. 353a; and Capellari, *Campidoglio,* vol. 3, fol. 206v.

13. This was common practice, given the risks inherent in childbirth. Alessandri-
na's will is in ASV, Croce, B. 1157, Protocollo 1, fol. 74v, 10 August 1427.

14. ASV, Avogaria di Comun, Cronaca Matrimoni, B. 106/1, fol. 57v.

15. Franceschina was not directly related to Doge Nicolò Tron; see also chap. 3,

sec. 3 and n. 84. Pietro had died in 1468 (or late 1467), predeceasing his second wife by ten years; see Correr, MSS P. D. c. 869/28 (Molin), a parchment dated 23 June 1468, recording an agreement between their sons and the sons of Andrea Molin. Nicolò, Benetto, and Marco are identified as "q. [*quondam*] Pietro" in this document of 1468, while their half-brother Alessandro was identified as "de Piero" in 1467 in ASV, Avogaria di Comun, Cronaca Matrimoni, B. 106/1, fol. 58r. A testament by Pietro has not been found, assuming that he made one and that it survives. Nevertheless, given the burials in the Frari of his father and of at least some of his kinsmen, we may reasonably imagine that Pietro too was interred there, and possibly also his first wife, Alessandrina. However, the endowment of the sacristy chapel has nothing to do with them.

16. Both wills are ASV. The first is preserved among the papers of Diodato da Miani, B. 734, no. 72, 2 July 1432; and the second was written by the notary Francesco Gritti, B. 560, no. 255, 7 June 1442.

17. ASV, Miani, B. 734, no. 72. The will is dated 2 July 1432 in another hand, presumably the notary's. "Mi Francesquina, mugier de misser Piero da Qua' da Pexaro, fo de misser Andrea de chonfinio de San Benedeto, sana del chor[po] e de la mente, vogio questo sia el mio testamento, e vogio que sia mie fedel chomesario mio mario [marito] ser Piero da Qua' da Pexaro e mia madre e mio fradelo e mia sorela e vogio questi mie chomesarii die dar in pirtuti mie legati, e laso ducati 2 que me sia dito le mese de San Griguol [Gregorio] per anema mia, e laso ducati 3 al Chorpo de Xpo [Corpus Christi] per l'anema mia e laso ducati 3 a Sancto Andrea per l'anema mia e laso ducati 3 a Sancto Alovixe per l'anema mia e laso ducati 3 a San Gerolumo per l'anema mia e laso ducati 3 ale munege [monache] di Agnoli [S. M. degli Angeli] de Murano per l'anema mia e laso ducati 3 ale munege de San Bernardo de Murano per l'anema mia e laso ducati 6 que me sia manda asixa [Assisi] una persona de bona fame que priega dio per l'anema mia e laso ducati 4 que me sia dito le mese de la Madona per l'anema mia e laso ducati 3 que sia dadi a qualque bona persona que vada a [S. Pietro di] Chastelo agno vene retuor el perdun per l'anema mia uno ano e laso ducati 2 que sia dadi a qualque persona de bona chonsienzia que vada uno ano de longo angomer chore tuor el perdon a San Lorenzo e laso ducati 6 que me sia chavado uno prexonare per l'anema mia e laso ducati 2 dona Malgarita de Lubana que la priega dio per l'anema mia que mia mare [madre] la tegnua per amor de dio e laso ducati 3 a mio fante Nicholò de Soria qual que trovi in qua' da Pexaro per l'anema mia e laso ducati 2 a mia neva [nipote] Mariza que la priega dio per l'anema mia e laso ducati 2 a la mia femena Albanexe per l'anema mia e laso ducati 10 que sia despensadi a puoveri que sia de grandisima nezesità per l'anema mia e laso ducati 6 que sia despensadi ai puoveri de Sancto Lazaro e laso ducati 2 a Santa Brizida que i priega di[o] per anema mia e laso ducati 2 a la Charità per anema mia e laso ducati 3 a Sancto Zorzi da lega que diga mese per l'anema mia e laso ducati 4 a mia ameda madona Beruza Trevisan per l'anema mia e laso ducati 40 a mia madre e laso ducati 25 a mio frar [fratello] e laso ducati 23 a mia suor e laso ducati 100 a mio mario e laso tuto el mio rexidio a mie fioli si mascholi chome femene inqualmente; anchora vogio e hordeno que tuti i

mie beni mobeli stabeli chaduchi e hordenadi hover deshordenadi que m'as-
petase per alguna via e muodo hover in zenio vogi sia de mie fioli si mascholi
chome femene inqualmente; manchando l'un, vada de l'un in l'altro in fina
que isia aetade que se posa hordenar, non se trovando nasun de lor in fina que
la etade, laso ducati 400 a m[io] marido laso ducati 90 a mia madre e laso
ducati 90 a mio far [fratello] e laso ducati 50 a mia sorela per lo rexiduo que
sia mesi in la quamera de in presente e sia tolto el pro e sia despensado tra far
dir mese e puoveri e laso ducati 3 al noder." In a different hand, presumably
the notary's, an additional bequest of 2 ducats to S. Maria di Nazareth is
entered.

18. In her will of 1427, Alessandrina had identified herself as living in the *confinio*
of S. Giovanni Decollato.

19. Palazzo Pesaro at S. Benetto, also called the Pesaro degli Orfei, is now the
Museo Fortuny. Edoardo Arslan has dated the building to the mid-fifteenth
century for reasons of style, now partially substantiated by the evidence of
Alessandrina's and Franceschina's testaments; see *Gothic Architecture in Venice*,
trans. Anne Engel (London, 1972), pp. 331–32.

20. ASV, Gritti, B. 560, no. 255: "Ego Franceschina uxor viri noblis Ser Pietro
de Cha' da Pexaro quondam domini Andreas confinio S. Panthaleonis. . . ."
The date is unclear and may be read as either 1432 or 1442, but the contents
of the will suggest that the latter is correct. Note, for example, that in her
other will Franceschina named her husband, mother, brother, and sister as her
commissaries, whereas that list was extended in this notary's document to
include her children, evidently now old enough to assume the responsibility.
Franceschina's grandson Girolamo referred in his testament to his two parishes
of S. Benedetto and S. Angelo; see chap. 2, sec. 3 and n. 127.

21. I assume that the "S. Andrea" of the earlier testament is S. Andrea della Zirada,
as here. Neither S. Bernardo nor Corpus Christi survives. For the nuns of
Corpus Christi in 1395, see Lia Sbriziolo, "Per la storia delle confraternite
veneziane: Dalle Deliberazioni Miste (1310–1476) del Consiglio dei Dieci, *Sco-
lae Comunes, Artigiane e Nazionali,*" *Atti dell'Istituto Veneto di Scienze, Lettere
ed Arti* 130 (1967–68), *Classe di scienze morali, lettere ed arti* 126, p. 422.

22. ASV, Gritti, B. 560, no. 255: "Item dimitto uni personam que vadat Assis et
Roma per anima mea ducatos duodecem auris. . . ."

23. For Alessandrina's sons, see n. 12 above.

24. I have been unable to find another will. I am most grateful to Dr. Tiepolo,
Director of the Archivio di Stato in Venice, for allowing consultation of var-
ious indices of testaments on my behalf. These archival indices of testaments
are unfortunately not accessible to the public. Cf. the wills of two other
women, not to be confused with Pietro's wife Franceschina: a will of Fran-
ceschina Tron in ASV, Dalla Torre, B. 1062, no. 138, 11 December 1474,
naming her son "misser Lucha" as commissary; and a will of Franceschina,
the widow of Domenico da Cha' da Pesaro, 18 September 1478, ASV, An-
tonio Savina, B. 1235, no. 42.

25. Venetian chroniclers recorded a salutary procession held because of the plague
in 1478; see Nicolò Trevisan et al., *Cronica de Venetia*, Biblioteca Nazionale
Marciana, MS It. VII.519 (8438), fol. 289r. (formerly fol. cclxxi b): "De una

gran peste che fu in Venetia: Essendo la peste qui in Venetia prencipiada per modo che tutta la terra se messe in gran spamento, et in pochi zorni linsite de Venetia i tre quarti di citadini della terra e tutti i forestieri, et messer lo Dose [Giovanni Mocenigo] con la Signoria andò con li piati a S. Vido il zorno della procession, che mai più segni tal cossa. . . ." It was during the plague of 1478 that brothers of the Scuola di S. Rocco deemed it prudent to return to the old traditions of the medieval Scuole dei Battuti; see Brian Pullan, *Rich and Poor in Renaissance Venice, The Social Institutions of a Catholic State, to 1620* (Oxford, 1971), pp. 41–42.

26. See Max Ongaro, *Cronaca dei ristauri dei progetti e dell'azione tutta dell'Ufficio regionale ora Soprintendenza ai Monumenti di Venezia* (Venice, 1912), pp. 84–88, for the Pesaro construction, the damage it caused, and the restoration of the sacristy. Ongaro was in charge of the early twentieth-century restoration of the Frari. The sacristy had been restored also in the nineteenth century, in 1868–70 and in 1890 (see the Parish Archives, Armadio G, B. 2). That the apse was constructed as an addition to the sacristy is evident from the fabric of the exterior. Buttresses were added at the joint of the apse and sacristy wall, probably at the time when the apse itself was constructed. (The lower parts of these buttresses have been restored.) Note also that the stone level is homogeneous. I am grateful to the friars of the Frari for permitting me to study the apse from the area they call the "Giardino dei gatti," and to Caroline Bruzelius for her expert observations about the fabric.

27. The gate of the Corner Chapel was replaced in 1890–91, according to records in the Parish Archives, Armadio G, B. 4.

28. The arms of the keystone are still colored blue and gold, and presumably the arms in the capitals were also originally painted with the Pesaro colors. A small Pesaro stemma is set into the central window of the chapel.

29. The frescoes were discovered by Ongaro, *Cronaca*, p. 88. See also Aldo Scolari, "La chiesa di S.ta Maria Gloriosa dei Frari ed il suo recente restauro," *Venezia, Studi di arte e storia* 1 (1920): 161, with photographs of the sacristy before restoration.

30. The decoration of the *Cappella dei Mascoli* was begun in 1430 (the date of the inscription above the altar) and was still in progress in 1449. Michele Giambono signed the mosaics. However, except for the six apostles on the right, evidently by Giambono, the *Dormition* is clearly not by a Venetian and has been convincingly attributed to the Florentine Castagno by Thode, followed by Hartt. Castagno's presence in Venice is documented by his signing and dating of the vault frescoes in S. Tarasio (at S. Zaccaria) in 1442; in February 1444 he was back in Florence, and it was probably at that time that Giambono was commissioned to complete the mosaic cycle. See Frederick Hartt, "The Earliest Works of Andrea del Castagno," *Art Bulletin* 41 (1959): 168–81, on the frescoes, and pp. 225–32 and 234–36, on the mosaics.

31. See Ongaro, *Cronaca*, p. 85, figs. 65 and 66, for photographs of Gabriel before and after restoration. For the suggested attribution to a Paduan artist, perhaps Montagnana, see Antonio Sartori, *Guida storico-artistica della Basilica di S. M. Gloriosa dei Frari in Venezia* (Padua, 1949), p. 134.

32. A notable example of the *Annunciation* represented on the arch of a chancel is

Giotto's fresco in the Scrovegni Chapel, Padua; see Ursula Schlegel, "On the Picture Program of the Arena Chapel" (1957), in James H. Stubblebine, *Giotto: The Arena Chapel Frescoes* (New York and London, 1969), pp. 194–96. On Quattrocento depictions of the Annunciation, see Samuel Y. Edgerton, Jr., "*Mensurare temporalia facit Geometria spiritualis:* Some Fifteenth-Century Italian Notions about When and Where the Annunciation Happened," in *Studies in Late Medieval and Renaissance Painting in Honor of Millard Meiss,* ed. I. Lavin and J. Plummer (New York, 1977), vol. 1, pp. 115–30, esp. p. 121.

33. A lavabo in the style of the Lombardo was added to the right of the entrance arch. An inscription on the lavabo is dated 1828, but the style and quality of the carving suggest that it is a fifteenth-century piece.

34. Ongaro, *Cronaca,* p. 94, records the demolition of the houses. At present the exterior of this entrance to the sacristy is concealed by another, modern doorway. Inside, the stone step leading up to the sacristy chapel has been cut at the ends. If the step originally continued all the way to the side walls of the sacristy, as seems most likely, thus continuing across the doorway as well, then the entrance is a later addition.

35. Inscribed in the fictive gold mosaic of Bellini's Frari triptych; translated by Giles Robertson, *Giovanni Bellini* (Oxford, 1968), p. 89: "Sure Gate of Heaven, lead my mind, direct my life, may all I do be committed to thy care." The text is considered in chap. 2, sec. 2 of the present volume.

36. On the dedication of the church to the Assumption, see chap. 1, sec. 2, and chap. 3, secs. 3 and 5.

37. For the S. Giobbe altarpiece, see Erich Hubala, *Giovanni Bellini, Madonna mit Kind, Die Pala di San Giobbe* (Stuttgart, 1969), passim, and fig. 11 for a photomontage of the panel in its original frame, still in the church of S. Giobbe. See also Sandra Moschini Marconi, *Gallerie dell'Accademia di Venezia, Opere d'arte dei secoli XIV e XV* (Rome, 1955), pp. 67–69; and now Rona Goffen, "Bellini, S. Giobbe and Altar Egos," in *Artibus et Historiae,* vol. 7, no. 14 (1986): 57–70. Although it is generally dated ca. 1485, I find completely convincing Huse's dating of the S. Giobbe altarpiece to ca. 1480; see Norbert Huse, *Studien zu Giovanni Bellini* (Berlin and New York, 1972), pp. 48–55.

38. The frame of the triptych is signed on the back by Jacopo da Faenza, according to Sartori, *Guida,* p. 139. See also John McAndrew, *Venetian Architecture of the Early Renaissance* (Cambridge, Mass., and London, 1980), p. 61. Another inscription dated 1488 (the date of Bellini's signature) was written on the back of the central panel: "1488 addì 15/de febraio mat . . . / la ghemo da un [soazar]"; see Renato Ghiotto and Terisio Pignatti, *L'opera completa di Giovanni Bellini* (Milan, 1969), p. 100, no. 134. However, no matter who actually carved this frame, Bellini himself was clearly involved with the design. Of course, in itself the idea of combining real and illusionistic space was not a new one. It had already been exploited by Trecento artists, notably the Lorenzetti, and by Bellini's brother-in-law Andrea Mantegna, in his S. Zeno altarpiece in 1459. On the frames and formats of altarpieces, see H. Fechner, *Rahmen und Gliederung venezianischer Anconen aus der Schule von Murano* (Munich, 1969); and Creighton Gilbert, "Peintres et menuisiers au début de la Renaissance en Italie," *Revue de l'art* 37 (1977): 9–28.

39. From the saint's testament of 1226, translated by Benen Fahy, in Marion A. Habig, ed., *St. Francis of Assisi, Writings and Early Biographies, English Omnibus of the Sources for the Life of St. Francis* (Chicago, 1972), p. 67. See also Saint Francis's letter to all the Superiors of his order (ibid., p. 113).

40. For the artist's images of private devotion, see Goffen, "Icon and Vision: The Half-Length Madonnas by Giovanni Bellini," *Art Bulletin* 57 (1975): 487–518.

41. On the Brera altarpiece, see Millard Meiss, *La Sacra Conversazione di Piero della Francesca* (Florence, 1971); and an English translation of extracts by Meiss, in *The Painter's Choice: Problems in the Interpretation of Renaissance Art* (New York et al., 1976), pp. 142–47. Elsewhere—notably, in the *Madonna di Sinigallia*—Piero had adopted the Eyckian device of light flooding through a window, which is what Jan himself had represented in the panel now in Berlin, the exquisite *locus classicus* for the imagery of the Madonna in the church. For Jan van Eyck's *Madonna,* see Erwin Panofsky, *Early Netherlandish Painting: Its Origins and Character* (Cambridge, Mass., 1966), vol. 1, pp. 144–48 (hereafter *ENP*). As art historians have frequently observed, although the idea of a church setting for Madonna paintings is obviously suitable, it was not much used in fifteenth-century Italy, with the notable exceptions of Piero, Antonello, Bellini, and lesser north Italian masters influenced by Bellini.

42. Johannes Wilde reconstructed the altarpiece, of which only fragments survive, as an interior, with windows around the base of a dome. According to Frank Jewett Mather, however, the artist opened the rear wall to the sky. For the altarpiece, now in the Kunsthistorisches Museum, Vienna, see Vinzenz Oberhammer, *Katalog der Gemäldegalerie, I. Teil, Italiener, spanier, franzosen, engländer* (Vienna, 1965), pp. 2–3, with bibliography.

43. Bellini's panel was destroyed in 1867, in the same fire that consumed Titian's *St. Peter Martyr.* Roger E. Fry published a copy of Bellini's work in *Giovanni Bellini* (London, 1899); and Zanotto's engraving of the altarpiece is reproduced in Huse, *Studien,* pl. 12. For new archival evidence regarding the patronage of Bellini and Titian in SS. Giovanni e Paolo, see Goffen, "Bellini and the Altarpiece of St. Vincent Ferrer," in *Renaissance Studies Presented to Craig Hugh Smyth,* ed. E. Borsook et al. (Florence, 1985), pp. 277–96.

44. To cite only three examples, all in the Accademia in Venice: Marco Basaiti, *Agony in the Garden*; Vittore Carpaccio, *Apotheosis of St. Ursula*; and G. B. Cima da Conegliano, the *Sacra Conversazione* from the church of S. Maria della Carità.

45. I discuss the patronage and imagery of this altarpiece further in my essay on "Bellini, S. Giobbe and Altar Egos."

46. The same change is seen in Bellini's images for private devotion. In his Madonna paintings of the seventies, the master had used dark backgrounds, but he abandoned this scheme for settings of sky and landscape in his panels of the 1480s and thereafter. See Goffen, "Icon and Vision," pp. 492–93.

47. Bellini used the conception of the open sides of the architecture revealing sky and landscape again in his last great altarpiece of the Madonna, the masterpiece still in situ in S. Zaccaria, signed and dated 1505. See Huse, *Studien,* pp. 72–78.

48. I thank Sarah Wilk for this suggestion. For an example in late fifteenth-century

Venetian sculpture and architecture, see Sarah Wilk, *The Sculpture of Tullio Lombardo: Studies in Sources and Meaning* (New York and London, 1978), pp. 87 and 119–20, on Tullio's Bernabò Chapel of the Coronation in S. Giovanni Crisostomo, ca. 1499–1502. For pastophories in the illusionistic architecture of fifteenth-century tabernacles, see the master's thesis by Jack Freiberg, "The *Tabernaculum Dei*: Masaccio and the 'Perspective' Tabernacle Altarpiece," appendix A, pp. 93ff. For pastophories in architecture, see Günther Bandmann, "Über Pastophorien und verwandte Nebenräume im mittelalterlichen Kirchenbau," in *Kunstgeschichtliche Studien für Hans Kauffmann*, ed. W. Braunfels (Berlin, 1956), pp. 19–58, and n.b. figs. 1, 3, and 9 for the plans of Karab-Sems, Bourj-Haidar, and S. Maria Antiqua in Rome, all with pastophories resembling Bellini's in the Frari triptych. For similar churches in the Veneto, see Adriano Alpago-Novello, "Influenze bizantine ed orientali nel Veneto settentrionale (in relazione ad alcuni monumenti inediti)," *Archivio storico di Belluno, Feltre, e Cadore* 40 (1969): 81–95, kindly brought to my attention by Professor Wilk. On the Greek revival in fifteenth-century Venice, see Goffen, "Icon and Vision," pp. 487–90; and John McAndrew, "Sant'Andrea della Certosa," *Art Bulletin* 51 (1969): 15–28.

49. In this regard, also note Bellini's similar use of the parapet in his half-length images of the Madonna for private devotion; see Goffen, "Icon and Vision," pp. 499–500, for the illusionism and symbolism of the parapet.

50. Robertson, *Bellini*, p. 88. Fry thought the triptych must have been begun many years earlier and only completed in 1488, the year inscribed on the pedestal of Mary's throne (*Bellini*, p. 33). However, at least one of Bellini's patrons had very stylish taste—at the end of his life if not before—and that was Benedetto, as revealed by the specifications for his tomb (see chap. 2, sec. 3, and n. 113). It is also worth noting that two altarpieces completed for the Frari just prior to Bellini's were also triptychs: the signed and dated works by Bartolomeo Vivarini for the Corner Chapel of St. Mark in 1474 and for the Bernardo Chapel of the Madonna in 1482 (fig. 22).

51. To be sure, there are some "quasi precedents." In his altarpiece of the *Nativity of the Virgin*, dated 1342, Pietro Lorenzetti had made the antechamber of Anna's bedroom coincide with the left wing, while Anna's room is interrupted by the frame of the right wing. Now in the Museo dell'Opera in Siena, Pietro's painting originally included two additional flanking compartments with the figures of St. Savinus and St. Bartholomew. See Enzo Carli, *Pietro Lorenzetti* (Milan, n.d.), pl. xix. In the Mérode Altarpiece, Robert Campin represented the outside and two completely separate rooms of the inside of Mary's house; see Shirley Neilsen Blum, *Early Netherlandish Triptychs: A Study in Patronage* (Los Angeles, 1969), pp. 9–11. In 1457–59, Andrea Mantegna, Bellini's brother-in-law, combined the actual architecture of the frame with the fictive architecture of his S. Zeno altarpiece, still in situ in that church in Verona; but Mantegna's architecture does not represent an ecclesiastical setting.

52. For the Rogierian panels, now in Antwerp, Koninklijk Museum voor Schone Kunsten, see Panofsky, *ENP,* vol. 1, pp. 282–84. Panofsky argues for a date ca. 1460.

53. For Jan's altarpiece and the identity of the donor, see Panofsky, *ENP,* vol. 1, p. 184; and Elisabeth Dahnens, *Jan van Eyck* (New York, n.d.), pp. 385–86.

54. Masaccio's *Trinity* represents pastophories; see Freiberg, *"Tabernaculum Dei,"* p. 19; and, on the sacramental imagery of the painting, Goffen, "Masaccio's *Trinity* and the Letter to Hebrews," *Memorie domenicane,* n.s. 11 (1980): 489–504. In Masaccio's fresco, however, only the entrances to the pastophories are visible; Mary and John the Evangelist have joined the Persons of the Trinity in the apse of the illusionistic church.

55. The coincidence of these commissions, and also the late fifteenth-century sculpture triptych for the Trevisan Chapel of St. Michael may indicate that the friars themselves were encouraging the use of the triptych format for their new altarpieces.

56. The change in Bartolomeo's style in the eight years separating his two works for the Frari is extraordinary and probably due in no small measure to the influence of Giovanni Bellini. For the Corner altarpiece, see chap. 1, sec. 5; for the Bernardo altarpiece, with the family arms on the frame, see Rodolfo Pallucchini, *I Vivarini (Antonio, Bartolomeo, Alvise)* (Venice, n.d.), p. 126; and chap. 3, sec. 5 of the present volume. The Madonna is flanked by saints Andrew and Nicholas on the left and Peter and Paul on the right.

57. Tullio Lombardo's architecture in the Bernabò Chapel in S. Giovanni Crisostomo closely resembles Bellini's fictive structure. Flanking the Bernabò altar are pastophories with rectangular plans, flat roofs, and tall windows in the side walls, recalling Bellini's elimination of the side walls in the Frari altarpiece. Moreover, in his relief altarpiece of the *Coronation* for the same chapel, Tullio depicted illusionistic pastophories. Wilk discusses and illustrates Tullio's altar of ca. 1499–1502 in *Sculpture,* pp. 119–20, n. 80 on p. 120, and fig. 160.

58. For the cloth of honor in Bellini's work, see Goffen, "Icon and Vision," pp. 496–98.

59. For the consecration of the Frari, see chap. 1, sec. 2, and n. 46. It is worth noting that mosaic decoration was not used even in the Byzantinizing churches constructed in Venice in the later fifteenth century. For two fourteenth-century churches with mosaic decoration, see Sergio Bettini, *Mosaici antichi di San Marco a Venezia* (Bergamo, 1944), p. 12, kindly brought to my attention by Fulvio Zuliani.

60. Goffen, "Icon and Vision," p. 488.

61. For the date in Venetian historiography and its ritual significance, see Edward Muir, *Civic Ritual in Renaissance Venice* (Princeton, N.J., 1981), pp. 70–72ff. The political imagery of the Madonna in Venetian art is discussed further in chap. 5 of the present volume.

62. Other paintings with fictive gold mosaics include the following: by Bellini himself, the S. Giovanni Crisostomo altarpiece (1513); the *St. Peter* in the Accademia, Venice, ascribed to Bellini; Carpaccio's *Presentation,* also in the Accademia (and formerly adjacent to Bellini's S. Giobbe altarpiece in that church); the *Circumcision* by Marco Marziale (possibly copying a lost work by Gentile Bellini), in the National Gallery, London; another canvas by Marziale, a *Madonna and Saints* dated 1507, from S. Gallo in Cremona and now also in the National Gallery, London; Pordenone's *S. Lorenzo Giustinian,* in the Accademia; and Nicolò Rondinelli, *St. John the Evangelist Appearing to Galla Placidia,* Milan, Brera. For these various paintings, see: Martin Davies, *Earlier*

Italian Schools (National Gallery Catalogues), 2d ed. rev. (London, 1961), pp. 345–47; Ettore Modigliani, *Catalogo della Pinacoteca di Brera in Milano* (Milan, n.d. [1966]), p. 84; Moschini Marconi, *Accademia*, pp. 86–87 and 105–06; and idem, *Gallerie dell'Accademia di Venezia, Opere d'arte del secolo XVI* (Rome, 1962), pp. 174–75. For Bellini's S. Giovanni Crisostomo altarpiece, see Huse, *Studien*, pp. 99–102.

63. On the prelate, see Ludwig Mohler, ed., *Kardinal Bessarion als Theologie, Humanist und Staatsmann*, 3 vols. (Paderborn, 1923–42); the biography by H. Vast, *Le Cardinal Bessarion (1403–1472), Etude sur la chrétienté et la Renaissance vers le milieu du XVᵉ siècle* (Paris, 1878); and the following articles in the *Rivista di studi bizantini e neoellenici*, n.s. 5 (1968): by Joseph Gill, "East and West in the Time of Bessarion, Theology and Religion," pp. 3–27; Nicola B. Tomadakis, "Oriente e Occidente all'epoca del Bessarione," pp. 29–40; and Theodoros N. Vlachos, "Bessarion als päpstlicher Legat in Venedig im Jahre 1463," pp. 123–25. Cardinal Bessarion bequeathed two great gifts to the Serenissima, his library and the relic of S. Teodoro. Bessarion's donation of his library is considered in D. J. Geanakoplos, *Byzantine East and Latin West: Two Worlds of Christendom in Middle Ages and Renaissance, Studies in Ecclesiastical and Cultural History* (Oxford, 1966), p. 116. For Bessarion's influence on the "Byzantine revival" in late fifteenth-century Venice, see Goffen, "Icon and Vision," pp. 487–90.

64. ASV, Frari, B. 2, fol. 91v.

65. Bessarion compared Venice to Byzantium in a letter of 1468 to Doge Cristoforo Moro; see Geanakoplos, *Byzantine East*, p. 116.

66. We are so accustomed to Bellini's representing the Madonna enthroned that some observers see a throne here, even though it was omitted (e.g., Huse, *Studien*, p. 50).

67. Perhaps the date of the triptych is related somehow to the tenth anniversary of Franceschina's death in 1478 and to her bizarre request that her body be kept above ground for ten years after her demise (ASV, Gritti, B. 560, no. 255): "Et vollo . . . hoc ante quam corpus meum sepulter tendatur quia vollo tenery per annum dicem naturaliter supra terram primus quam corpus meum sepuliat in honore constitate meorum commissiorum."

68. Bellini was evidently an accomplished musician, judging from the knowledgeable way in which he depicted music-making; see Emanuel Winternitz, "A *Lira da Braccio* in Giovanni Bellini's *The Feast of the Gods*," *Art Bulletin* 28 (1946): 114–15.

69. Both texts are quoted in Yrjö Hirn, *The Sacred Shrine* (London, 1912), p. 337. See also Ingvar Bergström, "Medicina, Fons et Scrinium. A Study in Van Eyckean Symbolism and Its Influence in Italian Art," *Konsthistorisk Tidskrift* 26 (1957): 17; and Goffen, "Icon and Vision," p. 505. For Bellini's visualization of specifically Franciscan texts in another context, see now John V. Fleming, *From Bonaventure to Bellini: An Essay in Franciscan Exegesis* (Princeton, N.J., 1982).

70. See chap. 1, sec. 3, with bibliography in n. 52 of that chapter.

71. Translated by Raphael Brown in Habig, *St. Francis*, p. 1429. Brown explains (p. 1285) that this anonymous author, probably from southern Tuscany, put

most of the Latin *Actus* by Brother Ugolino into Italian, ca. 1370–85, and entitled the translation the *Fioretti*. The anonymous author then compiled a new treatise, "The Considerations," combining five chapters of the *Actus* with material from Celano, Bonaventure, and other writers. A fifteenth-century manuscript of the *Fioretti* incorporating the "Trattato delle sacre stimmate" is preserved in the Biblioteca Nazionale Marciana, MS. It. I.9 (5230); the treatise is fols. 103a–146b. On the "Mass of the Five Wounds" and the "Prayer of the Five Wounds," see Louis Gougaud, *Devotional and Ascetic Practices in the Middle Ages,* trans. G. C. Bateman (London, 1927), pp. 82–83. For the endowment of a hospital in Venice named the "Five Poor [Men] of God," in honor of the five wounds, see the will of Marco Disenove, ASV, Procuratia de Ultra, B. 117A, 3 October 1350, published by Dennis Romano, "Charity and Community in Early Renaissance Venice," *Journal of Urban History* 11 (1984): 79, n. 25.

72. The S. Giobbe altarpiece is considered above, chap. 2, sec. 2, with bibliography in n. 37. For the *Coronation of the Virgin,* see the doctoral dissertation by Carolyn Wilson, "Giovanni Bellini's Pesaro Altarpiece: Studies in Its Context and Meaning" (New York University, Institute of Fine Arts, 1976). On the *Francis,* see Millard Meiss, *Giovanni Bellini's St. Francis in the Frick Collection* (Princeton, N.J., 1964); and, more recently, with a discussion of the artist's Franciscan iconography, Fleming, *From Bonaventure to Bellini.* Note also another work with probable Franciscan associations, the *S. Giustina* (Milan, Bagatti Valsecchi Collection), evidently commissioned by the Borromeo family for a reliquary of that saint in S. Francesco, Milan. See Bernard Berenson, *The Study and Criticism of Italian Art, Third Series* (London, 1916), pp. 38–61; and Robertson, *Bellini,* pp. 62 and 64, with further bibliography in the notes.

73. The panels have been separated; the main part of the altarpiece is in the Musei Civici of Pesaro, while the *Pietà* is in the Vatican Pinacoteca. See Gustavo Frizzoni, "A Plea for the Reintegration of a Great Altarpiece," *Burlington Magazine* 22 (1913): 260–69.

74. I have taken this description of Mary as *Sacred Shrine* from Hirn's indispensable book with that title. For the comparison of Bellini's triptych frame with a tabernacle, see the doctoral dissertation by Julia Helen Keydel, "A Group of Altarpieces by Giovanni Bellini Considered in Relation to the Context for Which They Were Made" (Harvard University, 1969), pp. 173–74. N.b. also that Titian's *Assunta* for the high altar of the Frari is enframed by a relief of the dead Christ and a statue of the Resurrected. See chap. 3, sec. 3 of the present volume.

75. Helen S. Ettlinger, "The Iconography of the Columns in Titian's Pesaro Altarpiece," *Art Bulletin* 61 (1979): 64 and nn. 9, 54, and 67. Ettlinger points out that by 1500, illustrations of Ecclesiasticus 24 in altarpieces signified the Immaculate Conception. For Ecclesiasticus and the Wisdom iconography of the Madonna, see David Rosand, "Titian's *Presentation of the Virgin in the Temple* and the Scuola della Carità," *Art Bulletin* 58 (1976): 68, n. 74; and idem, *Painting in Cinquecento Venice: Titian, Veronese, Tintoretto* (New Haven and London, 1982), pp. 106–07.

76. Goffen, "A Bonaventuran Analysis of Correggio's *Madonna of St. Francis,*"

Gazette des Beaux-Arts 103 (1984): 15; and, for the iconography of the high throne, Sinding-Larsen, "La 'Madone Stylithe' di Giorgione," in *Giorgione, Atti del Convegno Internazionale di Studi* (Castelfranco Veneto, 1978), pp. 285–91.

77. For Mary as the Sedes Sapientiae, see Louis Bouyer, *The Seat of Wisdom,* trans. A. V. Littledale (Chicago, 1965), pp. 20–27, 45, 192–98, and passim.

78. Above, n. 25. See Ettlinger, "Iconography," p. 63 and n. 56, for the Virgin Immaculate as a protectress against the plague. This may be relevant to the Bellini commission, as Franceschina died during a plague year. Perhaps her sons intended their altarpiece to have a salutary benefit ex post facto. Too, the quotation from Nogarolis in the fictive mosaic may suggest that the painting was planned between 1478 and 1480, when Sixtus IV approved another Office of the Conception, by de Bustis, for use by the Franciscan order. On this, see chap. 3, sec. 1, above.

79. John Duns Scotus, *Opus Oxoniense,* L. III, d. 3, q. 1, n. 3, XIV, inter alia; as discussed by Berard Vogt, "Duns Scotus, Defender of the Immaculate Conception—An Historical-Dogmatic Study," *Studia Mariana* 9 (1954): 168, n. 33; 169, n. 34; and 172, n. 43. John R. Spencer points out to me that the word *ianua* was also used in Medieval documents for the portals of cathedrals, e.g. those by Bonanus for Pisa. A different image of the gate or portal, Ezekiel's "porta clausa" (Ezek. 44 : 2), was associated by St. Ambrose and others with the Virgin Birth; see Hirn, *Sacred Shrine,* p. 335 and n. 6. The doctrine of the Immaculate Conception is discussed further in chap. 3, sec. 1, and chap. 5, sec. 2, above.

80. For early observance of the feast of the Conception, see chap. 3, sec. 1. Wadding incorrectly claimed that the Friars Minor were observing the feast already in 1263; see *Annales,* vol. 4, p. 244; and A. LeCarou, *L'Office divin chez les Frères Mineurs* (Paris, 1928), p. 207. For Wadding's error, see H. Golubovich, "Statuta Liturgica Seu Rubricae Breviarii Auctore Divo Bonaventura in Generali Capitulo Pisano An. 1263 Editore," *Archivum Franciscanum Historicum* 4 (1911): 62–73.

81. Cherubinus Sericoli, *Immaculata B. M. Virginis Conceptio iuxta Xysti IV Constitutiones (Bibliotheca Mariana Medii Aevi,* Fasc. 5 [Sibenic and Rome, 1945]); the bull *Cum praecelsa* is pp. 153–54. For further information on the history and the meaning of the feast, see LeCarou, *L'Office divin,* p. 207; Heiko Augustinus Oberman, *The Harvest of Medieval Theology, Gabriel Biel and Late Medieval Nominalism* (Cambridge, Mass., 1963), p. 285 and n. 9; and chap. 3, sec. 1, above.

82. See chap. 3, sec. 1.

83. S. Maria dei Miracoli, the first church in Venice consecrated to the *Immacolata,* was begun in 1480, although altars had certainly been dedicated to the Conception in Venice before that date (see Ettlinger, "Iconography," p. 63). For a chapel dedicated to the Immaculate Conception in the Cathedral of Treviso by the Franciscan bishop Giovanni Zanetto in 1483, see Gerolamo Biscaro, "Note storico-artistiche sulla Cattedrale di Treviso," *Nuovo archivio veneto* 17 (1899): 135–94, which was kindly brought to my attention by Wolfgang Wolters. On the cult of the Conception in Venice, see chap. 5, sec. 2, below.

84. As Staale Sinding-Larsen has noted: "La pala dei Pesaro e la tradizione dell'immagine liturgica," in *Tiziano e Venezia* (Vicenza, 1980), p. 201.

85. See Wadding, *Annales,* vol. 11, p. 98 (no. 39) for the year 1439; Francesco Fapanni, *Chiese claustrali e monasteri di Venezia,* Biblioteca Marciana, MS Ital. VII.2283 (9121), fol. 136v; Lucio Pusci, "Profilo di Francesco della Rovere poi Sisto IV," in *Storia e cultura al Santo,* ed. Antonino Poppi, vol. 3 of *Fonti e studi per la storia del Santo a Padova, Studi 1* (Vicenza, 1976), p. 281; and Giuseppe Bettiolo, *La 'Fradaja' de Missier Santo Antonio de Padoa alla "Ca' Grande" (1439), Studio di documenti inediti* (Venice, 1912), pp. 37–38.

86. Della Rovere served as minister general for five years during the period when his then admirer Bessarion was acting as Cardinal Protector (1458–72). The two prelates later had a falling-out. Attendance at the General Chapter that della Rovere convoked for 1469 was rewarded with indulgences by Pope Paul VII in a bull dated 6 May 1464; see ASV, Frari B. 106, fasc. xxxii, no. 12. The bull indicates that the chapter was celebrated during Pentecost. For the consecration of the altar of the Frari, see chap. 1, sec. 2.

87. John Moorman calls the papacy of Sixtus IV "the Golden Age for the friars"; *A History of the Franciscan Order from Its Origins to the Year 1517* (Oxford, 1968), p. 513. Before Sixtus, there had been only two other Franciscan popes, Nicholas IV (1288–92) and Alexander V (1409–10). After Sixtus, the next Franciscan pope was his nephew and protégé, Julius II della Rovere (1503–13). Ultimately, Sixtus's measures intended to strengthen the Friars Minor proved divisive: the Observants were opposed to some of the special privileges he granted and the Conventuals became, with Sixtus's encouragement, even more intransigent. (Sixtus himself was a Conventual Franciscan.) See Moorman, pp. 486–500, for the election of della Rovere and "The Drift towards Division"; and chap. 1, sec. 1, and chap. 3, sec. 2, of the present volume for the friars of Venice and for the division of the order in 1517.

88. *Magnum Bullarium Romanum,* vol. 1, pp. 404–05, the feast of St. Francis, "ut duplex ab omnibus celebratur"; pp. 408–11, *Mare Magnum;* pp. 432–34, *Bulla Aurea,* of which paragraph 4 (p. 433) grants indulgences for contributions for the construction of Mendicant churches; pp. 437–39, the canonization of St. Bonaventure. For the feast of the Immaculate Conception, see chap. 3, sec. 1.

89. W. Carew Hazlitt, *The Venetian Republic, Its Rise, Its Growth, and Its Fall 421–1797* (London, 1900), vol. 2, pp. 130–31.

90. See Lodovico da Besse, *Il B. Bernardino da Feltre e la sua opera* (Siena, 1905), vol. 1, pp. 141–42; and Timoteo Spimbolo, *Storia dei Frati Minori della Provincia Veneta di S. Francesco* (Vicenza, 1933), vol. 1, pp. 86–88.

91. In 1465, Nicolò was sopracomito di galera for the armada against the Turks and general in the fleet under Doge Cristoforo Moro. In 1480, Nicolò was named capitano di Vicenza; and four years later he served the Republic first in the war with Ferrara and then in the treaty negotiations. He fought the Turks again in 1490 and in 1498, as proveditor di l'armata. One of his sons, Pietro, became a friend of Henry VIII of England, and another, Girolamo, was buried in the Frari in 1555. (See Capellari, *Campidoglio,* vol. 3, fols. 206v–207r.) For Nicolò's career, see ibid., fol. 206v; and Gabriele Moro, "Orazione in morte di Benedetto da Pesaro Capitanio Generale della Veneta Armata, e Procurator di S. Marco," in *Orazioni, Elogie e Vite scritte da letterati veneti patrizi . . . ,* 2d ed. (Venice, 1798), vol. 1, p. 163. For Nicolò's marriage in

1463, see ASV, Avogaria di Comun, Cronaca Matrimoni, B. 106/1, fol. 58r, in which he is identified as Nicolò de Piero Pesaro "da Londra." For the name "Pesaro of London," see also n. 99 below.

92. L. D. Ettlinger points out that the *Immacolata* was represented together with saints Peter, Francis, and Anthony in Sixtus's funerary chapel in Old St. Peter's; see "Pollaiuolo's Tomb of Sixtus IV," *Journal of the Warburg and Courtauld Institutes* 16 (1953): 239–74.

93. Titian's votive painting, now in Antwerp, is considered further in chap. 4, sec. 1.

94. The Pesaro's devotion to the Madonna is discussed in chap. 4, sec. 2.

95. See chap. 3, sec. 1.

96. Moro, "Orazione," p. 161.

97. As discussed in chap. 1, sec. 5, with bibliography in the notes.

98. Capellari, *Campidoglio,* vol. 3, fol. 206v. In 1470, Marco married a daughter of Francesco Venier; ASV, Avogaria di Comun, Cronaca Matrimoni, B. 106/1, fol. 58r (not a Molin, as recorded by Barbaro, *Arbori,* Biblioteca Nazionale Marciana, MS 8492, fol. 354a).In 1497, one of Marco's daughters married a grandson of Doge Francesco Foscari, whose tomb is in the chancel of the Frari; see Barbaro, ibid., fol. 189a. One of Marco's sons, Francesco, was married to Clara, the daughter of procurator Francesco Foscari; a document recording her division of property with her two sisters, dated 27 July 1520, is preserved in the Biblioteca Correr, MSS P. D., Opuscula 191–2, c. 1297, 5.

99. ASV, Avogaria di Comun, Cronaca Matrimoni, B. 106/1, fol. 58r, and ibid. for the identification of his brother Nicolò as "da Londra." Benedetto himself was identified in this way by Sanuto, *Diarii,* vol. 3, col. 558. Aside from the indispensable diarist, the most valuable sixteenth-century sources for Benedetto are the deposition by his secretary, Marco Zorzi, dated 1503 (Biblioteca Correr, Codice Cicogna 2941, III/3); Pietro Bembo, *Della Istoria Viniziana* (Edizione de' classici italiani, 57 [Milan, 1978]), vol. 1, pp. 317–99; and Sigismondo dei Conti, *Storia de' suoi tempi* (Rome, 1883), vol. 2, pp. 276–79. Secondary sources include: Guido Almagià, "Pesaro, Benedetto," in *Enciclopedia italiana di scienze, lettere ed arti* (Rome, 1935), vol. 26, p. 932; Mario Brunetti, "Un implacabile ammiraglio della Serenissima," *Rassegna veneziana di lettere ed arti* (1932), pp. 7–14; G. Cogo, "La guerra di Venezia contro i turchi (1499–1501)," *Nuovo archivio veneto* 18, pt. 1 (1899, Anno 9): 5–76 and 348–421; ibid., 19, pt. 1 (1900, Anno 10): 97–138; Nicolao Crasso, *Pisaura gens* (Venice, 1652), p. 436; Sydney Nettleton Fisher, "The Foreign Relations of Turkey 1481–1512," *Illinois Studies in the Social Sciences* 30 (1948): 9–124; Mario Nani Mocenigo, "Il capitano generale da mar Benedetto Pesaro," *Rivista di Venezia a cura del comune,* ser. 1, vol. 11 (1932), pp. 385–99 and 496–507; and Zabarella, *Carosio,* pp. 54–56.

100. A sixteenth-century copy of the manifestum of 10 May 1486 is preserved in the Biblioteca Correr, MS Dandolo, P. D. c. 1101, 11. The Pesaro paid 600 ducats for the land. For the name "S. Stin," see chap. 1, n. 12. On the Venetian fraterna, or family "corporation," see Frederic C. Lane, "Family Partnerships and Joint Ventures in the Venetian Republic," *Journal of Economic History* 4 (1944): 178–79 and 194–95; and Jacques Heers, *Le Clan familial au*

moyen age (Paris, 1974), pp. 233–34. Jacopo Usnago, who was also buried in the Frari, declared in 1521 that he had been the agent (*factor*) of the fraterna of Nicolò Pesaro and his brothers for over forty years, a reference reflecting Nicolò's status as the oldest brother; see ASV, Frari, B. 5, fols. 9v–10r, and B. 137, for the original testament, filed with papers of the Usnago family.

101. The documents were published by Rinaldo Fulin (the editor of Sanuto's diaries), "Gli inquisitori dei Dieci, VI," *Archivio veneto* 1 (1871): 305–16.

102. Sanuto, *Diarii,* vol. 1, col. 667, and vol. 2, cols. 80 and 487–88.

103. Ibid., vol. 2, col. 619, and vol. 3, col. 558. Benedetto's son Girolamo was married on 10 April 1499, and the Council adjourned so that everyone might attend the party (ibid., vol. 2, col. 601). The marriage was registered by the Avogaria in 1498: ASV, Avogaria di Comun, B. 107/2, fol. 261r.

104. Sanuto, *Diarii,* vol. 2, col. 1305, and vol. 3., cols. 553ff. and 557. See ibid., vols. 3 and 4, passim, for Benedetto's dispatches. Bembo also commented upon Benedetto's exceptional authority; *Istoria,* p. 317. In this war against the Turks, a crusade called by Alexander VI Borgia, the Venetians were seen as "Christianity's first line of defense"; see Alberto Tenenti, "The Sense of Space and Time in the Venetian World of the Fifteenth and Sixteenth Centuries," in *Renaissance Venice,* ed. J. R. Hale (London, 1973), pp. 28 and 25–26, on the difficult period ca. 1500, after the loss of Negroponte. See also Frederic C. Lane, "Naval Actions and Fleet Organization, 1499–1502," in *Renaissance Venice,* pp. 146–73, especially pp. 165–66 and notes.

105. Sanuto, *Diarii,* vol. 3, col. 558: "Et poi, reduto sier Beneto da cha' da Pesaro, capetanio zeneral di mar, vestito damaschin cremexin, a manege averte, bareta di raso cremexim, con il senato, vene a lai il principe, *juxta morem,* per venir a tuor el stendardo in chiesia di San Marco. . . . Et, udito messa, fo benedì il stendardo, qual per non haver il suo fato, li fo dà quello fo di sier Francesco di Prioli, fo zeneral; et fo acompagnà da la chieresia e principe fino al montar in galia grossa. . . . Et, dirò cussì, fo gran cossa, sì presto si expedisse, et degna cossa di gloria a la caxa sua. Va con bon animo, è disposto farsi honor, è cognominato da Londra, fo *alias* capetanio di le galie di Fiandra."

106. Ibid., cols. 1272–73; Marco Zorzi, *Deposition* [1503], Correr, Codice Cicogna, 2941, III/3, passim; and Fisher, "Foreign Relations," p. 78 and nn.

107. Fisher, "Foreign Relations," pp. 82–83.

108. Sanuto recorded Benetto's letters of 26 June 1501 and 21 January 1501 (*m.v.*) reporting the arrest and execution of the two noblemen; *Diarii,* vol. 4, cols. 87 and 231. Doge Loredan was portrayed by Giovanni Bellini; National Gallery, London, no. 189: Davies, *Earlier Italian Schools,* pp. 55–56. In 1529, the doge's grandson, also named Leonardo, was married to Maria, a daughter of Antonio Pesaro, one of Benedetto's cousins. Their marriage contract is preserved in ASV, Pesaro, B. 2, no. 6.

109. Sanuto, *Diarii,* vol. 5, col. 568, reported a complaint brought against the recently deceased admiral on 18 December 1503. The case continued for some time, and accusations were also brought against Pesaro's surviving relatives (e.g., see ibid., cols. 892–93). Benedetto's secretary, Marco Rizzo, was accused as well, but was finally absolved of charges on 21 February 1506, in the *Quarantia Criminal* (ibid., vol. 6, cols. 301–02). Benedetto remembered his secretary

in his will: "Item dimitto Marco Ritio, secretario meo et notario, pro mercede conficiendi testamentum et in signum amoris, ducatos vigintiquinque. . . . Marcus Ritius, secretarius meus [inter alia], in quibus plurimum me confido, sint ad gubernium et ad curam tam pecuniarum qua aliorum bonorum que reperio habere in presentiarum apud me"; ASV, Cristoforo Rizzo, B. 1227, no. 74, fols. 2r–v. I thank Professor Gino Corti, who very kindly helped me with this passage.

110. Sanuto, *Diarii,* vol. 5, cols. 57 and 65.

111. Antonio had not been paid for his biscuits in 1500. See ibid., vol. 3, cols. 1396–97.

112. For the admiral's death, see ibid., vol. 5, col. 67; and Zorzi, *Deposition,* fol. 14r. On the peace with Turkey, see Fisher, "Foreign Relations," p. 86. The treaty had been concluded on 30 July 1503, and Santa Maura was consigned to Turkey on 31 August.

113. Benedetto's testament is ASV, Cristoforo Rizzo, B. 1227, no. 74, 11 July 1503. The following clauses are from fol. 1r: "Ego Benedictus de Cha' de Pesaro, Procurator S. Marci, Capitaneus Generalis Maris Serenissimi Dominii Venetiarum . . . volo et ordino . . . quod corpus meum imprimis sepeliatur in ecclesia Sancti Francisci Venetiarum Ordinis Minorum in capella nostra que est in sacristia eiusdem ecclesie Fratrum Minorum. Et pro memoria volo quod commissarii mei hic inferius nominandi et describendi fieri faciant super portam eiusdem sacristie unum nobile monumentum marmoreum cum collumnis marmoreis, ubi corpus meum postea reponatur, et fieri faciant epitaphium rerum per me gestarum super ipso monumento, in quo expendant usque ad summam ducatorum mille, et de hoc onero conscientias eorum. Et intentio mea est quod porta eiusdem sacristie destinatur et reducatur in forma convenienti non accipiendo ob hoc aliquid eiusdem ecclesie, et postea super ipsam portam conficiatur superscriptum monumentum marmoreum cum eis collumnis, prout superius dictum est." (I am grateful to Gino Corti for his help with this passage.) On fol. 1v of the testament, Benedetto provided 25 ducats for daily masses in perpetuity for his soul and requested masses of the Blessed Virgin: "Item volo et ordino quod pro anima mea celebretur et dicatur quotidie usque in perpetuum una missa in dicta ecclesia S. Francisci Venetiarum Ordinis Minorum, per eius celebratione dare debonent ipsam ecclesiam ducatos vigintiquinque omni anno, et hoc volo quod sit ultra obligationem . . . quotidie unam missam in ipsam capella sacristie. . . . Item volo et ordino quod dicantur misse Beatissime Marie Virginis et S. Gregorii pro anima mea. . . ." On fol. 2r, Benedetto made a bequest to one Friar Mark, who was asked to pray for the admiral's soul: "Item dimitto venerabile domino Fratri Marco de Venetiis, Ordinis S. Francisci Minorum, sacra theologie professori, ducatos decem ut habeat causam orandi pro me. . . ."

114. For Savelli, see chap. 1, sec. 2, and n. 37. Marcello was fatally wounded at the seige of Gallipoli in 1484, as the inscription of his monument records: "Iacobo Marcello chr. f. viro. innocentiss. et/clarriss. summis. Domi. forisq. dignitatib. ex/repub. functo. qui quum. postremo. dificili/oribus. reip. temporib. quib. cum. universa. ita./lia. bellum. gerebatur. classis. imp. ageret. ora./maritima. undiq. fideliter. constanter. q. de/fensa. urbem. galipolin. in.

salentinis. aggre/ssus. expugnavit. in. ipsa. victoria. intrepide. x/occumbens. veteris. disciplinae. documenta./civibus. suis. reliquit. causam. honorificis.pr/ aebitae. pacis. condicionibus. dedit. publicis/ lacrymis. in. funus. elato. ludovicus. et. petr.ˢ/ filii. pientiss. posuere. MCCCCLXXXIIII." The monument was plastered over in the seventeenth century and uncovered in 1899 (Sartori, *Guida*, p. 149). Traditionally ascribed to Pietro Lombardo, the Marcello tomb has more recently been attributed to Buora by Munman, followed by A. M. Schulz. See Robert Munman, "Giovanni Buora: The 'Missing' Sculpture," *Arte veneta* 30 (1976): 41 and 47–52; and Anne Markham Schulz, "Giovanni Buora lapicida," *Arte lombarda*, n.s. 75, pt. 2 (1983): 51. An inscription in the pavement in front of Marcello's monument identifies the tomb of one of his descendants, Alvise, who died in 1517. Buried between Jacopo Marcello and Pesaro is the Blessed Pacifico, who seems a saintly interloper in this company. For the monument of the Blessed, see Gino Fogolari, "L'urna del Beato Pacifico ai Frari," *Atti del Reale Istituto Veneto di Scienze, Lettere ed Arti* 89, pt. 2 (1939): 937–53; and Wolfgang Wolters, *La scultura veneziana gotica (1300–1460)* (Venice, 1976), vol. 1, pp. 187 and 269–70. B. Pacifico may have been B. Giovanni da Chioggia, called "Carissimo," as suggested by Sartori, *Guida*, p. 127.

115. Restoration was completed in August 1984. See Giovanna Nepi Scirè, "Recenti restauri alle Gallerie dell'Accademia," *Quaderni della Soprintendenza ai Beni Artistici e Storici di Venezia* 13 (1985), in press at the time of this writing. The tomb had been repaired in 1826; see ASV, Pesaro, B. 102, n. 5.

116. The pirate to whom the inscription refers was the Turk Kemāl Re'īs, called Camali in Venetian sources. See, for example, Bembo, *Istoria*, p. 343.

117. This is Sansovino's attribution, with the exception of the figure of Mars, which he gives to Baccio di Montelupo (*Venetia*, p. 66r). Modern scholars seem to agree with Sansovino. Pietro di Osvaldo Paoletti concurs, adding that Lorenzo's brother Giovanni Battista assisted him ("Bregno, Lorenzo," *Thieme-Becker*, vol. 4, p. 570). John McAndrew dates the work soon after 1500 but places the pediment somewhat later, around 1520–25 (*Venetian Architecture*, pp. 483–84 and 487). Most recently, see Anne Markham Schulz's article on "Lorenzo Bregno" in the *Berliner Jahrbuch* 26 (1984), which was in press while this book was being prepared for publication. Dr. Schulz kindly made her text pertaining to the Pesaro monument available to me prior to publication. Zabarella published an inscription dated 1537 (of which there is no trace in the church), evidently recording a commemorative action by Benedetto's son Gerolamo: "Hieronymus Pisaurus Imperator Classis Venetae contra Turcas Anno Christi M. D. XXXVII Patri Monumentum Posuit"; see Zabarella, *Carosio*, p. 56; and also Jürg Meyer zur Capellen, "Beobachtungen zu Jacopo Pesaros Exvoto in Antwerpen," *Pantheon* 38 (1980): 152, n. 48.

118. Sinding-Larsen has noted the "Christ-like attitude with banner in hand" of the Marcello effigy; see "Titian's Triumph of Faith and the Medieval Tradition of the Glory of Christ," *Istitutum Romanum Norvegiae, Acta* 6 (1975): 328–29. For a further consideration of the standing posture, see, more recently, Goffen, "Carpaccio's *Portrait of a Young Knight*: Identity and Meaning," *Arte veneta* 37 (1983): 42–43.

119. See Jan Białostocki, "The Sea-Thiasos in Renaissance Sepulchral Art," in *Studies in Renaissance and Baroque Art Presented to Anthony Blunt on his Sixtieth Birthday* (London and New York, 1967), pp. 69–74. Brunelleschi used dolphin capitals in the Pazzi Chapel, and Bellini used them in his fictive architecture, repeating the stone frame of the S. Giobbe altarpiece.

120. Sansovino, *Venetia* (1581), p. 68v.

121. McAndrew also discusses the Pesaro monument's resemblance to an arch of triumph; *Venetian Architecture*, pp. 483–84 and 487.

122. Howard Burns pointed out to me that the use of columns in the Pesaro monument is much in keeping with the latest Venetian taste ca. 1500—for example, in addition to the monuments cited in the text, the Vendramin tomb, the base of the *Colleoni,* the exterior of the Zen chapel, and the facade of S. Zaccaria, as well as the fictional architecture in Gentile Bellini's *St. Mark Preaching in Alexandria* and in the *Hypnerotomachia Polifili*.

123. Whose kinsman Marco Loredan Benedetto had executed by decapitation; chap. 2, sec. 3.

124. Sanuto, *Diarii,* vol. 5, cols. 78–79. "Et hessendo zonta la galia dil zeneral Pesaro in questa terra, il corpo in una cassa fo portato in chiesia di San Beneto, et poi ozi, luni, a dì 4, fu fato lo exequio *honorifice* in chiesia di Frati menori, dove in la sacrestia è la sua archa e sarà sepulto. Prima, portata la cassa a San Marco, vene el capitolo di San Marco e quel di Castello, la scuola di San Zuane, tutte le congregazioni, et era torzi di lire 2 l'uno numero 100 e la scuola, et altri 100 di lire 8 l'uno, *videlicet* portati 20 da frati menori, 20 da jesuati, 20 da preti, et 40 da marinari. Atorno la cassa 12 homini con mantelli con gran coa e capuzi in cao; la cassa portada da quelli di la scuola con il pomo d'oro del stendardo di zeneral; e sopra la cassa era il stendardo d'oro, che copriva tutta la cassa con una celada e spada lavorada a la damaschina. Lo acompagnò il principe, con li oratori e la Signoria, et assa' patricii. . . . Et veneno per terra di San Marco fino a li Frati menori, dove era in mezo la chiesia preparato con pani negri dove fu posto la cassa; *etiam* atorno la chiesia con telle negre, assa' luminarie. Fu bel exequio; fu fato la oration funebre per sier Gabriel Moro qu. sier Antonio, laudandolo assai, la qual fo butada in stampa, et poi el principe tornò con li piati a San Marco etc." The participation of members of the Scuola di S. Giovanni in Benedetto's funeral rites suggests that he was a brother of the confraternity.

125. The oration has been published, as Sanuto noted: Gabrielis Mauri [Gabriele Moro], "In funere Benedicti Pisauri . . . Oratio," in *Orazioni, elogi e vite scritte da letterati veneti patrizi,* 2d ed. rev. (Venice, 1798), vol. 1, pp. 161–67. Also singled out for praise was Benedetto's uncle Luca, who had triumphed over the Genoese in 1443, and who in 1459 was made Procurator de Ultra. He died in 1462. (For Luca, see Capellari, *Campidoglio,* vol. 3, fol. 206v.) Benedetto's brothers had died before him, as is clear from his designation of his nephews as commissaries of his estate: "Commissarios autem meos volo et ordino hoc esse: dominam Helisabeth Teupulo, sororem meam, Petrum de Cha' da Pesaro, filium quondam domini Nicolai fratris mei, Franciscum de Cha' da Pesaro, filium quondam domini Marci fratris mei, nepotes meos charissimos, dominum Hieronimum Duodo olim socerum meum, dominum Lazarum Mo-

cenigo, generum meum, filium magnifici domini Ioannis, et Ieronimum de Cha' da Pesaro, unicum et dilectissimum filium meorum" (ASV, Rizzo, B. 1227, no. 74, fol. 2r).

126. Girolamo's marriage to Donata Donado was registered by the Avogaria di Comun in 1498, and Sanuto recorded their wedding party in 1499 (*Diarii*, vol. 2, col. 601). Girolamo, one of the *Pregadi,* was elected Captain of the Galleys of Flanders in 1503; and in 1511, he was made Podestà and Captain of Treviso (ibid., vol. 5, col. 28, 30 April; and vol. 13, col. 212, 9 November; see also vol. 13, col. 500, 22 February, for his entrance into Treviso). In 1515, on the feast of the Assumption—which may suggest something about Giro-lamo's devotion to the Virgin—he made his ceremonial entrance into Padua as captain of the city (ibid., vol. 20, col. 514). Capellari, *Campidoglio,* vol. 3, fol. 207r, also summarizes Girolamo's public career. His surviving son, Be-nedetto, was born in 1511 and married Lucrezia Valier in 1533. The birth of Benedetto di Girolamo is listed in in ASV, Avogaria di Comun, Nascite, B. 51/I, fol. 233r, and his wedding in ASV, Avogaria di Comun, Cronaca Ma-trimoni, B. 106/1, fol. 58v. The bride was evidently portrayed in the famous *Lucrezia* by Lorenzo Lotto, and her sons, Girolamo, b. 1536, and Francesco, b. 1537, in a double portrait optimistically attributed to Titian. These boys and their father were the heirs and commissaries of Girolamo q. Benetto. See Michael Jaffé, "Pesaro Family Portraits: Pordenone, Lotto and Titian," *Bur-lington Magazine* 113 (1971): 696–702; and, more recently, for the double por-trait, idem, in *The Genius of Venice,* ed. J. Martineau and C. Hope (London, 1983), pp. 224–25.

127. There are two contemporaneous "copies" known to me: ASV, Francesco Bianco, B. 126, no. 472; and ibid., B. 128, fols. 161r–64v. A late copy is included in ASV, Pesaro, B. 1, n. 10, fols. 1r–21v. This will, Girolamo ex-plained, was to take precedence over all earlier testaments and codicils made by him: "cassando et annullando tutti & cadauni altri mei testamenti per mi per avanti fatti pregati et quoius modo scripti insieme cum tutti & cadauni codicilli et gionte che se attrovasseno talmente che siano nulli et de nisun vallore ma sollamente questo sia fermo et vallido . . ." (B. 128, fol. 161r). An abbreviated eighteenth-century plan of the northeast end of the Frari, preserved in the Archivio di Stato in Venice, shows the altar of S. Carlo immediately to the east of the Cappella Corner, to which Girolamo refers in his will. See ASV, Frari, B. 129, "Corner" (i.e., the plan is filed with papers regarding the Corner family); B. 2, fol. 13r, no. 57; and B. 106, fasc. xxxiii, no. 5i, nine-teenth-century notes on the location of Girolamo's tomb at the door near the Corner chapel. For restorations around the altar of S. Carlo in 1855–56, see the Archives of the Parish, Armadio G, B. 2, Rubrica 5, sezione 1, cartella 20, fasc. 20-B.

128. Dante mentioned the custom critically as a hypocritical deathbed gesture in the *Inferno,* canto 27, ll. 112–14. Sixtus IV, however, encouraged it by re-warding burial in the habit with indulgences in 1479; ASV, Frari, B. 2, fols. 5r–v.

129. For Franceschina's will of 1432, see chap. 2, sec. 1, and n. 17.

130. Girolamo's will is transcribed below in n. 132. On the Miracoli and the cult of the Immaculate Conception, see chap. 3, sec. 1, and chap. 5, sec. 2, below.

131. But cf. "Item volgio chel sia sanctiffato et fate dir una messa in perpetuo in la contra[da] de S. Benedeto de Venetia per l'anima del q. [quondam] messer Nicolò da Cha' da Pesaro et del q. messer Andrea suo fiol. Et chel sia dato al mansionario ducati quindese all'an[n]o come me son obligato, et se dice al presente per uno fratte del Convento de S. Stephano . . ." (ASV, Bianco, B. 128, fols. 163r–v). This clause, endowing a fund for S. Stefano and masses for his uncle and cousin in the parish of S. Benedetto, may indicate that they were interred there. If that is so, perhaps the chapel in the Frari sacristy had become more specifically the funerary chapel of the family of Benedetto Pesaro and his heirs. They would presumably have been buried beneath Franceschina's tombstone.

132. ASV, Bianco, B. 128, fols. 161v–63r: "el qual corpo io volgio chel sia vestito del habito de misser S. Francesco di Conventuali, et alle exequie, siano quatro torze de conveniente peso, et sì alle dicte mie exequie quanto per el tempo che stara el dicto mio corpo in chiesia de San Benetto [Benedetto]. Item quatro capitoli, zoè S. Marco, [S. Pietro di] Castello, S. Beneto, et Sancto Anzolo, et tutti quelli mansionarii che dicono messa in le dicte mie contrade. Item dodese Iesuati cum torze numero dodese, de lire quatro l'una. Et volgio che el cavalleto dove sarà el mio corpo sia tolto, et portato da marinari a Sancta Maria de Fratti Menori, et lì messo in uno deposito, nella sacrestia de dicta chiesia, dove che se la nostra Capella. . . . Item volgio che siano dati ducati diese [dieci] al convento del monasterio de Fratti Menori, et ducato uno al Sagrestano di esso Convento, per la spesa et hellimosina della ditta mia sepultura. Et sia etiam dato alli fratonzelli di esso monasterio ducati doi [due] per hellimosina. Et per respecto che de proximo son aseso per gratia della bontà de Dio, et de questo illustrissimo dominio, al grado de Procuratore, perho io son contento che parendo alla mazor parte delli predetti mei commissarii loro possino acresser alle mie exequie quel piùj numero de gierici et cere che li parrerano; volgio che siano ditte le messe della Madona et de San Gregorio, per l'anima mia; volgio chel sia mandato a Roma et a Sixa [Assisi] per l'anima mia cum la hellimosina consueta. Item volgio che sia date per hellimosina ducato uno per cadauno delli ditti monasterii de monache per far oratione quando parera alli mei commissarii, zoè a S. Maria Mazore, a li Miracoli, S. Sepulchro, Ogni Sancti, S. Chiara de Muran, alli Anzoli, S. Andrea de Zirra [Zirada], S. Stephano, S. Iustina, S. Servolo, S. Crose de Venetia et a S. Crose dalla Zudecha. . . . Item volgio che per li mei commissarii sia ellecto uno capellan de bona vita, prete o fratte, che continuamente dica messa per l'anima mia nella contra[da] che habitera la descendentia mia . . . et habia ad havere ditto capellan in perpetuo a rason de anno ducati vinti correnti per hellimosina, da esser pagato de tempo in tempo per li mei commissarii, . . . cum questa obligatione de tenir el dicto mansionario, perche la bona memoria del clarissimo mio progenitor et padre honorandissimo lasso al convento de Fratti Menori ducati quindese all'anno per una messa della qual io da poi ho fatto per piùi tempo la satisfactione. . . . Item volgio che per l'anema della bona memoria de mio padre et de mia madre che sia fatto uno exequio principiando dal zorno dello annual de mio padre per el convento de Fratti Menori, et de mia madre poi, cum dir una messa allo altar grando, cantada, fazendo le

sollite exequie davanti la sua archa come e consueto, et andare alle arche el zorno di morti et etiam in sagrestia dove se sepulta mia madre et mia molgier et fioli; et fino chel sara el mio deposito nella ditta sacrestia, et quando el sara posto nella archa, andar alla ditta archa lo anno poi subsequente se fazi etiam lo annuario mio, ritornando sempre al modo predicto de anno in anno. Per li qualli tre annuali habiano ad haver ducato uno corrente per hellimosina, et siano obligati li mei commissarii et heredi ogni anno a far star impiato uno torzo de lire sei la vigillia delli morti et il giorno davanti la archa de mio padre, et uno altro davanti el mio deposito et archa quando sara fatta, et in quella posto el mio corpo. Item volgio chel sia rechiesto al convento predicto, che contenti di lassar far la mia archa sopra la porta che se esse de giesia, nella crosera, retotramite per mezo alla porta della sacrestia dove se l'archa de mio padre, et che consenti che quanto sarra conveniente dalla banda de dentro, de lassar coprir quella fenestra longa che immediate de sopra la possate far; et per spender meno in dicta archa, volgio dove che quella de mio padre se de quatro collone, sia fatta de due collonne, et a fin se possi meter due figure, io volgio che alladi de esse collone sia fatto come sonno alla porta che intra nella chiesa de San Zorzi Mazor, et chel sia tirato tanto quello bassamento de conveniente rellievo, et così nello architravo, friso, et cornise di sopra, che sopra el rellievo della cornise possi capir abbelmente. Per cadauna delle bande, una figura che vegnera a essere apresso le due collone dalle bande di fuora, et di sopra delle qual due collone habia a far quel precise che fa nella archa de mio padre, la qual io volgio che sia de piera viva, excepto nelli frisi che siano investiti de tavolete de marmoro, et la investison che intrera tra le due collone di sopra, et le fegure, et tuto il resto sia de piera viva, senza orro alcuno, excepto nelle arme che fusseno fatte, et nel casson far intaiar: in li doi terzi la città de Brandizo; et in l'altra parte el castello del Scoio della dicta città de Brandizo da mar; et ne l'altra terza parte la città de Scardona. Et per che essa fabricha de l'archa saria bislonga sella [se la] se fasse sopra al longo del frontespizo alla porta, volgio che tanto quanto se la porta de legno che è sotto ditto frontespizo habia a andar le due prime collone cum quel piui tornasse bene alle mesure conveniente di essa fabricha; et poi chel sia tirato di sopra el friso cum l'architravo et cornise, si che essa porta restando come si attrova in oppera dalla banda de dentro, resti quadra, et se possi aprir tutta quella di legno, come si fà al presente, et dalla banda de fuora resti con el suo frontespizo, lavorando per modo che de fuori non sia impedito; si come habelmente si po fare; et perche le ballestrade de essa porta appar uno poco mazor di sopra, far si debba uno tavolado per modo che non desdigi alla fabrica nova. Le tre figure: sarrà una i.e. sopra l'archa al modo de quella de mio padre, le altre due che anderano apresso quelle collone di sopra, quelle cornise ho ditto di sopra siano fatte de tanto rellievo che abbelmente possano star di sopra, de grandeza conveniente; l'una de qual figure habia ad tenir in mano el gaiardo [literally, "the powerful one," but in this context signifying "the ship's pennant"] et nell'altra mano uno scudo cum l'arma, et l'altra in mano in cima de uno bastone la cellada, et nell'altra el scudo come ho ditto dell'altra. Et perché attorno el ditto frontespizo se attrova uno certo foiame antigo cum una figura de Nostra Donna in qual medemo loco che la si attrova nell'archa de mio padre, et che fazi quello effecto

che fa quella, et quando el convento volgi che di sopra l'archa sia fatto uno poco di sopra per non desdir alla forma del'archa quella antiquità, sia reposta per metter quella fegura de Nostra Dona overo sopra a quell'altra porta che va nella capela di Corneri, cum quelli lavori che è sulla Nostra Donna, o altrove; volgio che sia remesso a spesa della mia commissaria. Et nella ditta sia acomodata la tavola del epitaphio nella qual sia le opperatione publice per mi fatte, la qual oppera io volgio che sia fatta per comodità della mia commissaria in anni diese a parte a parte si che in ditto tempo sia finita. . . ." See also ASV, Frari, B. 3, fol. 26v, a copy of two clauses from Girolamo's will. He asserts that his commissary will assume the obligation of his father's endowment of fifteen ducats a year to the Frari in case the source of funds diminishes. Second, the clause regarding the endowment of masses is copied there, and again in Catastico 31, fol. 50v. Note also B. 3, fol. 19r, regarding the family's bequest to the Frari of rent from a house in Padua in 1522.

133. The excerpts from the "supplication" of 1550 are from ASV, Frari, B. 133, "Pesaro": "Dexiderando io Beneto da Cha' da Pexaro, fo del clarissimo messer Ieronimo il Procurator, reverendi padri, prior et convento, far uno depoxito al ditto quondam mio padre ne la vostra giexia di Fra Menori, et parendomi a zie loco abile et conveniente farlo sopra la porta che esse di la giexia al'incontro di la porta di la sagrestia sopra la qual è il dipoxito dil quondam mio avo, et ancor che abi forma credenza che caduna di Vostre Reverende Paternità serano pronte a concedermi ditto locho, si perché el ditto depoxito sera di non picolo adornamento di la sua gexia et porta, si è cia per el dexiderio che so esser in loro di gratificarmi, come per il pasato si an[n]o dimostrati pronti verso tuta caxa nostra, mi ha parso con la presente suplicar Vostre Reverende Paternità a conciedirmi che possi far ditto depoxito sopra ditta porta senza percho detrimento alcuno si di quel muro et porta, anzi a conservatione di l'uno et l'altra, et ancora chel suo convento ne recevi qualche altro utile per conta nostra, mi offero in segno di gratitudine darli ducati 25 in elemoxina et oltra zia offerendomi sempre pronto in ogni ocorentia al comodo utile et beneficio di le Paternità Vostre Reverende ale qual mi ricomando." At the bottom of the page is a note dated 6 February [1550] indicating the friars' agreement. The document was later summarized in ASV, Frari, B. 2, fol. 13.

134. ASV, Frari, B. 106, fasc. xxxiii.4, fols. 44r–v. This is listed among "Oblighi passivi" in a catalogue of "Perpetual obligations, both outstanding and fulfilled" (fol. 43r).

135. Sartori, *Guida,* p. 62, asserted that the tomb was demolished for this reason. See also idem, p. 33, of the 1956 edition.

136. Ibid. See also Vincenzo Zenier, *Guida per la chiesa di S. Maria Gloriosa dei Frari di Venezia* (Venice, 1825), p. 7, for the Pesaro stemma at the portal of S. Carlo.

CHAPTER III

1. Iacopone da Todi, "O Vergen plu ca femena," *Laude,* ed. Franco Mancini, Scrittori d'Italia, 257 (Rome, 1974), p. 86.

2. Bernardino de Bustis, "Officium et Missa de Immaculata Conceptione [1480]," *Acta Ordinis Fratrum Minorum,* vol. 23, fasc. 12 (1904), p. 406. Bernardino was

paraphrasing Ct 4, 7: "Tota pulchra es amica mea et macula non est in te." A volume of his sermons on Mary was published in Strasbourg in 1498: *Mariale, sive Sermones 63 de B. V. Maria.*

3. On Germano's patronage and the date of the high altar, see sec. 3 and nos. 68–71 of this chapter.

4. The division of the order is discussed in sec. 2. For the dissension between the Conventuals and the Spirituals (future Observants) during the mid-thirteenth century, see Rosalind Brooke, *Early Franciscan Government, Elias to Bonaventure* (Cambridge, Eng., 1959), pp. 181–82 and passim.

5. *Ineffabilis Deus,* 8 December 1854. Approval of the feast for the entire church is discussed later in chap. 3, sec. 1.

6. Ignatius Brady, "The Doctrine of the Immaculate Conception in the Fourteenth Century," *Studia Mariana* 9 (1954): 95 and n. 104. The tract *Contra Disceptationes . . .* by Henricus de Sassia (Heinrich Heynbuch von Langstein) was published in Milan in 1480.

7. Sanuto, *Diarii,* vol. 32, cols. 192–93, 1 December 1521. Sanuto recounted that the Dominicans of Treviso did not want the Franciscans to build a new church and convent in their neighborhood because of their disagreement regarding the Immaculate Conception.

8. Vatican, Pinacoteca, no. 293. See Fabrizio Mancinelli and Ezra Nahmad, *Musei Vaticani, Pinacoteca* (Florence, 1981), s.v. "Maestro Lucchese dell'Immacolata Concezione." The related panel, no. 295, shows two enemies reconciled by the Immaculate Virgin as a result of the prayers of one of them before her altar, with an altarpiece showing Christ with his hand over the head of the kneeling Madonna.

9. *Summa,* III, Q. 27, a. 2, ad.2, trans. Berard Vogt, "Duns Scotus, Defender of the Immaculate Conception—An Historical-Dogmatic Study," *Studia Mariana* 9 (Second Franciscan National Marian Congress [San Francisco, 1954]), p. 163. Saint Thomas died in 1274. In 1278 his teachings were given the official approval of his order. At the Dominican General Chapter of 1315, held in Bologna, it was decreed that convent libraries acquire useful books, and most especially works by Saint Thomas Aquinas. The 1489 inventory of codices in S. Maria Novella made by Sardi lists ninety books by him, far more than any other author. (Next was Aristotle and commentaries on his work: 58 volumes.) See Stefano Orlandi, *La biblioteca di S. Maria Novella in Firenze dal sec. XIV al sec. XIX* (Florence, 1952), pp. 6 and 24.

10. Scotus, *Opus Oxoniense,* L. III, d. 3, n. 14, XIV, 171, as translated by Vogt, "Scotus," p. 170. For Scotus's powerful influence on the debate concerning Mary's Immaculacy, see X. Le Bachelet, in *Dictionnaire de théologie catholique,* vol. 7¹ (Paris, 1927), cols. 1073–78, s.v. "Immaculée Conception." The entry by Le Bachelet and M. Jugie, monographic in length, is still the prolegomenon for all serious study of the Conception; ibid., cols. 845–1218.

11. Scotus argued this in the *Opus Oxoniense* and in the famous debate in Paris in 1307; see Vogt, "Scotus," pp. 167 and 170; and Martin Jugie, *La Mort et l'assomption de la sainte Vierge* (Vatican City, 1944), pp. 539–41. I thank Salvatore I. Camporeale, O.P., for his generous help regarding this and other theological issues. If I have committed any doctrinal error despite Professor

Camporeale's knowledgeable assistance, the blame, of course, is entirely my own.

12. Bernardino De Bustis, "Officium," p. 403. In the hymn "Gaude Mater Salvatoris," Bernardino apostrophises Mary as the "true temple of Solomon" (ibid., p. 402).

13. Vogt, "Scotus," p. 173.

14. Le Bachelet, "Immaculée Conception," col. 1089; Vogt, "Scotus," p. 162; and Brady, "Doctrine," p. 72.

15. Le Bachelet, "Immaculée Conception," cols. 1073–78; and Brady, "Doctrine," p. 70.

16. In fact, the correct translation of the original New Testament Greek is "Be graced," and it was the mistranslation in the Vulgate which became the traditional scriptural reference in the theology of the attribution of privileges to Mary—including her Immaculate Conception. For the Angelic Salutation and Mary's privileges, see Le Bachelet, "Immaculée Conception," cols. 861–64. (Le Bachelet explains furthermore that Elizabeth's words of greeting to Mary in the Visitation, Luke 1 : 42, were also considered proof of her special privileges: "Blessed art thou among women.") For Aquinas's interpretation of the Angelic Salutation, see Jugie, *Mort*, pp. 393–94, and n. 1 on p. 393. The problematic translation of the Angelic Salutation in the Vulgate was criticized by Martin Luther in his "Sendbrief vom Dolmetschen," dated 12 September 1530; see *D. Martin Luthers Werke* (Weimar, 1909), vol. 30, pt. 2, pp. 638–39, and pp. 632–46 for the entire text of the letter on problems of translation. I thank Professors Camporeale and David C. Steinmetz for their help with these matters.

17. Designed by Ghirlandaio, the windows were executed in 1492 by Alessandro Agolanti, called Il Bidello. The choir cycle was commissioned by Giovanni Tornabuoni in 1485, and work was completed in 1490; see Jan Lauts, *Domenico Ghirlandajo* (Vienna, 1943), pp. 34 and 52. The Dominican Marian cycle of S. Maria Novella and the Immaculatist interpretation of the Assumption according to the Franciscans are considered further in chap. 3, sec. 5.

18. Jugie, *Mort*, pp. 195–97.

19. Petrus Thomae, *Liber de Originali Virginis Innocentia*, written between 1316 and 1327; see Brady, "Doctrine," pp. 76–79.

20. For the celebration of the feast in the east, see Jugie, "Mort," pp. 245–46; and idem, in *Dictionnaire de théologie catholique*, vol. 7¹ (Paris, 1927), cols. 893–975, s.v. "Immaculée Conception" (a section within the monographic article by Le Bachelet).

21. Le Bachelet, "Immaculée Conception," col. 987. The Neapolitan calendar was written between 840 and 850.

22. In the twelfth century the liturgies of the Nativity and of the Conception might be used interchangeably, which implies that Mary's conception was understood merely as a date in her life; see Andrea M. Cecchin, "La concezione della Vergine nella liturgia della chiesa occidentale anteriore al secolo XIII," *Marianum* 5 (1943): 97–99.

23. Allan B. Wolter, "Doctrine of the Immaculate Conception in the Early Franciscan School," *Studia Mariana* 9 (1954): 26–28.

24. Brady, "Doctrine," p. 101. For fourteenth-century Italian and Franciscan bre-
 viaries that list the feast of the Conception, see Le Bachelet, "Immaculée Con-
 ception," col. 1098. For the feast in fifteenth-century Venetian missals, see
 Silvio Tramontin, "Il 'Kalendarium' veneziano," in *Culto dei santi a Venezia*
 (Venice, 1965), p. 323. The chronicler Wadding wrongly believed that the
 Order of Friars Minor had been observing the feast of the Conception since
 1263. For Wadding and his error, see chap. 2, n. 80, above.
25. On the Council of Basel, see Johannes Haller, *Concilium Basiliense: Studien und
 Quellen zur Geschichte des Concils von Basel,* 7 vols. (Basel, 1896–1926); E. I.
 Hefele and H. Leclercq, *Histoire des Conciles* (Paris, 1916), vol. 7; Le Bachelet,
 "Immaculée Conception," cols. 1108–15; Heiko Augustinus Obermann, *The
 Harvest of Medieval Theology* (Cambridge, Mass., 1963), p. 285; and Brady,
 "Doctrine," p. 110.
26. For the role of the Venetian clergy at the Council, see Antonio Niero, "L'azi-
 one veneziana al concilio di Basileia," in *Venezia e i concili* (Venice, 1962),
 pp. 3–46; and Paolo Prodi, "The Structure and Organization of the Church
 in Renaissance Venice: Suggestions for Research," in *Renaissance Venice,* ed.
 J. R. Hale (London, 1973), p. 420.
27. In their dreams, della Rovere's mother and father saw their baby son receive
 the Franciscan habit and knotted cord from the hands of saints Francis and
 Anthony. For this saintly career planning and Sixtus's education by the Con-
 ventuals, see Lucio Pusci, "Profilo di Francesco della Rovere poi Sisto IV,"
 in *Storia e cultura al Santo,* vol. 3, ed. Antonino Poppi (*Fonti e studi per la storia
 del Santo a Padova, Studi, 1* [Vincenza, 1976]), pp. 279–81 and passim; Egmont
 Lee, *Sixtus IV and Men of Letters* (Rome, 1978), pp. 11–28; and Wadding,
 Annales, vol. 11, pp. 98–99. As Pope Sixtus, the former Minister General of
 the Franciscan order continued to wear the friar's habit under his papal robes,
 and he was buried in the habit; see Raphael M. Huber, *A Documented History
 of the Franciscan Order from the Birth of St. Francis to the Division of the Order
 Under Leo X (1182–1517)* (Milwaukee and Washington, D.C., 1944), p. 441.
 Sixtus greatly increased the privileges of the Mendicant orders, most notably
 with his bulls *Mare Magnum* (1474) and the *Bulla Aurea* (1479); see Huber,
 pp. 419–22, and Roger Aubenas, in Aubenas and Robert Ricard, *L'Eglise et la
 Renaissance (1449–1517)* (*Histoire de l'église,* vol. 15, ed. A. Fliche and V. Martin
 [n.p., 1951]), p. 85. For della Rovere's devotion to the Immaculate Conception
 and to the cult of the Virgin in general—it was he who instituted the feast of
 the Visitation in 1475, for example—see Aubenas, *L'Eglise,* p. 86; Le Bachelet,
 "Immaculée Conception," cols. 1120–24; and A. Teetaert, in *Dictionnaire de
 théologie catholique,* vol. 14² (Paris, 1941), cols. 2208–09, s.v. "Sixte IV." On
 the public disputation on the Conception held before Sixtus in 1477, with the
 Dominicans opposing and the Franciscans defending belief, see Huber, *History,*
 p. 434. Sixtus IV built two chapels dedicated to the Immaculate Virgin. For
 his funerary chapel in Old St. Peter's, see L. D. Ettlinger, "Pollaiuolo's Tomb
 of Sixtus IV," *Journal of the Warburg and Courtauld Institutes* 16 (1953): 239–74.
 (The Sistine Chapel was also dedicated to the Virgin, with explicit connota-
 tions of her Immaculacy.) In addition, Sixtus also erected an altar to the Im-
 maculate Virgin in the Lower Church of S. Francesco in Assisi; see Ludovico

da Pietralunga, *Descrizione della basilica di S. Francisco e di altri santuari di Assisi* (1570–80), ed. Pietro Scarpellini (Treviso, 1982), p. 71. For Sixtus and the Frari, see chap. 2, sec. 2 of the present volume. On the pope's Franciscan partisanship, see my forthcoming article, "Friar Sixtus and the Sistine Chapel," *Renaissance Quarterly* 39 (1986): 218–62.

28. See Cherubinus Sericoli, *Immaculata B. M. Virginis Conceptio iuxta Xysti IV Constitutiones* (Bibliotheca Mariana Medii Aevi, 5 [Sibenic and Rome, 1945]); *Cum Praecelsa* is on pp. 153–54. See also Teetaert, "Sixte IV," col. 2209; and Brady, "Doctrine," p. 70.

29. On Leonardo de Nogarolis, see Le Bachelet, "Immaculée Conception," col. 1122; and Helen S. Ettlinger, "The Iconography of the Columns in Titian's Pesaro Altarpiece," *Art Bulletin* 61 (1979): 53 and n. 48.

30. For the papal brief *Libenter,* issued 4 October 1480, see L. Grifus in Sericoli, *Immaculata,* p. 155; idem, in Bernardino de Bustis, "Officium," p. 401, n. 4 (with the text of the brief); and Michael Brlek, "Legislatio Ordinis Fratrum Minorum de Immaculata Conceptione B. M. V.," *Antonianum* 29 (1954): 28; for the office itself, see Bernardino de Bustis, "Officium," pp. 401–20. For Sixtus's approval of Bernardino's office and for the determination of the day of the feast of the Conception, see Wadding, *Annales,* vol. 14, pp. 293 and 296, and ibid., pp. 195, 268, and 328, for the pope's championship of the doctrine.

31. On the continued use of this text by the Franciscan order, see Frederick G. Holweck, in *Catholic Encyclopedia* (New York, 1910), vol. 7, p. 680, s.v. "Immaculate."

32. Bernardino de Bustis, "Officium," p. 402: "Veri templum Salomonis. Sponsa Dei, Stella maris, Porta coeli tu vocaris . . ."; p. 403: "In sole posuit tabernaculum suum Dominus . . . tabernaculum suum Altissimus"; and on p. 406: "porta coeli . . . in coeli ianua . . . ," and so on. For Bernardino's paraphrase of Ct 4, 7, see the quotation used as an epigraph to this chapter and n. 2 above. Bernardino also compares Mary to the "lily of the valley," etc. (Ct 2 : 1).

33. For Sixtus's bulls of 1482–83, *Grave Nimis,* "prior" and "posterior," Sericoli, *Immaculata,* pp. 156–61. On the continuing controversy, see Le Bachelet, "Immaculée Conception," cols. 1120–24; and Oberman, *Harvest,* p. 285 and n. 9.

34. Le Bachelet, "Immaculée Conception," cols. 1124–25. (Bandello was following Aquinas; see n. 9 above.)

35. Ibid. Few copies of the *Opusculum* survive in Italian libraries; only ten are listed by E. Valenziani and E. Cerulli, *Indice generale degli incunaboli delle biblioteche d'Italia* (Rome, 1965), p. 259.

36. Oberman, *Harvest,* p. 285 and n. 9. N.b. also the concessions made by Sixtus IV in 1484 and by Alexander VI in 1499; see Brlek, "Legislatio," p. 30.

37. Of noble birth, Giustiniani was consecrated bishop of Venice (S. Pietro di Castello) in 1433 and patriarch in 1451 (bull of Nicholas V, October 8). He was canonized by the Venetian pope Alexander VIII (Ottoboni) in 1690. See Edward Muir, *Civic Ritual in Renaissance Venice* (Princeton, N.J., 1981), p. 242; and Vittorio Piva, in *Enciclopedia cattolica,* vol. 7 (Vatican City, 1951), cols. 1554–55, s.v. "Lorenzo Giustiniani, santo." For the patriarchate itself, see Prodi, "Structure," pp. 415–17.

38. For Jacopo's image of Giustiniani, see Georg Gronau, *Die Künstlerfamilie Bellini* (Bielefeld and Leipzig, 1909), p. 9; and Juerg Meyer zur Capellen, *La figura del San Lorenzo Giustinian di Jacopo Bellini,* Centro Tedesco di Studi Veneziani, Quaderni, no. 19 (Venice, 1981).

39. This is the earliest dated painting by Gentile, inscribed: "MCCCCLXV/ Opus.Gentilis.Bellini/Veneti." See Sandra Moschini Marconi, *Gallerie dell'Accademia di Venezia, Opere d'arte dei secoli XIV e XV* (Rome, 1955), p. 61.

40. See Francomario Colasanti, *San Lorenzo Giustiniani nelle raccolte della Biblioteca Nazionale Marciana, Catalogo di Mostra* (Venice, 1981), pp. 18 and 44. Colasanti (p. 56) notes the publication of the first biography of Giustiniani by his nephew Bernardo in 1475, though it was probably written already in 1471. See Agostino Pertusi, "Gli inizi della storiografia umanistica nel Quattrocento," in *La storiografia veneziana fino al secolo XVI, aspetti e problemi* (Florence, 1970), ed. idem, p. 318, n. 2. Bernardo's biography has recently been reprinted: I. Tassi, *Vita beati Laurentii Iustiniani Venetiarum Proto Patriarchae* (Rome, 1962).

41. *Opera Divi Laurentii Iustiniani Venetiarii Prothopatriarcha* (Bressanone, 1506); a copy is found in Venice, Biblioteca Nazionale Marciana, Rari 257. An Italian translation by Andrea Picolini was published in Venice in 1565: *Devoti sermoni delle solennità de Santi del beato Lorenzo Giustiniano . . . primo patriarca di Venezia.* On the saint's writings, see Silvio Tramontin, "La cultura monastica del Quattrocento dal primo patriarca Lorenzo Giustiniani ai Camaldolesi Paolo Giustiniani e Pietro Quirini," in *Storia della cultura veneta* (Vicenza, 1980), vol. 3, pp. 431–57.

42. *Opera,* sermon on the Annunciation, xx recto: "Ab ipsa namque sui concæptione in benedictionibus est praeventa dulcedinis atque a damnationis aliena chirographo prius est sanctificata, quam nata. In ipso enim utero materno iam posita super illam gratia santificationis effulsit: utpote ci quae electa erat ut pareret deum. Noverat opus suum ille qui fecerat et quale futurum erat certissime agnoscebat. Hinc est quod virginem ipsam tam largo imbre spiritus irroavit. Erat plane sicut a carnis colluvione immunis, ita et ab omni peccati labe extranea." Le Bachelet refers to this text and notes Giustiniani's emphasis on the cult in his writings ("Immaculée Conception," col. 1117). In the 1506 *Opera,* each writing is paginated separately.

43. *Opera,* sermon on the Nativity, liii recto: "immaculatum templum."

44. Ibid., sermon on the Purification, xvi recto: "Hoc ipse eius mater immaculata virgo perfecit. Venit et illa ad templum, ut purificationis mysteria celebraret. Nequaquam in hac parte tenebatur sub lege, quippe quae non ex virili semine sed de spiritu sancto concæperat prolem. . . . Ut autem deum veneraretur in lege formamque humilitatis ex hoc praeberet per legem, legem voluit purificationis implere." For the significance of the feast of the Purification in Venice, see chap. 5, sec. 1.

45. *Le prediche volgari di San Bernardino da Siena dette nella Piazza del Campo l'anno MCCCCXXVII,* ed. Luciano Banchi (Siena, 1884), vol. 2, pp. 391–92. See also Yrjö Hirn, *The Sacred Shrine, A Study of the Poetry and Art of the Catholic Church* (London, 1912), pp. 450–51 and 460. For Saint Bernardino and his cult in Venice and in the Frari, see Appendix I *supra.*

46. John R. H. Moorman, *A History of the Franciscan Order from Its Origins to the*

Year 1517 (Oxford, 1968), pp. 576 and 581. See Amato Pietro Frutaz, "La chiesa di S. Francesco in Assisi, 'Basilica patriarcale e cappella papale,' " *Miscellanea francescana* 54 (1954): 426, for bulls issued by Gregory IX in 1230 in which the pope called the church "caput et mater" of the Order of Friars Minor.

47. Moorman, *History,* pp. 573–74 and 580. See also Teetaert, "Sixte IV," col. 2213.

48. Grimani, who was Cardinal Protector of the order from 1503 until his death in 1523, was also the cardinal-priest of S. Marco (Rome), administrator of Nicosia (Cyprus) and Ceneda (Aquileia), and patriarch of Aquileia. See Conradus Eubel and Guilelmus van Gulik, *Hierarchia Catholica Medii et Recentioris Aevi,* vol. 3 (Regensberg, 1923), pp. 5, 65, 114, and 162.

49. 22 November 1510; Moorman, *History,* p. 574.

50. Ibid., p. 582.

51. When Sixtus IV, a Conventual, tried to subordinate the Observants to the Conventuals in 1472, he was overwhelmed by letters of protest. In the face of such widespread and deeply felt support for the Observants, the pope had to withdraw his plan. He was humorous, if somewhat snide, in his defeat: "Ego putavi mihi rem esse cum mendicis et pediculosis fratribus, non cum universis Principibus." See Huber, *History,* p. 411 and n. 14.

52. Sanuto, *Diarii,* vol. 24, cols. 321–22, 2 June 1517, referring to letters from Rome: "Ozi [May 25?] è stà Concistorio sopra la materia di frati Menori et Observanti zercha il far dil zeneralado, et è stà deputati 7 cardinali a expedir questa cossa, *videlicet* il cardinal San Zorzi, Grimani, Voltera, Sorento, Montibus, Grassis et Santi Quarto. . . . *Dil dito, dì 27.* Come à ricevuto letere di la Signoria nostra portateli per il ministro di la provintia di Santo Antonio di l'ordine di frati Conventuali di San Francesco, et un'altra portata per fra' Francesco Zorzi, per li Observanti, in loro recomandatione, imponendoli parli al Papa e reverendissimi cardinali che non li fazi alteratione in diti ordeni, ma le cosse stagino come sono state fine hora. Et cussì questa matina, reduti li cardinali in congregatione per questa materia, andò a palazo, dove intrato, in la prima sala trovò piena di diti frati di San Francesco Conventuali et Observanti, che erano in gran numero. Poi introe da' diti reverendissimi cardinali zà reduti, et *demum* dal Papa, qual, udito messa fece una bona colazione, et li parloe iusta le letere, *ut supra.* Qual disse harìa rispeto a queste cosse et a le religion, e di questa mente era stà *etiam* Soa Santità e havia avuto letere in questa materia dil re Christianissimo e dil re Catholico, lo persuadeno si fazi li Conventuali observanti. . . ." (See also Moorman, *History,* pp. 582–85.) For the number of friars in the early sixteenth century, see the figures quoted by Sanuto on 26 October 1517: "vene il ministro Zeneral di frati Observanti di San Francesco [Francesco Licheto] in Colegio . . . dicendo era soto de lui frati Obscrvanti numero 70 milia, Conventuali 50 milia, et monache 40 milia" (*Diarii,* vol. 26, col. 146). However, for Sanuto's lack of reliability when it comes to numbers, cf. David Herlihy's figures on the population of Venice in the fifteenth and sixteenth centuries: "The Population of Verona in the First Century of Venetian Rule," in *Renaissance Venice,* ed. J. R. Hale (London, 1973), p. 93 and nn. 1 and 2.

53. Moorman, *History*, p. 584.
54. Sanuto, *Diari*, vol. 24, col. 324: "li frati Observanti facesseno uno zeneral loro e li Conventuali uno altro . . . , e che uno zeneral non desse obedientia a l'altro."
55. Ibid., cols. 476–77, 17 July 1517: "dove [a S. Marco] in questo zorno fo il principio di lo acordo fato tra frati Observanti et Conventuali di San Francesco, *videlicet* vadino tutti soto la + di Conventuali, ma dove prima andavano poi li fratizeli li Observanti, hora vadino prima li Conventuali e li Observanti restino da driedo; sichè cussì si observera *de caetero*."
56. For example, Sanuto (ibid., vol. 21, cols. 45–49) described at length the splendid procession of 8 September 1515 in honor of the Nativity of the Madonna, which began with the scuole, followed by the religious orders, then the comandadori, the clergy of S. Marco carrying relics of the basilica, the patriarch and other dignitaries, and finally the doge himself. See also chap. 5, sec. 1 of the present volume; and Muir, *Civic Ritual*, pp. 185–211, on ducal processions.
57. Innocenzo Giuliani, "Genesi e primo secolo di vita del Magistrato sopra monasteri," *Le Venezie Francescane* 28 (1961): 52ff., on Contarini (patriarch 1508–24) and his concern with reform. Giuliani explains the complicated motivations for the reform, reasons both moral and financial.
58. Ibid., pp. 65–68.
59. Ibid., pp. 114–17.
60. Sanuto, *Diarii*, vol. 27, col. 317, 21 May 1519: "non voler per alcun modo farse Observante, hessendo Conventual, e si castigasse chi feva mala vita, etc." For the Venetian Franciscans in the early sixteenth century, see the *Privilegia et Indulgentie Fratrum Minorum Ordinis Sci. Francisci*, published in Venice in 1502 (Biblioteca Marciana, miscell. 1946.5). A copy of the Observant rule of 1523 and the statutes of 1526 are also preserved in the Marciana (65.C.98.35): *Statuta Generalia Fratrum Minorum Regularis Observantie* (Venice, 1526), pp. 498–509.
61. Sanuto, *Diarii*, vol. 31, col. 162: "Veneno in Colegio l'abadessa di Santa Chiara di Veniexia, Suor Anzola Boldù, vechia di anni 106, con 6 altre zentildonne monache Conventual de ditto monastero, insieme con maestro Zerman di frati Menori e altri soi parenti . . . si dolse che per le monache Observanti non li era dato el suo viver e crepavano di fame, cossa da non poter suportar." The case is discussed by Giuliani, "Genesi," pp. 106–09. Some twenty-eight years later Girolamo Pesaro made a bequest to S. Chiara; see chap. 2, sec. 3 of the present volume.
62. "In Assumptione Beatae Mariae Virginis," in *Opera*, fol. xlviii verso.
63. For Germano's positions, see the concession of the altar of the Conception to Jacopo Pesaro and his brothers in 1518, quoted in chap. 4, sec. 2. At the Franciscan chapter held in Treviso in 1525, Germano was made minister or superior of the province of the Veneto; see Sanuto, *Diarii*, vol. 38, col. 348, 26 May 1525. Germano held that office until 1528, and he died 1 December 1533; see Antonio Sartori, *La Provincia del Santo dei Frati Minori Conventuali, Notizie storiche* (Padua, 1958), p. 331.
64. On the Franciscan coat of arms, see Leone Bracaloni, "Lo stemma francescano

nell'arte," *Studi francescani (Numero speciale, VII centenario del Terz'Ordine Francescano)* 7 (1921): 221–26; and Carmichael Montgomery in Emma Gurney Salter, *Franciscan Legends in Italian Art, Pictures in Italian Churches and Galleries* (London, 1905), pp. 139–40. According to Bracaloni, the stemma first came into use at Assisi during the generalate of Francesco Nani, whom Sixtus IV called "Samson."

65. That is the premise of such compilations as the various *sepoltuari* that ascribe ownership of a chapel according to the inscriptions of tombs; see, for example, the sepoltuario of S. Croce in Florence, compiled in 1439 and copied in 1596, preserved in ASF, MS 618. N.b. also the complaint of a branch of the degli Asini of Florence regarding the family chapel in S. Croce in 1569; evidently, old inscriptions had been removed and replaced by new ones in order to obliterate evidence of ownership; see Marcia B. Hall, *Renovation and Counter-Reformation, Vasari and Duke Cosimo in Sta Maria Novella and Sta Croce 1565–1577* (Oxford, 1979), pp. 142–43.

66. See ASVi, Convento di S. Corona, B. 110, fols. 1–7, dated 1522 (the year of the patron's death), for a record of the Dominicans' concession in 1500, allowing Garzadori to endow a chapel of St. John the Baptist in S. Corona. The patron's testament of September 1522, providing for burial in the chapel, is ASVi, Archivio Notarile (Francesco de Sorio), Testamenti 1521–1522, Libro 63. Howard Burns did everything possible to facilitate my foray into the archives of Vicenza, and I am deeply grateful to him. For the Garzadori Chapel, built in accordance with the donor's vow upon his return from the Holy Land in 1500, see Domenico Bortolan, *S. Corona, Chiesa e convento dei Domenicani in Vicenza, Memorie storiche* (Vicenza, 1889), pp. 263–65.

67. Garzadori's inscription reads "dicavit," referring to his vow in 1500 to dedicate an altar to the Baptist. For the dates of construction of the altar, see the *Cronica praeteriti temporis,* quoted by Bortolan, *S. Corona,* pp. 264–65. For Bellini's altarpiece, see Norbert Huse, *Studien zu Giovanni Bellini* (Berlin and New York, 1972), pp. 93–97.

68. For another view of the inscription's significance, see Creighton E. Gilbert, "Some Findings on Early Works of Titian," *Art Bulletin* 62 (1980): 53, n. 74.

69. It is certainly possible that the altar was both commissioned and erected within the year 1516, but there is no evidence that it was "in the works" before that time. See David Rosand, who suggests that Titian had begun working on the high altar "by 1516," in his *Titian* (New York, 1978), p. 84. The frame was attributed to Lorenzo Bregno and his studio by Pietro Paoletti in Thieme-Becker, *Allgemeines Lexikon der bildenden Künstler* (Leipzig, 1910), vol. 4, p. 568. Rosand argues convincingly that Titian was involved in the design; see *Painting in Cinquecento Venice: Titian, Veronese, Tintoretto* (New Haven and London, 1982), pp. 57–58.

70. Sanuto, *Diarii,* vol. 25, col. 418: "A dì 20 [May 1518]. . . . Et eri fu messo la palla granda di l'altar di Santa Maria di Frati Menori suso, depenta par Ticiano, et prima li fu fato atorno una opera grande di marmo a spese di maistro Zerman, ch'è guardian adesso."

71. Gilbert, "Some Findings," n. 74, suggests that an altar and an altarpiece may be commissioned by different individuals. In Renaissance Venice, however,

all the chapel commissions known to me involved endowments for the complete decoration of the chapels, including altars, altarpieces, and tombs. That is certainly the case for every documented chapel in the Frari, including the family chapels of the Bernardo, the Corner, the Miani, and the Pesaro, and the chapels of the confraternities of the Florentines, the Milanese, and the Scuola di S. Antonio, inter alia, as discussed in this volume, chap. 1, sec. 5; chap. 2; and chap. 4. Moreover, as private patrons were buried in their family chapels, it may be that Germano was buried before the high altar of the Assumption, in accordance with the recommendation of Saint Ambrose regarding the burial of priests; see I. Schuster, *The Sacramentary (Liber Sacramentorum)*, trans. A. Levelis-Marke (London, 1924), vol. 1, p. 205; and Goffen, "*Nostra Conversatio in Caelis Est*: Observations on the *Sacra Conversazione* in the Trecento," *Art Bulletin* 61 (1979): 215.

72. Igino Benvenuto Supino, "La pala d'altare di Iacobello e Pier Paolo dalle Masegne nella chiesa di S. Francesco in Bolgona," *Memorie della R. Accademia delle Scienze dell'Istituto di Bologna, Classe di scienze morali*, ser. 1, vol. 9, Sezione di Scienze Storico-Filologiche (1914–15), pp. 113–14 and passim. On the mechanism of conventual patronage among the Dominicans, see the dissertation by Joanna Louise Cannon, "Dominican Patronage of the Arts in Central Italy: The *Provincia Romana, c.* 1220–*c.* 1320," Courtauld Institute of Art, University of London, 1980, pp. 119–24. Cannon notes the role of the prior (the Dominican counterpart of a Franciscan guardian) as the supervisor of buildings and works of art.

73. Now in Dresden, the Gemäldegalerie. For an explanation of Correggio's altarpiece as a public declaration of Conventual ideals at the time of the division of the Franciscan order, see Rona Goffen, "A Bonaventuran Analysis of Correggio's *Madonna of St. Francis*," *Gazette des beaux-arts* 103 (1984): 11–18. On the separation of the Conventuals and the Spirituals, see chap. 3, sec. 2 above.

74. The altarpiece is now in the Vatican. The inscription on the altar read: "Almae Virgini Mariae, Redemptoris Matri, Hanc Aram Frater Germanus Divi Nicolai Guardianus dicavit M D XXII." See Gastone Vio, "La pala di Tiziano a S. Nicolò della Lattuga (S. Nicoletto dei Frari)," *Arte veneta* 34 (1980): 210. S. Nicolò was destroyed in the nineteenth century, but Titian's painting had already been taken to Rome in 1770. For the altarpiece, see Vio, pp. 210–13; and William Hood and Charles Hope, "Titian's Vatican Altarpiece and the Pictures Underneath," *Art Bulletin* 59 (1977): 534–52.

75. The Victories in the spandrels are well illustrated in color in plate 2. These figures were painted by Titian in fresco, according to Zanotto, *Guida* (Venice, 1864), p. 481, as noted in B. 2, no. 72, of the Parish Archives of the Frari; but Zanotto incorrectly identified the figures as an Annunciation group. In the vault above the *Assunta*, geometrical designs surround a polychromed relief of a half-length blessing figure, presumably God the Father. The vault to the west is decorated with symbols of the Evangelists in tondi and a half-length figure of Mary holding the Child.

76. *Opera*, fol. xlviii verso.

77. S. Bonaventurae, "Sermo III, De Sanctissimo corpore Christi," in *Opera Omnia*, vol. 5, ed. Aloysii Parma (Quaracchi, 1896), p. 559, no. 20: "Hoc mel

produxit apis nostra, Virgo Maria. . . . Debet habere patrocinium beatae Mariae Virginis qui vult gustare huius mellis dulcedinem in Sacramento altaris absconditum; et propter hoc legitur Ionathas in manu sua tenuisse virgam, priusquam veniret ad dulcedinem melleam." Bonaventure then cites Isaiah 11 : 1, and continues, "Ille ergo manibus tenet virgam, qui in omni operatione sua habet beatae Virginis memoriam, cuius extensione mel attingitur, quia non nisi patroncinio beatae Mariae Virginis ad virtutem huius Sacramenti pervenitur." Beginning in 1407 in Venice, the Host was carried in procession on the feast of Corpus Christi; see Muir, *Civic Ritual,* pp. 223–30.

78. On Bellini's altarpiece for S. Francesco in Pesaro, see above, chap. 2, sec. 2. For Fra Angelico, see Eve Borsook, "Cults and Imagery at Sant'Ambrogio in Florence," *Mitteilungen des Kunsthistorisches Institutes in Florenz* 25 (1981): 168 and 197, n. 148. Borsook also cites Sassetta's altarpiece for the Arte della Lana. See also John Pope-Hennessy, *Fra Angelico,* 2d ed. (Ithaca, N.Y., 1974), pp. 34–35, 215–16, and pl. 127. Andrea Sansovino's Sacrament Altarpiece still in situ in S. Spirito in Florence combined the Annunciation and the Coronation in a similar Eucharistic program; see Sarah Wilk, *The Sculpture of Tullio Lombardo: Studies in Sources and Meaning* (New York and London, 1978), p. 102.

79. On Tullio's marble altarpiece, ca. 1499–1502, which is opposite Giovanni Bellini's altarpiece in S. Giovanni Crisostomo, see Wilk, *Sculpture,* pp. 85–144 and 98–106 on the Eucharistic meaning of the sculpture, including its illusionistic pastophories.

80. See Rodolfo Pallucchini, *I Vivarini (Antonio, Bartolomeo, Alvise)* (Venice, n.d.), pp. 50–51 and 126.

81. Brady, "Doctrine," p. 78.

82. *Le prediche volgari,* vol. 2, pp. 391–92, as quoted in chap. 3, sec. 1, and n. 45.

83. For the relationship of the statues of the frame and the altarpiece, see also Rosand, *Painting in Cinquecento Venice,* pp. 55–57.

84. For the tomb of Doge Foscari, see Anne Markham Schulz, *Niccolò di Giovanni Fiorentino and Venetian Sculpture of the Early Renaissance* (New York, 1978), pp. 5 and 9–18; and Wolfgang Wolters, *La scultura veneziana gotica (1300–1460)* (Venice, 1976), vol. 1, pp. 292–94. The doge's funeral oration was delivered by Bernardo Giustinian: "Oratio Funebris Habita in Obitu Francisci Fuscari Ducis," *Bernardi Iustiniani, Oratoris Clarissimi Orationes,* Biblioteca Marciana, Incunabuli, V. 129, fols. 8v–20r; see also chap. 5, sec. 1 above. For the monument of Doge Tron—who was not closely related to the Franceschina Tron buried in the sacristy—see Debra Pincus, "The Tomb of Doge Nicolò Tron and Venetian Renaissance Ruler Imagery," in *Art the Ape of Nature, Studies in Honor of H. W. Janson,* ed. Moshe Barasch and Lucy Freeman Sandler (New York, 1981), pp. 127–50; and Schulz, *Antonio Rizzo, Sculptor and Architect* (Princeton, N.J., 1983), pp. 47–49. On "L'elezione del Doge Nicolò Tron," see Antonio Pilot, in *Nuova rassegna di letteratura moderna* (1906), pp. 2–17. Tron's will is in ASV, Antonio Marsilio, B. 1214, no. 1043, August 1466: "hordono il mio chorpo sia sepolitto a Fr[at]i Minory. . . ." Interestingly, his dogaressa, Dea Morosini Tron, was not interred with her husband but rather in the Observant Franciscan church of S. Giobbe: "Io Dea Trun moglier del quondam Serenissimo Prencipe de Venexia Misser Nicolò Trun . . . lasso

chel mio corpo sia sepulto a Sancto Iob . . ." (ASV, Domenico Guppi, B. 1186, fol. 32r, dated 1478).

85. Dr. Anne Markham Schulz kindly pointed out to me that the Christ of the Ascension above the Foscari tomb is a departure from the more customary depiction of the Resurrected Christ in such funerary monuments.

86. On the chapel of Sixtus IV, see the bibliography cited above in n. 27; and for Titian's *Madonna,* chap. 4, sec. 1.

87. See chap. 1, sec. 4, on the stigmata as the seal of divine approbation. Of course, that is why the Franciscan stemma displays the identically wounded hands of Francis and of Christ. The Conventuals argued that they were superior to the Observants in obedience to the Rule, interpreting Francis's injunction that the friars obey him and his successors to mean obedience to the ministers general and the provincial ministers of the order. The Observants, on the contrary, replaced provincial ministers with vicars of their own choosing; see Moorman, *History,* p. 580.

88. For the scuola of St. Anthony, established in the Frari since 1439, see chap. 1, sec. 5. The Scuola dei Mercanti or Merchadanti, dedicated jointly to the Madonna and to Saint Francis, had their altar in the central chapel to the left of the chancel. The chapel was conceded to the confraternity on 29 April 1421 (ASV, Frari, B. 97, no. 2), and its coat of arms is displayed above the entrance arch. In 1576, the confraternity merged with the Scuola di S. Cristoforo at S. Maria dell'Orto; see Annalisa Perissa Torrini, in Madile Gambier et al., *Arti e mestieri nella Repubblica di Venezia* (Venice, 1980), p. 76.

89. When Saint Anthony's tomb was opened on 8 April 1263, his body was found in ashes except for his tongue, which had survived intact; it is still venerated in the Santo today. The Solemnity of the Incorrupt Tongue of St. Anthony was celebrated in the Frari on the fourth Sunday in August; see Pietro Contarini, *Venezia religiosa o guida per tutte le sacre funzioni che si praticano nelle chiese di Venezia* (Venice, 1853), p. 303. In part as a result of the discovery of the tongue, the province of the Veneto, earlier formed under the names of Saint Francis and Saint Anthony, was listed as the province of St. Anthony in 1272. The new name was used until 1517. See Timoteo Spimbolo, *Storia dei Frati Minori della Provincia Veneta di S. Francesco* (Vicenza, 1933), vol. 1, pp. 11 and 41–42. Jürg Meyer zur Capellen has noted Saint Anthony's significance as patron of the Province; "Überlegungen zur 'Pietà' Tizians," *Müncher Jahrbuch der bildenden Kunst* 22 (1971): 125. The Chapter of the province was held at the Frari in April 1521; sec Sanuto, *Diarii,* vol. 30, col. 128. On the cult of Saint Anthony in Padua, see Sarah Wilk, "La decorazione cinquecentesca della Cappella dell'Arca di S. Antonio," in *Fonti e studi per la storia del Santo a Padova,* vol. 8, *Le Sculture del Santo a Padova,* ed. G. Lorenzoni (Vicenza, 1985), pp. 109–72.

90. On the celebration of the Origin of Venice on March 25 and governmental concern with religious affairs, see also chap. 5, sec. 1 above. For the depiction of the Annunciation in tombs, especially in the Veneto, see Ursula Schlegel, "On the Picture Program of the Arena Chapel" (1957), in James H. Stubblebine, *Giotto: The Arena Chapel Frescoes* (New York and London, 1969), p. 195. Another tomb with the Annunciation in the Frari itself is the monument of

B. Pacifico (d. 1437), decorated with a fresco *Annunciation* based upon Pisanello's Brenzoni monument (1424–26) in S. Fermo Maggiore, Verona.

91. Saint Anthony was considered the "Saint Paul" of the Franciscan Order, being compared to Paul as a preacher, educator, and doctor of the church, according to the Medieval legend of Saint Anthony; see Leone Bracaloni, *L'arte francescana nella vita e nella storia di settecento anni* (Todi, 1924), pp. 226–27. On Anthony and the Conventuals, see also Goffen, "Bonaventuran Analysis," p. 14.

92. Although the autograph of Francis's letter to Anthony, probably written in 1222, does not survive, there is general agreement about its contents and its historical significance. For the text, see Nicolaus Glassberger, *Chronica* (1508), published as *Analecta Franciscana* 2 (1887): 34–35; and the "Chronica XXIV Generalium Ordinis Minorum," *Analecta Franciscana* 3 (1897): 132. Francis's letter is translated by Benen Fahy in Marion A. Habig, *St. Francis of Assisi, Writings and Early Biographies: English Omnibus of the Sources for the Life of St. Francis* (Chicago, 1973), p. 164. For its effect on the order, see Huber, *History*, pp. 41–42.

93. See chap. 3, sec. 2. Two relics of saints with special significance for the Conventuals were venerated in the Frari, part of a rib of Saint Bonaventure (obtained by a German merchant in Lyons in 1506) and some unidentified bones of Saint Catherine (one of the saints mentioned in the dedication of the high altar and the titular saint of her own altar in the right aisle). Bonaventure was generally considered a champion of the Conventuals (and was much disliked by the Observants), and Catherine was esteemed by the Conventuals as a patroness of learning. On the significance of these saints for the Conventuals, see Goffen, "Bonaventuran Analysis," pp. 14–15 and n. 24 *bis* (intended to be part of the text and incorrectly printed as a note by the editors). For the relics in the Frari, see ASV, Frari, B. 2, fol. 10v (Bonaventure) and B. 106, fasc. xxxiii (St. Catherine); Flaminio Cornelio [Corner], *Ecclesiae Venetae Antiquis Monumentis . . .* (Venice, 1749), vol. 6, p. 285; idem, *Notizie storiche delle chiese e monasteri di Venezia e di Torcello* (Padua, 1758), pp. 363–64; and Biblioteca Correr, Raccolta Cicogna, B. 3063, no. 14. Saint Catherine was also venerated at her own altar in the Frari, endowed by the Salamon family and later decorated with an altarpiece by Palma; see Sartori, *Guida*, p. 176; and Stefania Mason Rinaldi, *Jacopo Palma il Giovane, L'opera completa* (Milan, 1984), p. 129. In addition, the Frari possessed three outstanding relics from the Morea presented to the church in 1500 by the general of the Conventuals: a fragment of the column used in the Flagellation of Christ, a finger of Saint Nicholas, and the uncorrupted foot of the prophet Daniel, missing, however, the big toe (Corner, *Notizie*, p. 363). In regard to the Frari's sense of Conventual identity, note also that there were several rival Observant convents in Venice and Murano; see chap. 1, sec. 1 and nn. 5 and 8 above.

94. Jugie, *Mort*, pp. 195–97.

95. Ibid., p. 198. For the early development of the theme in art, see Ludmila Wratislaw-Mitrovic and N. Okunev, "La Dormition de la Sainte Vierge dans la peinture médiévale orthodoxe," *Byzantinoslavica* 3 (1931): 134–80.

96. Jugie, *Mort*, p. 199.

97. On the significance of the Damascene's First and Second Homilies on the

Assumption, see Graef, "Second Eve," pp. 228–29 and n. 2. Note that Alexander of Hales cited the Damascene in the text quoted below in n. 99.

98. "Eva siquidem quae serpentis nuntio aures praebuit, hostisque suggestionem auscultavit, sensu suo per falsae ac fallacis voluptatis assultum delinito, mœroris et tristitiæ sententiam retulit, ut dolores partus sustineret, et una cum Adamo morte condemnata, in imis inferni recessibus collocatur: hanc autem vere beatissimam quæ Dei verbo aures submisit, et Spiritus sancti operatione impleta est, atque, archangelo sequestro, de complacito Patris prægnans effecta, quæque sine voluptate ac viri congressu Dei Verbi personam, cujus omnia plena sunt, concepit, ac pro eo, ut decebat, sine doloribus peperit, quæque totam secum Deo copulavit, quomodo mors devoraret?" Migne, *Patrologia Greca* (Paris, 1891), vol. 96, cols. 727–28; translated by Graef, "Second Eve," p. 229.

99. Alexander de Hales, *Summa Theologica*, III, n. 170, ed. Pacifici M. Perantoni (Quaracchi, 1948), vol. 4, p. 240. This is from Alexander's treatise "De Resurrectione Christi et Demonstratione Resurrectionis": "Item, secundum Ioannem Damascenum, quaedam dicitur appropriata, talis: 'Resurrectio est eius quod cecidit secunda surrectio,' et haec potest convenire B. Virgini, secundum quod pie creditur a quibusdam quod iam surrexerit; nec ponitur ibi 'dissolutum,' quia nihil de corpore eius invenitur; unde non creditur incineratum, sed ponitur casus qui refertur ad mortem. Alia est propria Domini, talis: Resurrectio est corporis facti incorrupti, id est impassibilis, iterata unio; nec ponitur ibi 'casus,' quia mors Christi non fuit casus oppositus naturae rectae." The passage is discussed by Celestino Piana, "Contributo allo studio della teologia e della leggenda dell'Assunzione della Vergine nel secolo XIV," *Studi Francescani,* ser. 3, 16 [41] (1944): 98–99 and n. 2. Cf. the Dominican Voragine, who asserted that the faithful must believe in Mary's resurrection even though it is uncertain; sermons for the Feast of August 15, *Sermones de sanctis per anni totius circulum. De assumptione sermo I* (Venice, 1573), fols. 301v–02v, cited in Jugie, *Mort,* p. 393 and n. 1.

100. The Franciscan Tomaso De Rossi, *Quaestio de concept. Virg. immaculatae,* quoted by Piana, "Contributo," p. 100, n. 6. Piana also cites a slightly earlier reference to the church's belief in the Assumption of Mary, body and soul. The Assumption of Saint John the Evangelist, on the contrary, was not avowed with such certainty; idem, p. 101, and chap. 5, sec. 1 of the present volume.

101. See Piana, "Contributo," pp. 107–08.

102. Biblioteca Nazionale Marciana, MS Ital. Z5 (4738), fols. 179v–80r: "Siando passado lo terzo dì . . . lo fiol de Dio desexe de ciello in tera chon una grandissima chonpagnia de agnolli e zonse a quello precioxo chorpo dela Verzene Maria loqual iera in lo molimento onde San Michiel Archanzolo revolse la piera delo molimento . . . zaxando hapostolli e l'altra chompagnia . . . e tolse la Vergene Maria fuora del molimento chon anzolly chy chanty e aprexentalla al suo dolze fiol in charne viva. . . . E li agnoly de Dio tolse lo chorpo santo senza alguna machula dela Verzene Maria. . . ."

103. See Piana, "Contributo," p. 102; J. Bellamy, in *Dictionnaire de théologie catholique* (Paris, 1931), vol. 1, col. 2128, s.v. "Assomption de la Sainte Vierge"; and above, chap. 3, sec. 1.

104. "In Assumptione Beatae Mariae Virginis," in *Opera,* fol. xlviii verso: ". . . sicut ab omni mentis et corporis corruptione extitit libera: ita a mortis dolore aliena."

105. For the offices by Bernardino de Bustis and Leonardo de Nogarolis, both approved by Sixtus IV, see above, chap. 2, sec. 2, and chap. 3, sec. 1. For the use of Ecclesiasticus 24, which is inscribed on the book held by St. Benedict in Bellini's Frari triptych, see chap. 2, sec. 2.

106. Chap. 3, sec. 1.

107. On the unanswered question of Mary's death, see J. M. Egan, "The Doctrine of Mary's Death during the Scholastic Period," *Marian Studies* 8 (1957): 100–24; and J. W. Langlinais, in *New Catholic Encyclopedia* (New York et al., 1967), vol. 1, p. 975, s.v. "Assumption of Mary."

108. See J.-P. Migne, *Patrologia Latina* (Paris, 1865), vol. 36, col. 335: "Maria ex Adam mortua propter peccatum, Adam mortuus propter peccatum, et caro Domini ex Maria mortua est propter delenda peccata." This is from the "Enarratio in Psalmum xxxiv, Sermo II, habitus die proximo post superiorem sermonem."

109. Now in the church of S. Pietro Martire on Murano, the canvas originally belonged to S. Maria degli Angeli there. See Felton Gibbons, "Giovanni Bellini and Rocco Marconi," *Art Bulletin* 54 (1962): 127–31; and Giles Robertson, *Giovanni Bellini* (Oxford, 1968), p. 121. N.b. also Francia's *Conception* in S. Frediano, Lucca, in which Mary is accompanied by Solomon and David and saints Augustine, Anselm, and Anthony of Padua; see Bracaloni, *L'arte francescana,* p. 322.

110. See Rosand, *Painting in Cinquecento Venice,* p. 52.

111. Saint Jerome, quoted in Bernardino de Bustis, *Officium et missa de Immaculata Conceptione,* p. 403.

112. On the vivid language of epideictic sermons that make the listener feel present at the events described, see John W. O'Malley, *Praise and Blame in Renaissance Rome, Rhetoric, Doctrine, and Reform in the Sacred Orators of the Papal Court, c. 1450–1521* (Durham, N.C., 1979), p. 66 and passim. For catalogue data on Titian's panel, which measures an extraordinary 6.90 × 3.60 meters, see Harold E. Wethey, *The Paintings of Titian* (London, 1969), vol. 1, pp. 74–76. For the history of the theme in art, see Hans Feldbusch, *Die Himmelfahrt Maria* (Düsseldorf, 1951); and Olav Sinding, *Mariae Tod und Himmelfahrt, Ein Beitrag zur Kenntnis der frühmittelalterlichen Denkmaler* (Christiania, 1903), 2 vols. On the recent cleaning, see Francesco Valcanover, "Il restauro dell'Assunta" in *Tiziano, nel quarto centenario della sua morte, 1576–1976* (Venice, 1977), pp. 41–51. Possibly the first Italian representation of the Assumption of the Virgin which did not include the scene of the Dormition was the oculus designed by Ghiberti for Florence Cathedral in 1404–05; for the window and its Trecento Sienese source, see Richard Krautheimer and Trude Krautheimer-Hess, *Lorenzo Ghiberti* (Princeton, N.J., 1970), vol. 1, p. 76, and vol. 2, figs. 7 and 8. In Ghiberti's window, Christ holds a crown over the Madonna's head. Donatello also depicted the Virgin's assumption with no allusion to her death in his relief for the tomb of Cardinal Rainaldo Brancacci, Naples, S. Angelo a Nilo, 1427–28; H. W. Janson, *The Sculpture of Donatello* (Princeton, N.J., 1963),

pp. 88–92 and pls. 87–88. On the separation of the Assumption from the Dormition in art, see Marita Horster, *Andrea del Castagno* (Ithaca, N.Y., 1980), p. 177. For Castagno's *Death of the Madonna,* see ibid., pp. 19–20 and 173.

113. For the fresco, ca. 1456, in the Ovetari Chapel of the Eremitani in Padua, see Paul Kristeller, *Andrea Mantegna,* ed. S. Arthur Strong (London, New York, and Bombay, 1901), pp. 60–118 and 466–67 for excerpts from the will and codicil of the patron, Antonio Ovetari (January 5, 1443, and April 22, 1446). The fresco was severely damaged by Allied bombing in World War II. Titian, of course, knew these frescoes: he lived and worked in Padua in 1510–11; see Wilk, "Titian's Paduan Experience and Its Influence on His Style," *Art Bulletin* 65 (1983): 51–60.

114. Inevitably, the *Assunta* invites comparison with Raphael's *Disputa.* S. J. Freedberg has analyzed the composition of the Vatican fresco as representing the apse of a church constructed of the bodies of the theologians, saints, and others whose teachings defend and define the church; see *Painting of the High Renaissance in Rome and Florence* (Cambridge, Mass., 1961), vol. 1, pp. 118–19. For "The Florentine Source of the *Assumption,*" see sec. 2 of Gilbert, "Some Findings," pp. 52–62.

115. On the scenographic relationship of the *Assunta* to its site, see Rosand, "Titian in the Frari," *Art Bulletin* 53 (1971): 196–200; and idem, *Painting in Cinquecento Venice,* pp. 55–56.

116. Bradwardine (ca. 1290–1349) is quoted in Samuel Y. Edgerton, Jr., *The Renaissance Rediscovery of Linear Perspective* (New York, 1975), p. 20. Rosand, *Painting,* p. 55, notes "the golden circle of heavenly radiance." On "The Centrally Planned Church and the Renaissance," see Rudolf Wittkower, *Architectural Principles in the Age of Humanism* (New York, 1962), pp. 1–32.

117. If the stone on which Titian wrote his name is in fact meant to reveal a glimpse of Mary's tomb, it is very well concealed. The stone seems to have an uneven surface; it is not a block of ashlar masonry or a finished piece of stone such as Titian painted for the Virgin's tomb in his *Assumption* in Verona (fig. 40).

118. Biblioteca Nazionale Marciana, MS It. I.34 (5232), fol. 26r. For the Franciscan use of "gloriosa," see also Brlek, "Legislatio," pp. 6, 13, and 16. For "gloriosa" used to signify the Virgin Assumed into Heaven, see Salvatore Battaglia, *Grande dizionario della lingua italiana* (Turin, 1970), vol. 6, p. 935, s.v. "Glorioso." Similarly, "glorificazione" may refer explicitly to the Resurrection and Ascension of Christ—and, by extension, the Assumption of his mother; see ibid. on p. 934.

119. Biblioteca Nazionale Marciana, MS It. I.29 (5022), fol. 127v: ". . . et faro il corpo chome l'anima glorioso ella tua sedia porra al lato alla mia in cielo dove non sara tribulatine . . . ma perpetuale allegrezza. . . ."

120. Ibid., fol. 130v: "Et fu levata di terra et portata in cielo chon allegrezza e canti quella anima gloriosa et benedetta."

121. *Prediche volgari,* vol. 2, p. 393: ". . . e come la carne di Cristo non si poteva corumpere, così anco quella di Maria; e così si legge, che come essa morì, così fu assunta in cielo."

122. The Franciscan author of *De Vita et Laudibus B. M. Virginis* had died in 1401, but his "Life and Praise of the Blessed Virgin" was published in Venice in

1596, indicating a continuing interest in his writing during the sixteenth century. See Piana, "Contributo," p. 110; and Paschal Robinson, in *The Catholic Encyclopedia* (New York, 1907), vol. 2, p. 316, s.v. "Bartholomew of Pisa."

123. Biblioteca Nazionale Marciana, MS It. Z 5 (4738), fol. 134r: ". . . sovra tuti li agnoli . . . senpre per nuy pechatory ella die Dio pregar. E per la zente chatolicha lo so fiol debie orar . . . pregar per tuty li pechatory."

124. For the Pesaro wills, see chap. 4, sec. 2.

125. Like the Franciscans, the Dominicans were also dedicated to the Madonna; see the *Enciclopedia cattolica* (Vatican City, 1952), vol. 8¹, p. 99, s.v. "Maria, santissima." Given the profundity and the longevity of their disagreement about the Immaculate Conception of the Virgin, a comparative study of Madonna paintings for Dominican and for Franciscan institutions might be expected to yield interesting results. For Lippi's frescoes, see Carlo Bertelli, "Appunti sugli affreschi nella cappella Carafa alla Minerva," *Archivum Fratrum Praedicatorum* 35 (1965): 115–30; Cesare Brandi, "The First Version of Filippino Lippi's *Assumption*," *Burlington Magazine* 67 (1935): 30–35; and, most recently, by Gail L. Geiger, the doctoral dissertation "Filippino Lippi's Carafa Chapel: 1488–1493, Santa Maria sopra Minerva, Rome" (Stanford University, 1975), and her article, "Filippino Lippi's Carafa 'Annunciation': Theology, Artistic Conventions, and Patronage," *Art Bulletin* 63 (1981): 62–75.

126. Geiger notes that Lippi repeated the coffering of the donor's adjacent burial chamber in the fictive coffers above Gabriel's head in the *Annunciation*; see her "Lippi's 'Annunciation,' " p. 71. The implication is that the architectural motif, associated with life, transmits this hopeful association to Carafa in his tomb.

127. For the arguments concerning the question of Mary's death, see chap. 3, sec. 4. Note, too, that Mantegna completely suppressed all references to Mary's tomb in his Ovetari Chapel fresco (fig. 37).

128. On Girlandaio's frescoes in S. Maria Novella, see the bibliography cited above, n. 17; and for the significance of the Angelic Salutation, chap. 3, sec. 1.

129. For Titian's painting in Verona, see Wethey, *Titian*, vol. 1, p. 76.

130. Philip Rylands has noted that the two subjects, Mary's Assumption and her giving the girdle to Saint Thomas as she ascends, were often combined; see "Palma Vecchio's 'Assumption of the Virgin,' " *Burlington Magazine* 119 (1977): 245–50.

131. For example, Christ greets his mother with many words of endearment in a fifteenth-century Venetian text: "O dolcissima la mia genetrixe chara o mare [madre] mia dileta dievi entrà in la mia abitazion che da mi tu rezevera perpetua chonsolazion . . ." (Biblioteca Nazionale Marciana, MS It. Z5 (4738), fol. 184r).

132. Alfred Nicholson wrote that this embrace was "unprecedented both in art and narrative"; *Cimabue, A Critical Study* (Princeton, N.J., 1932; repr. Port Washington and London, 1972), p. 15. On Cimabue's fresco, see more recently Belting, *Oberkirche,* pp. 58–60 and 126–31; Yves Christe, "L'Apocalypse de Cimabue à Assisi," *Cahiers archéologiques* 29 (1980–81): 157–74; Irene Hueck, "Cimabue und das Bildprogramm der Oberkirche von San Francesco in Assisi," *Mitteilungen des Kunsthistorisches Institutes in Florenz* 25 (1981): 279–324;

and Augusta Monferini, "L'Apocalisse di Cimabue," *Commentari* 17 (1966): 25–55. Cimabue's *Assumption* is adjacent to his *Coronation of the Virgin* and to the left of a scene of *Christ as Judge,* in which a triumphant Christ is enthroned in a mandorla above an altar. To be sure, these three frescoes are part of a larger cycle in the apse of the Upper Church. Nonetheless, the association of themes in the three is very similar to Titian's representation of the Assumption of the Virgin, including an angel who approaches with a crown, and set between the Eucharistic Christ of the tabernacle below and the Resurrected Christ above the frame.

133. Professor Salvatore I. Camporeale suggested this image to me in connection with the *Assumption*. For a recent edition of the anonymous fourteenth-century text, see *The Cloud of Unknowing,* ed. James Walsh (New York, Ramsey, and Toronto, 1981). Walsh (pp. 3–5), following the general consensus, suggests that the author was probably a Cistercian or a Carthusian.

134. On Saint Lorenzo Giustiniani, see chap. 3, sec. 1, and n. 40. "In Assumptione Beatae Mariae Virginis" is included in the section "Sermones in Sanctorum Solennitatibus" of the *Opera Divi Laurentii Iustiniani* (Bressanone, 1506), fols. xlvii verso–l recto (paginated within the section.)

135. For Gregory's antiphon, see Migne, *Patrologia Latina* (Paris, 1895), vol. 78, col. 798. The Canticle echoes in the liturgy of the Assumption and in other religious writings. N.b., for example, St. Bonaventura, "De Assumptione B. Virginis Mariae. Sermo II," in *Opera Omnia,* ed. David Fleming (Quaracchi, 1901), vol. 9, pp. 691–92.

136. "In Assumptione," in *Opera,* fol. xlviii recto: ". . . quanta humanum genus omnipotens pater diligat caritate: qualiterue ob nimium sui amorem unigenitum suum in similitudine carnis peccati misit in mundum: quatenus de peccato damnaret peccatum: et per crucis patibulum amicos faceret: quos inobedientia originalis culpae constituerat inimicos. . . . quaetenus eorum corda sancti amoris urantur incendio. Quem (oro) [*sic*] dilectione non accendat mediatoris exhibita caritas: et assumptae humanitatis perfusa benignitas: atque per pessae passionis incomparabilis cruciatus. O syncaere Amor: o affectus spontanee: o amabilis dilectio redemptoris. . . . Hoc igne interiora nostra comple. . . ."

137. Ibid., fol. xlix verso: "Vix sancta dei genetrix verba finierat: et ecce honorabiliter et cum exultatione cunctorum exaltata est super choros angelorum in coelestia regna." Mary's merciful mediation is described in ibid., fols. xlix verso–l recto.

138. Ibid., fol. xlviii verso: "Hodie cum ingenti guadio triumphavit in coelis. Porro quod concupierat vidit: quod quaesi erat tenuit. Vidit inque non per speculum in aenigmate [I Corinthians 13 : 9]: neque mortali carne velatum: sed facie ad faciem immortalitatis candore vestitum. Tenuit autem cordis brachiis: et pii amoris amplexibus: quem quaesierat mente naturali impellente assectu: habita conversatione excitante: ac spiritu interius dirigente. Nam nullus (ut arbitror) ardorem virginis sufficit explicare: quanto desideriorum cremabatur incendio: quanto crebris suspiriis angebatur: quamve suavissimis cogitationibus exercebatur. Detinebatur tantum in saeculo corpore: affectu autem et mente commorabatur in coelo. Ibi erat votis: ubi unicum suum filium esse noverat: ubi fruitio eius habet in idipsum: ubi beatorum spirituum frequentia in laude con-

ditioris intendit. Nec ab re. Censendum est iugiter nedum angelica: verum etiam filii virginem fratrem esse visione: atque exultasse colloquio: tanque sanctitate praecipua insignitam: divinaque caritate succensam: ac continua supra se mentis contemplatione provectam. Illi etenim coelestis visio debebatur: cui incomparabilis gratiae inerat plenitudo: plena devotio: ardor continuus: ac puritatis delectabile bonum. Quamobrem resolutionis carnis imminente articulo sicut ad omni mentis et corporis corruptione extitit libera: ita a mortis dolore aliena."

139. Ibid., fol. xlix recto: "Quaenam est ista: quae candidatorum agiminum fulta comitatu ascendit ad nos: quasi aurora consurgens: pulchra ut luna: electa ut sol. . . . Hanc tanque virgula fumi ex aromatibus myrrhae: et thuris: et universi pulveris pigmentarii ascendentem deliciisque spiritualibus affluentem honoremus pro posse." Gregory the Great likewise quoted Ct 6 : 9 in the same context in his antiphon for the Assumption; see above, n. 135. The sun and the moon are common metaphors in both literary and visual imagery of Mary's Immaculacy. For the sun and the moon, see also Philippe Verdier, *Le Couronnement de la Vierge, Les origines et les premiers développements d'un thème iconographique* [1972] (Montreal and Paris, 1980), p. 161, n. 32. Verdier discusses two paintings by Paolo Veneziano that make use of the sun-and-moon imagery (Milan, Brera; New York, Frick Collection) and relates these to Bonaventure's second sermon on the Assumption (in the *Opera Omnia*, vol. 9, p. 691).

140. *Opera*, fol. xlix r, directly following the passage cited in the preceding note: "illique procedamus obviam: ac gratiarum actionis debitum persoluamus affectum. Genetricem mox ut filius ascendentem vidit: eam officiosissime salutans inquit. Vedi de Libano mater mea: columba mea: imaculata mea: formosa mea: suavis et decora tanquam Hierusalem. Coronaberis de capite amaranto de vertice Senir et Hermon. . . . Thronum paratum conscende: coronam gemmis ornatam suscipe."

141. Ibid., fols. xlix recto–verso: "Et virgo. Unde haec (inquit) mihi: ut deus et dominus meus tanto cum honore veniat ad me. Quid merui quid egi. Quo interveniente: quo interpellante factum est hoc. . . . Caeterum ad culmen perfectae dilectionis gloriaeque triumphum: nunc quodque in praeclaras mansiones coeli tanto cum honore me provehis. Quid igiturretribuam domino per omnibus: quae retribuit mihi. . . . Non reclamabo: non renitar: sed reverendo quodam mentis assensu voluntati tuae annuens: eademque quando te genui: protuli verba: nunc repeto dicens. Ecce ancilla domini: fiat mihi secundum verbum tuum" [Luke 1 : 38].

CHAPTER IV

1. From the concession of the altar of the Conception to the family of Jacopo Pesaro in 1518; ASV, Pesaro, B. 102, no. 1; cited at length in chap. 4, sec. 2.
2. Marino Sanuto saw the newly finished altarpiece on the feast of the Conception, 8 December 1526 (*Diarii*, vol. 43, col. 396, quoted in chap. 5 of the present volume, sec. 2, and n. 34). Francesco Valcanover, "La Pala Pesaro," *Quaderni della Soprintendenza ai Beni Artistici e Storici di Venezia* 8 (1979): 59–

60, n. 7, reprints the transcription of the receipts by Angelo Scrinzi. (See also Scrinzi, "Ricevute di Tiziano per il pagamento della Pala Pesaro ai Frari," *Venezia, Studi di arte e storia,* I [1920]: 258–59.) The document was also transcribed by Antonio Paravia in Pier-Alessandro Paravia, "Sopra la pala di Tiziano detta della Concezione," *Giornale sulle scienze e lettere delle provincie venete* 18 (1822): 6–7. For the documents, see G. B. Cavalcaselle and J. A. Crowe, *Tiziano, La sua vita e i suoi tempi* (Florence, 1878), vol. I, pp. 277–78, n. I; Charles Hope's letter, "Documents Concerning Titian," *Burlington Magazine* 115 (1973): 810; and David Rosand's criticisms of Hope's ideas regarding three periods of payment, in *Painting in Cinquecento Venice: Titian, Veronese, Tintoretto* (New Haven and London, 1982), p. 258, n. 38. Cyprus had been under Venetian protection since 1473 and incorporated with the Signoria in 1488, when Catherine Cornaro abdicated; see W. Carew Hazlitt, *The Venetian Republic, Its Rise, Its Growth, and Its Fall 421–1797* (London and New York, 1900), vol. 2, pp. 133–34.

3. See chap. 2, sec. 2 above.

4. For early observance of the feast, see chap. 3, sec. 1, and n. 24. Antonio Sartori cites documents of 1361 referring to an altar of the Immaculate Conception near the third pair of piers; *Guida storico-artistica della Basilica di S. M. Gloriosa dei Frari in Venezia* (Padua, 1949), p. 12.

5. A later copy of the Capitoli or Mariegola of the Confraternity of the Immaculate Conception is preserved among the documents of the Pesaro family archive, ASV, Pesaro, B. 102, no. 1, fols. 12r–16v. The approval of the Friars Minor and the date MCCCCLXXXXVIII are given on fol. 12v. See also chap. 4, sec. 3, and n. 99.

6. For Querini's testament of 22 September 1499 and the sentence on his will, dated 2 September 1513, see ASV, Frari, B. 5, fols. 33r–v, and B. 106, fasc. xxxiii, no. 5d. The concession of the altar to the Pesaro in 1518 refers explicitly to the altar of the Conception; quoted in chap. 4, sec. 2, and n. 30.

7. ASV, Frari, B. 5, fol. 33r, dated 2 September 1513, quoting the will of 22 September 1499: ". . . volo corpus meum tumulari ad Sanctam Mariam Fratrum Minorum cum habitu Sancti Francisci . . . et dictum cadaver meum ponatur in deposito donec facta fuerit una capella contigua sub titolo Conceptionis Virginis Gloriose et ibidem ponatur dictum corpus meum. . . ." Querini's family were also to be buried in the tomb, and daily masses were to be said for their souls. Lodovico was the son of Gradeniga Gradenigo and Nicolò Querini, according to Marco Barbaro, *Arbori de' patritii veneti,* vol. 6, fol. 322 (ASV, Misc. Codici I, Storia Veneta 22).

8. St. Peter sponsored Jacopo Pesaro in his votive picture by Titian, probably ca. 1506; see sec. 1 and n. 26 of this chapter. Saint Peter was also the patron of the Friars Minor, who were placed under the protection of the papacy. Saint Francis as the founder of the order was compared with Saint Peter as the founder of the church in the *Legenda S. Antonii;* see Leone Bracaloni, *L'arte francescana nella vita e nella storia di settecento anni* (Todi, 1924), pp. 226–27. Peter was also the titular saint of the cathedral of Venice, S. Pietro in Castello.

9. This is the kind of spatial confusion or distortion that one associates with Central Italian Mannerism, albeit not so extreme or alarming as the similar spatial disparities in, for example, Parmigianino's *Madonna del collo lungo.*

10. See Helen S. Ettlinger, "The Iconography of the Columns in Titian's Pesaro Altarpiece," *Art Bulletin* 61 (1979): 59–67, with extensive bibliographic references in the notes. On the high throne, see Staale Sinding-Larsen, "La 'Madone Stylithe' di Giorgione," in *Giorgione, Atti del Convegno Internazionale di Studi* (Castelfranco Veneto, 1978), pp. 285–91; and Goffen, "A Bonaventuran Analysis of Correggio's *Madonna of St. Francis*," *Gazette des beaux-arts* 103 (1984): 15. On the subject in general, see Eva Tea, "Iconografia della Immacolata in Italia e in Francia," in *Relations artistiques entre la France et les autres pays depuis le haut Moyen Age jusqu'à la fin du XIX^e siècle, Actes du XIX^e congrès internationale d'histoire de l'art* (Paris, 1959), pp. 275–84; chap. 3, sec. 1, and chap. 4, sec. 1, of the present volume.

11. Staale Sinding-Larsen also noted the dissociation of the pictorial from the real space; see "La pala dei Pesaro e la tradizione dell'immagine liturgica," in *Tiziano e Venezia, Convegno Internazionale di Studi* [1976] (Vicenza, 1980), p. 203. Cf. David Rosand, *Painting,* pp. 58–69. Rosand considers Titian's asymmetrical composition and the changes in his illusionistic architecture in relation to the location of the altarpiece in the left aisle of the church.

12. For Bellini's illusionistic use of frames, see the discussion in chap. 2, sec. 2; and Julia Helen Keydel, "A Group of Altarpieces by Giovanni Bellini Considered in Relation to the Context for Which They Were Made" (Ph.D. diss., Harvard University, 1969), passim. For the style and iconography of Tullio's *Coronation,* executed between 1499 and 1502, see Sarah Wilk, *The Sculpture of Tullio Lombardo: Studies in Sources and Meaning* (New York and London, 1978), pp. 85–144.

13. Rosand, "Titian in the Frari," *Art Bulletin* 53 (1971): 200–07; idem, *Painting in Cinquecento Venice,* pp. 55–56; and chap. 3, sec. 4 of the present volume.

14. See Valcanover, "Pala Pesaro," with technical notes by Lorenzo Lazzarini, pp. 57–71, especially 68ff.

15. Alberti had recommended that a character in a painting draw the viewer's attention by means of a glance, thereby establishing a relationship between viewer and image; see Leon Battista Alberti, *On Painting and On Sculpture, The Latin Texts of "De Pictura" and "De Statua,"* trans. and ed. Cecil Grayson (London, 1972), p. 83. However, this was often the exception rather than the rule in earlier Venetian Renaissance painting of religious subjects. In Bellini's sacred art, as in his portraiture, figures may exchange glances with each other or, more often, seem to be absorbed in reverie. Rarely does any of them turn his eyes toward the viewer, a notable exception being the St. Benedict of the Frari triptych. The same introspection is typical also of the figures in sacred paintings by Giorgione or by those closely related to him. However, Savoldo represented a donor who looks directly toward the viewer while unveiling the Infant Christ in a canvas belonging to the queen of England and recently considered by Creighton Gilbert in *The Genius of Venice 1500–1600,* ed. J. Martineau and C. Hope (London, 1983), pp. 204–05, and a color illustration on p. 73. Here the donor's glance is understood in relation to his act of *revelatio,* usually performed by the Madonna or by a saint.

16. In *Spirituality in Conflict: St. Francis and Giotto's Bardi Chapel* (University Park, PA, 1988), I argue that the saint's character in art is determined by his stigmata

and the compassionate intermediation that they guarantee. See also chap. 2, sec. 2 of this volume, along with bibliography on Bellini's *St. Francis* in the Frick Collection in n. 72.

17. Thomas of Celano, *First Life,* ii, 18, trans. Placid Hermann, in Marion A. Habig, ed., *St. Francis of Assisi, Writings and Early Biographies: English Omnibus of the Sources for the Life of St. Francis* (Chicago, 1973), p. 332. For the Latin text, see Celano, *Vita Prima S. Francisci Assisiensis et eiusdem Legenda ad Usum Chori* (Quaracchi, 1926), p. 132.

18. See Goffen, "Icon and Vision: Giovanni Bellini's Half-Length Madonnas," *Art Bulletin* 57 (1975): 501, n. 82, with further bibliography. Michelangelo's *Madonna of the Steps* and Raphael's *Madonna with the Veil* represent the same imagery.

19. For the canvas in the Louvre, and formerly in the collection of the Gonzaga of Mantua, see Hope, *Titian* (London, 1980), pp. 47–48; Rosand, *Titian* (New York, 1978), p. 102; and Harold E. Wethey, *The Paintings of Titian, Complete Edition,* vol. 1, *The Religious Paintings* (London, 1969), pp. 89–90. Hope writes that the *Entombment* is contemporary with Titian's works for the Frari, and David Rosand tells me that he, too, now favors an earlier dating than 1525–30.

20. See chap. 1, sec. 4; Sinding-Larsen, "Pala dei Pesaro," p. 201; and, for Francis's veneration of the Innocents who anticipate Christ's Passion, Goffen, "Bonaventuran Analysis," p. 13.

21. St. Bonaventure, *Major Life,* x, 7 (Greccio) and xiii, 3 (the Stigmatization), trans. Benen Fahy, in Habig, *St. Francis,* pp. 710–11 and 730–31.

22. See, most recently, Valcanover, "Pala Pesaro," pp. 66–67.

23. For a brief of Alexander VI against the infidel in 1501, see ASV, Frari, B. 2, Libro 4, fol. 21v. The pontiff died on 18 August 1503. Father of the unsavory Lucrezia and Cesare Borgia, he was perhaps the most notorious individual ever to sit on the throne of St. Peter, but Jacopo Pesaro remained loyal to his memory. It was Pope Alexander who called the Crusade against the Moors in 1500. For Jacopo's role in the war with the Turks, see the various references in Sanuto's Diaries, cited in chap. 4, sec. 3; Pietro Bembo, *Della Historia Vinitiana* (Venice, 1552), vol. 6, fols. 82r–85r; and Sigismondo dei Conti, *Le storie de' suoi tempi* (Rome, 1883), vol. 2, pp. 276–79. On the war in general, see Sydney Nettleton Fisher, "The Foreign Relations of Turkey 1481–1512," *Illinois Studies in the Social Sciences* 30 (1948): 9–124; Marco Zorzi, *Deposition,* MS dated 1503, Biblioteca Correr, Codice Cicogna, 2941, III/3; and chap. 2, sec. 3 above. For Pope Alexander, see Roger Aubenas, in idem and Robert Ricard, *L'Eglise et la Renaissance (1449–1517)* (*Histoire de l'Eglise depuis les origines jusqu'à nos jours,* ed. Augustin Fliche and Victor Martin, vol. 15 [n.p., 1951]), pp. 126–49.

24. In his testament, Jacopo's cousin Benedetto Pesaro freed those of his Turkish and Jewish slaves who converted to Christianity, although one fortunate Turk was granted freedom in any case: "Item volo et ordino quod quinque sclavi Turchi quos hic habeo, quatuor quorum sunt femine et unus mas[chio], sint liberi ab omni servitute, et si aliquis ipsorum effectus esset Cristianus, sit in Dei nomine. Item reperitur etiam alia sclava Iudea cum suo filio, que si volet

fieri Cristiana, sit libera et francha. Item volo et ordino quod Ricci Turcha, quam misi Venetias D[omino] Benedicto Trono ad ordinem meum per navem meam, sit libera et francha, tam si fuerit Turcha, quam si effecta esset Cristiana" (ASV, Rizzo, B. 1227, no. 74, fol. 2r).

25. The figure as Saint Mauritius was suggested by Philip Fehl, "Saints, Donors and Columns," in *Renaissance Papers 1974* (Southeastern Renaissance Conference [Durham, N.C., 1975]), pp. 79–80. Cf. Jürg Meyer zur Capellen, "Beobachtungen zu Jacopo Pesaros Exvoto in Antwerpen," *Pantheon* 38 (1980): 150, for an interpretation of the figure as a soldier. Sinding-Larsen notes that this group is represented according to the ancient traditional formula of offering to God; see "Pala dei Pesaro," pp. 201–02 and n. 6.

26. Hope dates the painting ca. 1506, in his *Titian*, pp. 23–26. See also Giles Robertson, in *Genius of Venice*, p. 219, and a color reproduction on p. 55; Walther Vanbeselaere, *Musée des Beaux-Arts, Anvers Catalogue Descriptif, Maîtres anciens*, 2d ed. (Antwerp, 1958), p. 218; Meyer zur Capellen, "Beobachtungen," pp. 144–52; and Wethey, *Titian*, vol. 1, p. 152. Robertson suggests a date of 1506 or earlier for completion of the canvas; Wethey argues for a later date, ca. 1512; and Meyer zur Capellen considers that there were two stages of execution. For the portrait of Jacopo, see the dissertation by Susan Gene Moulton, "Titian and the Evolution of Donor Portraiture in Venice" (Stanford University, 1977), pp. 45–59. Pesaro's votive picture was probably displayed in his palace, like the painting by Bellini for Doge Agostino Barbarigo in 1488, now in S. Pietro Martire, Murano. In his testament, the doge alluded to this picture in the *crozola*, the "crossing" of his palace. See Goffen, "Icon and Vision," p. 511 and n. 143.

27. On Titian's fictive antique relief in the Antwerp picture, see Ludwig Curtius, "Zum Antikenstudium Tizians," *Archiv für Kulturgeschichte* 28 (1938): 235–38; and Rudolf Wittkower, "Transformations of Minerva in Renaissance Imagery," *Journal of the Warburg and Courtauld Institutes* 2 (1938–39): 202–05.

28. From the epitaph of Jacopo Pesaro, translated and cited in full in chap. 4, sec. 2 above.

29. For "dal Carro," referring to the family's very lucrative business, see n. 70 below. For a brief history of the Pesaro family, see chap. 2, sec. 1 and the Pesaro Family Tree. The family was traditionally associated with the parish of S. Zan Degolà, S. Giovanni Decollato, of which the Pesaro were great patrons. See Marciana MS Ital. VII.794 (8503), fol. 58v, and Giacomo Zabarella, *Carosio overo origine regia et augusta della serenissima fameglia Pesari di Venetia* (Padua, 1659), p. 52.

30. For the original parchment concession, see ASV, Pesaro, B. 102, no. 2; a copy is found in ASV, Frari, B. 5, *Catastico vecchio*, 5r–v (to which previous publications have referred). See also ASV, Frari, B. 2, fols. 11v–12v. My transcription is based on the original parchment: ". . . in et pro debita executione deliberationis facte per consilium religiosorum patrum conventus Sancte Marie Domus Magne Fratrum Minorum Conventualium de Venetie Ordinis Sancti Francisci in quo consilio videntur interfuisse Reverendi Patres Domini Magister Germanus de Casali guardianus benemeritus euisdem monasterij et Magister Provincie Terre Sancte . . . et . . . patres infrascripti. . . . In quo

capitulo interfuerunt prefatus Reverendus Dominus Magister Germanus [et al.] . . . et constituentes totum suum capitulum considerantes singularem devotionis affectum quem Reverendissimus in Christo pater Dominus Jacobus Pisauro Episcopus Paphensis et nobilis Venetus una cum magnificis dominis fratribus suis gerit ad ecclesiam et religionem eiusdem monasterij volentesque propterea ipsum spiritualibus prosequi et confovere muneribus ut sibi charitative devinciatur agentes [que] propterea nomine prefati monasterij pro se et eorum successoribus ac omni meliore modo quo potuerunt et possunt dederunt et concesserunt in perpetuum prefato Reverendissimo in Christo Patri Domino Jacobo Pisauro Episcopo Paphense moderno et fratribus suis pro se et eorum heredibus ac successoribus in perpetuum licet absentibus sed mihi notario tamquam publice persone stipulanti pro eis et eorum nomine altare et sive capellam Beatissime Verginis Marie sub titulo eius Conceptionis positum seu positam in ecclesia prefati monasterij in latere dextro inter capellam Sancti Petri et portam de medio ipsius ecclesie nuncupatam la porta de la Madona cum omnibus iuribus habentiis et pertinentiis suis ad habendum gaudendum fabricandum exornandum et in ordine ponendum prout eisdem Domino Episcopo [et fratribus suis] placuerit cum his declarationibus obligationibus et conditionibus infrascriptis scilicet quod prefatus Dominus Episcopus possit et debeat nedum fabricare et exornare dictum altare sive capellam nedum etiam construere et fieri facere unam archam terrenam in pavimento ac unum tumulum in muro ab altero latere tantum dicti altaris cum suis insigniis epitaphiis et ornamentis condecentibus quibus et prout prefato Domino Episcopo placuerit et iusum fuerit expedire suis propriis sumptibus tam super altare sive capella quam super archa et tumulo predictis. Item quod prefatus Reverendissimus Dominus Episcopus teneatur dotare et stipendiare unam mansionariam perpetuam de ducatis vigenti quinque usque ad triginta vel circa annuis et singulis annis percipiendis per prefatos Dominos Guardianum et conventum ac eorum successores deputando pro tali mansionaria unum fundum liberum et expeditum sive gravetiis quam mansionariam iidem Domini Guardianus et conventus cum eorum successoribus per se ipsos officiare debeant et promiserunt celebrando singulis diebus missam pro salute et animabus prefati Reverendissimi Domini Episcopi et fratrum suorum ac defunctorum eorundem in perpetuum. Item quod prefatus Dominus Episcopus cum heredibus ac successoribus suis debeant singulo anno in festo predicte Conceptionis Beatissime Virginis Marie erogare et solvere prefatis Dominis Guardiano et conventui atque eorum successoribus ducatos duos pro facienda pietantia eiusdem conventus de anno in annum. Item quod prefati Domini Guardianus et conventus cum eorum successoribus sint obligati quolibet anno in universali [comme]moratione defunctoribus illuminare predictam arcam faciendam cum duobus torziis sive dopleriis cereis condecentibus tam ad missam quam ad vesperas et matutinum et sic successive de anno in annum in perpetuum. . . ."
The document was written by the notary Bonifacio Soliani and dated 3 January 1518.

31. Ibid., written on the same parchment as the initial agreement.
32. Ibid., fols. 9r–11v, a late copy of a document dated 7 September 1524.
33. The badly preserved family copy of the will, written in iron gall ink on paper,

is ASV, Pesaro, B. 1, no. 7; see also the better preserved copy, ASV, Archivio Notarile Zambelli, B. 1101, no. 121. Excerpts of the will (the latter citation) were published with some minor errors in the transcription by G. Ludwig, "Archivalische Beiträge zur Geschichte der venezianischen Kunst," *Italienische Forschungen* 4 (1911): 133–34. The clause regarding Jacopo's financial obligations to the Frari is copied in ASV, Frari, B. 5, fol. 48v, and in ibid., B. 133 [MO-PE], c. 32/48: "Item perchè semo obligati trovar uno fondo per le due mansionarie delli Frati Menori di ducati trenta all'anno et ducati dui per la piatanza del giorno della Conceptione della Madonna, et havendo lassato il quondam messer Francesco fu nostro fratello ducati quindeci per una de ditte mansionarie sopra le daie da Padoa comprate in nome nostro ducati quindeci siano consegnati al ditto monasterio di Frati Menori per conto dell'altra mansionaria." I thank Dr. Gino Corti for his kind assistance with this document.

34. See Goffen, "*Nostra Conversatio in Caelis Est*: Observations on the *Sacra Conversazione* in the Trecento," *Art Bulletin* 61 (1979): 198–222.

35. I have incorporated in my transcription the letters "er"—now worn away—in "ser," as recorded by Cicogna, Biblioteca Correr, B. 500, no. 9, fol. 120. In other respects our transcriptions agree. Cicogna also recorded another inscription, ibid., no. 121, evidently on the step or steps of the altar, of which I can see no trace whatsoever: ". . . andr . . . q . . . /carris. sibiq. mo . . . / p. a-i . . . par . . . /posuit/ . . . depositum/ . . . / . . . orruptibil . . . /MDIII."

36. The relevant passage is quoted in full in n. 39 below.

37. Smaller reliefs of the arms are carved on the bases of the columns of the frame. Logically, all of the arms must originally have been polychromed.

38. The bishop appears to be much the same age as in Titian's portrait, although note that funerary effigies often represented the deceased as being of some ideal age; see my "Carpaccio's *Portrait of a Young Knight*: Identity and Meaning," *Arte veneta* 37 (1984): 46.

39. ASV, Zambellli, B. 1101, no. 121, fol. 1r: "Il nostro corpo veramente . . . volemo che vestito com li habiti pontificali sia posto a requiescer fino al giorno del Santto Iudicio nel monumento che havemo fatto far in alto nella chiesa di Frati Menori della Casa Granda di Venetia, facendo fare li ditti nostri commissarii et infrascripti heredi l'exequie funebre secondo che conviene al grado et conditione nostra, et honor etiam di casa nostra, et non già perchè desideramo pompa della qual non si curamo." The bishop's modest wish was probably pro forma; n.b. the similar expression in the will of Doge Francesco Dandolo, cited below in n. 76. Traditionally in funerary images, the effigy of the deceased represented him wearing the clothing in which he was actually interred. For example, when the body of Paolo Savelli was exhumed, it was found dressed in a red velvet jacket and holding a baton in the right hand, just as he is depicted in the polychromed equestrian statue that surmounts his monument in the Frari. (See Sartori, *Guida,* p. 121.) Savelli and his tomb are considered further in chap. 1, sec. 2, and chap. 2, sec. 3, of the present volume.

40. His father, Leonardo, had been "conseier" in Cyprus. See Sanuto, *Diarii,* vol. 12, col. 242, 16 June 1511.

41. ASV, Zambelli, B. 1101, fol. 121: ". . . havemo deliberato . . . che havemo

il tempo disponer delli beni . . . li quali non sono acquistadi ne' pervenuti in noi per contto de' benefitii ecclesiastici, ma como beni paterni et fraterni, et con grande nostre fatiche et sudori quando che eramo layco sì a Constantinopoli como altrove havemo acquistadi."

42. For Jacopo's ecclesiastical career, see Conradus Eubel, *Hierarchia Catholica Medii aevii,* rev. ed. (Regensberg, 1914), vol. 2, p. 212. The Major Orders were the ranks of bishop, priest, and deacon; the Minor Orders of the ministry, i.e., those below the Major Orders, included acolytes, exorcists, and lectors; see *The Concise Oxford Dictionary of the Christian Church,* ed. Elizabeth A. Livingstone (Oxford, London, and New York, 1977), p. 338. In 1535, Jacopo Pesaro was "conservatore delle Bolle Apostoliche"; see Biblioteca Correr, Codice Cigogna 1445, p. 10.

43. T. J. Riley, in *New Catholic Encyclopedia* (New York et al., 1967), vol. 14, pp. 199–200, s.v. "tonsure."

44. Sanuto, *Diarii,* vol. 3, col. 847, 28 September 1500, and vol. 4, col. 256, 27 April 1502. Regarding the ties between the Pesaro and the Grimani, see Sanuto, vol. 30, col. 41, 14 July 1521; Jacopo's brother Francesco participated in a procession for the Solemnity of the Apparition of St. Mark in the company of the relatives of Doge Antonio Grimani. For further information on Jacopo's career, see the sources cited by Cavalcaselle and Crowe, *Tiziano,* vol. 1, p. 60, n. 3.

45. Sanuto, *Diarii,* vol. 4, cols. 45 and 256.

46. Ibid., cols. 276–77. For Benedetto's role, see chap. 1, sec. 3.

47. Sanuto, *Diarii,* vol. 4, col. 444.

48. The dates of birth are derived from the Registro, Balla d'oro, of the Avogaria di Comun, ASV, B. 164/III, fols. 293r–v. Cf. Valcanover, "Pala Pesaro," p. 59, n. 4. The years in which the brothers died are indicated on their testaments in ASV, Zambelli, B. 1101, fols. 89, 94, and 121: Francesco, 1529 with a codicil of 1533; Fantino, 1542; and Jacopo, 1542. Excerpts of Jacopo's will were published by Ludwig; see n. 33 above. The six brothers were the sons of Leonardo Pesaro and his wife, Bianca Querini, who were married in 1449; ASV, Avogaria di Comun, Registro 107, Cronaca Matrimoni 2, fol. 260v: 1449 Lunardo *q.* Zuanne *q.* Andrea and Bianca di Francesco Querini da S. Anzolo. (The Register is a later compilation or copy.) Was Bianca, I wonder, closely related to the Lodovico Querini who died in 1499 and wished to be buried at the altar of the Conception? (See n. 6 above.) Bianca was widowed in 1476; for Leonardo's death, see Girolamo Alessandro Capellari, *Il campidoglio veneto,* vol. 3, fol. 209r (Biblioteca Marciana, MSS It. VII.17 [8306], written ca. 1741). On April 29 of 1476 Bianca was a principal in a contract regarding a loan. The loan agreement was drawn by the notary Gerolamo Bonicardi: Biblioteca Correr, Cod. Cicogna 34261, no. 25, pergamena 5.

49. There is no listing of Giovanni Maria's birth in ASV, Avogaria di Comun, Nascite, B. 51/I, dated 1506 on 2r and 4r.

50. ASV, Avogaria di Comun Registro, B. 107/2, fol. 261v: "1506 Ser Vettor da Pesaro qual era Mercante in Cipro quondam Ser Lunardo . . . In la fia del Ser Antonio Morosini che si trova Consier in Cipro." Schiavona's name is given by Sanuto, who notes that Vittore's father had also been "consier" in Cyprus

(*Diarii,* vol. 12, col. 242). The marriages of Vittore's brothers Giovanni (1497) and Antonio (1506) are recorded in the Registro, B. 107/2, fols. 261r–v, and also in ASV, Avogaria del Comun, Cronaca Matrimoni, B. 106/1, fols. 58r–v, which includes Francesco's marriage in 1487. Antonio's marriage contract is preserved in ASV, Pesaro, B. 2, no. 2, 1506, 10 October.

51. Sanuto, *Diarii,* vol. 12, col. 242. Schiavona married that someone else on 16 June 1511.

52. ASV, Pesaro, B. 1, no. 3, for the parchment of Francesco's will of 12 April 1529 and the codicil of 20 July 1533, and ASV, Zambelli, B. 1101, no. 89, for the paper "copies." Attached to the parchment will is a document dated 28 July 1762 from the Cancelleria Inferiore to the effect that no later will was made by Francesco and that this testament and codicil were published by the notary on 20 December 1533. Francesco's commissaries were his brothers Jacopo, Fantino, and Giovanni, and their nephew, Leonardo, Antonio's son. For Fantino's testament of 22 August 1542, see ASV, Zambelli, B. 1101, no. 94. Fantino's commissaries were his by then only surviving brother, Jacopo, and once again Leonardo. Fantino endowed annual masses for the anniversaries of his own death and the deaths of two of his deceased brothers, Francesco and Antonio. The friars were to receive one ducat on the occasion of each anniversary. Jacopo took care of the remaining two brothers, endowing masses for the souls of Giovanni and Vittore, as well as for his own; ASV, Zambelli, B. 1101, no. 121. The relevant clauses from the wills of Jacopo and Fantino are copied in Frari, B. 3, fol. 25v, and B. 5, fols. 47v–48r (regarding Fantino).

53. See also Fehl, "Saints, Donors and Columns," p. 80.

54. ASV, Pesaro, B. 1, no. 3, and Zambelli, B. 1101, no. 89, codicil dated 1533: "in loco di carissima madre." The entire passage is quoted below, n. 68.

55. ASV, Pesaro, B. 1, no. 8 (parchment): "Item non si maraviglia alcuno se non lasso cosa alcuna al Reverendo messer Zuanmaria da Cha' da Pesaro mio nepote perchè el sta bene de beneficii ecclesiastici. Item non si maravigliera alcuno se non lasso a madonna Biancha Contarini et a madonna Maria Loredan mie nezze [nieces] cosa alcuna per star bene et non haver dibisogno del mio." See also ASV, Zambelli, B. 1101, no. 94, fol. 2v.

56. ASV, Pesaro, B. 1, no. 7, fols. 3v–4r, and Zambelli, B. 1101, no. 121, fol. 2v: "Item lassemo al Reverendo Messer Giovanni Maria da Cha' da Pesaro, fo fiol del ditto quondam Messer Vettor, fu nostro fratello, nostro charo nepote et a noi sempre obedientissimo, tutto quello che lui apparesse nostro debitor per li nostri libri, over per altra via, et oltra che lassemo in segno de amor uno bacil et uno ramin d'arzento ["de arzento" in Zambelli], meza dozena de tondi de arzento, meza dozena de scodelle de arzento, et meza dozena de fondelini de arzento, una dozena de pironi de arzento et una dozena de cuslier de arzento et uno paro di saliere di arzento, et una dozena dc cortelli con il manego de arzento et tre over 4 ["quatro" in Zambelli] sottane et rocheto et dui mantelli delli meglior ad electione et come parerà a esso messer Zuane Maria, et tutti li libri in theologia et philosophia et in Jure che sono nostri. Et più non li lassemo per haverlo accommodato del'episcopato et de tutti li nostri beneficii senza alcuna sua spesa ita che el potrà viver honoratamente da gentilhomo, et sapemo che per la sua gentil natura starà in amor et benivolentia con suo cusino

Lunardo nostro nepote, et cusí farà il ditto Lunardo, per amarse non da cusini ma da veri et dolci et chari fratelli, et cusí li exhortemo et pregamo esso messer Giovanni Maria a star et far alli fioli del ditto Lunardo come noi havemo fatto a lui."

57. Their membership in the Scuola Grande di S. Marco is documented in the brothers' testaments, as cited in n. 48 above. Their cousin Benedetto was affiliated with the Scuola Grande di S. Giovanni; see chap. 2, sec. 3, and Sanuto, *Diarii,* vol. 5, cols. 78–79.

58. N.b., for example, the priest Luca, an illegitimate son—"naturale"—of Nicolò Pesaro, mentioned by Sanuto, *Diarii,* vol. 33, col. 266.

59. ASV, Avogaria di Comun, B. 106/1, fol. 58v, and B. 107/2, fol. 261v. Elena was the daughter of Nicolò Malipiero. The contract itself is preserved in ASV, Pesaro, B. 2, no. 2, 10 October 1506.

60. Sanuto, *Diarii,* vol. 4, col. 423, 5 November 1502.

61. The parchment original of Elena's testament of 27 February 1530, ASV, Pesaro, B. 2, no. 4, and the notary's contemporaneous copy is ASV, Zambelli, B. 1101, no. 84r. For Antonio's death intestate, see the will and codicil of his brother Francesco in 1529 and 1533; ASV, Pesaro, B. 1, no. 3, and Zambelli, B. 1101, no. 89, fol. 1r. In the parchment will Francesco explains: ". . . havendo facto altre volte el mio testimento . . . sotto dì xii del mese de april 1529 . . . ho deliberato azonzer et minuir al dicto mio testamento alcuna cossa per causa dele occurrentie deli tempi . . . Item perchè el quandam M. Antonio nostro carissimo et cordial fratello morse senza testamento. . . ."

62. For the tradition and for Girolamo's burial in the habit of the Conventual Franciscans, see chap. 2, sec. 3. Likewise, Lodovico Querini ordered his burial in the Franciscan habit at the altar of the Conception; chap. 4, sec. 1 and n. 7.

63. The two sisters were mentioned in Fantino's will in the clause following his reference to Giovanni Maria, and were similarly excluded from inheritance; ASV, Zambelli, B. 1101, no. 94, and below, n. 92. Bianca's marriage contract, dated 15 September 1524, is preserved in ASV, Pesaro, B. 2, no. 3. She married Filippo Contarini *q.* Zaccaria, and the marriage was celebrated by none other than Fra Germano.

64. Nicolò's birth is registered in ASV, Avogaria di Comun, Nascite, B. 51/1, fol. 233v, March 1515.

65. ASV, Zambelli, B. 1101, no. 121, fol. 1r: ". . . parte de essi [beni] ultimamente havemo diviso tra li infrascritti nostri fratello [Fantin] et nepote [Lunardo] et la commissaria del quondam messer Francesco da Cha' da Pesaro . . . fu nostro fratello. . . ."

66. For the date of Leonardo's birth, see ASV, Avogaria di Comun, Nascite, B. 51/1, fol. 233r: "the last day of March 1509." He died at age seventy-six and was buried in the family tomb: "Ordeno et voglio chel mio corpo sia sepelito nella nostra archa alli Fra Menori . . ." (ASV, Pesaro, B. 1, no. 14, 19 October 1581). Bound together with the parchment will is a sheet copied from the *Libro de Morti* of the Frari, giving Leonardo's age at his death. Others have also identified the boy as Leonardo; see, for example, Meyer zur Capellen, "Beobachtungen," p. 150.

67. Cf. Fehl, "Saints, Donors and Columns," p. 80, who suggests a different

order. For Gentile's canvas, see Sandra Moschini Marconi, *Gallerie dell'Accademia di Venezia, Opere d'arte dei secoli XIV e XV* (Rome, 1955), p. 63. For the identities of the family members portrayed by Gentile, see Felton Gibbons, "New Evidence for the Birth Dates of Gentile and Giovanni Bellini," *Art Bulletin* 45 (1963): 54–58.

68. Both women were identified as the daughters of Nicolò Malipiero *q.* Stefano in ASV, Avogaria di Comun, B. 106/1, fol. 58v, and B. 107/2, fols. 261r–v, i.e., two Malipiero sisters married two Pesaro brothers. The relevant passages from Francesco's codicil (ASV, Pesaro, B. 1, no. 3, and Zambelli, B. 1101, no. 89) read as follows: "Item perché el quondam messer Zuanne nostro carissimo fradello, è, nelli preteriti zorni mancado de questa misera et caduca vita senza testamento et ordene alcuno havendo lassado la sua donna madonna Maria Malipiero et nostra carissima et cordialissima sorela et cugnata senza beneficio, perho Io che represento tutta la casa et sapendo la intentione de tutti li mei fratelli et carissimo nepote che quelli insieme cum mi la amano et l'hanno in loco di sorella et Lunardo in loco di carissima madre perho voglio et ordeno che fin la dicta madonna Maria nostra carissima cugnada et sorella viverà habia in casa nostra honoratamente el victo et vestito secundo el grado et condiction sua, et voglio sia honorata da tutti come la merita." Francesco considered himself responsible for his brother's widow because a married woman, like Maria Malipiero Pesaro, would be excluded from her father's will because she had already received her share of the estate as her dowry. Presumably Maria and Giovanni had no sons or unmarried daughters, or Francesco would have provided for the children as well as for the widow. Moreover, Francesco mentioned no children of his own in his will: he must have been without a male descendant. On the exclusion of a married woman from her father's will, see Stanley Chojnacki, "Dowries and Kinsmen in Early Renaissance Venice," *The Journal of Interdisciplinary History* 5 (1975): 571–600; idem, "Patrician Women in Early Renaissance Venice," *Studies in the Renaissance* 21 (1974): 176–203; and Edward Muir, *Civic Ritual in Renaissance Venice* (Princeton, N.J., 1981), p. 150.

69. ASV, Pesaro, B. 1, no. 3, and Zambelli, B. 1101, no. 89, fol. 1r: "Item voglio et ordino che in perpetuo sia celebrata la messa . . . laqual mesa voglio sia ditta ogni zorno in perpetuo al nostro altar dela Conception della Nostra Donna come al presente io fazo dir. . . ." This endowment, the tomb inscription, and the fact that Francesco outlived all but his two youngest brothers— all suggest that Francesco, looking younger than his years, is the first man to the proper left of the Madonna's throne.

70. On behalf of the Pesaro fraterna, Francesco represented his brothers in their investments at Lizzafusina on the mainland. This branch of the family was called "dal Carro" in reference to their service of transporting boats across the canal of Lizzafusina. See Sanuto, *Diarii*, vol. 19, cols. 77, 243, 277, and 320; idem, vol. 52, col. 331; and Andrea da Mosto, *I dogi di Venezia nella vita pubblica e privata* (Milan, 1966), p. 488. Representing the fraterna, Francesco inherited from his cousin Marino Morosini *q.* Domenico: "caratti ho in Lizafusina, sì nel hostaria como nel tragetto et nel lavar dele tane et nel canal siano di mei cusini de Cha' da Pexaro cioè Messer Francesco et fratelli . . ."

(ASV, Pesaro, B. 1, no. 2, fol. 1r, 20 April 1523). Associated with this document in the family archive (ibid., fol. 5r) is a financial statement by Francesco in 1530 regarding the business at Lizzafusina. For bibliography on the Venetian fraterna, see chap. 2, sec. 3 and n. 100.

71. Biblioteca Correr, MS P.D., c. 753/3: "Augustinus Barbadico Dei gratia Dux Venetiarum et cetera universis et singulis tam amicis quam fidelibus presentes letteras inspecturis salutem et syncere dilectionis affectum. Proficiscitur ad sanctam Mariam Laureti pro voto suscepto nobilis civis noster Franciscus de Cha' de Pesaro cum famulis et sociis suis: Icciro Amicos cognoscuntur Rogamus subditis et fidelibus nostris racomdantes quatenus prefatum nobilem cum bulgiis valisiis et aliis quibuscumque rebus et bonis suis per quascumque civitates terras, castra, oppida, portas, pontes, passus, aquas, flumina, maria, pallatas et quelibet alia loca vestra, seu vobis commissa transitum facientem euntem, stantem et redeuntem die noctuque; semel et pluries, tam equestrem quam pedestrem, et tam per terram quam per aquam transitari et expedire, ac transitari et expediri facere placeat et velitis eum secum, libere, favorabiliter, benigne, et expedita, sine solutione Alicuius pedagii trandinavis et estimis seu transitus omnique alio impedimento seu molestia cessante penitens et remota. . . ."

72. The typical behavior for a relic displeased with its environment involved aiding and abetting its own removal, i.e., acting as accessory before, during, and after the fact of its "sacred theft," as explained by Patrick Geary, *Furta Sacra: Thefts of Relics in the Central Middle Ages* (Princeton, N.J., 1978).

73. For the role of Sixtus IV, and his great interest in the shrine, see H. M. Gillett, *New Catholic Encyclopedia* (New York et al., 1967), vol. 8, pp. 993–94, s.v. "Loreto"; and Raphael M. Huber, *A Documented History of the Franciscan Order* (Milwaukee and Washington, D.C., 1944), p. 438. Pilgrimages to Loreto had begun ca. 1470 and were "universal" by the early sixteenth century, according to Louis Gillet, *Histoire artistique des ordres mendiants, Essai sur l'art religieux du XIII^e au XVII^e siècle* (Paris, 1912), p. 242. I am grateful to Professor Kathleen Weil-Garris Brandt for discussing with me the cult of Loreto in the late fifteenth and sixteenth centuries.

74. See chap. 2, sec. 2 and n. 85.

75. Sanuto, *Diarii,* vol. 4, col. 460, 21 November 1502, discussed further above, chap. 4, sec. 3, and with the text in n. 95. Examples of public service by the Pesaro brothers are numerous. Antonio's vital biscuit factory helped to feed the Venetian armada in the war with the Turks between 1500 and 1502 (ibid., vol. 3, cols. 730 and 1153, 27 September 1500 and 9 December 1500; vol. 4, cols. 423 and 491, 5 November 1502 and 29 November 1502). He was Capitano in Vicenza in 1518 (ibid., vol. 25, col. 556, 25 July). In 1510 both Antonio and his brother Giovanni were chosen as Pregadi (ibid., vol. 10, col. 612, 22 June). On 3 August 1515, Francesco lent a very generous 200 ducats to the Signoria, much more than most others on that occasion, when some noblemen lent as little as 30 ducats (ibid., vol. 20, col. 466).

76. For the lunette, see Michelangelo Muraro, *Paolo da Venezia* (University Park, Pa., and London, 1970), pp. 126–27; and Wolfgang Wolters, *Der Bilderschmuck des Dogenpalastes, Untersuchungen zur Selbstdarstellung der Republik Venedig im*

16. Jahrhundert (Wiesbaden, 1983), p. 94; for the tomb, see Wolters, *La scultura veneziana gotica (1300–1460)* (Venice, 1976), vol. 1, pp. 163–64. Francesco Dandolo had requested burial in the Frari in his testament, ASV, Procuratori de Citra, Testamenti, B. 12, no. 973, 26 October 1339; published in *Antichi testamenti tratti dagli archivi della congregazione di Carità di Venezia,* ser. 7 (1888), pp. 9–16. The passage regarding his tomb reads as follows in the published transcription (p. 10): "Corpus autem nostrum sepeliri volumus apud fratres minores sancte Marie de fratribus de Veneciis ubi fiat nobis tumulus honorabilis atque decens, tamen cum quam minori pompa et vanitate fieri possit, salvo in hoc quod condecet pro honore Ducatus. In quo si quidem reponatur corpus etiam consortis nostre predicte in suo decessu, si ei libuerit; sed archa nostra solita domus sit et remaneat posteris nostris comunis." For the inventory of Dandolo's estate, see Pompeo Molmenti, *La storia di Venezia nella vita privata dalle origini alla caduta della repubblica,* 5th ed. rev. (Bergamo, 1910), vol. 1, pp. 475–77 (ASV, Cancelleria Inferiore, B. 219). Paolo's lunette for the doge's tomb helped to establish the type of ducal votive picture; see Wolters, *Bilderschmuck,* p. 94.

77. See chap. 2, sec. 2, and n. 76; for the high throne, Sinding-Larsen, "Madone stylithe"; and H. S. Ettlinger, for the "Iconography of the Columns."

78. Fehl, "Saints, Donors," pp. 83–84, also sees in Titian's columns a reference to the Molo. For the identification of Venice and the Virgin, see chap. 5, sec. 1, of the present volume.

79. For Bellini's inscription, see chap. 2, sec. 2.

80. Sanuto, *Diarii,* vol. 4, col. 460, quoting Jacopo Pesaro. The passage is translated and cited in full in chap. 4, sec. 3, and n. 95.

81. Sinding-Larsen noted the relationship with votive pictures; see "Titian's Madonna di Ca' Pesaro and Its Historical Significance," *Acta ad Archaeologiam et Artium Historiam Pertinentia* (Institutum Romanum Norvegiae) 1 (1962): 148 and 151 (with a consideration of prototypes in the Bellini shop).

82. Fisher, "Foreign Relations," passim; and the bibliography cited in chap. 2, n. 99 and in chap. 4, n. 23. For the Antwerp picture as an expression of Jacopo's political views, see Meyer zur Capellen, "Beobachtungen," p. 149.

83. Sanuto, *Diarii,* vol. 23, col. 41, 11 October 1517: "In Colegio veneno molti frati di San Francesco di la Cha' Grande, per certi danari di la Cruciata è in la Procuratia etc." In 1518, the Emperor Maximilian urged the Italians to join the new crusade with Leo X against the Porte; see Hazlitt, *Venetian Republic,* vol. 2, p. 160; and Louis Brehier, *Catholic Encyclopedia* (New York, 1908), vol. 4, pp. 555–56, s.v. "Crusades."

84. St. Bonaventure, *Major Life,* ix, 8, trans. Fahy in Habig, *St. Francis,* p. 704. For a historical account of Saint Francis's appearance before the Sultan al-Kamil, who was "too kind and too highly civilized" to permit the friar to walk into the flames, see Steven Runciman, *A History of the Crusades,* vol. 3, *The Kingdom of Acre and the Later Crusades* (Cambridge, 1955), pp. 159–60. The King of Jerusalem attended the canonization of Saint Francis; see John Moorman, *A History of the Franciscan Order from its Origins to the Year 1517* (Oxford, 1968), p. 86.

85. T. S. R. Boase, *Kingdoms and Strongholds of the Crusaders* (Indianapolis and New

York, 1971), pp. 240–42. Clement's bulls *Gratias agimus* and *Nuper carissimae* confirmed donations of sacred sites by Robert of Anjou and Queen Sancia to the Franciscans in 1333. See Giovanni Odoardi, "La custodia francescana di Terra Santa," *Miscellanea francescana* 43 (1943): 233. Clement's bulls were confirmed by Martin V in *Dudum siquidem* of 14 February 1521 (see Odoardo, p. 235). For the Franciscan order in Constantinople, see Gualberto Matteucci, *La missione francescana di Costantinopoli,* vol. 1, *La sua antica origine e primi secoli di storia (1217–1585)* (Biblioteca di studi francescani, 9, Florence, 1971). The donations by Robert of Anjou gave the friars title to the Holy Land *iure donationis,* as explained by Pietro Antonio di Venezia, *Giardino serafico istorico delli tre ordini instituiti dal serafico padre S. Francesco* (Venice, 1710), vol. 2, p. 92.

86. On the altar of the B. Gentile and the Ca' Bernardo in 1463, see ASV, Frari, B. 2, fol. 91v. For the story of the beato, see Timoteo Spimbolo, *Storia dei Frati Minori della Provincia Veneta di S. Francesco* (Vicenza, 1933), vol. 1, p. 70.

87. For the original location of the painting, see Marco Boschini, *Le minere della pittura* (Venice, 1664), p. 299. When the convent was suppressed, among the relics in the Frari were some bones of the Franciscan saints; Biblioteca Correr, Raccolta Cicogna, B. 3063, no. 14, fol. 2v. The blood shed by such Franciscan missionaries gave the Friars Minor title to the Holy Land *iure belli,* according to Pietro Antonio di Venezia, *Giardino,* vol. 2, p. 91.

88. Germano is so identified in the document of 1518 conceding the altar of the Immaculate Concession to Jacopo Pesaro and his brothers, ASV, Frari, B. 5, fol. 5r; parts of the document are transcribed in n. 30 above.

89. See Odoardi, "Custodia," p. 244.

90. This is the subject of an important article by Lester J. Libby, Jr., "Venetian History and Political Thought after 1509," *Studies in the Renaissance* 20 (1973): 7–45.

91. For Andrea Navagero, see ibid., pp. 8ff., and 34–36 for the emphasis on the Venetian role in the Crusades. Libby notes the consideration of that subject in a work by G. B. Egnazio, *De Exemplis Illustrium Virorum Venetae Civitatis atque Aliarum Gentium,* published in Venice in 1554 but being written already in 1512.

92. She is remembered in the will of her brother Fantino, ASV, Pesaro, B. 1, no. 8, 22 August 1542: "Item lasso a Madonna Franceschina Navagier mia chara sorella fino che la vivera ogn'anno ducati vinti. Item lasso a messer Luca Navagier mio nepote, fiol della ditta madonna Franceschina mia sorella in segno d'amor ducati vinticinque per una volta sola." Her name, Francesca or Franceschina, is another reflection of Pesaro devotion to Saint Francis and may perhaps represent her parents' fondness for their cousin, Franceschina Tron Pesaro, the mother of the S. Benedetto branch of the family, buried in the sacristy of the Frari (see above, chap. 2, sec. 1). Jacopo's sister Franceschina dictated her will to the family notary, Zambelli, on 27 November 1542, identifying herself as the widow of Bernardo Navagero and ordering her burial in his tomb in the Madonna dell'Orto. The clause reads: ". . . quando che mi accadera morir voglio chel corpo mio vestito del habito dele pinzochare del Terzo Ordine de S. M. di Servi sia sepulto a S. Maria del Orto in l'archa dove se sepulto il q[uondam] mio marito . . ." (ASV, Zambelli, B. 1101, no. 100).

93. The treaty was concluded on 30 July and signed 10 August 1503. Santa Maura was consigned to the Turks at the end of that month, August 31. See Fisher, "Foreign Relations," p. 86; and Valcanover, "Pala Pesaro," p. 57, n. 1.
94. For a contemporary's account, see Sanuto, *Diarii,* vol. 4, cols. 313ff. and 351.
95. Ibid., col. 460: "In coleio. Vene il reverendo episcopo di Bafo, domino Jacobo de cha' de Pixaro, stato capetanio di le galie dil papa, et disse, comme di le operation sue non achadeva, ma sempre si havia exercitato a beneficio di la Signoria; e lui fè far la palifichada a Santa Maura e non il zeneral [Benetto]; et che era sempre per far, lui e soi fratelli, a beneficio di questa Signoria. Poi dimandò una gratia, che 'l suo vescoado di Baffo fosse scrito a Roma a l'orator otenisse dal papa, che 'l primo vescoado equivalente in queste parte l'avesse, acciò podesse far la residentia, et lui li daria questo in contracambio." This was not the first time that Jacopo had complained about the general; Sanuto also summarized his statement of 13 November 1502 (ibid., col. 444). It was Fehl who first called attention to the antipathy between Jacopo and Benedetto Pesaro; "Saints, Donors," p. 79 and n. 7.
96. Hazlitt, *Venetian Republic,* p. 139; and, for conflicts between Pope Alexander and the Serenissima, Paolo Prodi, "Structure and Organization of the Church in Renaissance Venice," in *Renaissance Venice,* ed. J. R. Hale (London, 1973), p. 412. See also F. Gaeta, "Origine e sviluppo della rappresentanza stabile pontifica in Venezia (1485–1533)," *Annuario dell'Istituto Storico Italiano per l'Età Moderna e Contemporanea* 9–10 (1957–58): 3–282.
97. Prodi, "Structure," pp. 417–18, explains the Venetian system of nominating bishops in the Senate for presentation to the pope for approval. Sanuto recorded that Jacopo was considered for the bishoprics of Cremona and Vicenza in 1503, and in 1507 for that of Vicenza; *Diarii,* vol. 4, col. 844; vol. 5, col. 19; and vol. 7, cols. 634–35. In 1524, he was considered for the patriarchate; ibid., vol. 37, col. 21. But Pesaro died Bishop of Paphos. (Cf. the unsubstantiated statement in Zabarella, *Carosio,* p. 59, that Jacopo became bishop of Torcello.)
98. ASV, Pesaro, B. 1, no. 7, fol. 3r, and Zambelli, B. 1101, no. 121, fol. 3r: "Item . . . che metta una mansionaria in perpetuo dove che a loro [Fantino e Leonardo] parerano elezendo uno prete secular che sia di bona condittione et fama qual sia obligato ogni giorno eccettuando uno giorno alla settimana che volemo che'l sia exempto, celebrar messa per l'anima della felice recordationis di Alessandro papa sexto, et della reverenda memoria del R.mo Cardinal Adriano quali furono nostri cordialissimi patroni. . . ." Cardinal Hadrian was Jacopo's guest from October to May 1518; see Sanuto, *Diarii,* vol. 25, cols. 33, 400–01, and 430–31.
99. The Mariegola of the Scuola della Concezione, dated 1498, is copied in ASV, Pesaro, B. 2, no. 1; n.b. fol. 12r: ". . . a honor e reverentia e stado e grandezza de la giesia romana e dal nostro protettore e pastore Papa Alessandro sexto. . . ."
100. Sanuto, *Diarii,* vol. 52, col. 331: "A dì 8 [December], mercore, fo la concetion de la Madona. . . . in chiesia di Frati menori, a l'altar novo di Pexaro *dal Caro,* fu etiam fato la festa de la comception; la chiexia benissimo conzada tutta et, tra le altre cose, fu preparato con 16 stendardi di doxi et capitanei zeneral . . . *Item,* quel del vescovo di Baffo, Pesaro. . . ." Decoration of the church with

banners of doges and captains general was not unique. Note, for example, Sanuto's record of the decoration of the Frari for the feast of St. Francis on 4 October 1525; ibid., vol. 40, col. 16.

101. ASV, Notarile Testamenti Cristoforo Rizzo, B. 1227, no. 74; discussed in chap. 2, sec. 3.

102. In fact, Benedetto had praised Jacopo for his part in the battle of Santa Maura in his letter to the Republic dated 30 August 1502, as reported by Sanuto on 15 September, *Diarii,* vol. 4, col. 315.

103. Titian was concerned with the paragone, the rivalry of the arts, throughout his long career. It is the theme of his early portrait, the so-called *Schiavona* (London, National Gallery), in which a profile portrait represented as a fictive stone relief is juxtaposed with the lady herself, and of his very late *Pietà* in the Accademia of Venice, for which see chap. 5, sec. 2.

104. For Girolamo's tomb, now destroyed, see chap. 2, sec. 3.

CHAPTER V

1. Biblioteca Nazionale Marciana, MS It. VII.299 (7868), fol. 11v.

2. For the consecration of the Frari, see chap. 1, sec. 2. On the cult of Mary in Venice, see Francesco Marchiori, *Maria e Venezia* (Venice, 1929); Edward Muir, *Civic Ritual in Renaissance Venice* (Princeton, N.J., 1981), pp. 138–45 and 152–53; Giovanni Musolino, "Culto mariano," in *Culto dei santi a Venezia,* ed. S. Tramontin et al. (Venice, 1965), pp. 241–74; David Rosand, "*Venetia Figurata*: The Iconography of a Myth," in *Interpretazioni veneziane: Studi di storia dell'arte in onore di Michelangelo Muraro,* ed. Rosand (Venice, 1984), pp. 177–96; and Sarah Wilk, *The Sculpture of Tullio Lombardo* (New York and London, 1978), pp. 108–19. Musolino, "Culto mariano," pp. 242–45, takes note of the numerous Venetian *Arti* and confraternities dedicated to the Virgin and the many ships named for her.

3. "Orazione recitata da Bernardo Giustiniano nell'esequie del Doge Francesco Foscari," *Orazioni, elogi e vite scritte da letterati veneti patrizi . . . ,* 2d ed. (Venice, 1798), vol. 1, pp. 21–59; this passage is from p. 58: "e tu, del sommo Dio madre alma, tu Maria, che non solo presiedi a questo tempio, ma inoltre venti amplissimi tempi al tuo nome, e 300 altari hai qua dedicati. . . ." For the Latin edition of the oration, see "Oratio Funebris Habita in Obitu Francisci Fuscari Ducis," *Bernardi Iustiniani Oratoris Clarissimi Orationes,* Biblioteca Nazionale Marciana, Incunabuli, v. 129, fols. 8v–20r. Bernardo was the first biographer of his uncle, Lorenzo Giustiniani. See chap. 3, sec. 1, on the patriarch; and, on his nephew, see Patricia H. Labalme, *Bernardo Giustiniani: A Venetian of the Quattrocento* (Rome, 1969). For a list of churches in Venice beginning in 1346, see Umberto Franzoi and Dina Di Stefano, *Le chiese di Venezia* (Venice, 1976), pp. xlii–xlvii. N.b. also that of the six scuole grandi, two were named for the Virgin, S. Maria della Carità and S. Maria della Misericordia.

4. The Sienese commemorated their victory and the declaration of Mary as their liege queen by commissioning, inter alia, Duccio's *Maestà* (1308–11) for the high altar of their cathedral and Simone Martini's secular variation on that theme, the fresco dated 1315 in the Palazzo Pubblico of Siena. For the political

implications of the depiction of Mary enthroned, see Ursula Nilgen, "Maria Regina—Ein politisches Kultbildtypus?" *Römisches Jahrbuch für Kunstgeschichte* 19 (1981): 1–33.

5. Marin Sanudo [Marino Sanuto], *Le vite dei dogi,* ed. Giovanni Monticolo (*Rerum Italicarum Scriptores,* ed. L. A. Muratori [1900]), vol. 22, pt. 4, p. 88: "A dì 15 avosto, el zorno di nostra Dona, [il doge] va a messa in chiexia di San marco, et poi lo disnar, a la predicha; e cussì li altri dì de nostra Dona." According to the editor, other than the Assumption, those feasts were the Nativity of the Virgin, the Purification, and the Annunciation (ibid., n. 6).

6. To be precise, Venice was founded at noon on the feast of the Annunciation, 421, according to the chronicle of the Paduan Jacopo Dondi; see Muir, *Civic Ritual,* pp. 70 and 139; Wilk, *Sculpture,* pp. 112–13; and also Giustina Renier Michiel, *Origine delle feste veneziane* (Milan, 1829), vol. 1, p. 40.

7. Otto Demus, *The Church of S. Marco in Venice, History, Architecture, Sculpture* (Washington, D.C., 1960), pp. 125–35, on the iconography of the west facade. For Hercules, see Demus, p. 132. The Virgin of the facade is an orant, whose gesture of prayer is a gesture of protection on behalf of the state. At the same time, her obvious association with Gabriel on the facade makes clear the reference to the Annunciation (Demus, p. 150). Demus also notes that the reliefs were in place as early as 1267 (p. 126). For the various images of Mary at S. Marco, see also Musolino, "Culto mariano," pp. 246–52.

8. For the bridge in general, see Ruggero Maschio, "Rialto," in *Architettura e Utopia nella Venezia del Cinquecento* (Milan, 1980), pp. 103–18.

9. Bonifacio's three paintings formed a single work, recalling earlier triptychs. See Sandra Moschini Marconi, *Gallerie dell'Accademia di Venezia, Opere del secolo XVI* (Rome, 1962), pp. 46–47; and Stefania Mason Rinaldi's catalogue entry for the central canvas in *Architettura e Utopia nella Venezia del Cinquecento* (Milan, 1980), p. 70. Mason Rinaldi points out that 1540 is the terminus post quem for the painting, because Bonifacio included Sansovino's Loggetta, completed in that year. Note also Jacopo del Sellaio's *Nativity* with its view of Venice, a tondo in Paris, Musée Jacquemart-André; see the catalogue entry by Ruggero Maschio in *Architettura e Utopia,* p. 69. Staale Sinding-Larsen notes the metaphor of the Incarnation-Annunciation-founding of Venice in sixteenth-century orations presented before newly elected doges; "L'Immagine della Repubblica di Venezia," in *Architettura e Utopia,* p. 40.

10. For the *Annunciation* on the chancel arch of the sacristy chapel, see chap. 2, sec. 1, and fig. 13.

11. For the two ducal tombs (figs. 34–35), see chap. 3, sec. 3. For the frequent depiction of the Annunciation in tombs of the Veneto, and for a religious explanation of the motif, see Leo Planiscig, "Geschichte der venezianischen Skulptur im XIV. Jahrhundert," *Jahrbuch der Kunstsammlung des Allerh. Kaiserhauses* 33 (1915): 136; and Ursula Schlegel, "On the Picture Program of the Arena Chapel" (1957), in James H. Stubblebine, ed., *Giotto: The Arena Chapel Frescoes* (New York and London, 1969), p. 195.

12. Sanuto explained the origins of the festival in *Vite,* vol. 1, cols. 128–29. Muir recounts the history of the festival and analyzes its unique importance in Venice as a celebration organized by the *contrade* (*Civic Ritual,* pp. 135–56). See also

Musolino, "Culto mariano," pp. 256–60, with further bibliography on pp. 272–73; and Silvio Tramontin, "Il 'Kalendarium' veneziano," in *Culto dei santi a Venezia,* ed. Tramontin et al., pp. 290–91. Tramontin notes that the Purification was listed in the eleventh-century "Kalendarium Venetum," and that it was a feast of the Ducal Palace by the twelfth century. The name "Twelve Marys" refers to the twelve wooden statues of Mary which were magnificently gowned and jeweled for the festival and displayed for public viewing in the houses of Venetian noblemen, open to the public during the festival. The culmination of the festival on February 2 involved a procession of boats that carried the Twelve Marys to the cathedral of Venice, S. Pietro di Castello, thence to S. Marco, and finally to S. Maria Formosa. S. Maria Formosa was honored in this way because the men of that parish were credited with having saved kidnapped Venetian brides and their dowries from Triestine pirates. See also Michiel, *Origine,* vol. 1, pp. 91–108, and chap. 5, sec. 1 in this volume, for the Annunciation play performed as part of the festival.

13. Muir, *Civic Ritual,* pp. 154–55.
14. Ibid., pp. 151–54.
15. For the annual ducal procession on February 1 from S. Marco to S. Maria Formosa, where the doge received symbolic gifts from the parish priest of oranges, wine, and a hat, see ibid., p. 155.
16. Ibid., p. 144, n. 22; and Giorgio and Pietro Dolfin, *Cronica* [ca. 1396–1458], Biblioteca Nazionale Marciana, MS It. VII.794 (8503), fol. 54r.
17. ASV, Frari, B. 5, fols. 23v–24r: "In Christi nomine amen. Anno nativitatis eiusdem millesimo quingentesimo decimo septimo . . . sexto mensis decembris. In et pro executione deliberationis facte per consilium religiosorum patrum conventus monasterii Sancte Marie Domus Magne Fratrum Minorum Conventualium Ordinis Sancti Francisci ut apparet annotatum et descriptum per manus Magistri Luce Lauden. scribe eiusdem conventus in libro suorum consiliorum sub die quarto mensis novembris proxime preteriti. In quo consilio tunc intervenisse videntur reverendissimi patres domini Germanus guardianus predicti monasterii, et Minister Provintie Terre Sancte . . . [et al.] . . . quem ad ecclesiam prefati monasterii gerit Magnificus Dominus Nicolaus Valerio quondam Domini Sylvestri dederunt et concesserunt in perpetuum prefato Domino Nicolao Valerio ibidem presenti stipulanti et recipienti pro se suisque heredibus ac successoribus in perpetuum capellam sub invocatione ad presens Sancti Bernardini positam in predicta . . . ecclasiam apud capellam Crucifixi Gloriosissimi cum suo altari et omnibus iuribus ac pertinentiis suis ad habendum et possidendum cum modis forma et condictionibus infrascritis . . . videlicet quod prefatus Dominus Nicolaus cum suis heredibus possit super dicto altari fieri facere unam altari sive palam tam sculptam quam pictam sub invocatione Beatissime Virginis Marie illiusque gloriosissime Purificationis cum aliis sanctis et figuris ac ornamentis quibus et prout eidem Domino Nicolao visum fuerit faciendo tamen etiam inter cetera imaginem Sancti Bernardini. Et similiter ante ipsum altarem fieri facere unam archam terrenam. . . ." Valier bequeathed an annual endowment to the Frari for prayers to be said at his altar and tomb. The document is signed by the notary Bonifacius Solianus (Soliano), who also wrote the concession of the altar of the Immaculate Conception to the Pesaro.

18. See Appendix I.
19. The *Nikopeia,* meaning "Victorious," was taken from Constantinople by Doge Enrico Dandolo in 1204 and presented to S. Marco in 1234. See Goffen, "Icon and Vision," pp. 508–09, with further bibliography; Musolino, "Culto mariano," pp. 245–46; and also James H. Moore, *"Venezia favorita de Maria*: Music for the Madonna Nicopeia and Santa Maria della Salute," *Journal of the American Musicological Society* 37 (1984): 299–355.
20. Sanuto, *Diarii,* vol. 3, col. 632, 15 August 1500: "Fo fato la precessiom atorna la piaza, e il patriarcha canto la messa, e fo portà una nostra Dona a torno, si dice fata di man de San Lucha." (For the public display of this icon, see also Musolino, "Culto mariano," p. 245.) Sanuto seems to have been recording an occasion that he took for granted. But cf. his elaborate account of the procession in the piazza on the feast of the Nativity of the Virgin, 8 September 1515, *Diarii,* vol. 21, cols. 45–49. The facade of S. Marco was draped with cloth of gold and with standards of doges and captains general, and the confraternities, the various religious orders, and the clergy of S. Marco marched in procession with their relics. At the end of the procession came the patriarch in a cope embroidered with pearls, followed by the doge carried in a litter. Among this group of dignitaries was Jacopo Pesaro, Bishop of Paphos.
21. For Cimabue in Assisi, see chap. 3, sec. 5, with bibliography in n. 132. On Giotto and other Tuscan examples juxtaposing the Assumption and the Coronation, see Richard Offner, *A Critical and Historical Corpus of Florentine Painting, The Fourteenth Century,* sec. 3, vol. 5 (New York, 1947), p. 246. Perhaps the most significant precedent for this juxtaposition of the two events is the west facade of the cathedral at Senlis, dedicated in 1191. The cycle of the Virgin at Senlis is recognized as the first representation of the Immaculate Conception in Western art. See Pia Wilhelm, *Die Marienkrönung am Westportal der Kathedrale von Senlis* (Hamburg, 1941), passim. Julian Gardner has called the Coronation "almost the preferred theme of Franciscan high altarpieces"; see "Some Franciscan Altars of the Thirteenth and Fourteenth Centuries," in *The Vanishing Past, Studies of Medieval Art, Liturgy and Metrology Presented to Christopher Hohler,* ed. A. Borg and A. Martindale (Oxford, 1981), p. 34.
22. Wilk considers the unique importance of Guariento's fresco as the only sacred scene depicted in the Ducal Palace decorations, in *Sculpture,* p. 116, and pp. 108–19 on "Political Symbolism: The Virgin as Venice." On Guariento's mural, now detached and in poor condition, see Francesca Flores D'Arcais, *Guariento* (Venice, 1965), pp. 72–73 and figs. 131–42; A. Moschetti, "Il 'Paradiso' del Guariento nel Palazzo Ducale di Venezia," *L'Arte* 7 (1904): 394–97; and Fritz Saxl, "Petrarch in Venice," in idem, *Lectures* (London, 1957), pp. 139–49 (repr. in Saxl, *A Heritage of Images, A Selection of Lectures* [Harmondsworth, 1970], pp. 43–56).
23. Sinding-Larsen, "Immagine della Repubblica," p. 43; idem, *Christ in the Council Hall, Studies in the Religious Iconography of the Venetian Republic (Acta ad Archaeologiam et Artium Historiam Pertinentia* [Institutum Romanum Norvegiae], vol. 5, Rome, 1974), pp. 45–56; Wilk, *Sculpture,* pp. 93, 112–13, and 116–18; and Wolfgang Wolters, *Der Bilderschmuck des Dogenpalastes, Untersuchungen zur Selbstdarstellung der Republik Venedig im 16. Jahrhundert* (Wiesbaden, 1983), pp. 289–305.

24. Flores D'Arcais, *Guariento*, p. 73, has noted the general influence of the fresco. The three copies to which I refer include two in the Accademia, by Jacobello del Fiore (1438) and by Giambono (ca. 1448), and a panel by Antonio Vivarini and Giovanni d'Alamagna (1444) in S. Pantalon in Venice. See Sinding-Larsen, *Council Hall*, p. 72; Sandra Moschini Marconi, *Gallerie dell'Accademia di Venezia, Opere d'arte dei secoli XIV e XV* (Rome, 1955), pp. 26–27 and 30–31; and Rodolfo Pallucchini, *I Vivarini (Antonio, Bartolomeo, Alvise)* (Venice, n.d.), pp. 19 and 102.

25. Sinding-Larsen, *Council Hall*, pp. 63–75; Wolters, *Bilderschmuck*, pp. 289–305; and Charles de Tolnay, "Il 'Paradiso' del Tintoretto: Note sull'interpretazione della tela in Palazzo Ducale," *Arte veneta* 24 (1970): 103–10. The relationship of Tintoretto's canvas to its Trecento predecessor is something like the kinship between Titian's *Assumption* and Bellini's *Immaculate Conception*: the Cinquecento works completely transform their ancestors with a new power and energy. In "Immagine della Repubblica," pp. 42–43, Sinding-Larsen notes that the saints who surround Mary and Christ in the *Paradiso* represent the calendar of saints according to the liturgy of S. Marco.

26. For the attribution and the date, see Wolters, *La scultura veneziana gotica (1300–1460)* (Venice, 1976), vol. 1, pp. 46–47 and 178–79. More recently, for another view of the imagery of "Veneçia," see idem, *Bilderschmuck*, pp. 236–46, and pp. 236f. on the relief by Calendario.

27. For this imagery, see Isa Ragusa, "Terror Demonum and Terror Inimicorum: The Two Lions of the Throne of Solomon and the Open Door of Paradise," *Zeitschrift für Kunstgeschichte* 40 (1970): 93–114, especially pp. 100 and 105–06. On "The Virgin Mary as the Throne of Solomon in Medieval Art," see the doctoral dissertation by Allan Dean McKenzie, 2 vols. (New York University, Institute of Fine Arts, 1965).

28. *Oratione di Luigi Groto cieco d'Hadria nella creation del Serenissimo Principe di Venegia, Luigi Mocenigo* . . . (Venice, 1570), fol. 3r, quoted in Wolters, *Bilderschmuck*, p. 240, no. 9. Venice was commonly compared to the Virgin in such orations read before newly elected doges; see Sinding-Larsen, "Immagine della Repubblica," p. 40.

29. See chap. 1, n. 63. The altars of the Immaculate Conception in the Frari are discussed in chap. 2, sec. 2, and chap. 4, sec. 1. For the altar of the Purification, conceded to the Valier in 1517, see ASV, Frari, B. 5, fols. 23v–24r; and for the altar of S. Maria del Campanile, ibid., fol. 12r, dated 1488, and B. 106, fasc. xxxiii, no. 5h, with documents of 1521, 1544, and 1658. (The exterior of the tower is decorated with sculptures of the Madonna above and the stigmatization of St. Francis below.) For the dedication of the Scuola dei Fiorentini to the Madonna and to the Baptist, see, inter alia, ASV, Frari, Catastico 1, 7 August 1433; the Mariegola of the scuola dated 8 March 1555, Biblioteca Correr, MS Cicogna IV, no. 71, Mariegola (formerly 2072); and above, chap. 1, sec. 5.

30. For the miraculous image, see Sartori, *Guida*, pp. 151 and 175.

31. The confraternity of the Misericordia were observing the Conception by 1493, according to an act of 14 August, ASV, Consiglio dei X, Misti, fol. 7, considered in Giuseppe Dalla Santa, "Di alcune manifestazioni del culto

all'Immacolata Concezione in Venezia dal 1480 alla metà del secolo XVI (Nota storica)," in *Serto di fiori a Maria Immacolata, Anno L* (Venice, 1904), p. 8. For observance of the feast in the Misericordia, see Sanuto, *Diarii*, vol. 25, col. 125, and idem, vol. 26, col. 246 (quoted in chap. 5, sec. 2, and n. 33). Founded in 1261, the Misericordia probably originated with a scuola dedicated jointly to the Virgin Mary and to Saint Francis. Until 1272, the brothers worshiped at the Frari and buried their dead there. See Brian Pullan, *Rich and Poor in Renaissance Venice, The Social Institutions of a Catholic State, to 1620* (Oxford, 1971), p. 38. The Scuola Grande della Carità observed the feast of the Conception beginning in 1496; see Dalla Santa, "Alcune manifestazioni," p. 11, referring to ASV, Consiglio dei X, Misti, fol. 10. In the Frari and S. Francesco della Vigna, the feast of the Conception was observed "according to an ancient papal concession": Pietro Contarini, *Venezia religiosa o guida per tutte le sacre funzioni che si practicano nelle chiese di Venezia* (Venice, 1853), pp. 380–81. For the Pesaro in S. Giacomo dell'Orio, see chap. 2, sec. 1.

32. Sanuto, *Diarii*, vol. 25, col. 125.

33. ibid., vol. 26, col. 246: ". . . fo la Conception di la Madona qual si varda in questa terra za pocho, e si fa solenne festa *maxime* ai Frari Menori et a San Jacomo di l'Orio. *Etiam* in la Scuola di la Misericordia, la qual ha electo questa Nostra Dona per la sua festa. . . ."

34. Ibid., vol. 43, col. 396: "A dì 8 [December 1526]. Fo la Conception di la Madona, et si varda, et fasi la festa a la Misericordia, *etiam* in molte altre chiesie et ai Frari menori a l'altar hanno fatto i Pexari in chiesia."

35. For the Concession of the altar of the Immaculate Conception to the Pesaro brothers and the wills of Jacopo and Francesco Pesaro, see chap. 4, sec. 2.

36. On the equivalence of the Assumption of Mary and the Ascension of Christ, see also chap. 3, secs. 1 and 4.

37. Saint Bonaventure, "Sermo I, De Assumptione Beatae Virginis Mariae," in *Opera Omnia*, vol. 9, ed. David Fleming (Quaracchi, 1901), p. 690: "Quae est ista quae ascendit de deserto . . . ? [Ct. 3, 6] Et hinc constare potest, quod corporaliter ibi est; nam cum ponat specialem modum perfectionis in caelesti civitate, scilicet per conversionem originantis in originatum; et ipsa secundum corpus sit originana, quia anima Christi ex eius anima non fuit, cum anima ex traduce non sit, sed corpus ex corpore: patet, (quod) hic modus perfectionis ibi non esset, nisi corporaliter ibi esset." This text is discussed by Martin Jugie, *La Mort et l'assomption de la Sainte Vierge, Etude historico-doctrinale* (Vatican City, 1944), pp. 400–01. Jugie, p. 392 and n. 3, also cites the *Speculum beatae Mariae Virginis*, traditionally attributed to Bonaventure but in reality by Conrad de Saxe (d. 1279). Here, too, Mary's resurrection is understood as an emulation of her Son's.

38. *Le prediche volgari di San Bernardino da Siena dette nella Piazza del Campo l'anno MCCCCXXVII*, ed. Luciano Banchi (Siena, 1884), vol. 2, p. 393: ". . . e come la carne di Cristo non si poteva corrompere, così anco quella di Maria; e così si legge, che come essa morì, così fu assunta in cielo." This text is also quoted and discussed in chap. 3, sec. 1.

39. For Bartholomew of Pisa (d. 1401) on the assumptions of Mary and the Evangelist, see Celestino Piano, "Contributo allo studio della teologia e della leg-

genda dell'Assunzione della Vergine nel secolo XIV," *Studia francescani*, ser. 3, vol. 16 ([41], 1944), pp. 100–01 and n. 4 on p. 101.

40. For the text and the translation of *Paradiso*, canto 25, verses 122–29, see Dante Alighieri, *The Divine Comedy*, trans. and ed. Charles S. Singleton (Princeton, N.J., 1975), vol. 3, *Paradiso*, pp. 286–87: "Why do you dazzle yourself in order to see that which has here no place? On earth my body is in earth, and there it shall be with the rest, until our number equals the eternal purpose. With the two robes in the blessed cloister are those two lights only which ascended; and this you shall carry back into your world."

41. Sansovino is quoted and translated by Muir, *Civic Ritual*, p. 124, with the original Italian in n. 53. For the history and meaning of the Sensa, with its imagery of marriage and male (Venetian) dominance, see Muir on pp. 119–34. Sexual connotations were inherent in this metaphor of marriage, and Muir has called the Sensa "a Venetian version of a spring fertility festival" (p. 131). See also Lina Padoan Urban, "La festa della Sensa nelle arti e nell'iconografia," *Studi veneziani* 10 (1968): 291–353; and the fundamental work by Gina Fasoli on the imagery of Venetian feasts, "Liturgia e ceremoniale ducale," in *Venezia e il Levante fino al secolo XV*, ed. Agostino Pertusi (Florence, 1973), vol. 1, pp. 261–95, and pp. 262 and 274–75 on the Sensa.

42. For Giustiniani's sermon, see chap. 3, sec. 5, and for the offices by Nogarolis and de Bustis, chap. 2, sec. 2, and chap. 3, sec. 1. Saint Bonaventure cited the Song of Songs in Sermons 1 and 5 on the Assumption, for example; see *Opera omnia*, vol. 9, pp. 690 and 699.

43. N.b. the modest words ascribed to the Virgin in Giustiniani's sermon, quoted in chap. 3, sec. 5. Until the late fourteenth century in Venice, as part of a unique eight-day celebration of the Purification of the Virgin (February 2), the Annunciation was reenacted on January 31 by two priests in order to provide new brides with an exemplar of humble wifely duty. For this reason, it was on January 31 of every year that Venetian priests solemnized marriages of the preceding year: see Muir, *Civic Ritual*, 142–43. On the related bridal imagery of Venice as the spouse of Saint Mark, see Wolters, *Bilderschmuck*, p. 240.

44. Felix Gilbert, "Venice in the Crisis of the League of Cambrai," in *Renaissance Venice*, ed. J. R. Hale (London, 1973), p. 278. On the cult of the doge, see Fasoli, "Liturgia," p. 279 and passim. Fasoli quotes Francesco Sansovino on the sacred implications of the ducal costume.

45. Wilk, *Sculpture*, p. 112. Wilk discusses this purposeful falsification of Venetian history in a consideration of the political imagery of the Madonna in Venice. On the subject of Venetian histories and the myth of Venice, see the following: Antonio Carile, "Aspetti della cronachistica veneziana nei secoli XIII e XIV," in *La storiografia veneziana fino al secolo XVI, Aspetti e problemi*, ed. A. Pertusi (Florence, 1970), pp. 75–126; Carile and Giorgio Fedalto, "Le origini di Venezia nella tradizione storiografica," in Carile, *Le origini di Venezia* (Bologna, 1978), pp. 19–123; Fasoli, "Liturgia," p. 261 and passim, and pp. 274–75 on the feast of the Sensa; idem, "I fondamenti della storiografia veneziana," in *Storiografia veneziana*, pp. 11–44; idem, "Nascita di un mito," in *Studi storici in onore di Gioacchino Volpe* (Florence, 1958), vol. 1, pp. 445–79; Franco Gaeta, "Alcune considerazioni sul mito di Venezia," *Bibliothèque d'Humanisme et Re-*

naissance 23 (1961): 58–75; Lester J. Libby, Jr., "Venetian History and Political Thought after 1509," *Studies in the Renaissance* 20 (1973): 7–45; and Pertusi, "Gli inizi della storiografia umanistica nel Quattrocento," in *Storiografia veneziana,* pp. 269–332. Of course, the identification of the state with the person of its saintly protector is itself based on the myth of the presence and preservation of Saint Mark's body in his basilica.

46. See Ellen Rosand, "Music in the Myth of Venice," *Renaissance Quarterly* 30 (1977): 528 and n. 43. Rosand quotes this poem from a book by the musician Baldassare Donato, *Il primo libro di canzon villanesche alla Napolitana* (Venice, 1550). The poem begins, "Gloriosa felice alma Vineggia / Di Giustizia, d'amore di pace albergo." In n. 65 on p. 537, Rosand quotes another text, published in 1580: "Ecco la cara Madre / Venetia, ch'apre il grembo / Virginal. . . ."

47. Biblioteca Nazionale Marciana, MS It. VII.299 (7868), fol. 11v. For the Angelic Salutation, see above, chap. 3, sec. 1, and on the lauds sung to the doge when he assumed office and on other special occasions, see Fasoli, "Liturgia," pp. 276–78.

48. [Tomaso Minotto], *Brevi notizie della chiesa e dell'ex convento di S. Maria dei Miracoli unica chiesa in Venezia col titolo della Immacolata Concezione* (Venice, 1855), p. 7. For Barbarigo's votive picture of the Madonna, signed and dated by Giovanni Bellini in 1488, and now in S. Pietro Martire, Murano, see Goffen, "Icon and Vision," pp. 500 and 511–12; and the reports published after the recent restoration in *La Pala Barbarigo di Giovanni Bellini (Quaderni della Soprintendenza ai Beni Artistici e Storici di Venezia* 3 [1983]).

49. Dalla Santa, "Alcune manifestazioni," p. 7.

50. On December 31, 1489: "Margherita, affido alla tua carità e al tuo fervido zelo queste ottime suore. Prega in un con esse la Madre delle Misericordie che ottenga da Dio alla nostra Repubblica prosperità e pace perenne . . ." Minotto, *Brevi notizie,* pp. 13–14.

51. Moschini Marconi, *Gallerie,* pp. 28–29. The painting carries the following inscriptions: "Exequar Angelicos Monitus Sacrataque Verba / Blanda Piis Inimica Malis Tumidisque Superba" and "Iacobellus De / Flore Pinxit 1421" on the central panel; "Suplicium Sceleri Virtutum Premia Digna / Et Michi Purgatas Anas Da Lance Benigna" on Michael's scroll (left panel); and "Virginei Partus Humane Nuncia Pacis / Vox Mea Virgo Ducem Rebus Te Poscit Opacis" on Gabriel's scroll (right). For an analysis of Jacobello's political imagery, see Sinding-Larsen, *Council Hall,* pp. 56 and 175. I have elaborated upon Sinding-Larsen's analysis, emphasizing Jacobello's representation of the Virgin Immaculate. The earliest representation of Venice-Justice is evidently the relief ascribed to Filippo Calendario on the west facade of the Ducal Palace, followed by Bartolomeo Bon's relief on the *Porta della Carta.* See Wolters, *Bilderschmuck,* pp. 236–38, on the reliefs, and pp. 238–39 on the Jacobello triptych. Wolters dates the Calendario relief ca. 1341—i.e., at the time of the construction of the Maggior Consiglio; see *Scultura,* vol. 1, pp. 40–48 and 178–79, cat. 49.

52. See Ragusa, "Terror Demonum," especially pp. 100 and 105–06; and McKenzie, "The Virgin Mary as the Throne of Solomon."

53. The concession of the adjacent altar of the Purification to the Valier in 1517

refers to the altar of the Crucifixion. The concession is quoted above in n. 17. For Crucifixion altars, see Joseph Braun, *Der christlichen Altar* (Munich, 1924), vol. 1, 401ff. See also Francesco Sansovino, *Venetia città nobilissima et singolare* (Venice, 1581), p. 66r: "Vi si honora . . . il Christo miracoloso situato a mezza Chiesa a cui piedi è sepolto quel Titiano che fu celebre nella pittura. . . ." In 1579, the friars conceded the altar to the Scuola della Passione; ASV, Frari, B. 51, fols. 58v–59v, cited by Jürg Meyer zur Capellen, "Überlegungen zur 'Pietà' Tizians," *Müncher Jahrbuch der bildenden Kunst* 22 (1971), p. 129, n. 18.

54. The central group of Mary and Christ was painted on a separate piece of canvas that was then enlarged on all sides. Charles Hope argues that these facts reflect the painting's original commission by the Marquis of Ayamonte, who requested Titian to paint a *Pietà* in 1575; subsequently, the master revised his first conception, adding the other figures and the illusionistic architecture. Hope notes that Titian may have offered the work to the Frari, but that it was never in the possession of that church. See Hope, *Titian* (London, New York et al., 1980), p. 165. Although the bearded man at the right of the finished painting is clearly a self-portrait, there has been great disagreement about Titian's guise in the *Pietà*: is he represented as Job, Nicodemus, Joseph of Arimathea, or Saint Jerome? For arguments about these various possibilities, see J. Bruyn, "Notes on Titian's Pietà," in *Album Amicorum J. G. van Gelder* (The Hague, 1973), pp. 66–75; Herbert von Einem, "Tizians Grabbild," *Bayerische Akademie der Wissenschaften, Philosophisch-Historische Klasse, Sitzungsberichte,* vol. 5 (1979), p. 15 (Jerome); Meyer zur Capellen, "Überlegungen," pp. 126–27 and nn. 43–45 (Job); Rosand, *Painting in Cinquecento Venice,* pp. 75–84 (Jerome); and Wolfgang Stechow, "Joseph of Arimathea or Nicodemus?" in *Studien zur toskanischen Kunst, Festschrift für Ludwig Heinrich Heydenreich zum 23 Marz 1963* (Munich, 1964), pp. 289–302. I thank Juergen Schulz and Anne Markham Schulz for bringing von Einem's article to my attention. To my mind, the particular identity that Titian intended for himself is secondary to his inclusion of a self-portrait, and to the consequent relationship of this *Pietà* to others meant by artists for their own tombs, of which the most notable is Michelangelo's in Florence. On this, see von Einem, "Tizians Grabbild," pp. 18–19; Irving Lavin, "The Sculptor's 'Last Will and Testament,' " *Allen Memorial Art Museum Bulletin* 35 (1977–78): 4–39; and Erwin Panofsky, *Problems in Titian, Mostly Iconographic* (New York, 1969), p. 26.

55. Nicola Ivanoff has associated the lions with the funerary hymn "Ab ore leonis," in his article "Tiziano e la critica contenutista," in *Tiziano, Nel quarto centenario della sua morte 1576–1976* (Venice, 1977), p. 192, n. 9. For the inscriptions behind the fictive statues of Moses and the Sibyl, which were copied by Zanotto in the nineteenth century, see Rosand, *Painting in Cinquecento Venice,* p. 263, no. 90. On the imagery of Moses with the tablets of the Law, representing *sub lege,* and the Sibyl with Cross and Crown of Thorns as *sub gratia,* see von Einem, "Tizians Grabbild," p. 15; and Staale Sinding-Larsen, "Titian's Triumph of Faith and the Medieval Tradition of the Glory of Christ," *Acta ad Archaeologiam et Artium Historiam Pertinentia* (Institutum Romanum Norvegiae), vol. 6 (Rome, 1975), p. 317. N.b. also the panel by Cosimo Tura in London, the National Gallery. The Madonna holds the sleeping Christ Child.

Her throne is decorated with the tablets of the Law and with eucharistic grapes. See Martin Davies, *The Earlier Italian Schools* (National Gallery Catalogues), 2d ed. rev. (London, 1961), pp. 513–16.

56. For the typological imagery of the Immaculate Conception and Moses, see Enriqueta Harris, "Mary in the Burning Bush, Nicolas Froment's Triptych at Aix-en-Provence," *Journal of the Warburg and Courtauld Institutes* 1 (1937): 281–86. Harris, in n. 2, cites a hymn published by Dreves and Blume in *Analecta Hymnica Medii Aevi*, vol. 9, p. 77. See also Rona Goffen, "A Bonaventuran Analysis of Correggio's Madonna of St. Francis," *Gazette des Beaux-Arts* 103 (1984): 11–18. Correggio's high altarpiece for a Franciscan church represents the Immaculate Virgin on a throne adorned with a fictive relief of Moses. In a forthcoming article on "Friar Sixtus and the Sistine Chapel" (*Renaissance Quarterly*, 1986), I deal more fully with the imagery of Moses and the Conception. N.b. that the Sistine Chapel was dedicated by the Franciscan Sixtus IV to the Assumption of the Virgin, a feast inherently and theologically related to her Immaculate Conception. In the chapel decorations, the typologies of the two Testaments are almost exclusively comparisons of Moses and Christ.

57. According to Lodovico Dolce, Titian was sent to Venice as a boy of nine to study "the art of the mosaic" with the Zuccati; see Mark W. Roskill, *Dolce's "Aretino" and Venetian Art Theory of the Cinquecento* (New York, 1968), pp. 184–85. For Titian's earlier works in the Frari, see Rosand, *Painting in Cinquecento Venice,* pp. 75–84; and chap. 3, sec. 5, and chap. 4, sec. 1, in the present volume. On Titian's retrospective mood in the *Pietà,* and in particular his references to the Paragone and to Michelangelo, see also Panofsky, *Problems,* pp. 25–26.

58. See Rosand, *Painting in Cinquecento Venice,* p. 13.

59. On Titian's last wishes, see the anonymous *Breve compendio della vita del famoso Titiano Vecellio di Cadore cavalliere, et pittore* (Venice, 1622).

60. See von Einem, "Tizians Grabbild," p. 16; and especially Rosand, *Painting in Cinquecento Venice,* pp. 83–84.

61. For the inscription, see Rosand, *Painting in Cinquecento Venice,* p. 263, n. 90. On the setting, in addition to the other references already cited here, see especially Kate Dorment, "Tomb and Testament: Architectural Significance in Titian's *Pietà,*" *Art Quarterly* 35 (1972): 399–418.

62. On the Immaculate Conception, see chap. 2, sec. 2, and chap. 3, secs. 1 and 4.

63. The fig leaves are symbolic of the Fall of Man and his redemption by Christ's Passion. For this much published plant, see, inter alia, André Chastel, "Sur deux rameaux de figuier," in *Studies in Late Medieval and Renaissance Painting in Honor of Millard Meiss,* ed. I. Lavin and J. Plummer (New York, 1977), vol. 1, pp. 83–87; Oswald Goetz, *Der Feigenbaum in der religiosen Kunst des Abendlandes* (Berlin, 1965); Frederike Klauncr, "Zur Symbolik von Giorgiones 'Drei Philosophen,' " *Jahrbuch der kunsthistorischen Sammlungen in Wien* 51 (1955): 145–88; and Mirella Levi D'Ancona, *The Garden of the Renaissance: Botanical Symbolism in Italian Painting* (Florence, 1977), pp. 135–42.

64. Pasquale Cicogna was doge from 1585 to 1595; this oration, delivered before him at the beginning of his dogate, is quoted by Sinding-Larsen, "Immagine della Repubblica," p. 40.

APPENDIX I

1. For the saint in Venice, see Camillo Bianchi and Francesco Ferrari, *L'Isola di San Francesco del Deserto, Ricerca storica e intervento di restauro* (Padua, n.d. [1974]), p. 89; and Dionisio Pacetti, "La predicazione di S. Bernardino in Toscana con documenti inediti estratti dagli atti del processo di canonizzazione," *Archivum Franciscanum* 33 (1941): 319–20. For his writings, see S. Bernardinus Senensis Ordinis Fratrum Minorum, *Opera omnia,* ed. Pacifici M. Perantoni (Quaracchi, 1950–59), 7 vols. See also L. Banchi, *Le prediche volgari di S. Bernardino da Siena dette nella Piazza del Campo, l'anno 1427* (Siena, 1880–88); republished by P. Bergellini, *Le prediche volgari* (Milan, 1936). For a historical consideration of the sermons, see Eugenio Garin, "Il francescanesimo e le origini del Rinascimento," in idem, *L'età nuova, Ricerche di storia della cultura dal XII al XVI secolo* (Naples, 1969), pp. 115–36. Garin, on pp. 126–27, notes Bernardino's appreciation of beauty and his admiration for the new learning, represented by such contemporaries as Coluccio Salutati. For a discussion of the literary and spiritual aspects of the sermons, see Carlo Delcorno, "L' 'exemplum' nella predicazione di Bernardino da Siena," in *Bernardino Predicatore nella società del suo tempo* (Convegni del Centro di Studi sulla Spiritualità Medievale XVI [Todi, 1976]), pp. 71–107. Delcorno, p. 92 and n. 1, cites Bernardino's frequent references to Dante and Jacopone. For the saint's Mariology, see L. Di Fonzo, "La Mariologia di San Bernardino da Siena," *Miscellanea Francescana* 47 (1974): 3–102. (N.b. "De B. Virgine" in the *Opera Omnia,* vol. 6.) See also Pacetti, "La Predicazione di S. Bernardino in Toscana con documenti inediti estratti dagli atti del processo di canonizzazione," *Archivum Franciscanum* 33 (1940): 268–318; and ibid. 34 (1941): 261–83. For further information on the vast bibliography for this saint, see V. Facchinetti, "Bollettino bibliografico: San Bernardino da Siena," *Aevum* 4 (1930): 319–81; and A. Ghinato, *Saggio di bibliografia bernardiniana* (Rome, 1960).

2. Biblioteca Marciana, MS Ital. VII.794 (8503), fol. 418v (formerly fol. 307v): ". . . fu canonizato San Bernardino di Siena dell'ordene di San Francesco. . . . El qual mì Zorzi Dolfin cognosciti et tochi la man et aldii [udii] molte sue devote predication in diversi tempi et simili io Piero Dolfin scriptor di questi annali so fiol vidi el ditto sancto, et udij le sue prediche sul campo de San Polo in Venezia." That the Dolfins were probably referring to Bernardino's visit to Venice in 1422–23 is suggested by Bianchi and Ferrari, *Isola di San Francesco,* p. 89.

3. British Museum, fol. 82b; see Victor Golubew, *Die Skizzenbücher Jacopo Bellinis* (Brussels, 1912), vol. 1, pl. 105. Bernardino was represented preaching in the Piazza del Campo of Siena by his compatriot Santo di Pietro (Siena, Duomo); and a cycle of his life was painted by Pinturicchio in the Aracoeli in Rome.

4. For Bernardino's Venetian address, see Bianchi and Ferrari, *Isola di San Francesco,* p. 89. It is likely that the saint stayed in S. Francesco del Deserto in 1422, and almost certain that he lived in S. Giobbe in 1429.

5. ASV, S. Giobbe, B. 5, no. 46, fols. 64–71r, is a copy of excerpts from the Mariegola of the scuola, founded 20 May 1450. For the saint's canonization

in 1450, six years after his death, see Celestino Piana, "I processi di canonizzazione. Su la vita di S. Bernardino da Siena," *Archivum Franciscanum Historicum* 44 (1951): 87–160, especially 155ff.

6. The story is recounted by Andrea da Mosto, *I dogi di Venezia nella vita pubblica e privata* (Milan, n.d.), p. 221.

7. Moro and his dogaressa, Cristina Sanudo (a kinswoman of the diarist), are buried in the chancel. The epigraph of their tomb is dated September 1470, and the doge died November 9 of the following year. See da Mosto, *Dogi,* pp. 225–26; and Pietro Paoletti, *L'architettura e la scultura del Rinascimento in Venezia, Ricerche storico-artistiche* (Venice, 1893), vol. 2, pp. 190–92. Moro's will is ASV, Testamenti, B. 1238, nos. 178 and 188, with a copy in ASV, S. Giobbe, B. 5, no. 46, fols. 46r–50v. For the church, see Ferdinando Finotto, *San Giobbe, La chiesa dei Santi Giobbe e Bernardino in Venezia* (Venice, 1971).

8. See Silvio Tramontin, "Il 'Kalendarium' veneziano," in *Culto dei santi a Venezia,* ed. idem (Venice, 1965), vol. 2, p. 299.

9. Ibid. N.b. also the sculpture group of the Madonna and Child flanked by Sts. Mark and Bernardino in the chapel of S. Clemente in S. Marco; the sculpture is inscribed "Duce Serenissimo Christophoro Moro MCCCCLXV." On the cult of the saint and his representation in art, see Daniel Arasse, "*Fervebat Pietate Populus*; Art, dévotion et société autour de la glorification de Saint Bernardin de Sienne," *Mélanges de l'Ecole Française de Rome* 89 (1977): 189–261. Patricia Fortini Brown very kindly brought this article to my attention.

10. As suggested by Raphael M. Huber, *A Documentary History of the Franciscan Order* (Milwaukee and Washington, D.C., 1944), vol. 1, p. 413. On the saint and the Conventuals, see Giovanni Odoardi, "S. Bernardino da Siena e la comunità dell'Ordine o Frati Minori Conventuali," *Miscellanea francescana* 81 (1981): 111–74 and 439–515. Bernardino held the office of Vicar General of the Observants from 1438 until 1442; see Bruno Korošak, in *Bibliotheca Sanctorum,* vol. 2 (Grottaferrata, 1962), cols. 1304–12.

11. For the relic of Saint Bernardino, see Flaminio Cornelio, *Ecclesiae Venetae Antiquis Monumentis* (Venice, 1749), vol. 6, p. 285; and Antonio Sartori, *Guida storico-artistica della Basilica di S. M. Gloriosa dei Frari in Venezia* (Padua, 1949), p. 183. For the indulgences, see ASV, Frari, B. 106, fasc. xxxii, no. 9 (7 July 1455) and no. 10 (30 May 1457).

12. For the documents, see chap. 5, sec. 1 and n. 17.

APPENDIX II

1. At the height of his popularity and success, General Benedetto was considered for the dogate, but Leonardo Loredan was elected instead in 1501. See Andrea da Mosto, *I dogi di Venezia nella vita pubblica e privata* (Milan, 1966), p. 268. For the immediate family of Doge Giovanni, see ibid., p. 486, with further bibliography on pp. 718–19. For Giovanni Pesaro's descent from Leonardo *q.* Antonio, see the Pesaro Family Tree and chap. 4, sec. 1, for Leonardo himself. An inventory of the palace at S. Stae was made by the public treasury in 1797: "Inventario de' mobili esistenti in tutta la casa di abitazione della famiglia

Pesaro fatto dalli Ministri della Commissione . . . ;" Venice, Biblioteca Correr, MS P.D. 597C/VI.

2. For this and the following summary of Giovanni's career, see da Mosto, *Dogi,* pp. 489–90.

3. Giovanni's speech is quoted in ibid., p. 490: "Se vogliamo portar la corona sul capo non la gettiamo ai piedi dei turchi . . . !"

4. Ibid.

5. On the Palazzo Pesaro, see Elena Bassi, *Palazzi di Venezia,* 3d ed. (Venice, 1980), pp. 53–55 and 174–89. For the painting, see Giacomo Zabarella, *Il Carosio, overo origine regia et augusta della serenissima fameglia Pesari di Venetia, Libro Primo* (Padua, 1659), pp. 59–60.

6. The inscription was copied by Zabarella, *Carosio,* pp. 59–60.

7. ASV, Testamenti Claudio Paulini, B. 799, no. 255 (old no. 274), fol. 1v: "Volemo . . . che nella Chiesa de' Frari sia eretto un deposito con spesa di dodeci milla ducati . . . con statue e colonne e con la n[ost]ra statua sedente. . . ." Giovanni's demands for "statues and columns" recall the similar instructions in the testaments of Benedetto Pesaro and his son Girolamo, considered in chap. 2, sec. 3.

8. See da Mosto, *Dogi,* p. 493. According to da Mosto, the doge was interred in the Pesaro family tomb in the pavement before the altar of the Immaculate Conception.

9. Ibid., p. 492.

Selected Bibliography

Manuscript Sources

FLORENCE

Archivio di Stato (ASF)

MS. 618. *Memorie cavate dal Libro del' 1441*. A *sepultuario* or inventory of chapels and tombs in S. Croce, compiled 1440–42 by Carlo del Rosso, Carmerlengo dell'Opera, and copied in 1596 by Gabriello di Michelangelo di Comenico Landini.

MS. 631 (no. 3). *Memorie sepolcrali et istoriche di più Nobili Famiglie Fiorentine esistenti in Venezia e suo Stato*. Compiled by Matteo del Teglia, Agente del Serenissimo Gran Duca in Venezia, in 1700.

Biblioteca Nazionale

Rosselli, Stefano. *Sepoltuario fiorentino, ovvero Descrizione delle chiese, cappelle e sepolture, loro armi et inscrizioni della città di Firenze e suoi contorni.* MS 11, IV, 534 (Magliabecchiana XXVI, 22).

Selected Bibliography

VENICE

Archivio di Stato (ASV)

Avogaria del Comun. Busta 164/III. *Balla d'oro, Registro*. Names of male patricians presented to the Avogaria at age eighteen as eligible for the Maggior Consilio; compiled between 1 October 1463 and 19 July 1499.

Avogaria del Comun. Busta 51/I. *Nascite*. A record of births of male patricians, including the names of both parents, beginning in 1506.

Avogaria del Comun. Registro 106/1. *Cronaca Matrimoni*. A list of patrician marriages, compiled in 1660 from earlier records.

Avogaria del Comun. Registro 107/2. *Cronaca Matrimoni*. Christian names of wives, in addition to their patronymics, have been added in some cases, derived from the Registri of the Balla d'oro and from the *Libri d'oro delle nascite*.

Barbaro, Marco. *Arbori de' patritti veneti* (1536). Copied by Tommaso Corner and Antonio Maria Tasca, 1743. Miscellanea Codici I, Storia Veneta 22.

Consiglio dei Dieci. Registro 10, *Miste*, fol. 28r. The Confraternity of the Milanese, 5 June 1420.

Consiglio dei Dieci. Registro 11, *Miste* (1430–37), fol. 131r. The Confraternity of the Florentines at SS. Giovanni e Paolo, 31 August 1435.

Frari. Documents and copies of documents pertaining to S. Maria Gloriosa dei Frari, arranged in numbered *buste* and partially indexed.

Notarile Testamenti. Testaments and related documents, arranged in buste by number and according to the notary's name. Notaries employed by the Pesaro include: Francesco Bianco, B. 126 and B. 128; Benedetto Croce, B. 1157; Francesco Gritti, B. 560; Diodato da Miani, B. 734; Cristoforo Rizzo, B. 1227; and Giacomo Zambelli, B. 1101.

Pesaro. Documents pertaining to the Ca' Pesaro and the altar of the Immaculate Conception in the Frari. Arranged in buste.

Biblioteca Correr

Cicogna MS IV, no. 54. Mariegola of the Confraternity of the *Madonna della Neve* (1563).

Cicogna MS IV, no. 71. Mariegola of the Confraternity of the Florentines.

Codice Cicogna, Busta 496 (formerly 475). *Chiese venete ed edificii pubblici*.

Codice Cicogna, Busta 500. *Iscrizioni veneziane nelle chiese e luoghi pubblici*. Emmanuele Cicogna's unpublished manuscript notes of inscriptions in Venetian buildings.

MS Dandolo, Prov. div. C. 1101, no. 11. Copy of a *manifestum*, dated 10 May 1486.

MS P.D. 597C/VI. "Inventario de' mobili esistenti in tutta la casa di abitazione della famiglia Pesaro fatto dalli Ministri della Commissione . . . ," Venice, 1797.

MS P.D. C. 753/3. Parchment written in the name of Doge Agostino Barbarigo for Francesco Pesaro's pilgrimage to Loreto, 10 April 1490.

Raccolta Cicogna, Busta 3063, no. 14. A list of relics in suppressed churches and monasteries, including relics in the Frari on fol. 2v.

Zorzi, Marco. "Deposition di M. Marco Zorzi, Proto di albori in l'arsenal de la

fation fate per M. Benetto da Cha' da Pesaro essendo Capitano Zeneral da Mar,"
1503. Codice Cicogna 2941, III/3.

Biblioteca Nazionale Marciana

Barbaro, Marco. *Arbori de' patritti veneti.* MS 8492.

Capellari, Girolamo Alessandro. *Il Campidoglio veneto.* Compiled ca. 1741. MSS
Italiani VII.17 (8306).

Dolfin, Giorgio, and Pietro Dolfin. *Cronica.* Written ca. 1396–1458. MS Italiano
VII.794 (8503).

Fapanni, Francesco. *Chiese claustrali e monasteri di Venezia.* MS Italiano VII.2283
(9121).

Trevisan, Nicolò et al. *Cronaca de Venetia.* MS Italiano VII.519 (8438).

MS Italiano I.29 (5022). A codex mostly written by Giovanni di Barduccio di
Cherichino de' Roncognani in 1442 (Florentine 1441). Includes the life of the
Franciscan tertiary Saint Elizabeth of Hungary (fols. 100v–108r), an oration to
the Madonna (fols. 109r–v), and the life of the Madonna (fols. 136r–138r).

MS Italiano I.34 (5232). A codex in two hands, written in the fourteenth and
fifteenth centuries, including prayers to Christ (fols. 21r–30r) and the Madonna
(fols. 25v–30r). The Psalms are given in Italian translation on fols. 30v–40v.

MS Italiano I.61 (4973). A fifteenth-century manuscript including the formula for
confession, the life of Saint Jerome, various pious writings and lauds, including
a laud to Saint Francis on fol. 84v.

MS Italiano VII.299 (7868). "Laus Illustrissimi Venetiarum Principis Nicolai
Troni."

MS Italiano VII.2540 (12432). *Miscellanea,* including a list of doges and where they
were buried, lists of convents and monasteries in Venice, the numbers of religious
in them, and population figures for the city, divided by *sestiere.*

MS Italiano Z 5 (4738). Fifteenth-century lives of Mary, Anne, and Joseph.

Parish Archives of Santa Maria Gloriosa dei Frari

Documents (including sixteenth-century baptismal records) and sources (including
records of restorations) preserved in the Convent of the Frari. These are kept in
buste and arranged in bookcases: e.g., Busta 2, Armadio G.

VICENZA

Archivio di Stato (ASVi)

Archivio Notarile de Sorio, Francesco, Testamenti 1521–22, Libro 63. The testa-
ment of Giambattista Garzadori.

Convento di S. Corona. B. 110, fols. 1–7, pertaining to the Garzadori Chapel.

Selected Bibliography

Published Works

Albanese, Adelaide. "L'archivio privato Gradenigo." *Notizie degli Archivi di Stato* 3 (1943): 3–21.

Alberti, Leon Battista. *On Painting and On Sculpture, The Latin Texts of "De Pictura" and "De Statua."* Translated and edited by Cecil Grayson. London, 1972.

Alexander de Hales. *Summa Theologica.* Vol. 4. Edited by Pacifici M. Perantoni. Quaracchi, 1948.

Alighieri, Dante. *See* Dante Alighieri.

Almagià, Guido. In *Enciclopedia italiana di scienze, lettere ed arti*, vol. 26, p. 922, s.v. "Pesaro, Benedetto." Rome, 1935.

Alpago-Novello, Adriano. "Influenze bizantine ed orientali nel Veneto settentrionale (in relazione ad alcuni monumenti inediti)." *Archivio storico di Belluno, Feltre, e Cadore* 30 (1969): 81–95.

Antichi testamenti tratti dagli archivi della congregazione di Carità di Venezia. 7th series. N.p. [Venice] 1888.

Arasse, Daniel. "*Fervebat pietate populus.* Art, dévotion et société autour de la glorification de Saint Bernardin de Sienne." In *Les Ordres mendiants et la ville en Italie Centrale. Mélanges de l'Ecole Française de Rome, Moyen-âge—temps modernes* 89 (1977): 189–261.

Arslan, Edoardo. *Gothic Architecture in Venice.* Translated by Anne Engel. London, 1972.

Aubenas, Roger, and Robert Ricard. *L'Eglise et la Renaissance (1449–1517).* Vol. 15 of *Histoire de l'église depuis les origines jusqu'à nos jours*, edited by Augustin Fliche and Victor Martin. N.p., 1951.

Bachelet, X. Le, with Martin Jugie. In *Dictionnaire de théologie catholique.* Vol. 7¹, cols. 845–1218, s.v. "Immaculée Conception." Paris, 1927.

Bandmann, Günter. "Über Pastophorien und verwandte Nebenräume im mittelalterlichen Kirchenbau." In *Kunstgeschichtliche Studien für Hans Kauffman*, edited by Wolfgang Braunfels, pp. 19–58. Berlin, 1956.

Bassi, Elena. *I palazzi di Venezia.* 3d ed. Venice, 1980.

Bellamy, J. In *Dictionnaire de théologie catholique.* Vol. 1, col. 2128, s.v. "Assomption de la Sainte Vierge." Paris, 1931.

Belting, Hans. *Die Oberkirche von San Francesco in Assisi.* Berlin, 1977.

Bembo, Pietro. *Della historia vinitiana.* Venice, 1552.

———. *Della istoria viniziana.* Edizione de' classici italiana 57. Milan, 1978.

Benvenuti Papi, Anna. "L'impianto mendicante in Firenze, Un problema aperto." In *Les Ordres mendiants et la ville en Italie Centrale. Mélanges de l'Ecole Française de Rome, Moyen-âge—temps modernes* 89 (1977): 597–608.

Berenson, Bernard. *The Study and Criticism of Italian Art. Third Series.* London, 1916.

Bergström, Ingvar. "Medicina, Fons et Scrinium. A Study in Van Eyckean Symbolism and Its Influence in Italian Art." *Konsthistorisk Tidskrift* 26 (1957): 1–20.

S. Bernardinus Senensis, Ordinis Fratrum Minorum. *Opera Omnia.* 7 vols. Edited by Pacifici M. Perantoni. Quaracchi, 1950–59.

[St. Bernardino of Siena]. *Examples of San Bernardino of Siena.* Edited by Ada Harrison. New York and London, n.d. [1926].

————. *Le prediche volgari di San Bernardino da Siena dette nella Piazza del Campo l'anno MCCCCXXVII.* 2 vols. Edited by Luciano Banchi. Siena, 1884.

Bernardino de Bustis. "Officium et Missa de Immaculata Conceptione" (1480). *Acta Ordinis Fratrum Minorum.* Vol. 23, fasc. 12 (1904).

————. *Mariale, sive Sermones 63 de B. V. Maria.* Strassburg, 1498.

Bertelli, Carlo. "Appunti sugli affreschi nella cappella Carafa alla Minerva." *Archivum Fratrum Praedicatorum* 35 (1965): 115–30.

Berti, Luciano. *Firenze/Santa Croce.* Tesori d'arte cristiana, III, 52. Bologna, 1967.

Besse, Lodovico da. *Il B. Bernardino da Feltre e la sua opera.* Vol. 1. Siena, 1905.

Bettiolo, Giuseppe. *La 'Fradaja' de Missier Santo Antonio de Padoa alla "Ca' Grande" (1439), Studio di documenti inediti.* Venice, 1912.

Białostocki, Jan. "The Sea-Thiasos in Renaissance Sepulchral Art." In *Studies in Renaissance and Baroque Art Presented to Anthony Blunt on his Sixtieth Birthday,* pp. 69–74. London and New York, 1967.

Bianchi, Camillo, and Francesco Ferrari. *L'isola di San Francesco del Deserto, Ricerca storica e intervento di restauro.* Padua, n.d. [1970].

Biebrach, Kurt. "Die holzgedeckten Franziskaner- und Dominikanerkirchen in Umbrien und Toskana." *Beiträge zur Bauwissenschaft* 11 (1908): 1–71.

Bihl, Michael. "Statuta Generalia Ordinis edita in Capitulis Generalibus Celebratis Narbonae an. 1260, Assisii an. 1279 atque Parisiis an. 1292." *Archivum Franciscanum Historicum* 34 (1941): 13–94 and 284–358.

Biscaro, Gerolamo. "Note storico-artistiche sulla Cattedrale di Treviso." *Nuovo archivio veneto* 17 (1899): 135–94.

Blum, Shirley Neilsen. *Early Netherlandish Triptychs: A Study in Patronage.* California Studies in the History of Art, 13. Berkeley and Los Angeles, 1969.

Boase, T. S. R. *Kingdoms and Strongholds of the Crusaders.* Indianapolis and New York, 1971.

S. Bonaventura. *Opera Omnia.* 10 vols. Quaracchi, 1882–1902.

Borsook, Eve. "Notizie su due cappelle in Santa Croce a Firenze." *Rivista d'arte,* 3d. ser., vol. 36, no. 11 (1961–62): 90–107.

————. *The Mural Painters of Tuscany.* 2d ed. rev. Oxford, 1980.

————. "Cults and Imagery at Sant'Ambrogio in Florence." *Mitteilungen des Kunsthistorisches Institutes in Florenz* 25 (1981): 147–202.

Bortolan, Domenico. *S. Corona, Chiesa e convento dei Domenicani in Vicenza, Memorie storiche.* Vicenza, 1889.

Boschini, Marco. *Le minere della pittura.* Venice, 1664.

Bouyer, Louis. *The Seat of Wisdom.* Translated by A. V. Littledale. Chicago, 1965.

Bracaloni, Leone. "Lo stemma francescano nell'arte." *Studi francescani* (Numero speciale, VII centenario del Terz'Ordine Francescano) 7 (1921): 221–26.

————. *L'arte francescana nella vita e nella storia di settecento anni.* Todi, 1924.

Brady, Ignatius. "The Doctrine of the Immaculate Conception in the Fourteenth Century." *Studia Mariana* 9 (1954): 70–110.

Brandi, Cesare. "The First Version of Filippino Lippi's *Assumption.*" *Burlington Magazine* 67 (1935): 30–35.

Braunfels, Wolfgang. *Santa Croce di Firenze.* Piccole guide delle chiese italiane, 4. Florence, n.d. [1938].

Brengio, Lodovico. "L'Osservanza francescana in Italia nel secolo XIV." *Pontificium*

Athenaeum Antonianum, Facultas Theologica, Thesis ad Lauream, no. 147. Studi e testi francescani, 24. Rome, 1963.

Breve compendio della vita del famoso Titiano Vecellio di Cadore cavalliere, et pittore. Venice, 1622.

Brlek, Michael. "Legislatio ordinis Fratrum Minorum de Immaculata Conceptione B.M.V." *Antonianum* 29 (1954): 3–44.

Brooke, Rosalind B. *Early Franciscan Government, Elias to Bonaventure.* Cambridge, 1959.

————. *Scripta Leonis, Rufini et Angeli, Sociorum S. Francisci, The Writings of Leo, Rufino and Angelo, Companions of St. Francis.* Oxford Medieval Texts. London, 1970.

————. "St. Bonaventure as Minister General." In *S. Bonaventura Francescano.* Convegni del Centro di Studi sulla Spiritualità Medievale, 14, pp. 75–105. Todi, 1974.

Brunetti, Mario. "Un implacabile ammiraglio della Serenissima." *Rassegna veneziana di lettere ed arti* (1932), 7–14.

Bruyn, J. "Notes on Titian's Pietà." In *Album Amicorum J. G. van Gelder,* pp. 66–75. The Hague, 1973.

Cacciarini, Gianni. "In S. Croce la chiesa del 1250." *Città di vita* 23 (1968): 53–61.

Cagli, Corrado. See Valcanover, Francesco.

Cahn, Walter. "A Note on the Pérussis-Altar in the Metropolitan Museum of Art in New York." In *Essays in Northern European Art Presented to Egbert Haverkamp-Begemann on his Sixtieth Birthday,* pp. 61–65. Doornspijk, 1983.

Cannon, Joanna Louise. "Dominican Patronage of the Arts in Central Italy: The *Provincia Romana, c.* 1200–*c.* 1320." Ph.D. diss., Courtauld Institute of Art, University of London, 1980.

Carile, Antonio. *Le origini di Venezia.* Bologna, 1978.

Carli, Enzo. *Pietro Lorenzetti.* Milan, n.d.

Cavalcaselle, G. B., and J. A. Crowe. *Tiziano, La sua vita e i suoi tempi.* 2 vols. Florence, 1878.

Cecchetti, B. "I nobili e il popolo di Venezia." *Archivio veneto* 3 (1872): 421–48.

Cecchin, Andrea M. "La concezione della Vergine nella liturgia della chiesa occidentale anteriore al secolo XIII." *Marianum* 5 (1943): 58–114.

Celano, Thomas de. *Vita Prima S. Francisci Assisiensis et Eiusdem Legenda ad Usum Chori.* Quaracchi, 1926.

Chenu, M. D. In *Dictionnaire de théologie catholique.* Vol. 14¹, cols. 1094–97, s.v. "Sang du Christ." Paris, 1939.

Chojnacki, Stanley. "In Search of the Venetian Patriciate: Families and Factions in the Fourteenth Century." In *Renaissance Venice,* edited by J. R. Hale, pp. 47–90. London, 1973.

————. "Patrician Women in Early Renaissance Venice." *Studies in the Renaissance* 21 (1974): 176–203.

————. "Dowries and Kinsmen in Early Renaissance Venice." *The Journal of Interdisciplinary History* 59 (1975): 571–600.

Christe, Yves. "L'Apocalypse de Cimabue à Assisi." *Cahiers archéologiques* 29 (1980–81): 157–74.

"Chronica XXIV Generalium Ordinis Minorum." *Analecta Franciscana* 3 (1897).

The Cloud of Unknowing. Edited by James Walsh. New York, Ramsey, and Toronto, 1981.

Cogo, G. "La guerra di Venezia contro i turchi (1499–1501)." *Nuovo archivio veneto* 18, pt. 1 (Anno 9, 1899): 5–76 and 348–421; and 19, pt. 1 (Anno 10, 1900): 97–138.

Colasanti, Francomario. *San Lorenzo Giustiniani nelle raccolte della Biblioteca Nazionale Marciana, Catalogo di Mostra.* Venice, 1981.

Contarini, Pietro. *Venezia religiosa o guida per tutte le sacre funzioni che si practicano nelle chiese di Venezia.* Venice, 1853.

Conti, Alessandro. "Pittori in Santa Croce: 1295–1341." *Annali della Scuola Normale Superiore di Pisa, Classe di Lettere e Filosofia,* 3d ser., vol. 2, pt. 1 (1972): 247–63.

Conti, Sigismondo dei. *Le storie de' suoi tempi dal 1475 al 1510.* 2 vols. Rome, 1883.

Cornelio, Flaminio. *Ecclesiae Venetae Antiquis Monumentis . . . illustratae.* 18 vols. Venice, 1749.

———. [Corner, Flaminio]. *Notizie storiche della chiese e monasteri di Venezia.* Padua, 1758.

Correr, Giovanni, and Agostino Sagredo et al. *Venezia e le sue lagune.* 3 vols. Venice, 1847.

Cozzi, Gaetano. "Marin Sanudo il Giovane: Dalla cronaca alla storia (Nel V centenario della sua nascita)." In *La storiografia veneziana fino al secolo XVI* (Civiltà veneziana, Saggi 18), edited by Agostino Pertusi, pp. 333–58. Florence, 1970.

Crasso, Nicolao. *Pisaura gens.* Venice, 1652.

Cresi, Domenico. "Statistica dell'ordine minoritico all'anno 1282." *Archivum Franciscanum Historicum* 56 (1963): 157–62.

Crowe, J. A. See Cavalcaselle, G. B.

Curtius, Ludwig. "Zum Antikenstudium Tizians." *Archiv für Kulturgeschichte* 28 (1938): 235–38.

Dante Alighieri. *Paradiso.* Vol. 3 of *The Divine Comedy,* translated and edited by Charles S. Singleton. (Bollingen Series, 80). Princeton, N.J., 1975.

Davies, Martin. *The Earlier Italian Schools.* National Gallery Catalogues. 2d ed. rev. London, 1961.

Davis, James Cushman. *The Decline of the Venetian Nobility as a Ruling Class.* The Johns Hopkins University Studies in Historical and Political Science, ser. 80, no. 2. Baltimore, 1962.

Delcorno, Carlo. *La predicazione nell'età comunale.* Florence, 1974.

———. *Giordano da Pisa e l'antica predicazione volgare.* Biblioteca di "Lettere italiane," 14. Florence, 1975.

———. "L' 'exemplum' nella predicazione di Bernardino da Siena." In *Bernardino predicatore nella società del suo tempo.* Convegni del Centro di Studi sulla Spiritualità Medievale, 16, pp. 71–107. Todi, 1976.

———. "Predicazione volgare e volgarizzamenti." In *Les Ordres mendiants et la ville en Italie centrale (v. 1220–v. 1350). Mélanges de l'Ecole Française de Rome, Moyen Age—Temps Modernes* 89 (1977): 679–89.

Dellwing, Herbert. *Studien zur Baukunst der Bettelorden im Veneto, Die Gotik der monumentalen Gewölgebasiliken.* Kunstwissentschaftliche Studien, 43. Ph.D. diss., University of Frankfurt am Main. Munich and Berlin, 1970.

Demus, Otto. *The Church of S. Marco in Venice, History, Architecture, Sculpture.* Dumbarton Oaks Studies, 6. Washington, D.C., 1960.

Dolcetti, Giovanni. *Il "Libro d'argento" dei cittadini di Venezia e del Veneto (1922–28).* 5 vols. in 2. Bologna, 1968.

Dorment, Kate. "Tomb and Testament: Architectural Significance in Titian's *Pietà*." *Art Quarterly* 35 (1972): 399–418.

Edgerton, Samuel Y., Jr. *The Renaissance Rediscovery of Linear Perspective.* New York, 1975.

————. "*Mensurare temporalia facit Geometria spiritualis*: Some Fifteenth-Century Italian Notions about When and Where the Annunciation Happened." In *Studies in Late Medieval and Renaissance Painting in Honor of Millard Meiss,* edited by Irving Lavin and John Plummer, vol. 1, pp. 115–30. New York, 1977.

Egan, J. M. "The Doctrine of Mary's Death during the Scholastic Period." *Marian Studies* 8 (1957): 100–24.

Egnazio, G. B. *De Exemplis Illustrium Virorum Venetae Civitatis atque Aliarum Gentium* (ca. 1512). Venice, 1554.

Einem, Herbert von. "Tizians Grabbild." *Bayerische Akademie der Wissenschaften.* Philosophisch-Historische Klasse, Sitzungsberichte, vol. 5 (1979).

Enciclopedia cattolica. Vol. 8¹, cols. 76–118, s.v. "Maria, santissima." Vatican City, 1952.

Esser, Cajetan. *Origins of the Franciscan Order.* Translated by A. Daly and I. Lynch. Chicago, 1970.

Ettlinger, Helen S. "The Iconography of the Columns in Titian's Pesaro Altarpiece." *Art Bulletin* 61 (1979): 59–67.

Ettlinger, L. D. "Pollaiuolo's Tomb of Sixtus IV." *Journal of the Warburg and Courtauld Institutes* 16 (1953): 239–74.

Eubel, Conradus. *Hierarchia Catholica Medii aevii.* Vol. 2. Rev. ed. Regensberg, 1914.

————, and Guilelmus van Gulik. *Hierarchia Catholica Medii et Recentioris Aevi.* Vol. 3. Regensberg, 1923.

Facchinetti, Vittorino. "Bollettino bibliografico: San Bernardino da Siena." *Aevum* 4 (1930): 319–81.

Fasoli, Gina. "Nascita di un mito." In *Studi storici in onore di Gioacchino Volpe,* vol. 1, pp. 445–79. Biblioteca Storica Sansoni, N.S. 31. Florence, 1958.

————. "I fondamenti della storiografia veneziana." In *La storiografia veneziana fino al secolo XVI, Aspetti e problemi,* edited by A. Pertusi, pp. 11–44. (Civiltà veneziana, Saggi 18). Florence, 1970.

————. "Liturgia e ceremoniale ducale." In *Venezia e il Levante fino al secolo XV,* edited by A. Pertusi, vol. 1, pp. 261–95. Florence, 1973.

Fechner, Heinz. *Rahmen und Gliederung venezianischer Anconen aus der Schule von Murano.* Munich, 1969.

Fehl, Philip. "Saints, Donors and Columns in Titian's *Pesaro Madonna*." In *Renaissance Papers 1974,* pp. 75–85 (Southeastern Renaissance Conference). Durham, N.C., 1975.

Feldbusch, Hans. *Die Himmelfahrt Maria.* (Lukas-Bücherei zur christlichen Ikonographie, 2). Düsseldorf, 1951.

Finlay, Robert. "Politics and the Family in Renaissance Venice: The Election of Doge Andrea Gritti." *Studi veneziani,* n.s. 2 (1978): 97–117.

Finotto, Ferdinando. *San Giobbe, La chiesa dei Santi Giobbe e Bernardino in Venezia.* Venice, 1971.

Fisher, Sydney Nettleton. "The Foreign Relations of Turkey 1481–1512." *Illinois Studies in the Social Sciences* 30 (1948): 9–124.

Fleming, John V. *From Bonaventure to Bellini, An Essay in Franciscan Exegesis.* Princeton Essays on the Arts, 14. Princeton, N.J., 1982.

Fliche, Augustin, Christice Thouzellier, and Yvonne Azais. *La Chrétienté romaine (1198–1274).* Vol. 10 of *Histoire de l'église depuis les origines jusqu'à nos jours,* edited by A. Fliche and E. Jarry. N.p., 1950.

Flores D'Arcais, Francesca. *Guariento.* (Profili e Saggi di Arte Veneta, 3). Venice, 1965.

Fogolari, Gino. "Gli scultori toscani a Venezia nel Quattrocento e Bartolomeo Bon, Veneziano." *L'Arte* 33 (1930): 427–65.

———. *Chiese veneziane, I Frari e i SS. Giovanni e Paolo.* Milan, 1931.

———. "L'urna del Beato Pacifico ai Frari." *Atti del Reale Istituto Veneto di Scienze, Lettere ed Arti* 89, pt. 2 (1939): 937–53.

Fonzo, L. Di. "La Mariologia di San Bernardino da Siena." *Miscellanea francescana* 47 (1947): 3–102.

[St. Francis of Assisi.] *Opuscula Sancti Patris Francisci Assisiensis.* Quaracchi, 1949.

Franzoi, Umberto, and Dino Di Stefano. *Le chiese di Venezia.* Venice, 1976.

Freedberg, S. J. *Painting of the High Renaissance in Rome and Florence.* 2 vols. Cambridge, Mass., 1961.

Freiberg, Jack. "The 'Tabernaculum Dei': Masaccio and the 'Perspective' Tabernacle Altarpiece." Master's Thesis, New York University, Institute of Fine Arts, 1974.

Frizzoni, Gustavo. "A Plea for the Reintegration of a Great Altarpiece." *Burlington Magazine* 22 (1913): 260–69.

Frutaz, Amato Pietro. "La chiesa di S. Francesco in Assisi, 'Basilica patriarcale e cappella papale.' " *Miscellanea francescana* 54 (1954): 399–432.

Fry, Roger E. *Giovanni Bellini.* London, 1899.

Fulin, Rinaldo. "Gli inquisitori dei Dieci, VI." *Archivio veneto* 1 (1871): 305–16.

Gaeta, Franco. "Origine e sviluppo della rappresentanza stabile pontifica in Venezia (1485–1533)." *Annuario dell'Istituto Storico Italiano per l'Età Moderna e Contemporanea* 9–10 (1957–58): 3–282.

———. "Alcune considerazioni sul mito di Venezia." *Bibliothèque d'Humanisme et Renaissance* 23 (1961): 58–75.

Gambier, Madile, et al. *Arti e mestieri nella Repubblica di Venezia.* Venice, 1980.

Gardner, Julian. "Some Franciscan Altars of the Thirteenth and Fourteenth Centuries." In *The Vanishing Past, Studies of Medieval Art, Liturgy and Metrology Presented to Christopher Hohler,* edited by A. Borg and A. Martindale, pp. 29–38. BAR International Series, 3. Oxford, 1981.

Geanakoplos, D. J. *Byzantine East and Latin West: Two Worlds of Christendom in Middle Ages and Renaissance, Studies in Ecclesiastical and Cultural History.* Oxford, 1966.

Geary, Patrick. *Furta Sacra: Thefts of Relics in the Central Middle Ages.* Princeton, N.J., 1978.

Geiger, Gail L. "Filippino Lippi's Carafa Chapel: 1488–1493, Santa Maria sopra Minerva, Rome." Ph.D. diss., Stanford University, 1975.

———. "Filippino Lippi's Carafa 'Annunciation': Theology, Artistic Conventions, and Patronage." *Art Bulletin* 63 (1981): 62–75.

Ghinato, A. *Saggio di bibliografia bernardiniana.* Rome, 1960.

Gibbons, Felton. "Giovanni Bellini and Rocco Marconi." *Art Bulletin* 54 (1962): 127–31.

———. "New Evidence for the Birth Dates of Gentile and Giovanni Bellini." *Art Bulletin* 45 (1963): 54–58.

Gilbert, Creighton. "Peintres et menuisiers au début de la Renaissance en Italie." *Revue de l'art* 37 (1977): 9–28.

———. "Some Findings on Early Works of Titian." *Art Bulletin* 62 (1980): 36–75.

———. In *The Genius of Venice 1500–1600*, edited by J. Martineau and C. Hope, pp. 204–05. London, 1983.

Gilbert, Felix. "Venice in the Crisis of the League of Cambrai." In *Renaissance Venice*, edited by J. R. Hale, pp. 274–92. London, 1973.

———. *The Pope, His Banker, and Venice*. Cambridge, Mass., and London, 1980.

Gill, Joseph. "East and West in the Time of Bessarion, Theology and Religion." *Rivista di studi bizantini e neoellenici*, n.s. 5 ([15] 1968): 3–27.

Gillet, Louis. *Histoire artistique des ordres mendiants, Essai sur l'art religieux du XIII^e au XVII^e siècle*. Paris, 1912.

Gillett, H. M. In *New Catholic Encyclopedia*, vol. 8, pp. 993–94, s.v. "Loreto." New York et al., 1967.

Giuliani, Innocenzo. "Genesi e primo secolo di vita del Magistrato sopra Monasteri, Venezia 1519–1620." *Le Venezie francescane* 28 (1961): 42–68 and 106–69.

Giustiniani, Bernardo. "Oratio Funebris Habita in Obitu Francisci Fuscari Ducis." In *Bernardi Iustiniani Oratoris Clarissimi Orationes*, fols. 8v.–20r. N.p. [Venice?], n.d. [before 1501].

———. "Orazione recitata da Bernardo Giustiniano nell'esequie del Doge Francesco Foscari." In *Orazioni, elogi e vite scritte da letterati veneti patrizi in lode di dogi, ed altri illustri soggetti, compresavi alcuni inedita, e tutte per la prima volta volgarizzate*, vol. 1, pp. 21–59. 2d ed. rev. Venice, 1798.

[———]. *Vita beati Laurentii Iustiniani Venetiarum Proto Patriarchae*. Edited by I. Tassi. Rome, 1962.

[Giustiniani, St. Lorenzo]. *Opera Divi Laurentii Iustiniani Venetiarii Prothopatriarcha*. Bressanone, 1506.

———. *Devoti sermoni delle solennità de Santi del beato Lorenzo Giustiniani . . . primo patriarca di Venezia*. Translated by A. Picolini. Venice, 1565.

Goffen, Rona. "Icon and Vision: Giovanni Bellini's Half-Length Madonnas." *Art Bulletin* 57 (1975): 487–518.

———. "*Nostra Conversatio in Caelis Est*: Observations on the *Sacra Conversazione* in the Trecento." *Art Bulletin* 61 (1979): 198–222.

———. "Masaccio's Trinity and the Letter to Hebrews." *Memorie Domenicane*, n.s. 11 (1980): 489–504.

———. "Carpaccio's *Portrait of a Young Knight*: Identity and Meaning." *Arte veneta* 37 (1983): 37–48.

———. "A Bonaventuran Analysis of Correggio's *Madonna of St. Francis*." *Gazette des beaux-arts* 103 (1984): 11–18.

———. *Spirituality in Conflict: Saint Francis and Giotto's Bardi Chapel*. University Park, Pa., and London, 1988.

Goldthwaite, Richard. *Private Wealth in Renaissance Florence, A Study of Four Families*, Princeton, N.J., 1968.

————. "The Florentine Palace as Domestic Architecture." *The American Historical Review* 77 (1972): 977–1012.

————. "The Building of the Strozzi Palace: The Construction Industry in Renaissance Florence." *Studies in Medieval and Renaissance History* 10 (1973): 99–194.

————. *The Building of Renaissance Florence: An Economic and Social History.* Baltimore and London, 1980.

Golubovich, H. "Statua Liturgica Seu Rubricae Breviarii Auctore Divo Bonaventura in Generali Capitulo Pisano An. 1263 Editore." *Archivum Franciscanum Historicum* 4 (1911): 62–73.

Gonzaga, Francisci. *De Origine Seraphicae Religionis Franciscanae eiusq. Progressibus, de Regularis Observanciae Institutione, Forma Administrationis ac Legibus, Admirabiliq. eius Propagatione.* Rome, 1587.

Graef, Hilda C. "The Theme of the Second Eve in Some Byzantine Sermons on the Assumption." In *Studia Patristica,* vol. 9, pp. 224–30. (Texte und Untersuchungen zur Geschichte der altchristlichen Literatur, 94. Papers Presented to the Fourth International Conference on Patristic Studies Held at Christ Church, Oxford, 1963, Part 3, Classica, Philosophica et Ethica, Theologica, Augustiniana, Post-Patristica, edited by F. L. Cross.) Berlin, 1966.

Gronau, Georg. *Die Künstlerfamilie Bellini.* Künstlermonographien, 96. Bielefeld and Leipzig, 1909.

Grundmann, H. *Movimenti religiosi nel medioevo.* Translated by M. Ausserhofer and L. N. Santini. Bologna, 1974.

Habig, Marion A., ed. *St. Francis of Assisi, Writings and Early Biographies, English Omnibus of the Sources for the Life of St. Francis.* Chicago, 1972.

Hall, Marcia B. "The 'Tramezzo' in S. Croce, Florence and Domenico Veneziano's Fresco." *Burlington Magazine* 112 (1970): 797–99.

————. "The *Ponte* in S. Maria Novella: The Problem of the Rood Screen in Italy." *Journal of the Warburg and Courtauld Institutes* 37 (1974): 157–73.

————. "The Italian Rood Screen: Some Implications for Liturgy and Function." In *Essays Presented to Myron P. Gilmore,* edited by Sergio Bertelli and Gloria Ramakus, vol. 2, pp. 213–18. (Villa I Tatti, The Harvard University Center for Italian Renaissance Studies, 2). Florence, 1978.

————. *Renovation and Counter-Reformation, Vasari and Duke Cosimo in Sta Maria Novella and Sta Croce 1565–1577.* Oxford, 1979.

Haller, Johannes, et al. *Concilium Basiliense. Studien und Quellen zur Geschichte des Concils von Basel.* 8 vols. Basel, 1896–1936. Reprint. Liechtenstein, 1971.

Hartt, Frederick. "The Earliest Works of Andrea del Castagno." *Art Bulletin* 41 (1959): 159–81 and 225–36.

Hazlitt, W. Carew. *The Venetian Republic, Its Rise, Its Growth, and Its Fall 421–1797.* 2 vols. London, 1900. Repr. New York, 1966.

Heers, Jacques. *Le Clan familial au moyen âge.* Paris, 1974.

Hefele, E. I., and H. Leclercq. *Histoire des Conciles.* 7 vols. Paris, 1916.

Héliot, Pierre. "Sur les églises gothiques des ordres mendiants en Italie Centrale." *Bulletin monumental* 130 (1972): 231–35.

Henricus de Hassia [Heinrich Heynbuch von Langstein]. *Contra Disceptationes. . . .* Milan, 1480.

Herlihy, David. "The Population of Verona in the First Century of Venetian Rule." In *Renaissance Venice,* edited by J. R. Hale, pp. 91–120. London, 1973.

Hirn, Yrjö. *The Sacred Shrine*. London, 1912.

Höger, Annegret. "Studien zur Enstehung der Familienkapelle und zu Familien-kappellen und -altären des Trecento in florentiner Kirchen." Ph.D. diss., University of Bonn, 1976.

Hood, William, and Charles Hope. "Titian's Vatican Altarpiece and the Pictures Underneath." *Art Bulletin* 59 (1977): 534–52.

Hope, Charles. "Documents concerning Titian." *Burlington Magazine* 115 (1973): 809–10.

———. *Titian*. London, New York et al., 1980.

———. *See* Hood, William.

Horster, Marita. *Andrea del Castagno*. Ithaca, N.Y., 1980.

Hubala, Erich. *Giovanni Bellini, Madonna mit Kind, Die Pala di San Giobbe*. Stuttgart, 1969.

Huber, Raphael M. *A Documented History of the Franciscan Order from the Birth of St. Francis to the Division of the Order under Leo X (1182–1517)*. Milwaukee and Washington, D.C., 1944.

Hueck, Irene. "Stifter und Patronatsrecht. Dokumente zu zwei Kapellen der Bardi." *Mitteilungen des Kunsthistorischen Institutes in Florenz* 20 (1976): 263–70.

———. "Cimabue und das Bildprogramm der Oberkirche von San Francesco in Assisi." *Mitteilungen des Kunsthistorischen Institutes in Florenz* 25 (1981): 279–324.

Huse, Norbert. *Studien zu Giovanni Bellini*. Berlin and New York, 1972.

Iacopone da Todi. *Laude*. Edited by F. Mancini. (Scrittori d'Italia, 257). Rome, 1974.

Isermeyer, Christian-Adolf. "Le chiese del Palladio in rapporto al culto." *Bollettino del Centro Internazionale di Studi di Architettura Andrea Palladio* 10 (1968): 42–58.

Jacopone da Todi. *See* Iacopone da Todi.

Jaffé, Michael. "Pesaro Family Portraits: Pordenone, Lotto and Titian." *Burlington Magazine* 113 (1971): 696–702.

———. In *The Genius of Venice,* edited by J. Martineau and C. Hope, pp. 224–25. London, 1983.

Janson, H. W. *The Sculpture of Donatello*. Princeton, N.J., 1963.

Jugie, Martin. *La Mort et l'assomption de la sainte Vierge, Etude historico-doctrinale*. (Studi e testi, 114). Vatican City, 1944.

Kaftal, George, and Fabio Bisogni. *Saints in Italian Art, Iconography of the Saints in the Painting of North East Italy*. Florence, 1978.

Kent, D. V., and F. W. Kent. *Neighbours and Neighbourhood in Renaissance Florence: The District of the Red Lion in the Fifteenth Century*. (Villa I Tatti, Harvard University Center for Italian Renaissance Studies, 5). New York, 1982.

Keydel, Julia Helen. "A Group of Altarpieces by Giovanni Bellini Considered in Relation to the Context for Which They Were Made." Ph.D. diss., Harvard University, 1969.

Korošak, Bruno. *Bibliotheca Sanctorum*. Vol. 2, cols. 1294–1316, s.v. "Bernardino da Siena, santo." Rome, 1962.

Krautheimer, Richard. *Die Kirchen der Bettelorden in Deutschland*. Deutsche Beiträge zur Kunstwissenschaft, 2. Cologne, 1925.

———. "Introduction to an 'Iconography of Medieval Architecture' " (1942). In idem, *Studies in Early Christian, Medieval, and Renaissance Art,* pp. 115–50. New York and London, 1969.

————, and Trude Krautheimer-Hess. *Lorenzo Ghiberti.* 2 vols. Princeton, N.J., 1970.

Kristeller, Paul. *Andrea Mantegna.* Edited by S. A. Strong. London, New York, and Bombay, 1901.

Kroenig, Wolfgang. "Caratteri dell'architettura degli ordini mendicanti in Umbria nell'età comunale." In *Atti del VI convegno di studi umbri 1968,* vol. 1, pp. 165–98. N.p. 1971.

Labalme, Patricia H. *Bernardo Giustiniani: A Venetian of the Quattrocento.* Rome, 1969.

Lambert, M. D. *Franciscan Poverty, The Doctrine of the Absolute Poverty of Christ and the Apostles in the Franciscan Order 1210–1323.* London, 1961.

Lanc, Frederic C. "Family Partnerships and Joint Ventures in the Venetian Republic." *Journal of Economic History* 4 (1944): 178–96.

————. "The Enlargement of the Great Council of Venice." In *Florilegium Historiale, Essays Presented to Wallace K. Ferguson,* edited by J. G. Rowe and W. H. Stockdale, pp. 237–73. Toronto, 1971.

————. "Naval Actions and Fleet Organization, 1499–1502." In *Renaissance Venice,* edited by J. R. Hale, pp. 146–73. London, 1973.

Lavin, Irving. "The Sculptor's 'Last Will and Testament,'" *Allen Memorial Art Museum Bulletin* 35 (1977–78): 4–39.

Lazzarini, Vittorio. "Obbligo di assumere pubblici uffici nelle antiche leggi veneziane" (1936). In *Proprietà e feudi, offizi, garzoni, carcerati in antiche leggi veneziane, Saggi,* pp. 49–60. (Storia e economia, 6). Rome, 1960.

LeCarou, A. *L'Office divin chez les Frères Mineurs.* Paris, 1928.

Lee, Egmont. *Sixtus IV and Men of Letters.* (Temi e testi, 26, ed. E. Massa). Rome, 1978.

Lewine, Milton J. "Roman Architectural Practice during Michelangelo's Maturity." In *Stil und Überlieferung in der Kunst des Abendlandes, Akten des 21. internationalen Kongresses für Kunstgeschichte in Bonn 1964,* vol. 2, pp. 20–26. Berlin, 1967.

Libby, Lester J., Jr. "Venetian History and Political Thought after 1509." *Studies in the Renaissance* 20 (1973): 7–45.

Löw, Giuseppe. "M[aria] nella liturgia occidentale da Medioevo ai giorni nostri." In *Enciclopedia cattolica.* Vol. 8, cols. 98–104, s.v. "Maria." Vatican City, 1952.

Luchaire, Achille. *Innocent III.* 6 vols. Paris, 1905–11.

Ludovico da Pietralunga. *Descrizione della basilica di S. Francisco e di altri santuari di Assisi* (1570–80). Edited by P. Scarpellini. Treviso, 1982.

Ludwig, Gustav. "Archivalische Beiträge zur Geschichte der venezianischen Kunst." *Italienische Forschungen* 4 (1911): 133–34.

McAndrew, John. *Venetian Architecture of the Early Renaissance.* Cambridge, Mass., and London, 1980.

McKenzie, Allan Dean. "The Virgin Mary as the Throne of Solomon in Medieval Art." 2 vols. Ph.D. diss., New York University, Institute of Fine Arts, 1965.

Magnum Bullarium Romanum a B. Leone Magno, usque ad S.D.N. Clementem X. 5 vols. Lyons, 1692.

Mallett, Michael. "Venice and Its Condottieri, 1404–54." In *Renaissance Venice,* edited by J. R. Hale, pp. 121–45. London, 1973.

Mariacher, Giovanni. *Il Museo Correr di Venezia, Dipinti dal XIV al XVI secolo.* Venice, 1957.

Martines, Lauro. *The Social World of the Florentine Humanists 1390–1460*. Princeton, N.J., 1963.

Mason Rinaldi, Stefania. *Jacopo Palma il Giovane, L'opera completa*. Milan, 1984.

Mathews, T. F. *The Early Churches of Constantinople, Architecture and Liturgy*. University Park, Pa., 1971.

Matteucci, Gualberto. *La missione francescana di Costantinopoli*. Vol. 1, *La sua antica origine e primi secoli di storia (1217–1585)*. (Biblioteca di studi francescani, 9). Florence, 1971.

Mauri, Gabrielis. *See* Moro, Gabriele.

Meersseman, Gerard Gilles. "Origini del tipo di chiesa umbro-toscano degli ordini Mendicanti." In *Il Gotico a Pistoia nei suoi rapporti con l'arte gotica italiana*, pp. 63–77. (Centro italiano di studi di storia e d'arte a Pistoia, Atti del 2° convegno internazionale di studi, 1966). Pistoia, 1972.

Meiss, Millard. *Giovanni Bellini's St. Francis in the Frick Collection*. Princeton, N.J., 1964.

———. *La Sacra Conversazione di Piero della Francesca*. (*Quaderni della Pinacoteca di Brera*, 1). Florence, 1971.

———. *The Painter's Choice, Problems in the Interpretation of Renaissance Art*. New York et al., 1976.

Meyer zur Capellen, Jürg. "Überlegungen zur 'Pietà' Tizians." *Münchner Jahrbuch der bildenden Kunst* 22 (1971): 117–32.

———. "Beobachtungen zu Jacopo Pesaros Exvoto in Antwerpen." *Pantheon* 38 (1980): 144–52.

———. *La figura del San Lorenzo Giustinian di Jacopo Bellini*. (Centro Tedesco di Studi Veneziani, Quaderni, 19). Venice, 1981.

Migne, J.-P. *Patrologia cursus completus, series Latina*. Vols. 36 and 78. Paris, 1865 and 1895.

———. *Patrologia Greca*. Vol. 96. Paris, 1891.

[Minotto, Tomaso]. *Brevi notizie della chiesa e dell'ex convento di S. Maria dei Miracoli unica chiesa in Venezia col titolo della Immacolata Concezione*. Venice, 1855.

Modigliani, Ettore. *Catalogo della Pinacoteca di Brera in Milano*. Milan, n.d. [1966].

Mohler, Ludwig, ed. *Kardinal Bessarion als Theologe, Humanist und Staatsmann; Funde und Forschungen*. 3 vols. Paderborn, 1923–42.

Molmenti, Pompeo. *La storia di Venezia nella vita privata dalle origini alla caduta della repubblica*. 5th ed. rev. 3 vols. Bergamo, 1910.

Monferini, Augusta. "L'Apocalisse di Cimabue." *Commentari* 17 (1966): 20–55.

Moore, James H. "*Venezia favorita da Maria*: Music for the Madonna Nicopeia and Santa Maria della Salute." *Journal of the American Musicological Society* 37 (1984): 299–355.

Moorman, John. *A History of the Franciscan Order from its Origins to the Year 1517*. Oxford, 1968.

Moro, Gabriele. "Orazione in morte di Benedetto da Pesaro Capitanio Generale della Veneta Armata, e Procurator di S. Marco." In *Orazioni, Elogi e Vite scritte da letterati veneti patrizi* . . . , vol. 1, pp. 161–67. 2d ed. Venice, 1798.

Moschetti, A. "Il 'Paradiso' del Guariento nel Palazzo Ducale di Venezia." *L'Arte* 7 (1904): 394–97.

Moschini Marconi, Sandra. *Gallerie dell'Accademia di Venezia, Opere d'arte dei secoli XIV e XV*. Rome, 1955.

———. *Gallerie dell'Accademia di Venezia, Opere d'arte del secolo XVI.* Rome, 1962.

Mosto, Andrea da. *I dogi di Venezia nella vita pubblica e privata.* Milan, 1966.

Moulton, Susan Gene. "Titian and the Evolution of Donor Portraiture in Venice." Ph.D. diss., Stanford University, 1977.

Mueller, Reinhold C. "The Procurators of San Marco." *Studi veneziani* 13 (1971): 105–220.

———. *The Procuratori di San Marco and the Venetian Credit Market.* New York, 1977.

Muir, Edward. "Images of Power: Art and Pageantry in Renaissance Venice." *American Historical Review* 84 (1979): 16–52.

———. *Civic Ritual in Renaissance Venice.* Princeton, N.J., 1981.

Muraro, Michelangelo. *Paolo da Venezia.* University Park, Pa., and London, 1970.

Musolino, G. "Culto mariano." In *Culto dei santi a Venezia,* edited by S. Tramontin et al., pp. 241–74. (Biblioteca agiografica veneziana, vol. 2). Venice, 1965.

Nani Mocenigo, Mario. "Il capitano generale da mar Benedetto Pesaro." *Rivista di Venezia a cura del comune,* ser. 1, 11 (1932): 385–99 and 496–507.

Niero, Antonio. "L'azione veneziana al concilio di Basileia." In *Venezia e i concili,* pp. 3–46. (Quaderni del Laurentianum). Venice, 1962.

Nilgen, Ursula. "Maria Regina—Ein politisches Kultbildtypus?" *Römisches Jahrbuch für Kunstgeschichte* 19 (1981): 1–33.

Oberhammer, Vinzenz. *Katalog der Gemäldegalerie, I. Teil, Italiener, spanier, franzosen, engländer.* Vienna, 1965.

Obermann, Heiko Augustinus. *The Harvest of Medieval Theology.* Cambridge, Mass., 1963.

Odoardi, Giovanni. "La custodia francescana di Terra Santa." *Miscellanea Francescana* 43 (1943): 217–56.

———. "S. Bernardino da Siena e la comunità dell'Ordine o Frati Minori Conventuali." *Miscellanea Francescana* 81 (1981): 111–74 and 439–515.

Offner, Richard. *A Critical and Historical Corpus of Florentine Painting, The Fourteenth Century,* sec. 3, vol. 5. New York, 1947.

O'Malley, John W. *Praise and Blame in Renaissance Rome, Rhetoric, Doctrine, and Reform in the Sacred Orators of the Papal Court, c. 1450–1521.* Duke Monographs in Medieval and Renaissance Studies, 3. Durham, N.C., 1979.

Ongaro, Max. *Cronaca dei restauri dei progetti e dell'azione tutta dell'Ufficio Regionale ora Soprintendenza ai Monumenti di Venezia.* Venice, 1912.

Origo, Iris. *The World of San Bernardino.* New York, 1962.

Orlandi, Stefano. *La biblioteca di S. Maria Novella in Firenze dal sec. XIV al sec. XIX.* Florence, 1952.

Pacetti, Dionisio. "La predicazione di S. Bernardino in Toscana con documenti inediti estratti dagli atti del processo di canonizzazione." *Archivum Franciscanum* 33 (1940): 268–318; and 34 (1941): 261–83.

Padoan Urban, Lina. "La festa della Sensa nelle arti e nell'iconografia." *Studi veneziani* 10 (1968): 291–353.

Pallucchini, Rodolfo. *I Vivarini (Antonio, Bartolomeo, Alvise).* Saggi e Studi di Storia dell'Arte, 4. Venice, n.d. [1961?].

Panofsky, Erwin. *Early Netherlandish Painting, Its Origins and Character.* 2 vols. Cambridge, Mass., 1966.

―――. *Problems in Titian, Mostly Iconographic.* The Wrightsman Lectures, 2. New York, 1969.

Paoletti, Pietro di Osvaldo. *L'architettura e la scultura del Rinascimento in Venezia, Ricerche storico-artistiche.* Part 1, *Periodo di transizione.* Venice, 1893.

―――. "Bregno, Lorenzo." In Thieme-Becker, *Allgemeines Lexikon der bildenden Künstler,* vol. 4, pp. 568–70. Leipzig, 1910.

Paravia, Pier-Alessandro, with Antonio Paravia. "Sopra la pala di Tiziano detta della Concezione." *Giornale sulle scienze e lettere delle provincie venete* 18 (1822); repr. Treviso, 1822.

Parronchi, Alessandro. *Donatello e il potere.* Florence and Bologna, 1980.

Passerini, Luigi. *Gli Alberti di Firenze, Genealogia, storia e documenti.* Vol. 1. Florence, 1869.

Pertusi, Agostino. "Gli inizi della storiografia umanistica nel Quattrocento." In *La storiografia veneziana fino al secolo XVI, aspetti e problemi,* edited by idem, pp. 269–332. Civiltà veneziana, Saggi, 18. Florence, 1970.

Piana, Celestino. "Contributo allo studio della teologia e della leggenda dell'Assunzione della Vergine nel secolo XIV." *Studi francescani,* ser. 3, 16 ([41] 1944): 97–117.

Pietro Antonio di Venetia. *Fasti serafici.* Venice, 1684.

―――. *Cronica della provincia di S. Antonio dei Minori Osservanti Riformati.* Venice, 1688.

―――. *Giardino serafico istorico delli tre ordini instituiti dal serafico padre S. Francesco.* Venice, 1710.

Pignatti, Terisio, and Renato Ghiotto. *L'opera completa di Giovanni Bellini.* Classici dell'arte, 28. Milan, 1969.

Pilot, Antonio. "L'elezione del Doge Nicolò Tron." *Nuova rassegna di letteratura moderna* (1906), pp. 2–17.

Pincus, Debra. "The Tomb of Doge Nicolò Tron and Venetian Renaissance Ruler Imagery." In *Art the Ape of Nature, Studies in Honor of H. W. Janson,* edited by Moshe Barasch and Lucy Freeman Sandler, pp. 127–50. New York, 1981.

Piva, Vittorio. In *Enciclopedia cattolica.* Vol. 7, cols. 1554–55, s.v. "Lorenzo Giustiniani, santo." Vatican City, 1951.

Pope-Hennessy, John. *Fra Angelico.* 2d ed. Ithaca, N.Y., 1974.

Privilegia et Indulgentie Fratrum Minorum Ordinis Sci. Francisci. Venice, 1502.

Prodi, Paolo. "The Structure and Organization of the Church in Renaissance Venice: Suggestions for Research." In *Renaissance Venice,* edited by J. R. Hale, pp. 409–30. London, 1973.

Pullan, Brian. *Rich and Poor in Renaissance Venice, The Social Institutions of a Catholic State, to 1620.* Oxford, 1971.

Pusci, Lucio. "Profilo di Francesco della Rovere poi Sisto IV." In *Storia e cultura al Santo,* edited by Antonino Poppi, pp. 279–87. (*Fonti e studi per la storia del Santo a Padova, Studi,* vol. III, 1). Vicenza, 1976.

Queller, D. E. "The Civic Irresponsibility of the Venetian Nobility." In *Economy, Society, and Government in Medieval Italy, Essays in Memory of Robert L. Reynolds,* edited by D. Herlihy et al., pp. 233–35. Kent, Ohio, 1969.

Ragusa, Isa. "Terror Demonum and Terror Inimicorum: The Two Lions of the Throne of Solomon and the Open Door of Paradise." *Zeitschrift für Kunstgeschichte* 40 (1970): 93–114.

Renier Michiel, Giustina. *Origine delle feste veneziane.* Vol. 1. Milan, 1829.

Robertson, Giles. *Giovanni Bellini.* Oxford, 1968.

———. In *The Genius of Venice 1500–1600,* edited by J. Martineau and C. Hope, p. 219. London, 1983.

Robinson, Paschal. In *The Catholic Encyclopedia,* vol. 2, p. 316, s.v. "Bartholomew of Pisa." New York, 1907.

Romano, Dennis. "Charity and Community in Early Renaissance Venice." *Journal of Urban History* 11 (1984): 63–82.

Rosand, David. "Titian in the Frari." *Art Bulletin* 53 (1971): 196–213.

———. "Titian's *Presentation of the Virgin in the Temple* and the Scuola della Carità." *Art Bulletin* 58 (1976): 55–84.

———. *Titian.* New York, 1978.

———. *Painting in Cinquecento Venice: Titian, Veronese, Tintoretto.* New Haven and London, 1982.

———. "*Venetia figurata*: The Iconography of a Myth." In *Interpretazioni veneziane: Studi di storia dell'arte in onore di Michelangelo Muraro,* edited by idem, pp. 177–96. Venice, 1985.

Rosand, Ellen. "Music in the Myth of Venice." *Renaissance Quarterly* 30 (1977): 511–37.

Roskill, Mark W. *Dolce's "Aretino" and Venetian Art Theory of the Cinquecento.* Monographs on Archaeology and the Fine Arts, 15. New York, 1968.

Runciman, Steven. *A History of the Crusades.* Vol. 3, *The Kingdom of Acre and the Later Crusades.* Cambridge, 1955.

Rylands, Philip. "Palma Vecchio's 'Assumption of the Virgin.'" *Burlington Magazine* 119 (1977): 245–50.

Sabellico, Marc'Antonio. *Del sito di Venezia città* (1502). Edited by G. Meneghetti. Venice, 1957.

Salter, Emma Gurney. *Franciscan Legends in Italian Art, Pictures in Italian Churches and Galleries.* London, 1905.

Sansovino, Francesco. *Venetia città nobilissima et singolare.* Venice, 1581.

———. *Venetia città nobilissima et singolare.* Edited by G. Martinioni. Venice, 1663.

Santa, Giuseppe Dalla. "Di alcune manifestazioni del culto all'Immacolata Concezione in Venezia dal 1480 alla metà del secolo XVI (Nota storica)." In *Serto di fiori a Maria Immacolata, Anno L* (offprint). Venice, 1904.

Sanuto, Marino. *De Origine Urbis Venetae et Vita Omnium Ducum.* Edited by Ludovico Antonio Muratori. In *Rerum Italicarum Scriptores,* vol. 23. Milan, 1733.

———. *I diarii.* 58 vols. Edited by Rinaldo Fulin et al. Venice, 1879–1903.

——— [Sanudo, Marin]. *Le vite dei dogi.* Edited by G. Monticolo and G. Carducci. In *Rerum Italicarum Scriptores,* vol. 22, pt. 4. 2d ed. Città di Castello and Bologna, 1900–02.

Sartori, Antonio. *Guida storico-artistica della Basilica di S. M. Gloriosa dei Frari in Venezia.* Padua, 1949; repr., 1956.

———. *La Provincia del Santo dei Frati Minori Conventuali, Notizie storiche.* Pubblicazioni della Provincia Patavina dei Frati Minori Conventuali, 1. Padua, 1958.

Saxl, Fritz. *Lectures.* 2 vols. London, 1957.

Sbriziolo, Lia. "Per la storia delle confraternite veneziane: Dalle Deliberazioni Miste (1310–1476) del Consiglio dei Dieci, *Scolae Comunes,* Artigiane e Nazionali." *Atti*

dell'Istituto Veneto di Scienze, Lettere ad Arti 130, *Classe di scienze morali, lettere ed arti* 126 (1967–68): 405–42.

Schlegel, Ursula. "On the Picture Program of the Arena Chapel" (1957). In James H. Stubblebine, *Giotto: The Arena Chapel Frescoes* (Norton Critical Study in Art History), pp. 182–202. New York and London, 1969.

Schulz, Anne Markham. *Niccolò di Giovanni Fiorentino and Venetian Sculpture of the Early Renaissance.* Monographs on Archaeology and Fine Arts of the American Institute of Archeology and the College Art Association, 33. New York, 1978.

———. *The Sculpture of Giovanni and Bartolomeo Bon and Their Workshop.* Transactions of the American Philosophical Society, 68, pt. 3. Philadelphia, 1978.

———. *Antonio Rizzo, Sculptor and Architect.* Princeton, N.J., 1983.

Schuster, I. *The Sacramentary (Liber Sacramentorum).* 2 vols. Translated by A. Levelis-Marke. London, 1924.

Sciamannini, Raniero. *La Basilica di Santa Croce.* Florence, 1951.

Scolari, Aldo. "La chiesa di S.ta Maria Gloriosa dei Frari ed il suo recente restauro." *Venezia, Studi di arte e storia* 1 (1920): 148–71.

Scrinzi, Angelo. "Ricevute di Tiziano per il pagamento della Pala Pesaro ai Frari." *Venezia, Studi di arte e storia* 1 (1920): 258–59.

Sericoli, Cherubinus. *Immaculata B. M. Virginis Conceptio iuxta Xysti IV Constitutiones.* Bibliotheca Mariana Medii Aevi, Textus et Disquitiones, Collecto edita cura Instituti Theologici Makarskensis, Croatia, Fasc. 5. Sibenic and Rome, 1945.

Sinding, Olav. *Mariae Tod und Himmelfahrt, Ein Beitrag zur Kenntnis der frühmittelalterlichen Denkmaler.* 2 vols. Christiania, 1903.

Sinding-Larsen, Staale. "Titian's Madonna di Ca' Pesaro and Its Historical Significance." *Acta ad Archaeologiam et Artium Historiam Pertinentia* (Institutum Romanum Norvegiae) 1 (1962): 139–69.

———. *Christ in the Council Hall, Studies in the Religious Iconography of the Venetian Republic. Acta ad Archaeologiam et Artium Historian Pertinentia* [Institutum Romanum Norvegiae]. Vol. 5. Rome, 1974.

———. "Titian's Triumph of Faith and the Medieval Tradition of the Glory of Christ." *Acta ad Archaeologiam et Artium Historiam Pertinentia* (Istitutum Romanum Norvegiae) 6 (1975): 315–51.

———. "La 'Madone Stylithe' di Giorgione." In *Giorgione, Atti del Convegno Internazionale di Studi,* pp. 285–91. Castelfranco Veneto, 1978.

———. "L'immagine della Repubblica di Venezia." In *Architettura e Utopia nella Venezia del Cinquecento,* pp. 40–49. Milan, 1980.

———. "La pala dei Pesaro e la tradizione dell'imagine liturgica." In *Tiziano e Venezia: Convegno internazionale di studi, Venezia, 1976,* pp. 201–06. Vicenza, 1980.

Spada, Nicolò. "I Frati Minori a Venezia nel terzo decennio del duecento." *Le Venezie francescane, Rivista storico-artistica letteraria* 1 (1932): 71–76.

———. "Le origini del convento dei Frari." *Le Venezie francescane, Rivista storico-artistica* 1 (1932): 163–71.

Spimbolo, Timoteo. *Storia dei Frati Minori della Provincia Veneta di S. Francesco, Volume Primo (1517–1800).* Vicenza, 1933.

Statuta Generalia Fratrum Minorum Regularis Observantie. Venice, 1526.

Stechow, Wolfgang. "Joseph of Arimathea or Nicodemus?" In *Studien zur toskan-*

ischen Kunst, Festschrift für Ludwig Heinrich Heydenreich zum 23 Marz 1963, pp. 289–302. Munich, 1964.

Supino, Igino Benvenuto. "La pala d'altare di Iacobello e Pier Paolo dalle Masegne nella chiesa di S. Francesco in Bologna." *Memorie della R. Accademia delle Scienze dell'Istituto di Bologna* (Classe di Scienze Morali, ser. 1: Sezione di Scienze Storico-Filologiche) 9 (1914–15): 111–55.

Tassi, I. *Vita beati Laurentii Iustiniani Venetiarum Proto Patriarchae*. Rome, 1962.

Tassini, Giuseppe. *Curiosità veneziane* (1863). Edited by L. Moretti. Venice, 1970.

Tea, Eva. "La Pala Pesaro e la Immacolata." *Ecclesia* 17 (1958): 605–09.

————. "Iconografia della Immacolata in Italia e in Francia." In *Relations artistiques entre la France et les autres pays depuis le haut Moyen Age jusqu'à la fin du XIX^e siècle, Actes du XIX^e congrès internationale d'histoire de l'art*, pp. 275–84. Paris, 1959.

Teetaert, A. In *Dictionnaire de théologie catholique*. Vol. 14², cols. 2199–2200, s.v. "Sixte IV." Paris, 1941.

Tenenti, Alberto. "The Sense of Space and Time in the Venetian World of the Fifteenth and Sixteenth Centuries." In *Renaissance Venice*, edited by J. R. Hale, pp. 17–46. London, 1973.

Thode, Henry. "Studien zur italienischen Kunstgeschichte im XIV. Jahrhundert." *Repertorium für Kunstwissenschaft* 18 (1895): 81–90.

Tolnay, Charles de. "Il 'Paradiso' del Tintoretto: Note sull'interpretazione della tela in Palazzo Ducale." *Arte veneta* 24 (1970): 103–10.

Tomadakis, Nicola B. "Oriente e occidente all'epoca del Bessarione." *Rivista di studi bizantini e neoellenici*, n.s. 5 ([15] 1968): 29–40.

Tramontin, Silvio. "Il 'Kalendarium' veneziano." In *Culto dei santi a Venezia*, edited by idem et al., pp. 275–327. (Biblioteca agiografica veneziana, vol. 2). Venice, 1975.

————. "La cultura monastica del Quattrocento dal primo patriarca Lorenzo Giustiniani ai Camaldolesi Paolo Giustiniani e Pietro Quirini." In *Storia della cultura veneta*, vol. 3: *Dal Primo Quattrocento al Concilio di Trento*, vol. 1, edited by G. Arnaldi and M. Pastore Stocchi, pp. 431–57. Vicenza, 1980.

Valcanover, Francesco. "Il restauro dell'Assunta." In *Tiziano, nel quarto centenario della sua morte, 1576–1976* (Lezioni tenute nell'Aula Magna dell'Ateneo Veneto), pp. 41–51. Venice, 1977.

————. "La Pala Pesaro." With technical notes by Lorenzo Lazzarini. *Quaderni della Soprintendenza ai Beni Artistici e Storici di Venezia* 8 (1979): 57–71.

————. "Il San Giovanni Battista di Donatello ai Frari." With technical notes by Lorenzo Lazzarini. *Quaderni della Soprintendenza ai Beni Artistici e Storici di Venezia* 8 (1979): 23–32.

————, and Corrado Cagli. *L'opera completa di Tiziano*. Classici dell'arte, 32. Milan, 1969.

———— et al. *La Pala Barbarigo di Giovanni Bellini. Quaderni della Soprintendenza ai Beni Artistici e Storici di Venezia*, 3. Venice, 1983.

Valentiner, W. R. "The Equestrian Statue of Paolo Savelli in the Frari." *Art Quarterly* 16 (1953): 281–92.

Vanbeselaere, Walther. *Musée des Beaux-Arts, Anvers Catalogue Descriptif, Maîtres anciens*. 2d ed. Antwerp, 1958.

Vast, H. *Le Cardinal Bessarion (1403–1472), Etude sur la chrétienté et la Renaissance vers le milieu du XVᵉ siècle.* Paris, 1878.

Verdier, Philippe. *Le couronnement de la Vierge, Les origines et les premiers développements d'un thème iconographique.* (Conférence Albert-le-Grand, 1972). Montreal and Paris, 1980.

Vio, Gastone. "La pala di Tiziano a S. Nicolò della Lattuga (S. Nicoletto dei Frari)." *Arte veneta* 34 (1980): 210–13.

Vlachos, Theodoros N. "Bessarion als päpstlicher Legat in Venedig im Jahre 1463." *Rivista di studi bizantini e neoellenici,* n.s. 5 ([15] 1968): 123–25.

Vogt, Berard. "Duns Scotus, Defender of the Immaculate Conception—An Historical-Dogmatic Study." *Studia Mariana* (Second Franciscan National Marian Congress, San Francisco) 9 (1954): 161–75.

Voragine, Jacobus de. *Sermones de sanctis per anni totius circulum.* Venice, 1573.

Waddingo, Luca. *Annales Minorum seu Trium Ordinum a S. Francesco Institutorum.* Edited by Joseph Maria Fonseca and Basilio Pandzic. 31 vols. Quaracchi, 1931–56.

Wagner-Rieger, Renate. "Zur Typologie italienischer Bettelordenskirchen." *Römische historische Mitteilungen* 2 (1957–58): 266–98.

Wethey, Harold E. *The Paintings of Titian, Complete Edition.* Vol. 1, *The Religious Paintings.* London, 1969.

Wilhelm, Pia. *Die Marienkrönung am Westportal der Kathedrale von Senlis.* Hamburg, 1941.

Wilk, Sarah. *The Sculpture of Tullio Lombardo, Studies in Sources and Meaning.* (Outstanding Dissertations in the Fine Arts). New York and London, 1978.

———. "Titian's Paduan Experience and Its Influence on His Style." *Art Bulletin* 65 (1983): 51–60.

———. "La Decorazione cinquecentesca della Cappella dell'Arca di S. Antonio," in *Fonti e studi per la storia del Santo a Padova,* vol. 8, *Le Sculture del Santo di Padova,* edited by Giovanni Lorenzoni (Vicenza, 1985), pp. 109–72.

Wilson, Carolyn. "Giovanni Bellini's Pesaro Altarpiece, Studies in Its Context and Meaning." Ph.D. diss., New York University, Institute of Fine Arts, 1976.

Winternitz, Emanuel. "A *Lira da Braccio* in Giovanni Bellini's *The Feast of the Gods.*" *Art Bulletin* 28 (1946): 114–15.

Wittkower, Rudolf. "Transformations of Minerva in Renaissance Imagery." *Journal of the Warburg and Courtauld Institutes* 2 (1938–39): 194–205.

———. *Architectural Principles in the Age of Humanism.* Columbia University Studies in Art History and Archaeology, 1. New York, 1962.

Wolter, Allan B. "Doctrine of the Immaculate Conception in the Early Franciscan School." *Studia Mariana* (Second Franciscan National Marian Congress, San Francisco) 9 (1954): 26–69.

Wolters, Wolfgang. "Der Programmentwurf zur Dekoration des Dogenpalastes nach dem Brand vom 20. Dezember 1577." *Mitteilungen des Kunsthistorischen Institutes in Florenz* 12 (1966): 271–81.

———. "Freilegung des Signatur an Donatellos Johannesstatue in S. Maria dei Frari." *Kunstchronik* 27 (1974): 83.

———. *La scultura veneziana gotica (1300–1460).* 2 vols. Venice, 1976.

———. *Der Bilderschmuck des Dogenpalastes, Untersuchungen zur Selbstdarstellung der Republik Venedig im 16. Jahrhundert.* Wiesbaden, 1983.

Wratislaw-Mitrovic, Ludmila, and N. Okunev. "La Dormition de la Sainte Vierge dans la peinture mediévale orthodoxe." *Byzantinoslavica* 3 (1931): 134–80.

Zabarella, Giacomo. *Il Carosio, overo origine regia et augusta della serenissima fameglia Pesari di Venetia, Libro Primo.* Padua, 1659.

Zawart, Anscar. "The History of Franciscan Preaching and of Franciscan Preachers (1209–1927), A Bio-bibliographical Study." *The Franciscan Educational Conference* 9 (1927): 242–587.

Zenier, Vincenzo. *Guida per la chiesa di S. Maria Gloriosa dei Frari di Venezia.* Venice, 1825.

Index

All monuments and institutions are in Venice, unless otherwise noted.